FROM THE FILMS OF

CREATURES
— of the —
WIZARDING WORLD

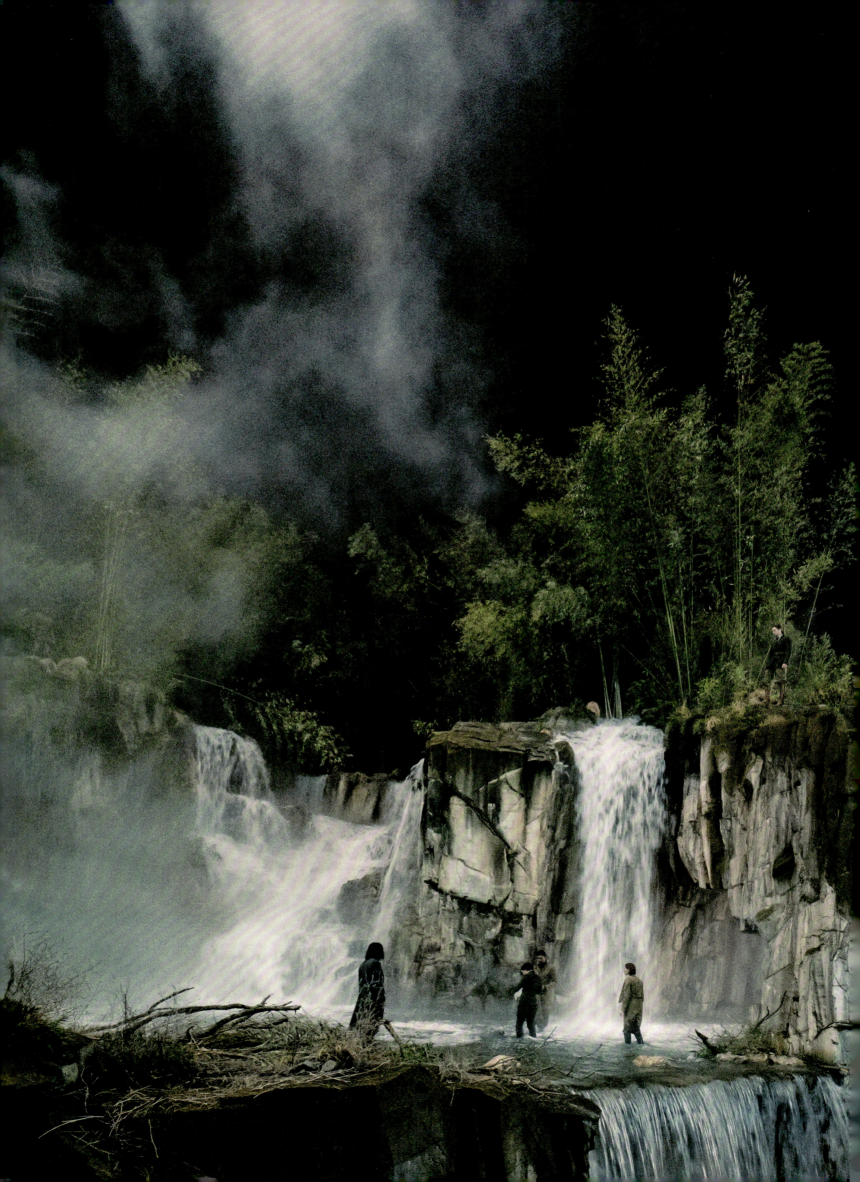

FROM THE FILMS OF

CREATURES
— of the —
WIZARDING WORLD

by

JODY REVENSON

SAN RAFAEL · LOS ANGELES · LONDON

Contents

Introduction . 6

HOGWARTS CASTLE & GROUNDS • 8

Cornish Pixies . 10	Centaurs . 34
Hippogriff . 13	Unicorn . 39
Boggart . 19	Thestrals . 40
Merpeople . 21	Three-Headed Dog . 45
Grindylows . 24	Troll . 46
Acromantula . 29	Giants . 49

DRAGONS • 53

Norwegian Ridgeback . 54	Common Welsh Green, Chinese Fireball & Swedish Short-Snout . 64
Hungarian Horntail . 57	Ukrainian Ironbelly . 69

COMPANIONS • 73

Fang . 74	Hedwig . 87
Mrs. Norris . 77	Pigwidgeon . 89
Crookshanks . 78	Errol . 90
Trevor . 80	Teddy . 93
Ginny's Pygmy Puff . 81	Pickett . 96
Fawkes . 82	

NEWT SCAMANDER'S CREATURES • 101

Murtlap . 102	Demiguise . 118
Fwooper . 104	Occamy . 121
Billywig . 105	Runespoor . 122
Diricawl . 107	Doxy . 123
Swooping Evil . 108	Erumpent . 126
Thunderbird . 111	

Nundu 131	Kelpie 140
Graphorn 132	Hinkypunk 141
Mooncalf 135	Leucrotta 142
Baby Nifflers 136	A Magizoologist's Tools 144
Augurey 139	Environments 149

ANIMAGI • 155

Cat Animagus: Minerva McGonagall 156	Rat Animagus: Scabbers/Peter Pettigrew 160
Dog Animagus: Padfoot/Sirius Black 159	

HOUSE-ELVES & GOBLINS • 163

Dobby 164	Gringotts Goblins 173
Kreacher 169	Griphook 176

WIDER WIZARDING WORLD • 181

Werewolf: Remus Lupin 183	Matagots 202
Werewolf: Fenrir Greyback 187	Serpent 204
Basilisk 189	Chupacabra 208
Dementor 193	Wyvern 209
Inferi 196	Quilin 210
Manticore 201	

CIRCUS ARCANUS • 213

Zouwu 214	Kappa 220
Firedrake 219	Oni 221

Introduction

Harry Potter: Creatures of the Wizarding World goes behind the feathers and fur to explore the visualization, creation, and significance of the many creatures that fly, swim, slither, and gallop in the Harry Potter and Fantastic Beasts films. Personal narratives of the concept artists, creature department designers, and visual effects crew members illustrate how dragons, Bowtruckles, and shape-shifters are brought to life on the screen, from an eighteen-foot-tall Acromantula to a four-inch-tall manticore. With years of filmmaking experience, the creature creators and digital artists have tackled every challenge given to them using time-honored techniques and new practical and digital technologies. Within this book, you'll embark on the most captivating and magical journey of the wizarding world's creatures.

Concept artists for the Harry Potter films explore not only the look of the creatures that appear with Harry Potter and other characters but also their personalities and individualism. Concept artist Dermot Power explains, "The most important part of our job is to ask questions." Power says it's the "sketchy stuff" he does at the start of the film, often just for himself, that helps him think through what questions need to be asked and answered: "So, what are the parameters of what we need to design? What are the character traits and what are the story points?" It takes many iterations of rough sketches, production paintings, and computer-created visuals with input from the director and producers before all the questions are answered, resulting in the beautiful artwork seen in books such as this one.

"On top of the actual look of the creature, we think about how the creature moves and behaves," says production visual effects supervisor Tim Burke. "We look at animation, we reference real-world creatures if we can. If it's a Thestral, we might start looking at how a horse moves. If it's a Hippogriff flying, we might look at how an eagle flies. We'll bring all these things into the mix to start analyzing how real creatures behave, and then create hybrids of movement and character that ... become the magical creature we want to create."

Throughout the series, the artists have always observed the principle that all the creatures must have a foundation in the natural world to ensure believability. "From the beginning, producer David Heyman always said that although this is a fantasy series, and it's about magic, it's real. It's got to read as real," says Nick Dudman, special creature and makeup effects designer for the eight Harry Potter films.

For this process, the fantastical creatures seen on-screen in the Harry Potter films would first be conceived in ink, pencil, or oils by the visual development artists, and then these images would be converted into three-dimensional sculpted maquettes, with complete coloring and textures. These models would provide inspiration and direction for the teams of animatronic designers if the creature was to be a practical construction. If the creature was to be rendered in a digital form, the maquettes would be cyberscanned for the visual effects artists to bring to life with movement and expression.

Fantastic Beasts and Where to Find Them changed this process by going directly from two-dimensional concepts to three-dimensional digital versions. For this, visual artists were brought into the film development process earlier than ever before. "We were given a lot of creative freedom from the beginning," says senior animation supervisor Pablo Grillo, who was in charge of the movement, performance, action, and design of many of the beasts seen in these films. "[Director] David Yates saw the value in bringing the animation team in from the start, to shape how these creatures were going to come together. There was almost an alarming level of trust in us and the team," he laughs. "We were put in charge of overseeing how the animals were going to grow into real characters, and not just the flat images we drew them as."

For several months, the animators, producers, and Yates would brainstorm dramatic or humorous moments that could be given to the creatures before selecting those that would make it into the final film. "From there, we could start to formulate behavior and visual gags; little quirks that actually informed the final script," says Grillo, "and build them into the big set pieces. It was an incredibly fulfilling process overall, mainly because of the challenges open to us."

The creatures in the Harry Potter and Fantastic Beasts films "are very important to the story," says David Heyman. Harry Potter's and Newt Scamander's stories could not be told without them. With a tip of a wizard's hat toward *The Monster Book of Monsters*, the following volume compiles striking artwork, memorable screen captures, and fascinating behind-the-scenes information about the magical, unforgettable creatures encountered on-screen in the Harry Potter and Fantastic Beasts films.

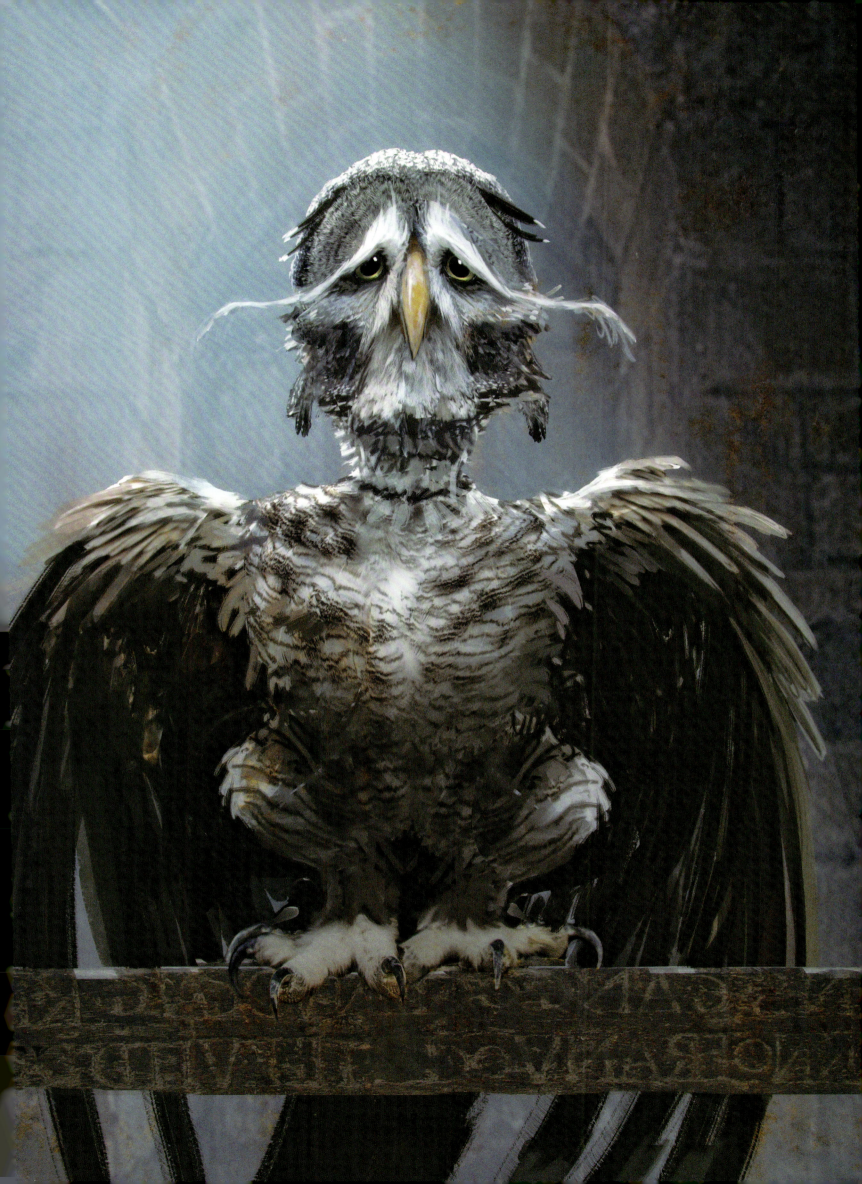

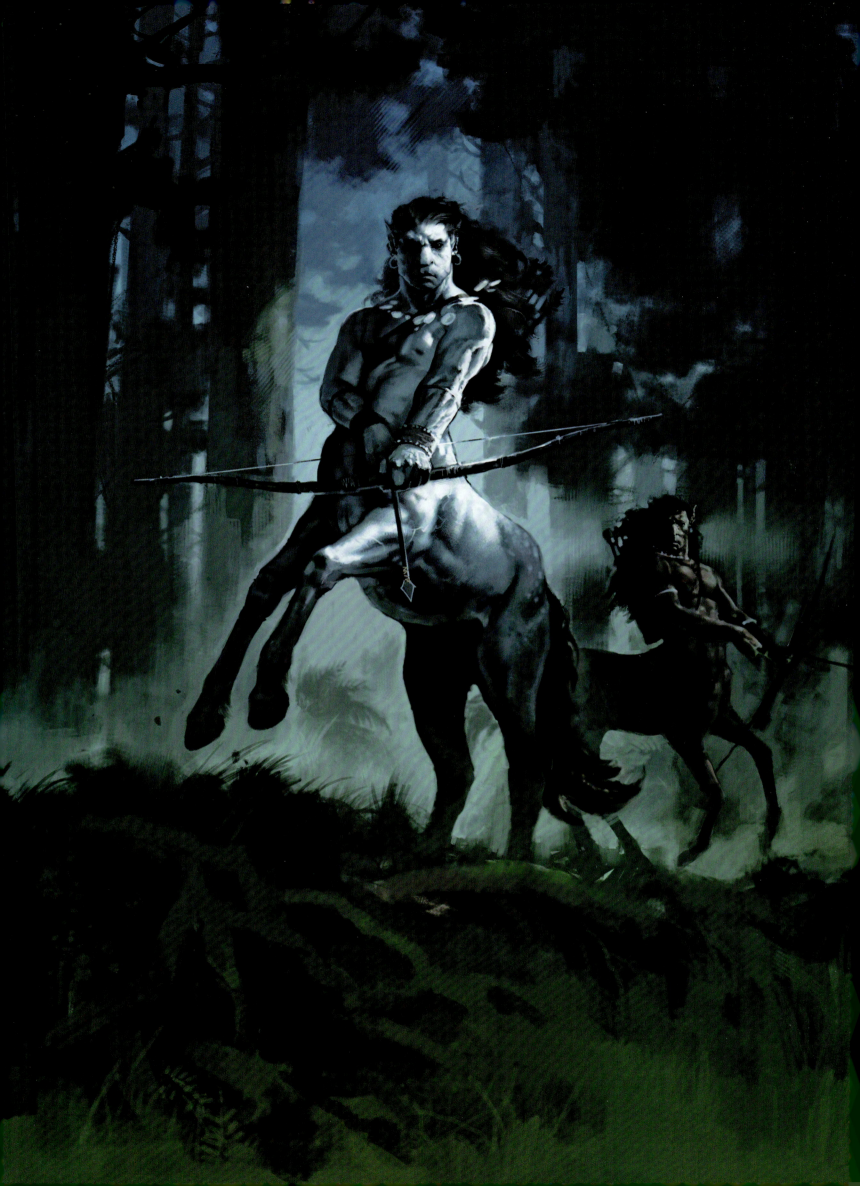

CHAPTER

1

HOGWARTS
CASTLE & GROUNDS

HOGWARTS CASTLE & GROUNDS

Cornish Pixies

For Professor Gilderoy Lockhart's first Defense Against the Dark Arts class, in *Harry Potter and the Chamber of Secrets*, he teaches the students how to arm themselves against "the foulest creatures known to wizard-kind." He knocks his wand against a small bell-shaped cage perched on a table next to his desk, causing the cage to shake back and forth. Then, with a showman's flair, Lockhart turns slowly, tells the class not to scream, and whips the covering off the cage. Inside are more than twenty electric blue creatures, roughly eight inches tall, with pointed faces and wings. They rattle the bars and pull bizarre faces at the students.

Seamus Finnigan laughs at the sight—they're Cornish Pixies! "Freshly caught Cornish pixies!" Lockhart admonishes him. And then opens the door to the cage.

Once released, the Cornish pixies become the ill-mannered, "devilishly tricky little blighters," as Lockhart describes them. They fly around the classroom knocking books off shelves and desks, pulling at the students' hair, and generally acting annoying and mischievous.

The creature department created life-size maquettes of Cornish pixies, which were then cyberscanned for the visual effects team to perform their own mischievousness. The team placed the computer-made Cornish pixies on three different levels within the scene—background, midground, and foreground—to create a sense of depth.

The special effects crew also worked their magic, using tried-and-true practical ways to cause mayhem. Thin wires tugged the books onto the floor and pulled at the actors' hair. Digital artists then painted these wires out. Some actors also surreptitiously pushed books off their desks.

In the scene, a pair of pixies raise Neville Longbottom up by his ears and hang him by his cloak on the classroom's chandelier. Actor Matthew Lewis wore clips on his ears to push them forward, thereby creating the effect of the two Pixies flying him up toward the ceiling. Lewis says that scene contains his favorite line of all for his character: "Why is it always me?"

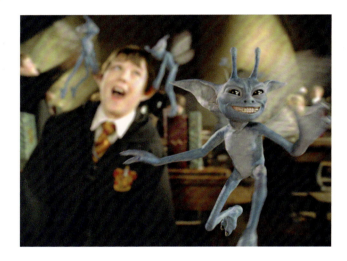

Then the pixies break the chain holding the dragon skeleton, dropping it to the floor. That's enough for Lockhart, who races up the stairs to his office, asking Harry, Ron, and Hermione to get the Pixies back in their cage. Hermione casts *Immobulus*, and the Cornish Pixies are suspended in air.

Though the Cornish pixies disappear after Lockhart's inept lesson, they're seen again in *Harry Potter and the Deathly Hallows – Part 2*. When Harry searches the Room of Requirement for the Ravenclaw Diadem, he climbs a mountain of furniture. Reaching inside to retrieve the diadem, he unintentionally grabs a pixie and flings it away just as a flock of pixies flies out and into another part of the room after having been discovered.

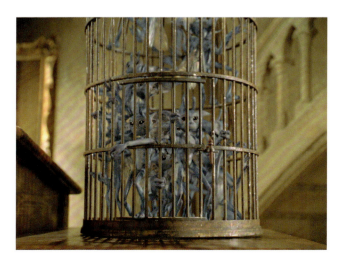

PAGE 2: **Unit photography for *Fantastic Beasts: The Secrets of Dumbledore* shows Credence Barebone (Ezra Miller) and other acolytes capturing a Qilin in the Tianzi Mountains.**
PAGE 7: **Concept artist Sam Rowan pictured the Augurey, a mournful-looking magical bird, with the attributes of an old, pompous knight for *Fantastic Beasts: The Crimes of Grindelwald*.**
PAGE 8: **Centaurs in the Dark Forest prepare to defend themselves in artwork by Adam Brockbank for *Harry Potter and the Order of the Phoenix*.**
LEFT: **A cage of "freshly caught" Cornish pixies used in Professor Lockhart's first Defense Against the Dark Arts lesson in *Harry Potter and the Chamber of Secrets*.**
TOP: **Cornish pixies carry Neville Longbottom (Matthew Lewis) upward by his ears and leave him hanging from a chandelier in class.**
OPPOSITE LEFT AND MIDDLE: **Electric blue Cornish pixies, portrayed by Rob Bliss.**
OPPOSITE FAR RIGHT: **A study of Cornish pixie wings by artist Rob Bliss.**

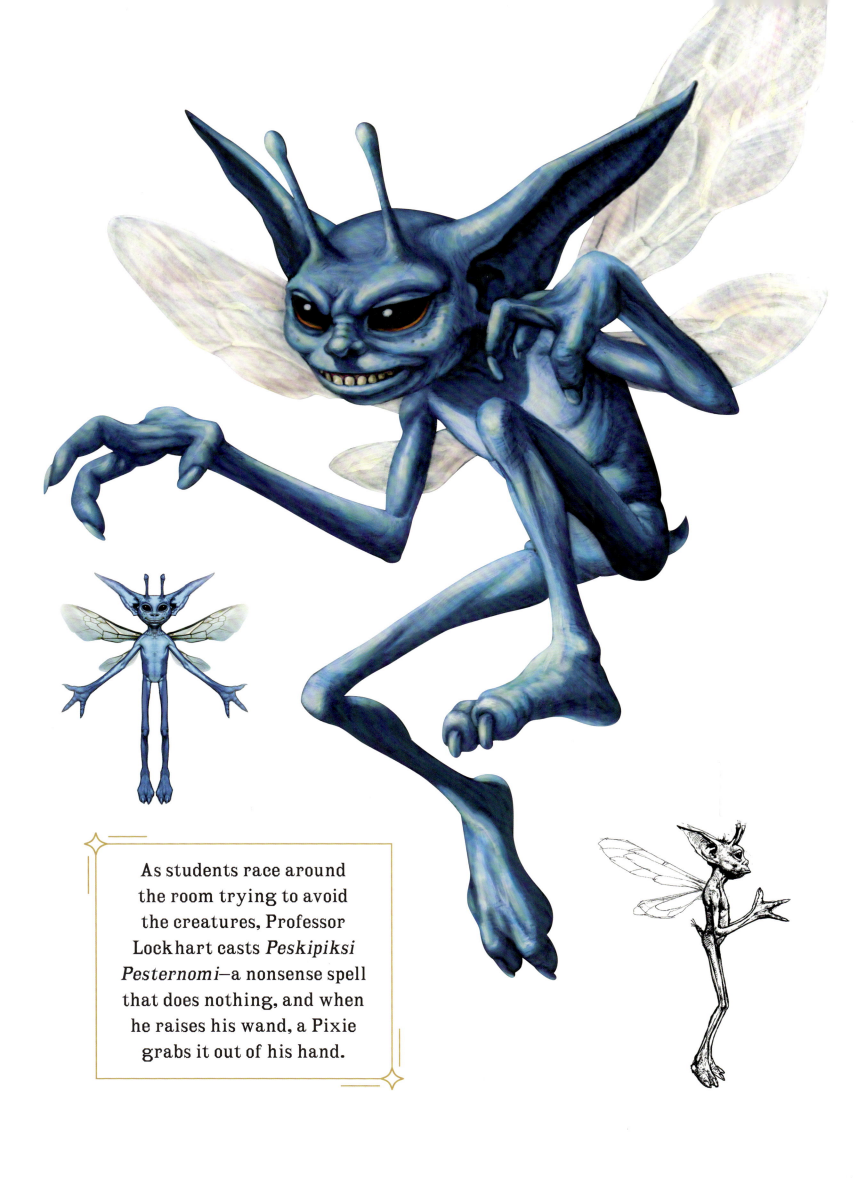

As students race around the room trying to avoid the creatures, Professor Lockhart casts *Peskipiksi Pesternomi*—a nonsense spell that does nothing, and when he raises his wand, a Pixie grabs it out of his hand.

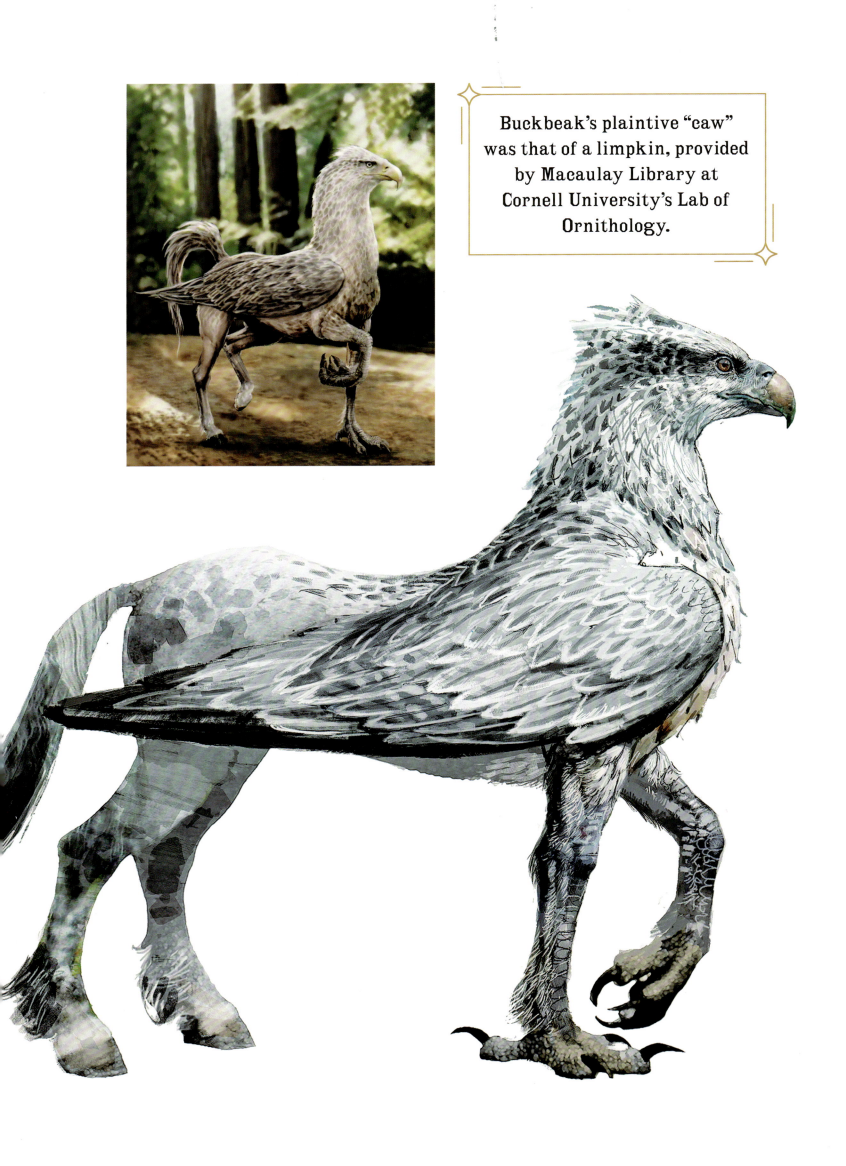

Buckbeak's plaintive "caw" was that of a limpkin, provided by Macaulay Library at Cornell University's Lab of Ornithology.

HOGWARTS CASTLE & GROUNDS

Hippogriff

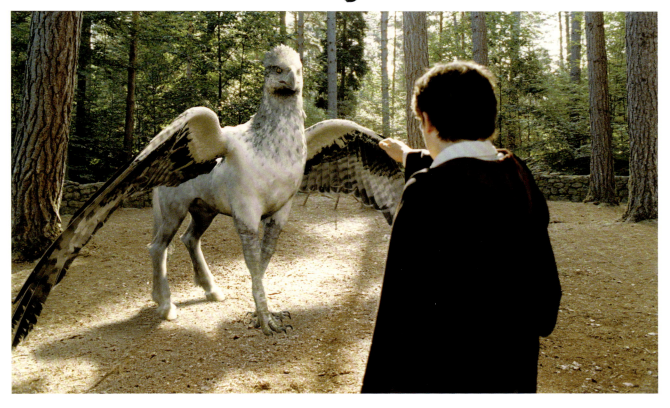

In the first lesson of Care of Magical Creatures, in *Harry Potter and the Prisoner of Azkaban*, new professor Rubeus Hagrid brings out a Hippogriff. "Isn't he beautiful?" asks Hagrid. "Say hello to Buckbeak."

The mythological Hippogriff is half horse, half eagle. Buckbeak is one of the few composite creatures in the Harry Potter films with a divide between its two species. The designers wanted the Hippogriff to be believable, so they met with veterinarians and biologists. They also visited bird sanctuaries to observe birds in flight and studied horses walking and galloping in fields, and noted how each animal's body was structured for different movements. Director Alfonso Cuarón's intention was that although Buckbeak was clumsy on the ground, when he flew it would be with grace and controlled power. Although the horse half was fairly generic, concept artist Dermot Power gave Buckbeak the profile of a golden eagle.

Once the Hippogriff's design was approved, it was used as a reference for a rough scanning model. Buckbeak's true form came through digital explorations of his modes of walking and flying. "One of the first things we did," remembers executive producer Mark Radcliffe, "was go to the computer and say, 'Okay, if it's a horse back end with bird front legs, how does it move, how does it run, and how does it fly? Just how wide do the wings have to be to carry a creature the size of a horse?'" These computer-generated studies helped the creature shop refine the proportions of the Hippogriff's limbs so that he wouldn't trip when he walked or fell to the ground when carrying passengers.

"I didn't realize how difficult it was going to be to create Buckbeak," admits director Alfonso Cuarón. "Once we worked out the physiology, the way his bones would actually move, we had to capture his personality, which is a mixture of regal elegance, particularly when he is flying, and the clumsy and greedy creature he becomes back on land." Early animation of Buckbeak had him jumping and playing in a puppyish manner, but Cuarón asked the visual effects team to age him up, saying Buckbeak should be like a "sloppy teenager."

ABOVE: **Harry Potter (Daniel Radcliffe) approaches the Hippogriff at the beginning of the Care of Magical Creatures class.**
OPPOSITE: **A study of Buckbeak by artist Dermot Power and the realized animatronic version seen in *Harry Potter and the Prisoner of Azkaban*.**
FOLLOWING PAGES: **Buckbeak the Hippogriff dips its talons in the waters of the Black Lake as he and Harry Potter take a thrilling ride.**

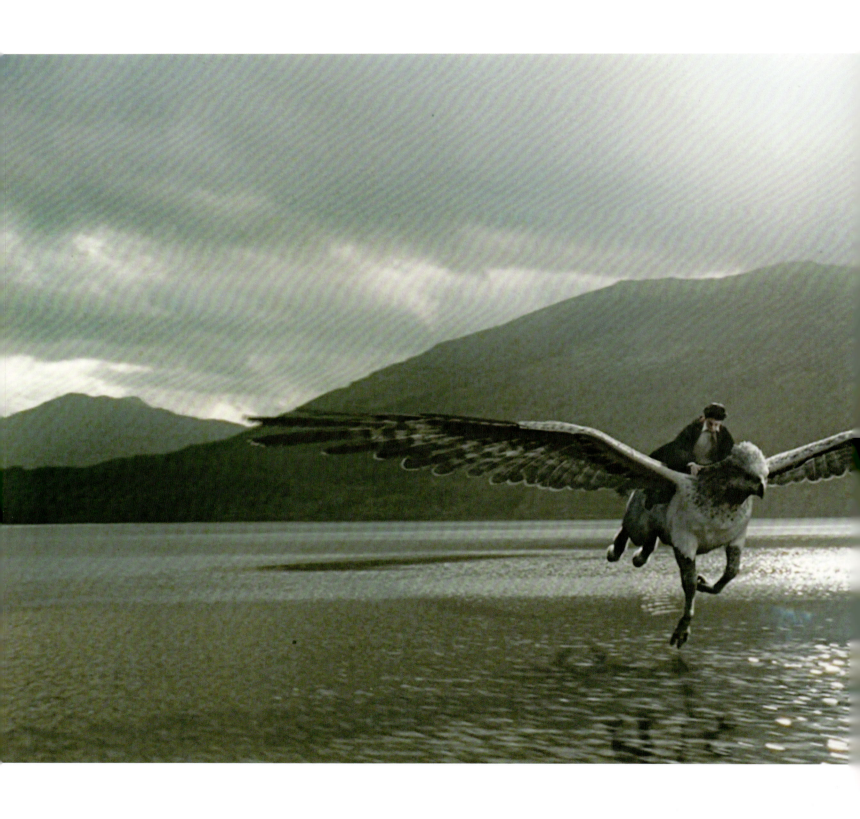

HOGWARTS CASTLE & GROUNDS

The finalized digital design was made into a full-size animatronic version that employed aquatronics for its movement. Aquatronics uses cables pumped with water instead of the oil-based system used in hydraulics.

The creatures effects team flocked, airbrushed, and painted the horse parts of the maquette. Flocking "shoots" small fuzzy hairs onto a creature model. First, the model is wetted with a layer of glue, then an electrical charge is sent through it while oppositely charged hairs are fired at the model. "Because they are oppositely charged, every hair that sticks to the sculpt stands on end," explains special creature and makeup effects designer Nick Dudman. "You've got exactly forty minutes before the glue sets to comb every single strand of fur and hair in place. If you make a mistake and don't finish in time, you have to start from scratch—and all the work is lost.

"That was nothing compared to the bird half," Dudman continues. "Each feather had to be individually inserted and glued." Feather expert Val Jones led the creatures effects team as it added feathers right up to the morning the first model was needed on set. The figure was cyberscanned for the computer graphics animators.

"Buckbeak was one of the most complicated elements because it was so interactive with our characters," Cuarón admits. "First, we had to decide how this character would move and how we could give it a sense of weight. Once

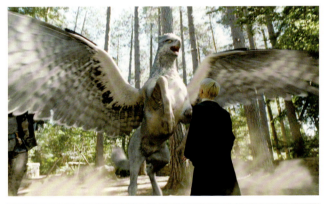

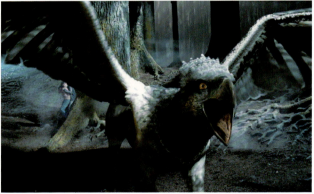

TOP RIGHT: **Golden eagles influenced the head and profile design of the Hippogriff. Artwork by Dermot Power for *Harry Potter and the Prisoner of Azkaban*.**
TOP: **Draco Malfoy's (Tom Felton) lack of respect for Buckbeak does not end well.**
ABOVE: **Hermione (Emma Watson) and Harry (Daniel Radcliffe) rescue Buckbeak from execution, hiding him in the Dark Forest.**
OPPOSITE: **Hagrid introduces Harry to Buckbeak the Hippogriff in artwork by Dermot Power.**

we got the main elements down, it became more about animating the character. And, again, we wanted to make something that would be realistic." So much so, he continues, "that if people watch carefully, in the scene where Buckbeak lives in the paddock, you will see he actually poos. Buckbeak poos! It's not a big deal; it's just a matter-of-fact thing that Buckbeak does."

Four Buckbeaks were created for the film. Three were life-size models built for specific purposes. "We had a lying-down Hippogriff built for the pumpkin patch," Dudman explains, which could move its wings, nostrils, eyes, tongue, and neck, and "a standing Hippogriff on a counterbalanced pole arm so we could control the creature in foreground shots." This one could curl its claws, splay its wings, and move its right foreleg and left hind leg to bow. The third Hippogriff stood in the background of shots, mainly used as reference for the computer artists, as he was not constructed for movement. The fourth Hippogriff was digital and did all the walking, running, and flying.

Although every effort was made for the Buckbeaks to match, there was a slight adjustment made in wing length between the radio-controlled and digital versions. The digital Buckbeak's wings extended to twenty-eight feet, which gave his flight majesty. Wings of that length would drag on the ground when closed, so the wings were "trimmed" to twenty feet when Buckbeak was earthbound, allowing them to fold properly against his body.

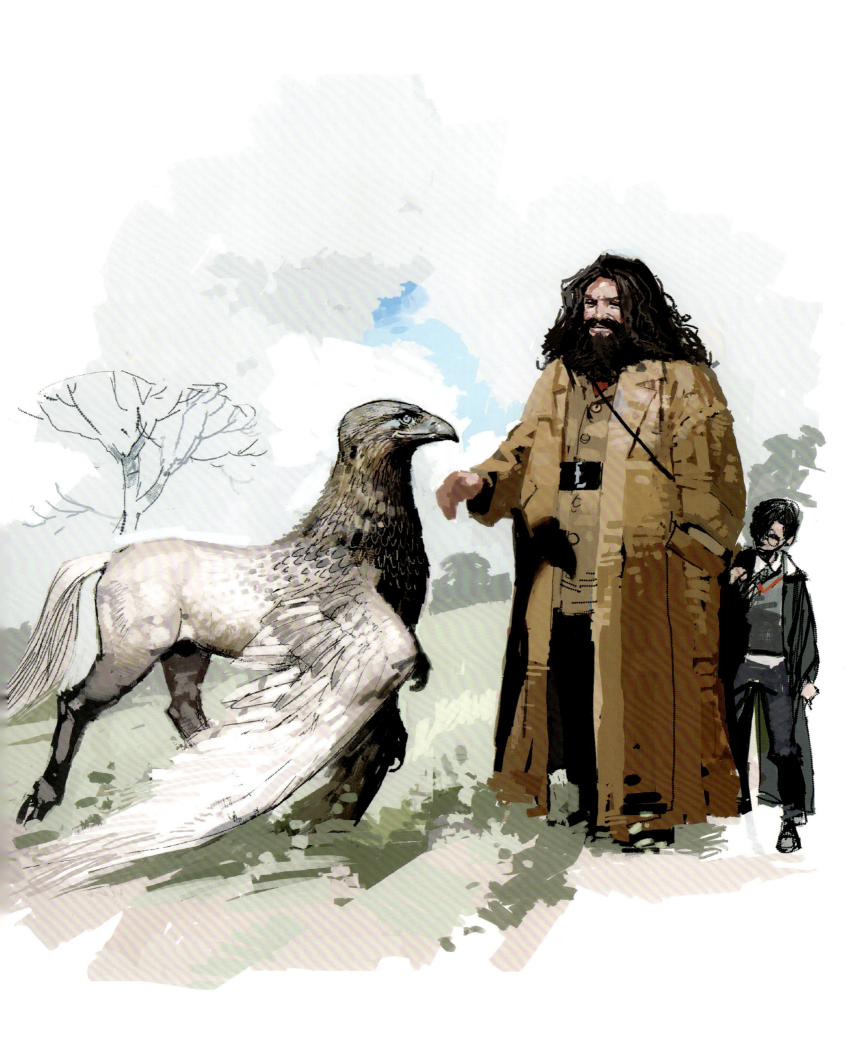

Remus Lupin uses the Boggart again in a private lesson with Harry to teach him the Patronus Charm in defense against Dementors. As Harry is not casting *Riddikulus*, the form Harry sees does not change.

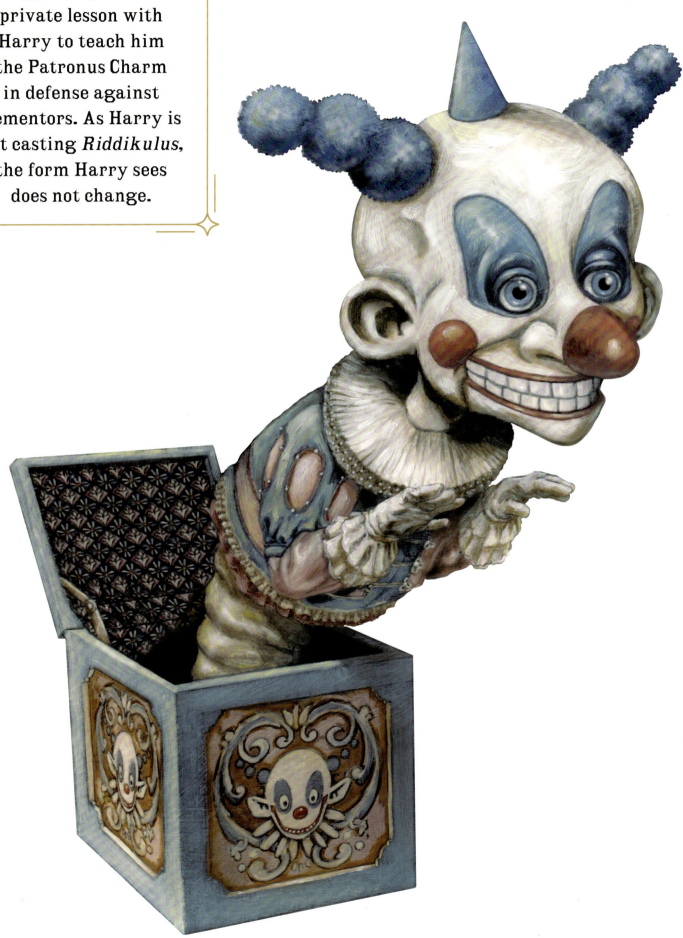

HOGWARTS CASTLE & GROUNDS

Boggart

In one of Harry's first classes with Defense Against the Dark Arts professor Remus Lupin, in *Harry Potter and the Prisoner of Azkaban*, the students find a large, mirrored wardrobe that shakes and rattles in place. "Would anyone like to venture a guess as to what is inside?" Lupin asks the students. Dean Thomas answers correctly: It's a Boggart. "Now," Lupin continues, "can anybody tell me what a Boggart looks like?" Hermione answers, "No one knows."

Boggarts are shape-shifting creatures that take the appearance of whatever a particular person fears the most. Lupin is there to teach them the *Riddikulus* charm, which is used to repel a Boggart, forcing the creature to assume a shape that the caster finds truly amusing. Boggarts can be defeated by laughter.

Lupin picks Neville Longbottom to be the first student to cast the charm. When asked by the professor what frightens him most of all, he can barely get the answer out: Professor Snape. Lupin murmurs, "Snape frightens all of us." Then he asks Neville about living with his grandmother and tells Neville to picture the clothes she wears.

Professor Snape emerges from the cabinet, but after Neville casts *Riddikulus*, Snape is suddenly wearing Neville's grandmother's tweed skirt ensemble and her large, bird-topped hat. Recalling the scene, actor David Thewlis (Lupin) cannot help but laugh. "I think it was Alan Rickman's worst fear!" he says. When asked in an interview what Snape would have thought about the transformation, Alan Rickman (Snape) replied, "Snape isn't one who enjoys jokes—I strongly fear that his sense of humor is extremely limited."

Ron Weasley sees a huge, eight-legged spider when the Boggart switches its attention to him. Once the charm is cast, there are roller skates on the spider's legs, which cause it to clumsily slip and slide around. Parvati Patil transforms a hissing cobra into a bouncing jack-in-the-box.

Harry Potter comes up next, and the Boggart turns into a Dementor. But Lupin intercedes and places himself in front of the Boggart, causing the Dementor to change into a full moon that peers out above a shadowy sky. Once Lupin casts *Riddikulus*, the moon turns into a white balloon that whips around the classroom while it deflates. Lupin locks the door when the Boggart disappears back into the cabinet.

Because no one knows the true appearance of a Boggart, the digital artists did not need to create one, but they did need to visualize the transition of the creature from each fear to its laughable version several times. Director Alfonso Cuarón didn't want this to be solid, nor did he want it to be transparent, so the designers interpreted the changes between the fearsome and funny iterations as a whirling tornado of both forms.

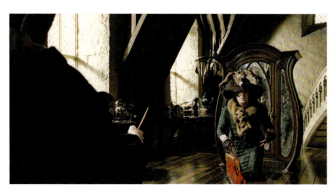

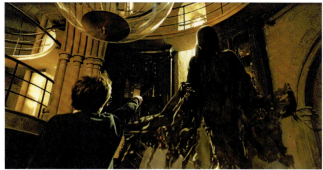

OPPOSITE: **Jack-in-the-box artwork for *Harry Potter and the Prisoner of Azkaban*.**
TOP LEFT: **Neville Longbottom's greatest fears combined and realized by the Boggart: Professor Severus Snape (Alan Rickman) in Neville's grandmother's bird-topped outfit.**
LEFT: **The Boggart manifests Harry Potter's fear: Dementors.**
ABOVE: **Parvati Patil turns her fear of a giant snake into a bobbing jack-in-the-box.**

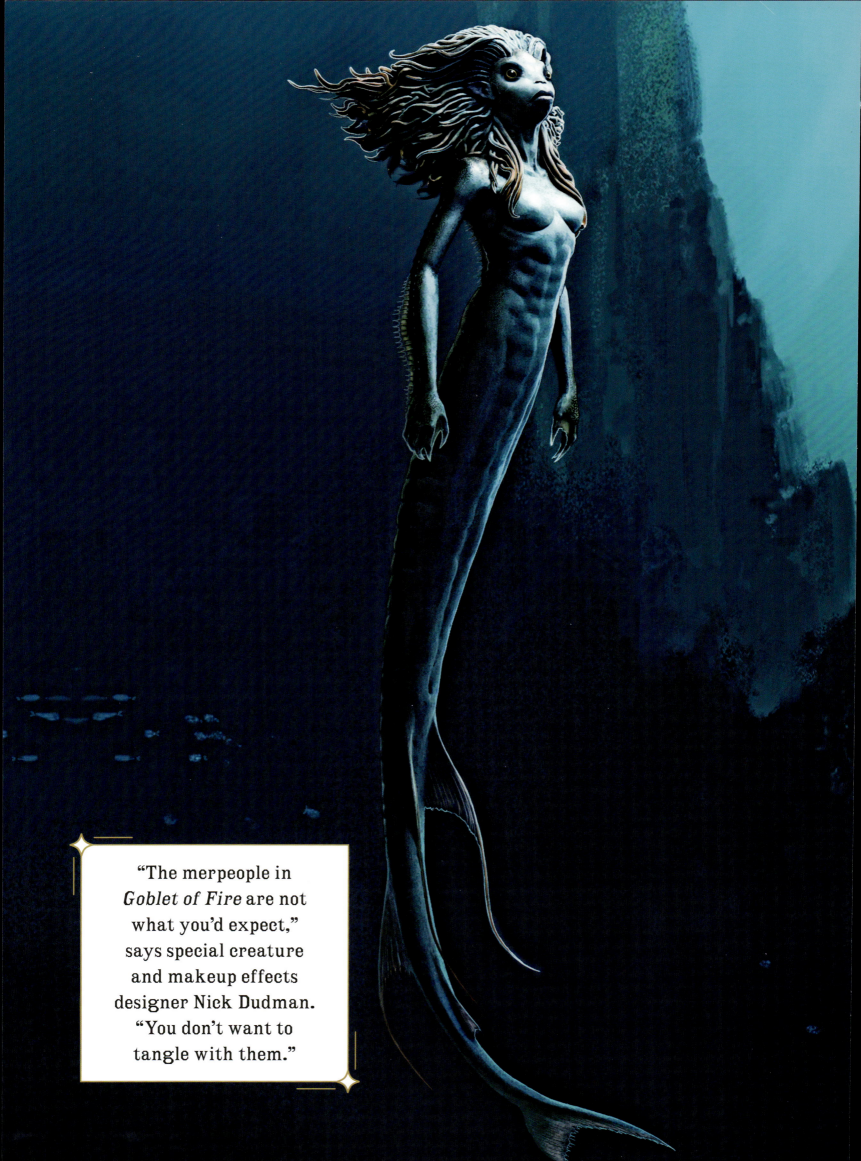

"The merpeople in *Goblet of Fire* are not what you'd expect," says special creature and makeup effects designer Nick Dudman. "You don't want to tangle with them."

HOGWARTS CASTLE & GROUNDS

Merpeople

The second task for the champions of the Triwizard Tournament is to retrieve someone dear to them—for Harry, it's Ron Weasley. This challenge, which they have one hour to accomplish, takes place under the waters of the Black Lake, as seen in *Harry Potter and the Goblet of Fire*. This proves to be easier said than done, as there are merpeople under the surface who are monitoring—but not helping—the champions and their actions.

Concept artist Adam Brockbank was assigned to visualize the merpeople, who are both beguiling and threatening. "In the previous films with the creature design, we'd set the principle of naturalism and believability," says Brockbank. "With the merpeople, it seemed a logical step to remain faithful to that philosophy. Rather than have the traditional break between the fish part and the human part like that of a mermaid, it was to not to have that break, and to continue that 'fishiness' up into the human part. So, the scales continue up the long body, and there are large, fishlike eyes and a fishlike mouth." The aggressive species also has very sharp teeth.

Instead of hair, early conceptions of the merpeople had tentacles like an octopus's. The idea of octopus parts was dropped, but from that came the final design of the merpeople's hair, which resembles the floating, translucent strands of sea anemones.

Other breaks with the traditional human–sea creature combination included a tail that moved side to side instead of up and down, and the addition of dorsal and pelvic fins for stability. The merpeople were heavily influenced by tuna and sturgeon for textures, proportions and, literally, scales. The merpeople's skin bears the bony, shield-like plates, called scutes, that appear in parallel rows down a sturgeon's body.

Another traditional characteristic of anthropomorphized aquatic creatures is a color palette of silvers and aquas. In keeping with the merpeople's antagonistic nature, designers chose a dark palette of muddy browns and greens instead. With the final design approved, filmmakers sculpted it into a series of reference maquettes, one at full size, to create the digital model.

One of the trickiest challenges the digital artists faced was accomplishing a shiny appearance for the merpeople's skin, as something that looks slimy out of water doesn't look slimy underwater. The merpeople's hair also needed a little extra attention. In order to avoid their tentacles "flattening" in the underwater environment, a little extra turbulence was required in the water around their heads.

With his own flippers and fins, courtesy of swallowing Gillyweed, Harry swims to the "treasures" and rescues Ron. Seeing that the sister of Beauxbatons champion Fleur Delacour has still not been freed and the hour is almost up, he tries to release her, too. He's stopped by a trident-wielding merperson insisting he can rescue only one. But Harry being Harry, he takes Gabrielle Delacour with him, ending up in second place for this second task.

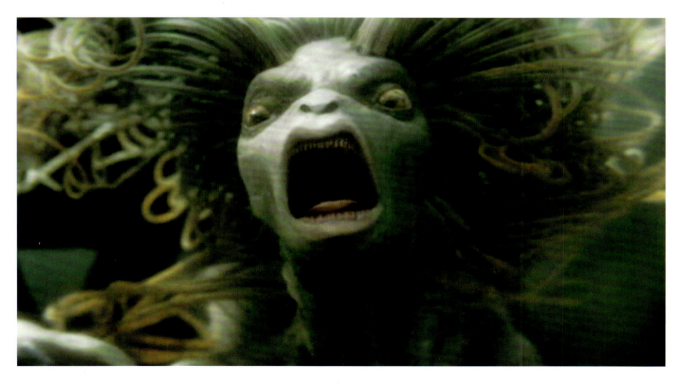

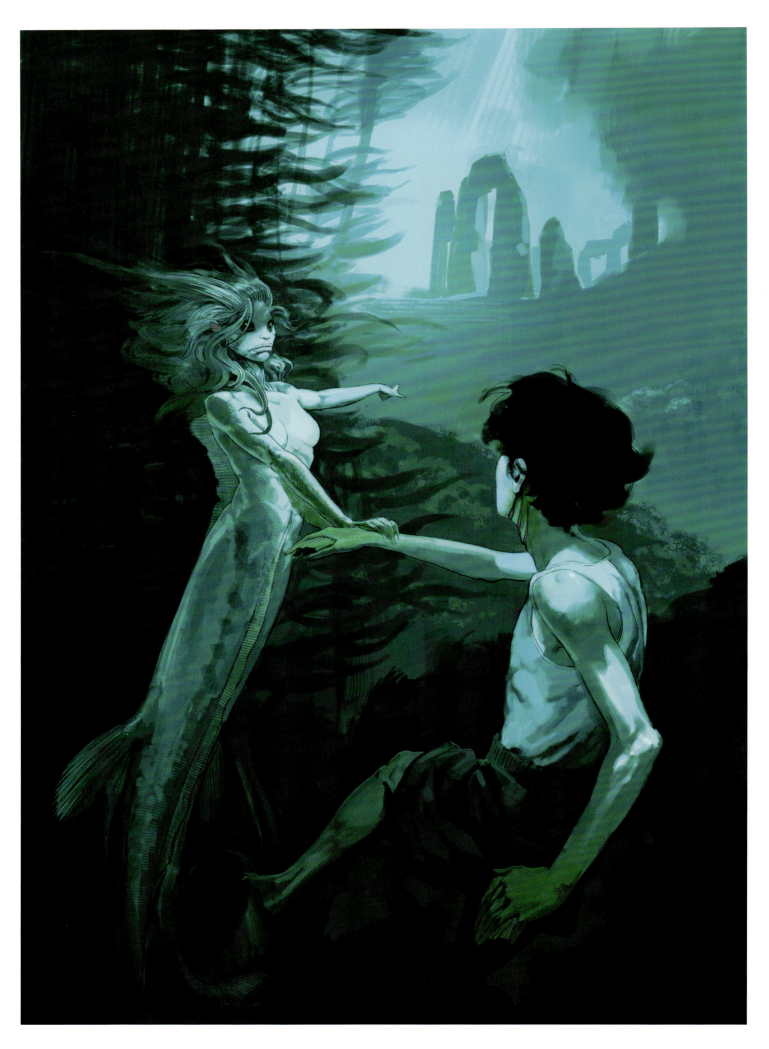

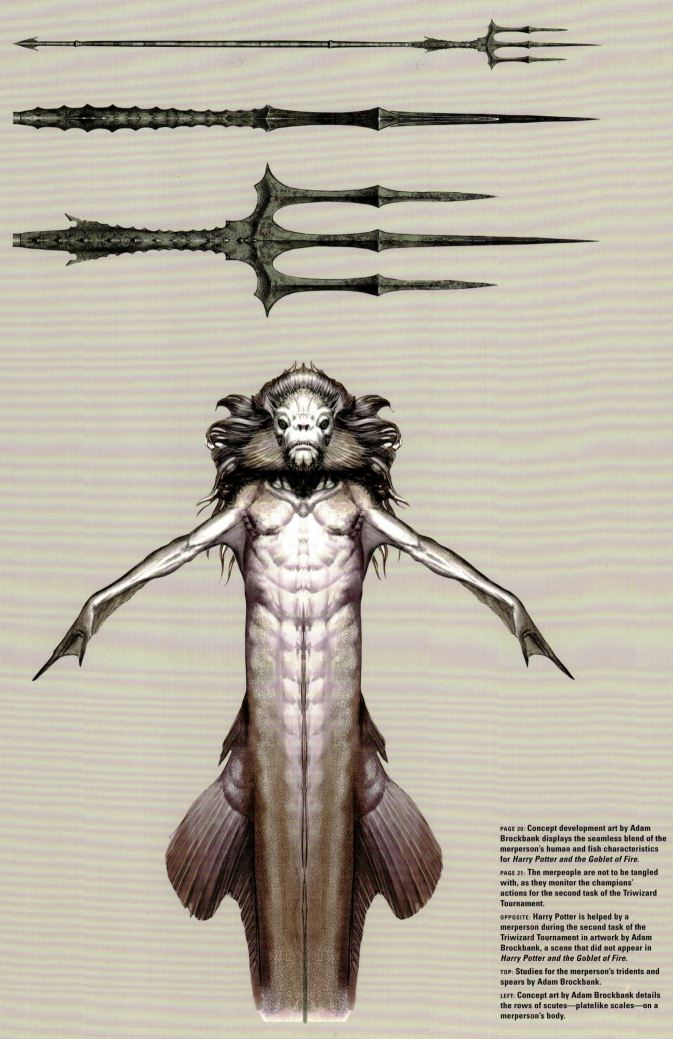

PAGE 20: Concept development art by Adam Brockbank displays the seamless blend of the merperson's human and fish characteristics for *Harry Potter and the Goblet of Fire*.

PAGE 21: The merpeople are not to be tangled with, as they monitor the champions' actions for the second task of the Triwizard Tournament.

OPPOSITE: Harry Potter is helped by a merperson during the second task of the Triwizard Tournament in artwork by Adam Brockbank, a scene that did not appear in *Harry Potter and the Goblet of Fire*.

TOP: Studies for the merperson's tridents and spears by Adam Brockbank.

LEFT: Concept art by Adam Brockbank details the rows of scutes—platelike scales—on a merperson's body.

HOGWARTS CASTLE & GROUNDS

Grindylows

During the second task of the Triwizard Tournament under the Black Lake, Harry also encounters Grindylows, nasty little creatures that special creature and makeup effects designer Nick Dudman describes as a cross between "an octopus and a demonic child."

As Harry struggles to get Ron Weasley and Gabrielle Delacour to the surface before time runs out on the task, a swarm of Grindylows suddenly pulls his feet down. Harry pushes the two upward and is left to deal with the creatures, who grab at his face and feet, just as the effects of Gillyweed, taken to temporarily grow gills and fins, begins to wear off. They drag him lower and lower until he casts a nonverbal spell to immobilize them, and then casts *Ascendio* so he can rise out of the lake.

The visual development artists spread a wide net to gather concepts. Early sketches of Grindylows by artist Paul Catling gave them small heads and only two legs. As ideas continued to develop, Grindylows were portrayed with two webbed feet, then eight webbed hands, and also with glowing eyes; huge, dark eyes; long tails; pointed ears; and even horns. Some resembled frogs or seals. There was also an angler, fishlike, luminescent version capable of deep-sea swimming, and one with a mermaid's tail.

"The design evolved over a long period of time," recalls Nick Dudman, "because nobody was quite sure what they wanted. Did they want them to be tentacled, did they want them to be finned, like fish, and what did they have to physically do? A lot of creature design develops from practicalities: The character needs to do a particular set of actions and it can't do that if it hasn't got the right gear to do that with. So a certain level of design needs to follow the logic of that."

As Catling and others continued to explore possibilities for these aquatic imps, they went more and more to the idea of giving Grindylows an octopus-like appearance, with suction cups on multiple legs and a huge, bulbous head. The Grindylow head became more detailed, with a large mouth containing rows of piranha-like teeth. The final design was based on what the Grindylows needed to do physically: grab Harry and keep him under the water.

Filmmakers created and painted full-size silicone maquettes, then cast and painted them again as fiberglass models to be cyberscanned. More than a hundred Grindylows appeared on-screen, as the sequence required a swarm of the creatures to attack Harry. Grindylows were given "squirty" movements, and each was hand-animated with the help of software called Choreographer developed by the digital team.

"They're just horrible, horrible creatures," Dudman adds.

LEFT: **Grindylows camouflage themselves in a kelp forest under the Black Lake in development artwork by Paul Catling for** *Harry Potter and the Goblet of Fire.*
TOP: **Harry Potter is attacked by a swarm of Grindylows during the second task of the Triwizard Tournament.**
OPPOSITE TOP: **Art by Paul Catling as part of a study of sketches showing various Grindylow expressions.**
OPPOSITE BOTTOM: **A digital version of a Grindylow maquette covered in octopus-like suckers by Paul Catling.**

Stuntmen pulled at actor Daniel Radcliffe's arms and legs in a green-screen underwater tank to imitate the Grindylows trying to drag Harry Potter down.

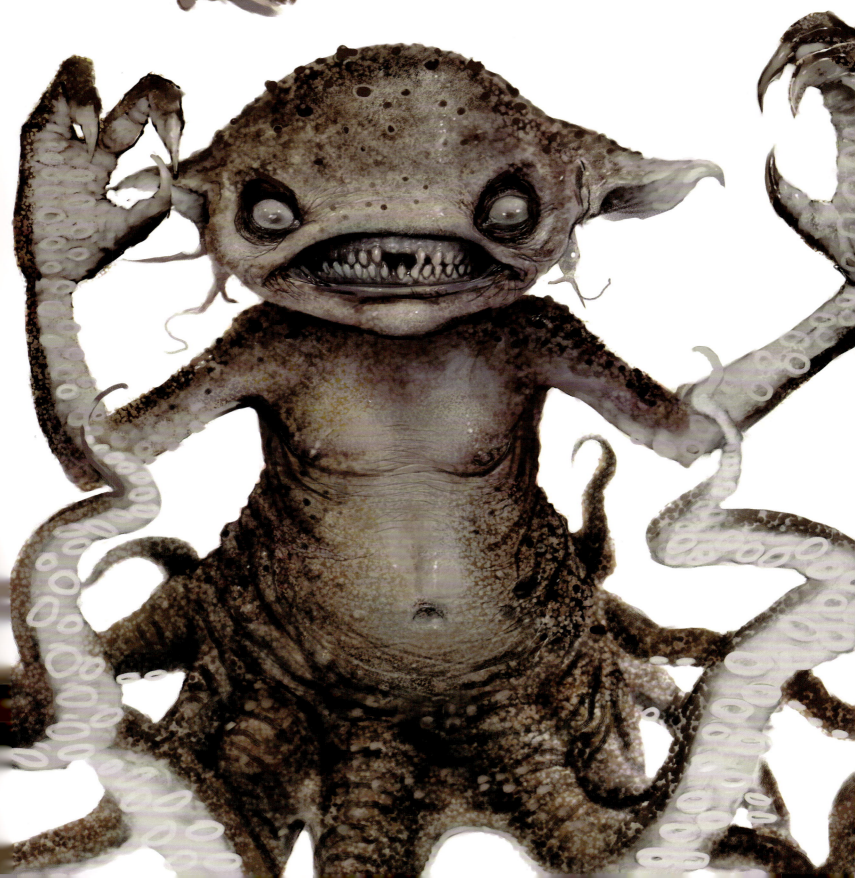

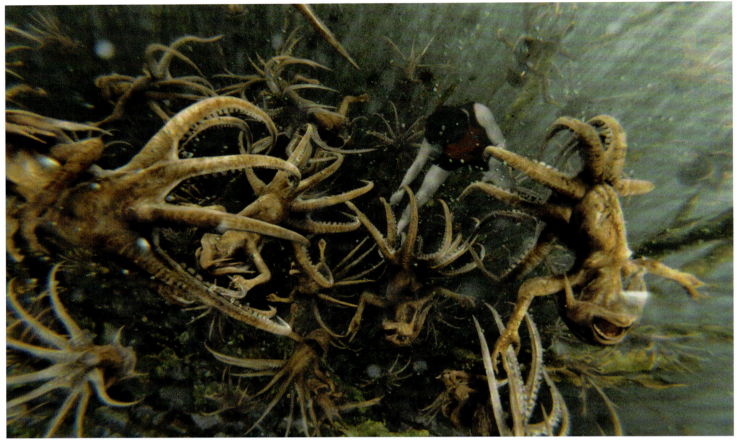
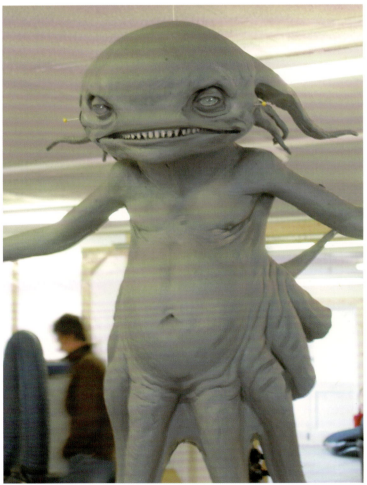
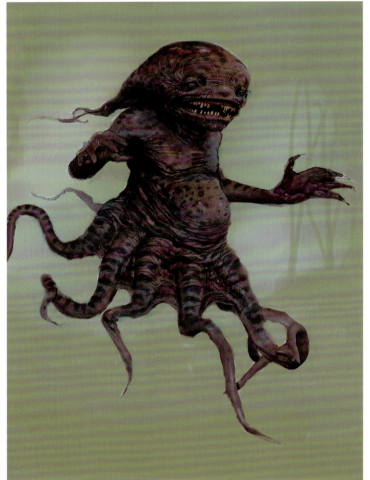

TOP: **Harry Potter escapes the attack by Grindylows by using the Ascension Charm, seen in the film *Harry Potter and the Goblet of Fire*.**

ABOVE LEFT: **A Grindylow maquette awaits cyberscanning in the creature shop.**

ABOVE RIGHT AND OPPOSITE: **Paul Catling explored many variations of Grindylows in his development art.**

Artist Adam Brockbank chose the look of the wolf spider for Aragog. "When you scale up a wolf spider to Aragog's size, they're pretty scary-looking creatures," he admits.

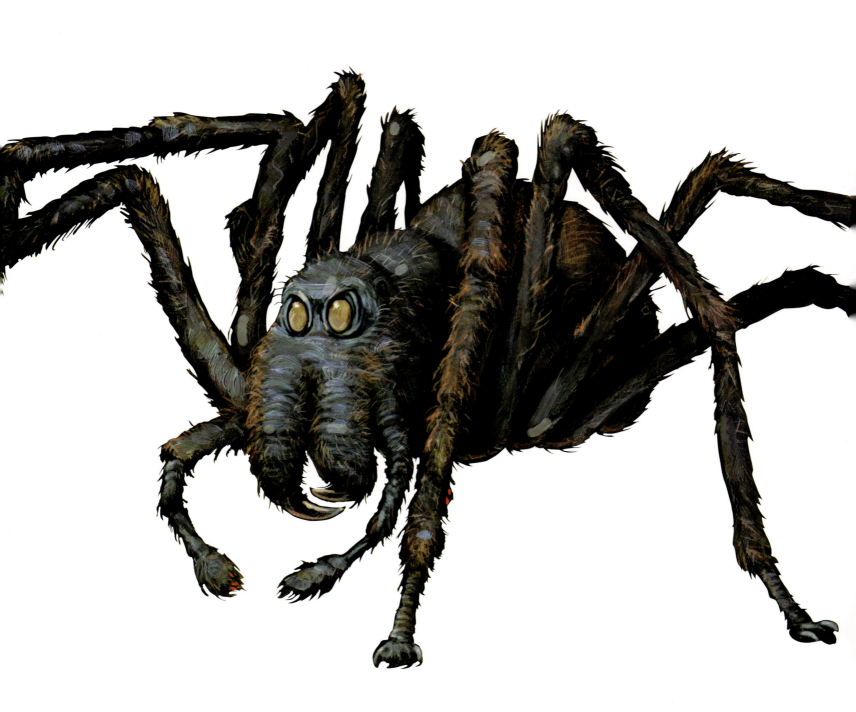

HOGWARTS CASTLE & GROUNDS

Acromantula

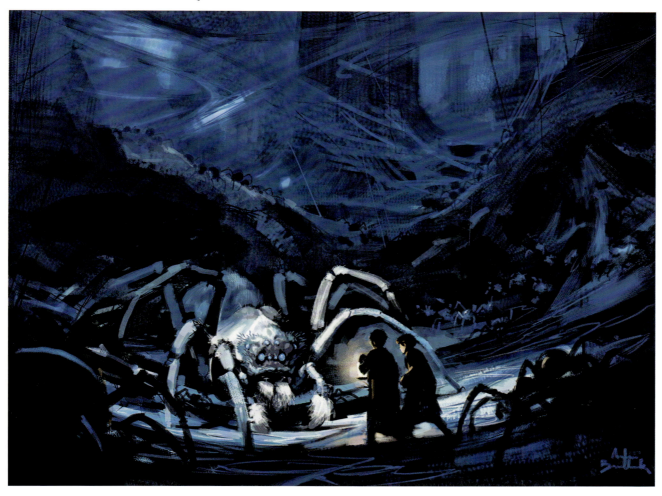

Deep within the Forbidden Forest on the grounds of Hogwarts is Aragog's Lair, where an Acromantula named Aragog lives with his thousands of descendants. Hagrid brought the spider to the school when it was "no bigger than a Pekingese." When Hagrid was unjustly accused of being the Heir of Slytherin, Aragog fled into the forest. Fifty years later, Harry and Ron seek out Aragog for information about the Heir, and when they find him, this king of arachnids has grown to the size of an elephant.

When the filmmakers read about such a huge creature in the script for *Harry Potter and the Chamber of Secrets*, they assumed it would be done digitally. But special creature and makeup effects designer Nick Dudman thought, "Well, all Aragog does is climb out of a hole and deliver some dialogue. We can build that. All those other spiders running up and down in the trees, yes, absolutely, digital. But we could and should build Aragog."

Aragog was created in latex and polyfoam, airbrushed to color his legs, head, and body, and then flocked. Larger hairs made from yak hair, sisal, and hemp from brooms were individually inserted by hand. The hairiest hairs were made using the center of a feather dabbed with adhesive fluff and dragged through Lurex, a type of yarn with a metallic finish.

In order to capture the unhurried, menacing movements of a spider, filmmakers employed an aquatronic system. "By using water, we were able to emulate that horrible, quiet way that spiders have," says Dudman. "Slow and delicate as they feel the air with all their little hairs."

The Acromantula's four front legs moved via a controller using a motion control device manipulating a miniature version of the spider. Everything the operator had the tiny Aragog do, the giant Aragog performed in real time. Puppeteers down in Aragog's Lair operated his rear legs. Aragog was mounted on a seesaw-like platform with a counterweight on one end, so when he was tipped up by the controllers and puppeteers, the five-thousand-pound creature literally walked forward.

HOGWARTS CASTLE & GROUNDS

Hagrid directs Harry and Ron to follow a trail of spiders, as they seek answers about what is in the Chamber of Secrets, to which Ron asks tremulously, "Why can't it be 'Follow the butterflies?'" Ron has a fear of spiders, as does actor Rupert Grint. "I don't even like rubber spiders," he says. "I wasn't acting," he confesses, of seeing Aragog for the first time. "I was genuinely scared. I didn't like looking at it at all. Filming that didn't help my fear at all!"

Although Nick Dudman can sympathize with cast and crew responses to Aragog, they did give him a certain sense of satisfaction. "They weren't reacting to the fear of being next to a large mechanical *thing*," Dudman says. "It was because it was a spider. It gave them the same feeling a real spider would give."

Aragog's eyes, his front teeth, and other parts of his face moved to simulate talking. A recording of actor Julian Glover as Aragog could be heard from a voice-activated system that worked in real time. "Everyone on set could hear the spider through a loudspeaker," Dudman explains. "We could literally pause the dialogue to allow Harry to say his lines, then cut in with the spider's dialogue."

Aragog passes away from old age in *Harry Potter and the Half-Blood Prince*. With Hagrid, his dog Fang, and Harry attending Aragog's burial, Potions professor Horace Slughorn delivers a heartrending eulogy. For the filmmakers, it was not a case of reusing the original Aragog, however. "When they told me Aragog was dead, and it wasn't going to need to do anything," says Dudman, "I thought, let us just build him, please." The lifeless Aragog was redesigned. "I wanted it to be translucent, like a dead, curled-up spider you would see in the bath," he continues. "When they catch the light, they look like they've gone hollow." The creature's decayed husk was cast in polyurethane. "And you can see the understructure of the creature through the surface when the evening light shines through his legs," says Dudman. This Aragog was completely solid, with a steel skeleton to give him enough weight so he wouldn't collapse when he slid into his grave.

The film crew was so touched by Aragog's death that they wore black armbands for his funeral. "Even an inanimate object can cause a truly emotive moment, which is nice," says Dudman. "You know you've gotten it right when people react to the creature as if it's real."

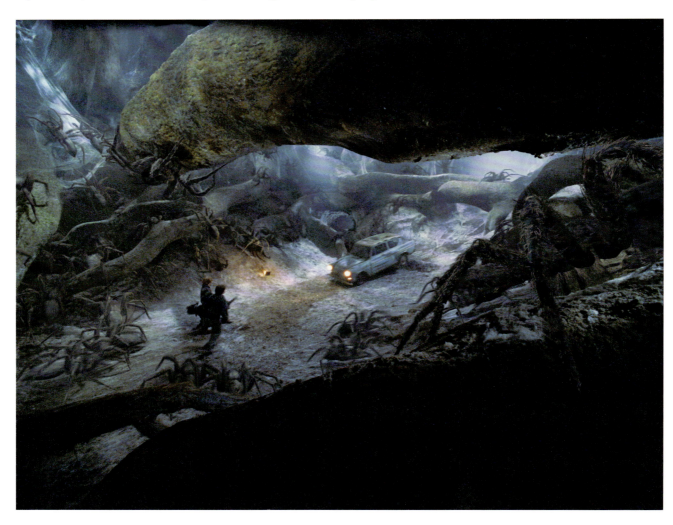

PAGE 28: **Acromantula art based on concept art by Adam Brockbank.**
PAGE 29: **Adam Brockbank portrays the first meeting between Aragog, king of the Acromantula, and Harry and Ron in the Forbidden Forest in *Harry Potter and the Chamber of Secrets*.**

ABOVE: **Harry and Ron are rescued from an attack by Aragog's children by the now-rogue Ford Anglia car in *Harry Potter and the Chamber of Secrets*.**
OPPOSITE: **Harry Potter comes face-to-mandible with Aragog in concept art by Dermot Power.**

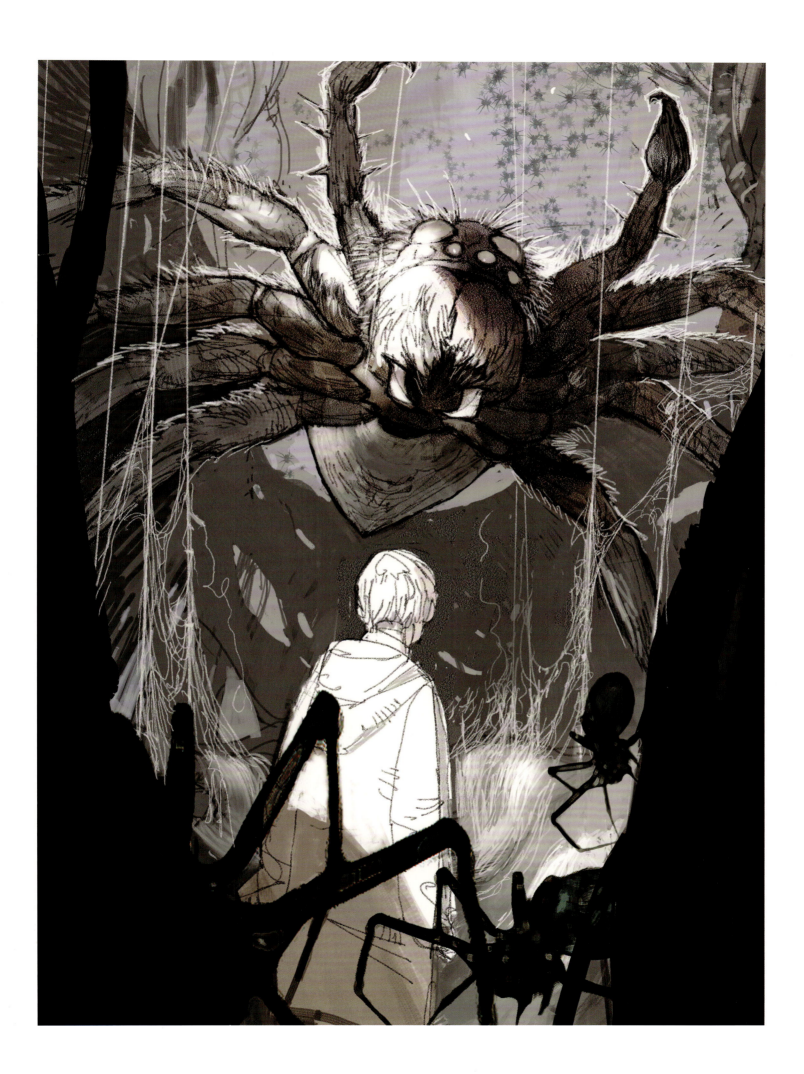

ABOVE: **Aragog's Lair in the Dark Forest, abounding with the sons and daughters of Aragog, as conceived for** *Harry Potter and the Chamber of Secrets*.

HOGWARTS CASTLE & GROUNDS

Centaurs

Centaurs are a species of creature that unite the aspects of both human and equine. Harry Potter encounters the centaur Firenze during detention in the Dark Forest in *Harry Potter and the Sorcerer's Stone*. The two speak face-to-mandible after Firenze saves Harry from an attack by Voldemort. The centaur in *Sorcerer's Stone* was entirely computer generated.

In *Harry Potter and the Order of the Phoenix*, Harry and Hermione bring Professor Dolores Umbridge into the forest as a ruse to save members of Dumbledore's Army, and they encounter a herd of centaurs who are not happy at the intrusion into their territory. Umbridge does nothing to aid the safety of her students, as she calls the centaurs "creatures of near-human intelligence" and "half-breeds."

Because centaurs played more of a role in this film, the creature designers had an opportunity to revisit the design and look of the creature. "I had yet to see a centaur on film that I actually think moved in a way that I accepted," explains special creature and makeup effects designer Nick Dudman. "There's something about the basic concept of the centaur that is great on a vase. It just doesn't work on film."

"We've approached it differently," he continues, referring to *Order of the Phoenix*, "and I feel what we've got is not half a man, half a horse. It's a totally unique creature that fulfills the brief of a centaur perfectly. It doesn't look like two separate things; it looks like a single object. We put a lot of thought into that."

Concept artist Adam Brockbank agrees with Dudman's evaluation of the images painted on Greek or Roman artifacts. "Our centaurs had to be animated," he says. "So we looked, as always, to the principle of naturalism. This couldn't be just a man dumped on top of a horse." Brockbank brought the horse part farther up, into the human part, with the horse's pelt and coloration enveloping the entire creature, not just the bottom half. "We introduced horselike features into their faces and heads." The centaurs were given long faces with horselike features that included flatness from cheekbone to jaw and broad foreheads. Pointed ears were set high up on the head. "And a horse's eyes are not where a man's eyes are, so the centaurs are very broad across the eyes," Brockbank explains. "Instead of anthropomorphizing a horse, it made more sense to animalize a human."

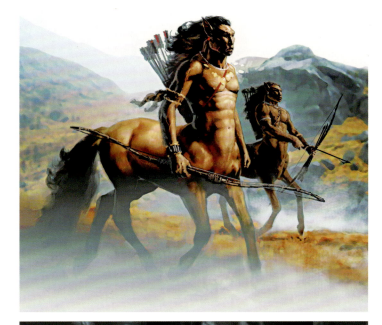

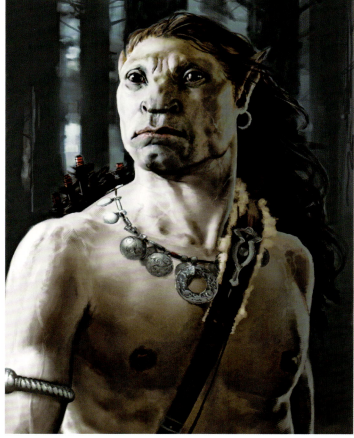

TOP: **Centaurs on patrol are portrayed in artwork by Adam Brockbank for *Harry Potter and the Order of the Phoenix*.**
RIGHT: **Adam Brockbank explores the reflection of the forest light upon a centaur.**
OPPOSITE: **A study of Bane, one of the centaurs' leaders, by Adam Brockbank.**

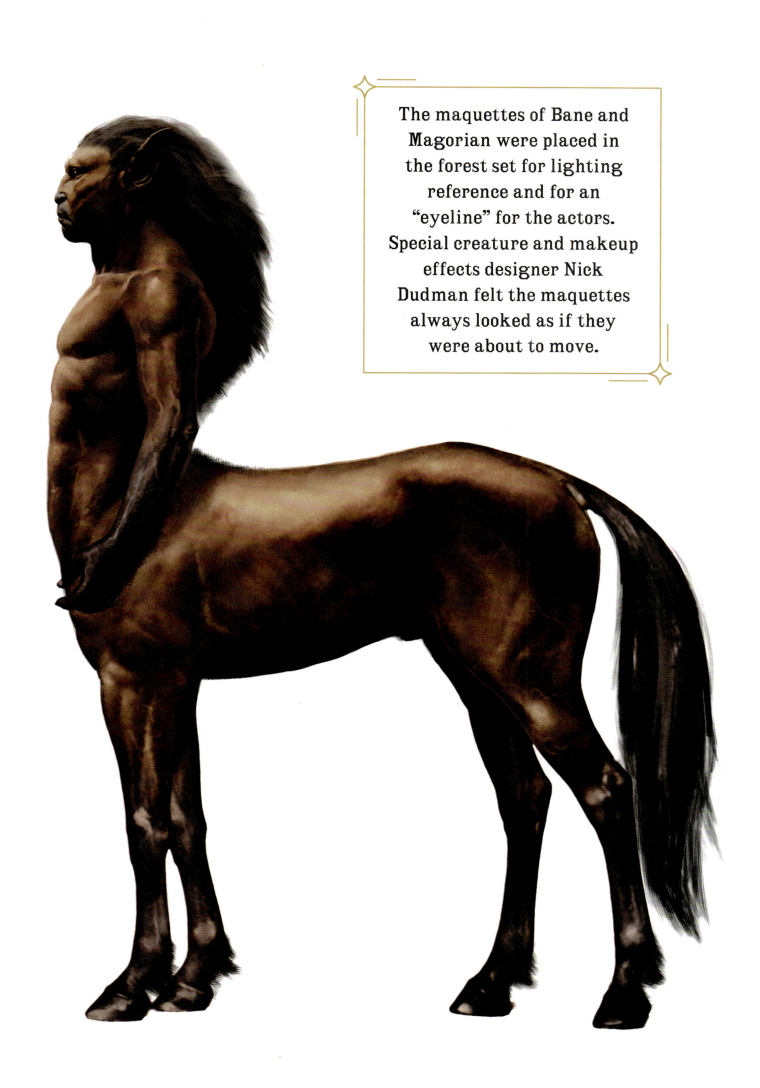

> The maquettes of Bane and Magorian were placed in the forest set for lighting reference and for an "eyeline" for the actors. Special creature and makeup effects designer Nick Dudman felt the maquettes always looked as if they were about to move.

HOGWARTS CASTLE & GROUNDS

The creature department created full-size maquettes of the centaurs Bane and Magorian, who play a central role in the confrontation. "Creating these models was a massive undertaking," says Dudman. "We tried to preserve the flavor of Adam's original drawings right down to the surface detail." The sculpt took about six weeks, and the molding process another six.

"Technically, the thing that was most challenging was getting the right hair on the centaurs," he continues. "We wanted the pelt to be the gleamy, sweaty coat that you get on a thoroughbred racehorse. To duplicate that artificially was incredibly difficult." To create their pelts, the centaur models were flocked. It took the team many rehearsals to ensure that the correct combinations of hair colors and hair lengths bonded to their assigned areas on the bottom coat. Then, longer hairs were punched into the models one hair at a time, followed by airbrushed artwork. This stage required four more people and two to three more weeks. Finally, a layer of airbrushed detail was applied, and the models were equipped with adornments and weapons. "So," Dudman finishes, "although we only made full-scale maquettes for the main centaurs, the process took forty to forty-five people about eight months."

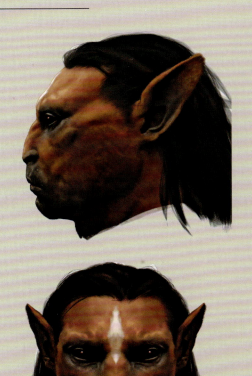

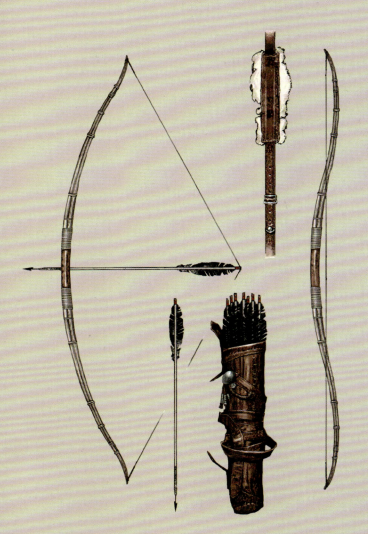

Dudman wanted to make sure the digital artists got everything they possibly could from the maquettes. "So, if I can go full scale on a centaur, you go full scale. That means you can sculpt it, but it also means you provide a fully art-finished creature, where every hair is in, every vein in the eyeball is there. Every eyebrow, every eyelash, the direction of the fur on the pelt is all there." The costume and props department also fitted the maquettes with handcrafted jewelry and weapons.

Professor Umbridge attacks the centaur Bane with the *Incarcerous* spell that chokes him with a rope around his neck, causing him to fall to the ground. The designers studied stallions jumping, walking, rearing, and being roped. They noted that horses' heads first move downward when lassoed, the opposite of a human's reaction. In the same way the centaurs' bodies are a composite, Bane's reaction when bound was a blend of both physical responses.

After Bane's release, Umbridge's prejudice against the centaurs reaches a head, and the centaurs drag her away into the depths of the forest.

TOP: Head studies of a centaur by Adam Brockbank, exemplifying the fusion of human and equine characteristics, for *Harry Potter and the Order of the Phoenix*.
LEFT: Draft work of the centaurs' bows, arrows, and quivers by Adam Brockbank.
OPPOSITE: Concept art of the centaur Magorian by Adam Brockbank.

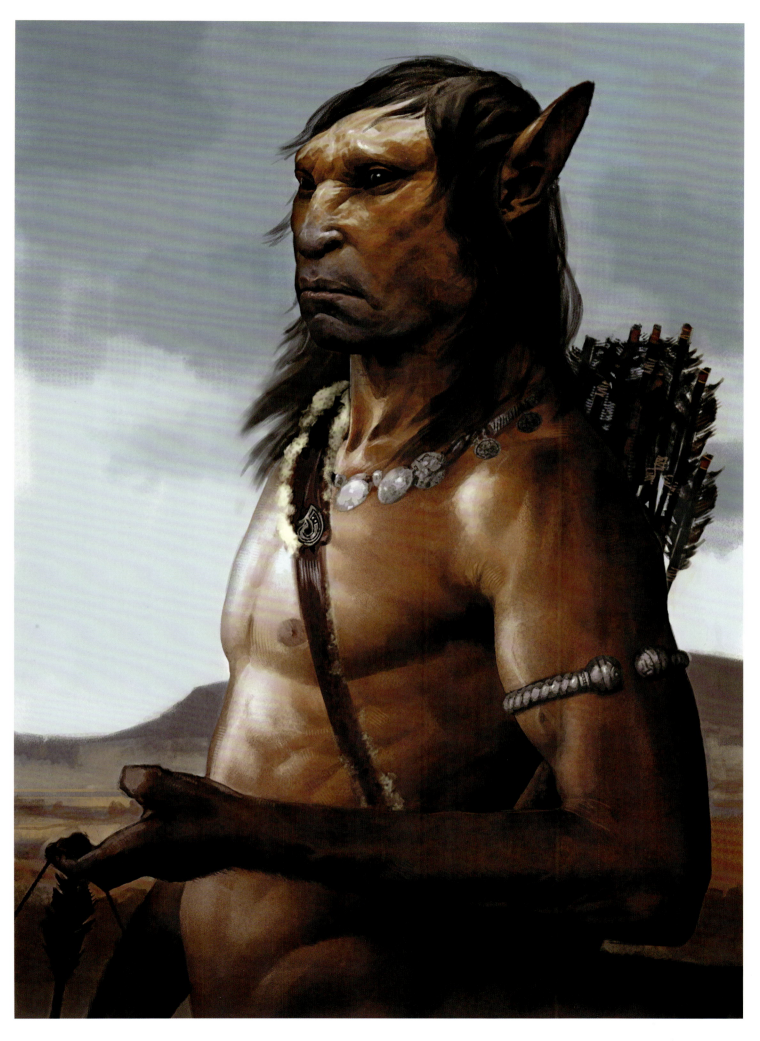

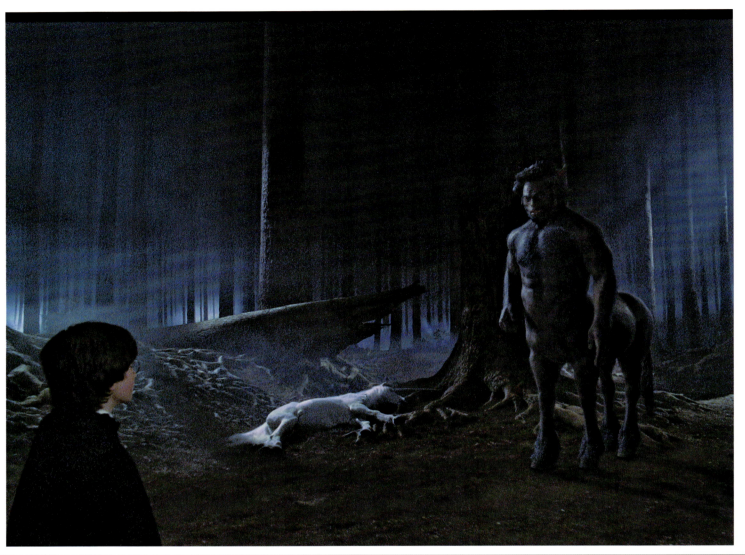
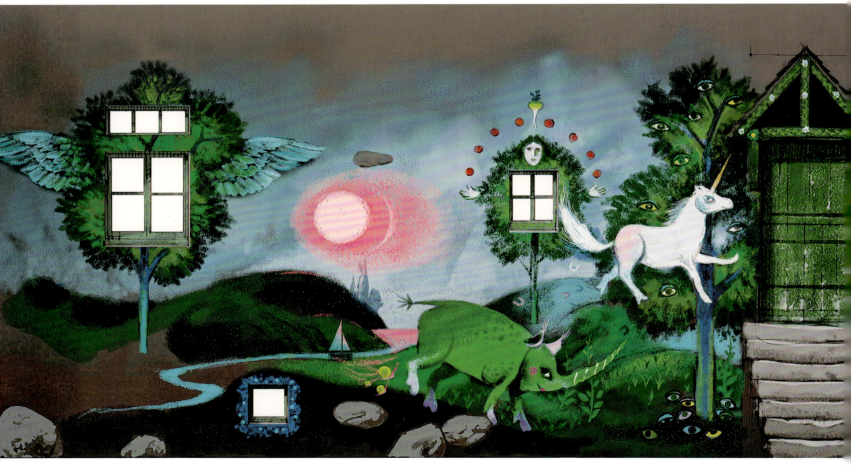

HOGWARTS CASTLE & GROUNDS

Unicorn

When Harry, Ron, and Hermione are caught outside of Hogwarts castle after hours in *Harry Potter and the Sorcerer's Stone*, they are given detention by Head of Gryffindor House Professor Minerva McGonagall. Draco Malfoy is assigned detention as well, as he was also outside the castle when he saw and reported them. This detention doesn't involve writing lines; it means going into the Dark Forest late at night and helping Hagrid in his search for the unicorns that are being attacked within the trees.

Hagrid spots a pool of unicorn blood—a thick, silvery, shiny substance—and divides up the students. Draco and Harry are paired together for this task, accompanied by Hagrid's dog, Fang, and they soon come upon a hooded figure drinking blood from the neck of an injured unicorn. Draco and Fang flee, but Harry stands fast until the figure moves toward him. Backing up, Harry gets caught in a tangle of roots, but he is saved by the centaur Firenze, who rears up on his hind legs and threatens the figure, causing it to quickly fly away.

Firenze tells Harry that what he has seen is a monstrous creature. "It is a terrible crime to slay a unicorn," he tells the young wizard. "Drinking the blood of a unicorn will keep you alive, even if you are an inch from death, but at a terrible price." Someone who does so, he cautions, "will have a half-life, a cursed life."

Unicorns are peaceful magical creatures, and their tail hairs are used as wand cores. The unicorn in *Sorcerer's Stone* resembles those in Muggle mythology, being a white horse with a single, spiraling horn coming from its forehead. The creature seen in the forest was not required to move, but it was still constructed with a fully articulated steel skeleton. Animatronic model designer John Coppinger sculpted the unicorn based on a real horse named Fado, with its pelt flocked in the same manner as the centaurs.

OPPOSITE TOP: Harry Potter learns the dangers of drinking unicorn blood when he encounters the centaur Firenze in *Harry Potter and the Sorcerer's Stone*.
THESE PAGES: Concept art by Adam Brockbank for *Harry Potter and the Deathly Hallows – Part 1* of a mural in the interior of Xenophilius Lovegood's house features a unicorn, a Thestral, and other mythic creatures. Luna Lovegood supposedly created this for their house.

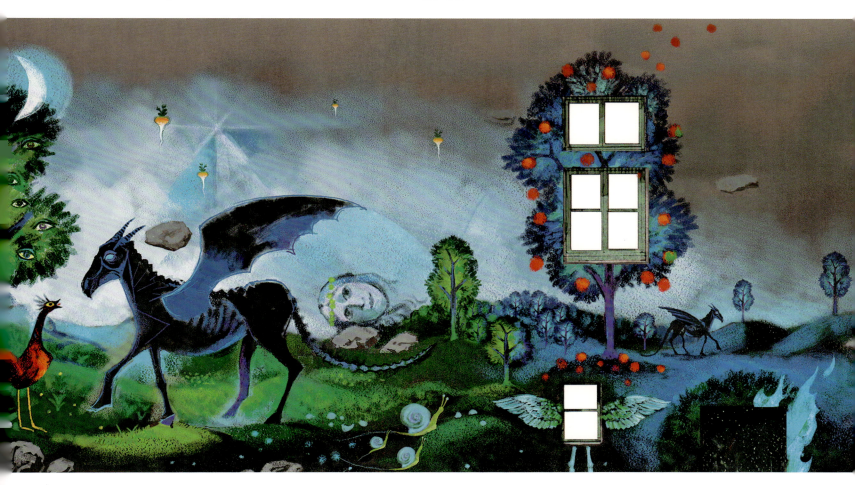

HOGWARTS CASTLE & GROUNDS

Thestrals

When Harry debarks the Hogwarts Express in *Harry Potter and the Order of the Phoenix*, he notices that for the first time there are actual creatures pulling the "horseless carriages" that take the second- through seventh-year students up to the castle. Thestrals are described as having a delicate walk, a quiet cry similar to whale song, and translucent, bat-like wings that add to their unearthly character. These dragon-faced creatures are unseen by most students, as they are only visible to someone who has seen death—including Harry Potter and Luna Lovegood, with whom he shares a carriage.

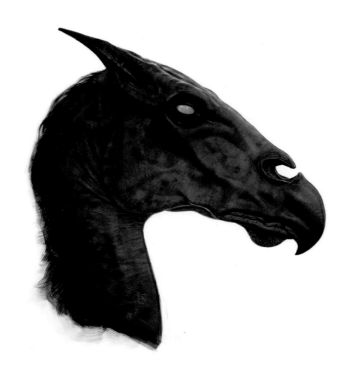

Concept artist Rob Bliss was given a brief for the Thestrals that had two requirements: First, director David Yates wanted the creatures to be regal. Second, as nonspeaking characters, their design had to convey their personalities. Bliss's final concept was of a skeletal creature that was both stately and disturbing.

The approved design was sculpted into a full-size maquette needing to be painted, which prompted concerns about its color. Thestrals are supposed to be jet-black, but a flat black color on-screen does not look real. "Black, or rather, the off-black coloring, was beautiful on two-dimensional artwork," explains special creature and makeup effects designer Nick Dudman. "But if we just mimicked the artwork, it was going to just photograph black." The maquette to be cyberscanned was painted a lighter shade, then detailed with veins and shadings. This way, digitally, the creature could be made as dark as desired and still retain distinct tones. Doing this preserved the mottling under the Thestrals' bellies and the translucency of their wings on-screen. The texture on the Thestrals' skin was based on an elephant's wrinkles.

The creature shop created full-size models of a baby and an adult Thestral and placed them on the set of the Forbidden Forest for lighting and camera purposes, and to ensure that the thirty-foot length of the adult Thestral's wingspan "wouldn't bang into the branches," says Dudman.

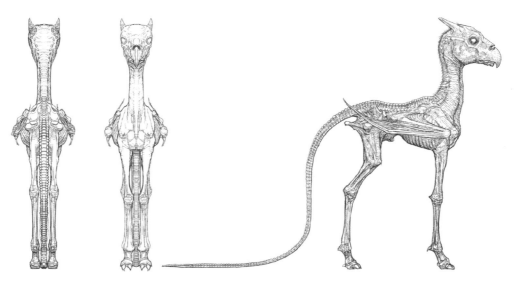

40

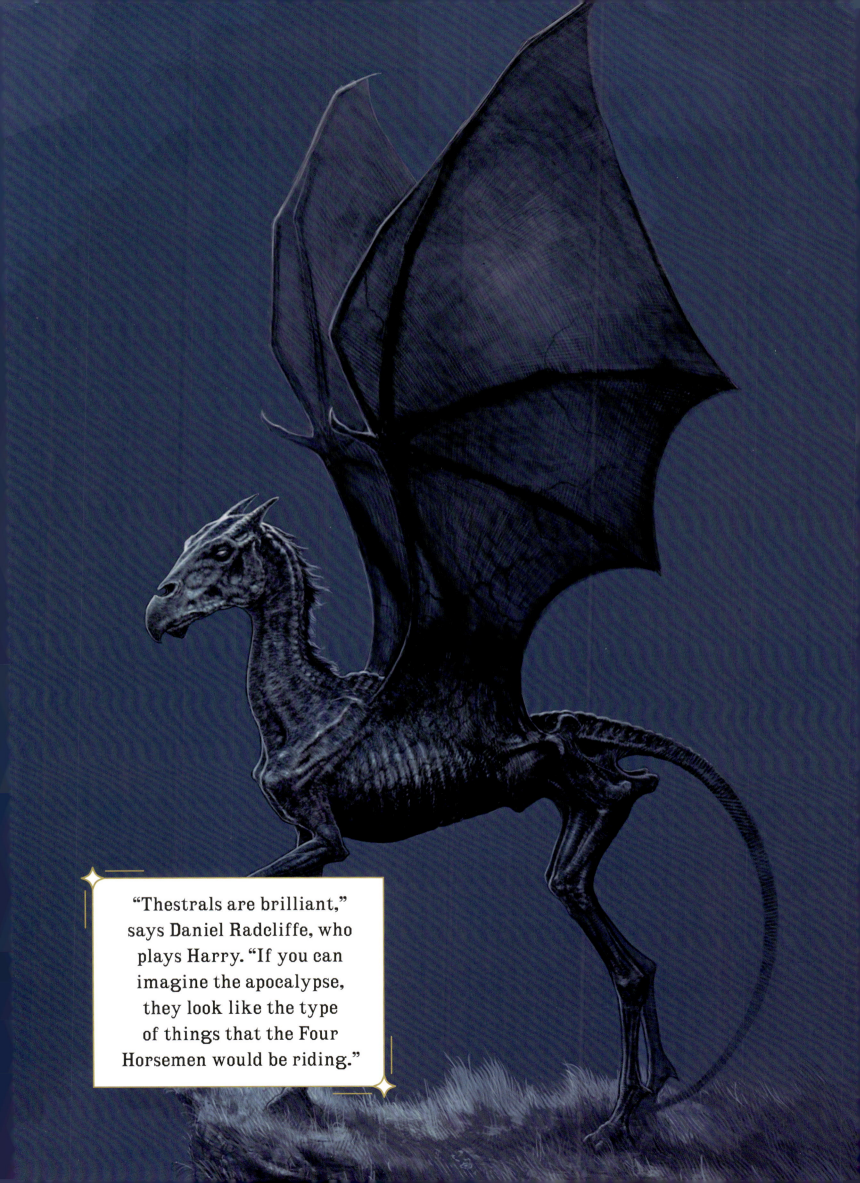

"Thestrals are brilliant," says Daniel Radcliffe, who plays Harry. "If you can imagine the apocalypse, they look like the type of things that the Four Horsemen would be riding."

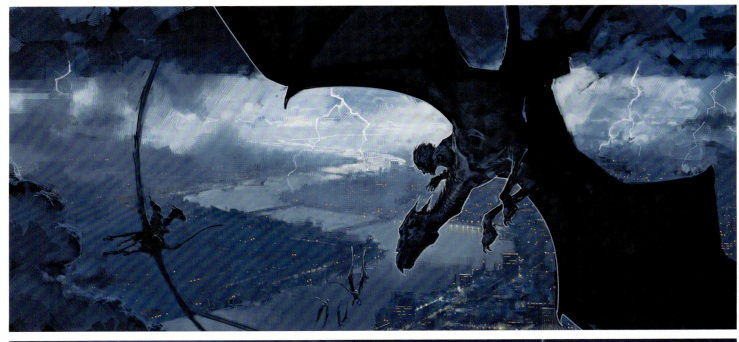
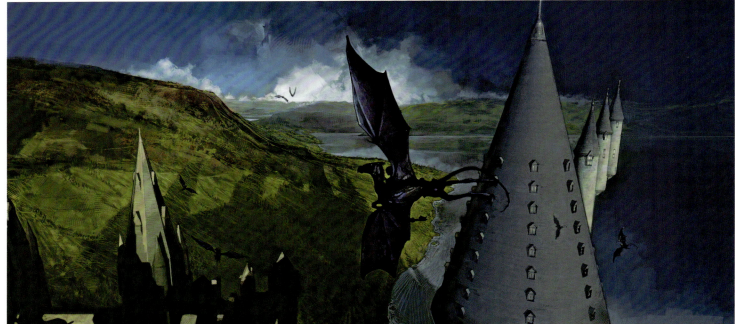
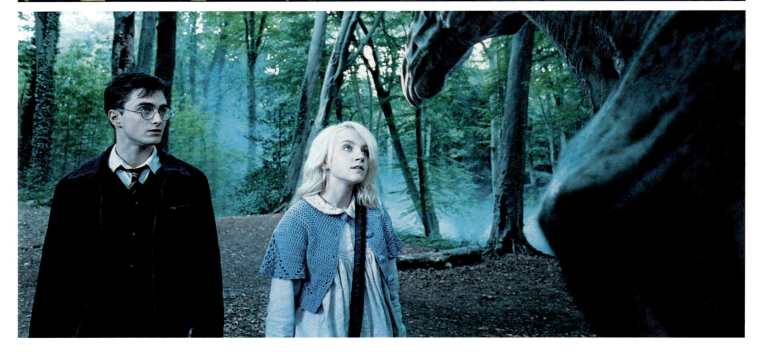

HOGWARTS CASTLE & GROUNDS

In the film, Harry comes upon Luna observing a herd of Thestrals in the forest. She's even petting one of the adults. The creature department sculpted and painted a Thestral head that was operated by a puppeteer for this scene. There were several generations included in the herd, as director David Yates wanted the Thestrals to seem recognizable, and so introduced Thestral families in the spirit of a nature documentary. To enhance the natural quality of the creatures, the digital designers referenced horses for their physicality and behavior. This inspired subtle actions by the Thestrals, such as small muscle flicks, that gave them authenticity.

Each original creature's design was based primarily on what story-directed actions or movements it would need to make. Sometimes, however, unexpected ideas would happen, necessitating a slight change. "We had the concept drawn up for the Thestrals," says visual effects producer Emma Norton. "A sculpt was made, scanned, and turned into a Thestral." Then, director David Yates asked for a Thestral to be drinking from a pond. "We went to our animation unit, and they tried to get the Thestral's head down," Norton continues. "But just from the way it had been designed, his head wouldn't reach the ground. Its legs were too long, and its neck was so short." Inspiration came from a real-life creature: the giraffe. Although it has a long neck, it spreads its forelimbs wide to get to something on the ground. The pond idea was also changed to Luna tossing something to a baby Thestral—first an apple, then a piece of raw meat.

Filmmakers quickly adjusted the Thestrals' proportions any time a situation called for it. For the scene where members of Dumbledore's Army ride Thestrals to London in *Order of the Phoenix*, it was determined that the Thestrals' wingspan would not be able to hold them. Consequently, the filmmakers made the wings bigger. They also sculpted and painted a separate Thestral back from the full maquette and placed it on a motion control rig that simulated not only its flying motion but the wings as well. Cameras filmed the actors riding rigs programmed to the movements of each student's Thestral. Finally, digital Thestrals replaced the rigs. For *Harry Potter and the Deathly Hallows – Part 1*, two people needed to ride on one Thestral, but its spine was too short to hold both, so the spine was made longer. "Sometimes there are decisions you just have to make as you go," says Norton. "No one knows how a Thestral moves. What do you do with its legs? Does it prance through the air? We thought that would be silly. So, what we did was we tucked them up. It's just a trial and error process."

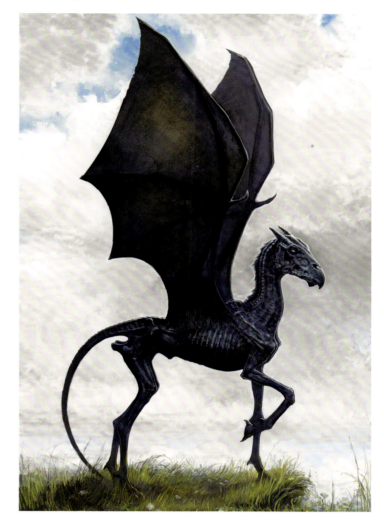

In *Deathly Hallows – Part 1*, Harry is conveyed from Privet Drive to The Burrow in a bit of subterfuge: Six other Harrys are created using Polyjuice Potion, and they ride brooms, a motorbike, and Thestrals for the journey. As horses had been referenced for the original design of the Thestrals, it only made sense that the scene with the members of the Order of the Phoenix waiting to depart on Thestrals was filmed on real horses. By doing this, "you get that 'shifting horse' effect," says Norton. The horses were digitally replaced with Thestrals for the finished film.

PAGE 40 TOP: **Study of shadows and blacks on a Thestral's head by Rob Bliss for *Harry Potter and the Order of the Phoenix*.**
PAGE 40 BOTTOM: **Studies of the Thestral's anatomy by Rob Bliss**
PAGE 41: **The Thestral, a creature both regal and menacing, in artwork by Rob Bliss.**
OPPOSITE TOP: **Members of Dumbledore's Army arrive in London hoping to rescue Sirius Black in artwork by Rob Bliss for *Harry Potter and the Order of the Phoenix*.**
OPPOSITE MIDDLE: **Harry and others leave Hogwarts for the Ministry of Magic on Thestrals in development art by Rob Bliss.**
OPPOSITE BOTTOM: **Luna Lovegood (Evanna Lynch) introduces Harry Potter (Daniel Radcliffe) to families of Thestrals living in the Dark Forest.**
ABOVE: **A graceful, serene Thestral depicted in daylight by Rob Bliss.**

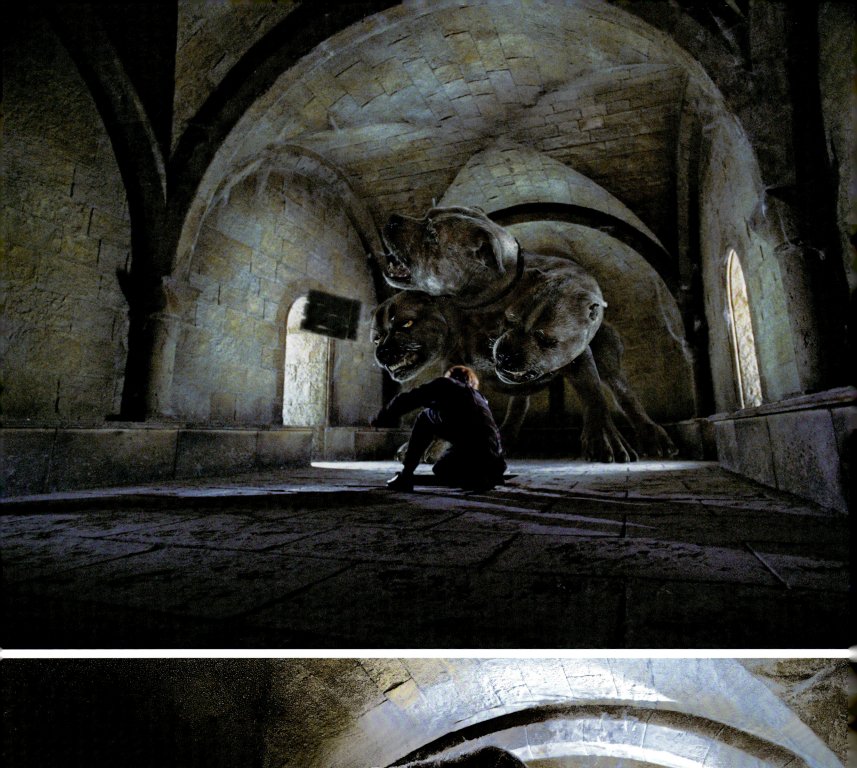
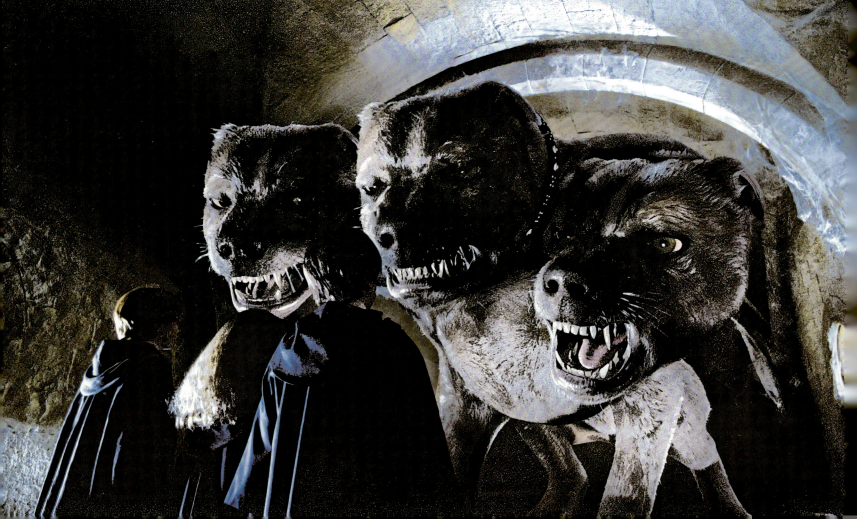

HOGWARTS CASTLE & GROUNDS

Three-Headed Dog

When a moving staircase takes an unexpected swing in *Harry Potter and the Sorcerer's Stone*, it deposits Harry, Ron, and Hermione on the third floor of Hogwarts, which is forbidden to first-year students. Almost immediately they're spotted by Mrs. Norris, the cat of caretaker Argus Filch, so they run down the corridor for a place to hide. Harry spots a locked door, and when they get through, they find out why it was locked: It's the home of a huge, three-headed dog named Fluffy. Fluffy, who guards a trapdoor, is the first of several challenges protecting the Sorcerer's Stone.

Concept artists based Fluffy's heads on that of a Staffordshire bull terrier. Once approved, the creature shop crafted the dog into a maquette as a reference for building the digital model.

The creature's digital designers were then tasked with making the unbelievable believable. There were a lot of considerations when creating the movements of the three-headed dog: Should the three heads move in synchronization? How should typical canine movements, such as twitching ears or facial tics, be adapted to a huge dog? And when director Chris Columbus asked that Fluffy snore when he slept, would all three heads snore at the same time? Or just one? After discussing the dog's anatomy, the filmmakers decided that although Fluffy had three heads, he had one chest and one set of lungs, so the three heads would snore at the same time.

To add to Fluffy's realism, the digital animators assigned a different personality to each of the heads, providing opportunities for comedic interaction. The head on the far left is the leader: He's calculating, and he thinks before he acts. The head on the far right is the most aggressive: He's quick to attack, but not so fast in anything else. Fluffy's middle head is a bit dim—it takes him a while to catch up on what's happening around him.

The visual effects crew wanted to fool the audience for Fluffy's initial appearance. In the scene, once Harry, Ron, and Hermione enter, they see what looks like the normal head of a sleeping dog. Then the camera pans right to show a yawning second head, and moves again to show a third head that's not too happy at being awakened. As if a three-headed dog isn't enough, the camera tilts upward as Fluffy stands, and the students see a twelve-foot-tall canine.

Fluffy's barks, growls, and snarls came via supervising sound editor Eddy Joseph and his team. "When you think about it," says Joseph, "something like Fluffy has to be pretty noisy. He's massive. When he barks, he's going to make a lot of noise." Joseph recorded several dogs for Fluffy's vocalizations. "In fact, my own dog is in there," he adds, "as well as the sound of my assistant Richard gnashing his teeth."

Harry, Ron, and Hermione must first bypass Fluffy as they pursue the Sorcerer's Stone. Hagrid has accidentally told them that if you play Fluffy a bit of music, he will fall asleep, and when they enter, he is in dreamland as a harp plays in the background. However, the trapdoor is covered by one of his massive paws, so the kids work to push it out of the way. The creature shop created a full-scale, weighted version of Fluffy's right paw for the actors to move. All seems well—and then Harry notices the music has stopped. What's worse, Ron notices a huge blob of dog drool flowing down his shoulder. The drool was also a practical, and unpleasant, effect.

> The movements of Fluffy's three heads are timed differently so that each head moves independently of the others.

OPPOSITE TOP: **Ron Weasley is the last to go down through the trap door to pursue the Sorcerer's Stone after eluding Fluffy the three-headed dog.**

OPPOSITE BOTTOM: **Ron Weasley, Harry Potter, and Hermione Granger encounter the biggest and perhaps most unique dog—Fluffy—who guards the Sorcerer's Stone in *Harry Potter and the Sorcerer's Stone*.**

HOGWARTS CASTLE & GROUNDS

Troll

During Harry's first year at Hogwarts, Professor Quirrell runs into the Great Hall at Halloween and shrieks about a troll in the dungeon before fainting to the floor. Dumbledore warns the students to immediately return to their dormitories. Except . . . Harry and Ron have just learned Hermione is crying in the girls' bathroom, and when they see the troll headed for that same bathroom, they go to save her.

Hermione tries to evade the troll by hiding in the stalls, but the troll's club smashes their wooden walls into splinters. Harry and Ron try to catch his attention by throwing shards of wood at the "pea brain," but the troll continues after Hermione, who takes refuge under the sinks. Determined to stop him, Harry grabs the creature's club, and is raised high enough to fall onto his shoulders. The troll tries to shake him off like a rag doll. "Do something!" Harry yells at Ron. So Ron casts *Wingardium Leviosa*—successfully, for the first time—and levitates the troll's club for a moment before it thuds down on the troll's head, knocking him out.

Trolls may be very large, but their brains are very small, and so the sequence is more comedic than scary. Concept artists, including Rob Bliss, researched medical photographs for the troll's saggy green skin, covered in carbuncles and grime. Yellow teeth protrude from the troll's mouth, and his warty feet end in two toes. There are tufts of scruffy hair on his head, in his armpits, and over his floppy belly. The creature shop constructed a maquette of the troll, warts and all, for the digital artists to cyberscan.

The troll was a blend of visual and special effects. As the film was shot before the ease of motion capture technology, performance capture of a costumed actor was filmed using traditional cameras. To create the troll's movements, the crew imagined him like a four-year-old child, knocking down everything in his way like a walking bulldozer.

> In *Harry Potter and the Order of the Phoenix*, there is a giant troll's foot umbrella stand in the hallway of Grimmauld Place. This was molded from the troll's foot seen in *Harry Potter and the Sorcerer's Stone*.

The creature shop also created practical versions of the troll at full size. Martin Bayfield, who doubled for Hagrid, wore the troll's hands, feet, and a pair of silicone legs, dubbed "troll trousers." Having practical pieces of the troll gave Emma Watson (Hermione) something to act against as Hermione is threatened with his club. The troll that lies unconscious is a twelve-foot-tall version molded in silicone, which gave a natural sag to his flesh. This fully painted and costumed troll had an animatronic head and fingers that twitched to give the impression he was coming to.

Many of the sight gags were practical creations: the bathroom doors and sinks were destroyed from a strike of the troll's club, which was operated by a pneumatic rig. Daniel Radcliffe was raised on a hydraulic rig to "drop" on top of the troll's shoulders and be tossed about, though it was a digitally created Harry that took the worst of the tosses. The digital shots were then timed to match the live-action footage of the actors. "This is opposite to the more common procedure of pre-visualizing the action before filming it," says visual effects supervisor Robert Legato. "We created something that we liked first and then tailored the sequence to it."

Once the troll is subdued and Harry removes his wand, now covered in "troll bogies," from the creature's nose, Professors McGonagall, Quirrell, and Snape arrive. McGonagall is quick to lay blame on the boys, but Hermione insists it's her fault—she went looking for the troll, thinking she could handle it. McGonagall takes five points from Gryffindor for Hermione's "serious lack of judgement," then awards five points each to Harry and Ron "for sheer dumb luck!"

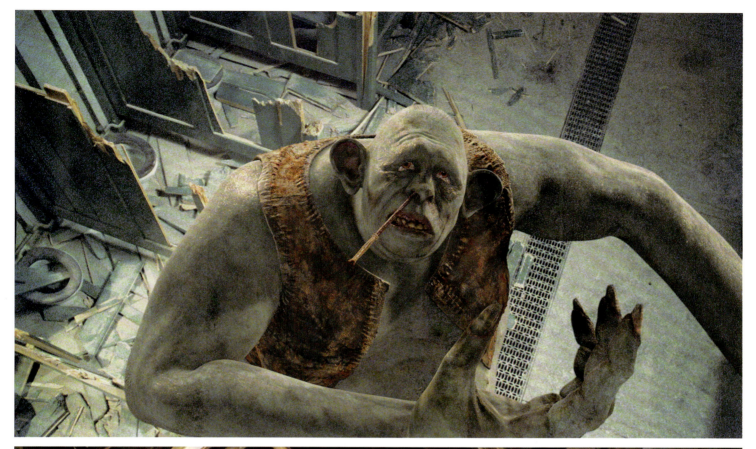

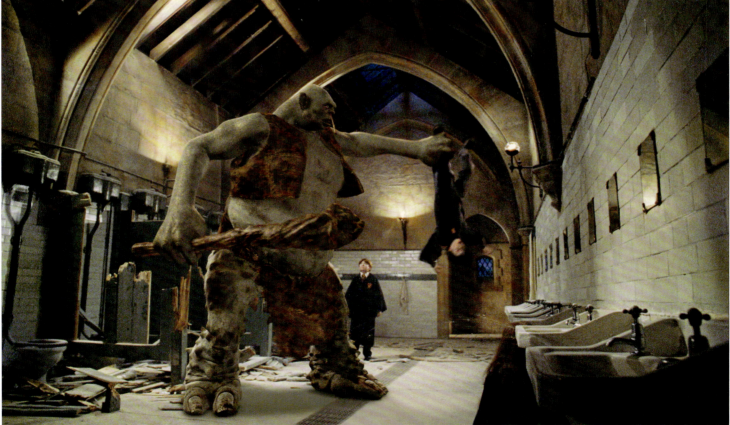

OPPOSITE: **Color concept artwork of the troll by Rob Bliss for *Harry Potter and the Sorcerer's Stone*.**
TOP: **The troll gets Harry's wand up his nose during a melee in the wrecked bathroom.**
ABOVE: **During their encounter, the troll grabs Harry by the leg, who yells for Ron to do something—"Anything!"—to free him.**

Emma Watson (Hermione) and Imelda Staunton (Dolores Umbridge) were filmed riding a motion-controlled full-scale giant's hand as part of being picked up by Grawp. That hand was replaced by a digital version, after which the two elements were composited together.

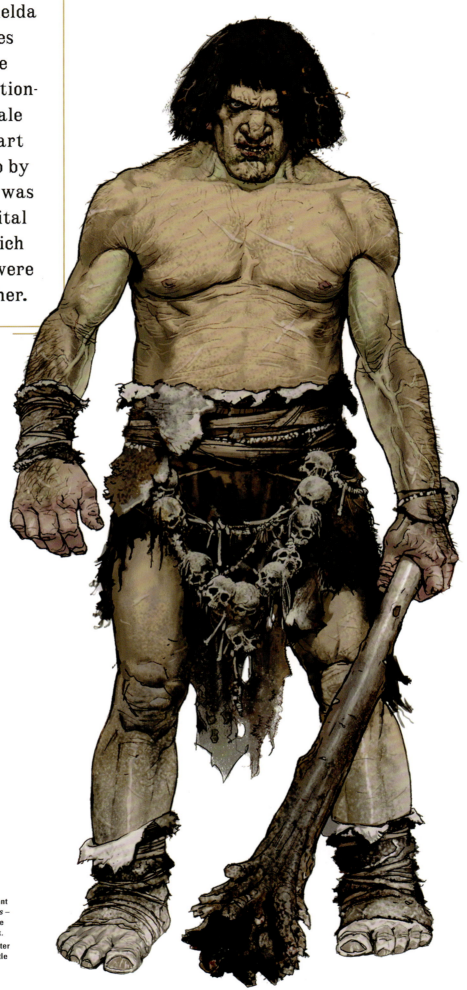

ABOVE: **Adam Brockbank's study of a giant for *Harry Potter and the Deathly Hallows – Part 2* gives a suggestion of his size: the weapon he holds is an entire tree trunk.**

OPPOSITE: **Development art of an encounter between giants and wizards in the Battle of Hogwarts by Adam Brockbank.**

HOGWARTS CASTLE & GROUNDS

Giants

Although Harry and his friends are aware of giants in the wizarding world, they have only met two half-giants: their dear friend Hagrid and the headmistress of Beauxbatons Academy of Magic, Madame Maxime. (And Madame Maxime insists she is just "big-boned.")

After Voldemort returns to his full physical body and begins gathering forces to create an army of followers, Dumbledore begins his own recruitment of allies, sending Hagrid to parley with the giants, as seen in *Harry Potter and the Order of the Phoenix*. When Hagrid returns, he speaks with Harry, Ron, and Hermione in his hut. He tells them he tried to convince the giants to join Dumbledore's cause, but at the same time, Death Eaters were also trying to persuade them to join Voldemort. Hagrid isn't sure which side they finally chose.

Hagrid brings someone back with him from his mission—his half brother Grawp, a young giant. Grawp is being kept in the forest for safety, but Hagrid fears for the only family he has left and asks Harry, Ron, and Hermione to watch over his half-sibling in case something happens to him. Grawp is sweet and unassuming (for his size) and develops a fondness for Hermione.

The sixteen-foot-tall Grawp was created digitally for the film, but filmmakers decided it would help the actors to have someone to work against in the scene. The creature department had already created a full-size head at four-and-a-half by three-and-a-half feet, complete with hair, teeth, and eyes to be cyberscanned. "It's very difficult to scale up hair," explains Nick Dudman, special creature and makeup effects designer. "So, we needed to produce something that would move the way hair does at that large a scale." The special makeup effects team constructed a hydraulically operated rig for the head, to be operated by puppeteer Tony Maudsley. Wearing a blue screen outfit, he performed at Grawp's height to provide an eyeline for the actors and offer a reference for the digital team. Maudsley also worked a set of giant arms proportionate to the forest set.

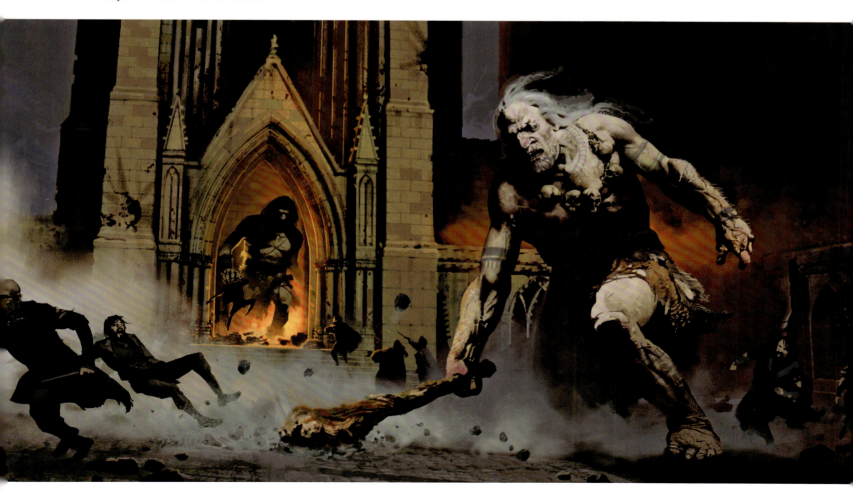

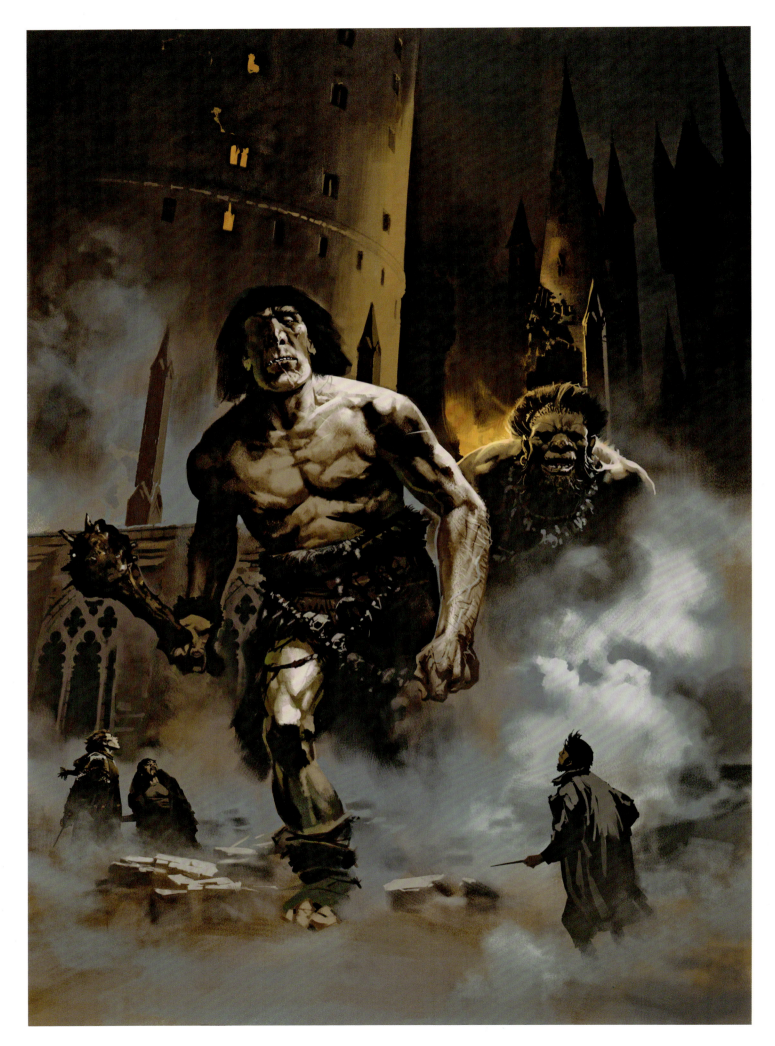

HOGWARTS CASTLE & GROUNDS

Full-size giants finally appear in *Harry Potter and the Deathly Hallows – Part 2*, when they side with the Dark Lord and fight in the Battle of Hogwarts. The filmmakers realized that giants would be more believable if real actors were filmed first—really *big* actors. "Getting the giants to work by using live-action actors," says visual effects supervisor Tim Burke, "and then changing their faces with CG helped us not to have to create full CG characters from scratch." As a guide for the eventual computer animation, the makeup department added prosthetics to the actors' faces to supersize their proportions, and they wore little except for loincloths. Cameras filmed them against a green screen standing in threatening poses and running on treadmills. The film was converted into a digital format and the animators distorted and scaled up the faces even more. The bottom half of each giant's legs was made broader to suggest a lower center of gravity, and the digital artists even gave some giants toes like an elephant's. The giants' costume design included belts of skulls or human teeth and hairstyles that contained branches and leaves.

For Hogwarts castle in the final battle, the filmmakers worked almost exclusively with a digital model of the castle, instead of the 1/24-scale physical model of the castle and grounds they had used in the films to that point. There was one little cheat, however. "We used a third-scale viaduct for the sequence with the giants," says Burke. "We scaled the architecture they were running on to make the actors look taller."

OPPOSITE: **Students stare in awe of the extremely tall giants in development art for a potential scene in *Harry Potter and the Deathly Hallows – Part 2* by Adam Brockbank.**
ABOVE: **Grawp, Hagrid's fully giant half brother in a pencil sketch by Adam Brockbank for *Harry Potter and the Order of the Phoenix*.**
BELOW LEFT: **A giant accompanied by Death Eaters in art by Adam Brockbank created for *Harry Potter and the Deathly Hallows – Part 2*.**
BELOW RIGHT: **Another giant stands in the smoky ruins of Hogwarts castle in art by Adam Brockbank.**

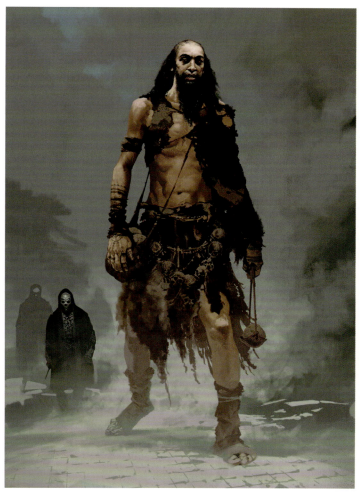
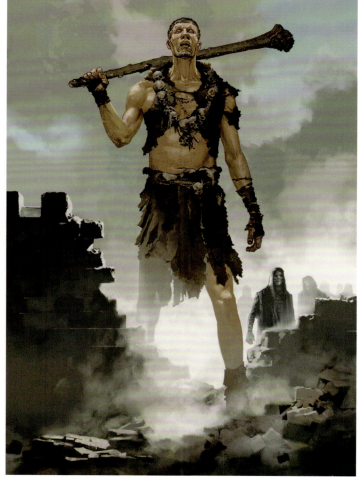

51

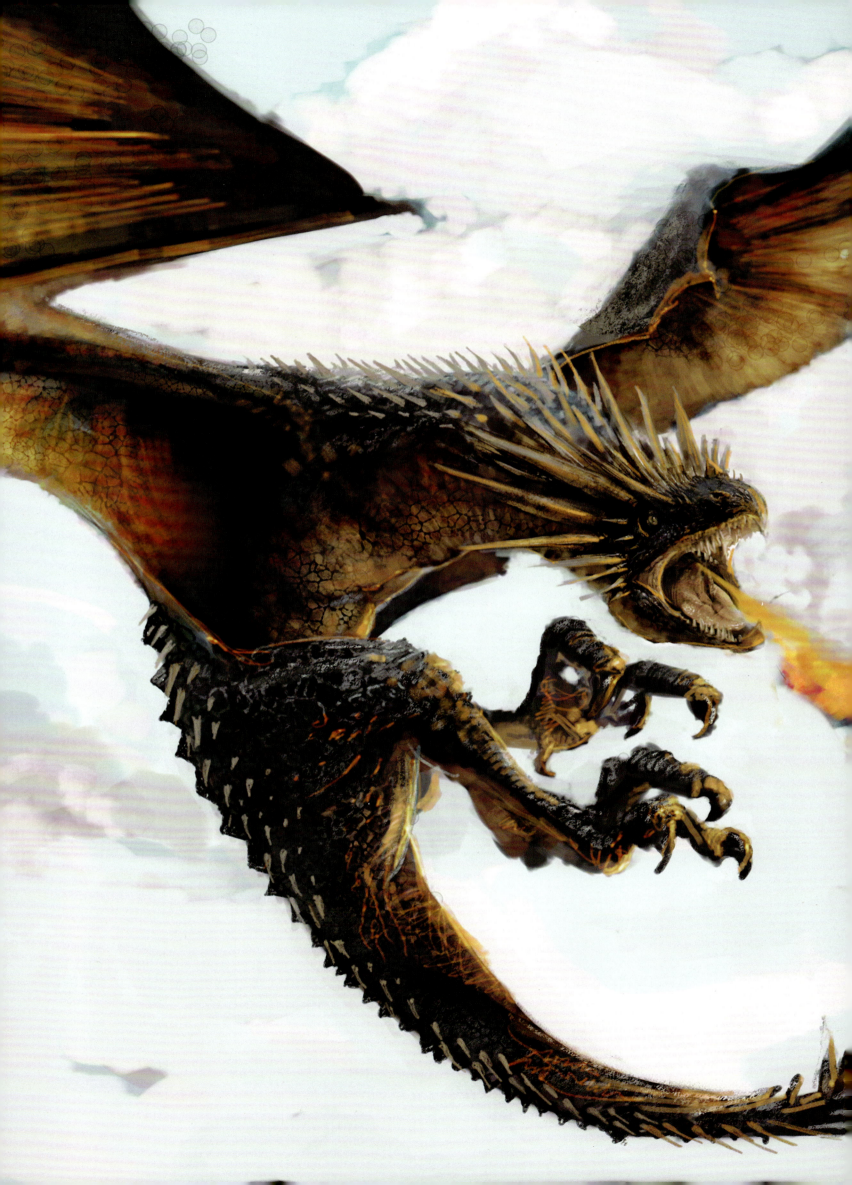

CHAPTER 2

DRAGONS

DRAGONS

Norwegian Ridgeback

Hogwarts groundskeeper Rubeus Hagrid is known for his affection for creatures of all sorts, including several that people might consider dangerous. The creature he wants most of all is a dragon. In *Harry Potter and the Sorcerer's Stone*, Harry, Ron, and Hermione visit Hagrid at his hut to discuss the titular object, and they discover he's acquired a dragon egg that's about to hatch. Hagrid brings it over to the table and the egg begins to wobble and roll. Suddenly, the shell cracks in an explosion of green gas, and a small, drooling baby Norwegian Ridgeback bursts out. Hagrid names him Norbert. The dragonet sniffles, shakes his head, and, after Hagrid tickles him under the chin, sneezes out his first flame, scorching Hagrid's beard.

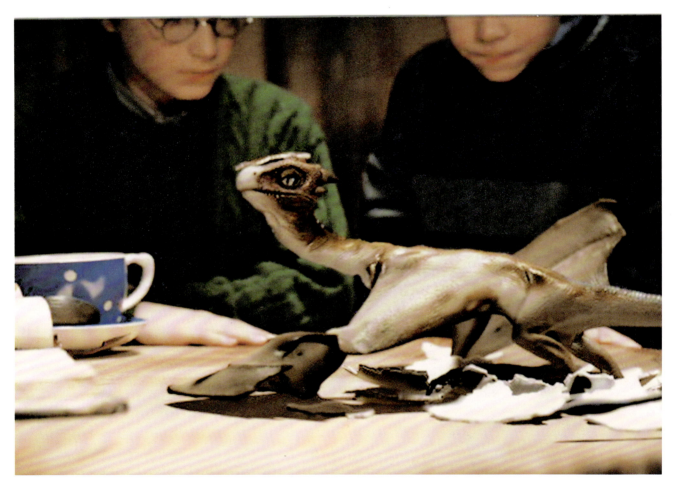

Air jets blown underneath a large prop dragon egg made it shake before it hatched; when Norbert emerged, he was a wholly digital creation. Fortunately, the fire in Hagrid's beard was also digital.

In early sketches, concept artist Paul Catling focused on giving Norbert "awkward gawkiness." Once the design was approved, Catling sculpted it into a maquette that was painted and used as a reference for the digital model. The digital model enhanced Norbert's color scheme by adding iridescence down his back.

The filmmakers decided that at this stage the ridge in his "ridgeback" wouldn't be too developed, so computer artists gave Norbert a bony rib cage, leathery bat wings, chicken feet, wrinkly skin, and a body like a lizard's. He was also given a pointy tongue, double eyelids, a set of horns on his head, and a tail with great swishing action. His large head, feet, and wings were designed to be out of proportion to the rest of his body, which is true for any infant mammal.

When Norbert emerges from the egg, he's very wobbly, and he slips on a piece of eggshell. Special effects designer John Richardson considers that "Norbert is very sweet and innocent, even though he's a dragon, and Hagrid just loves him."

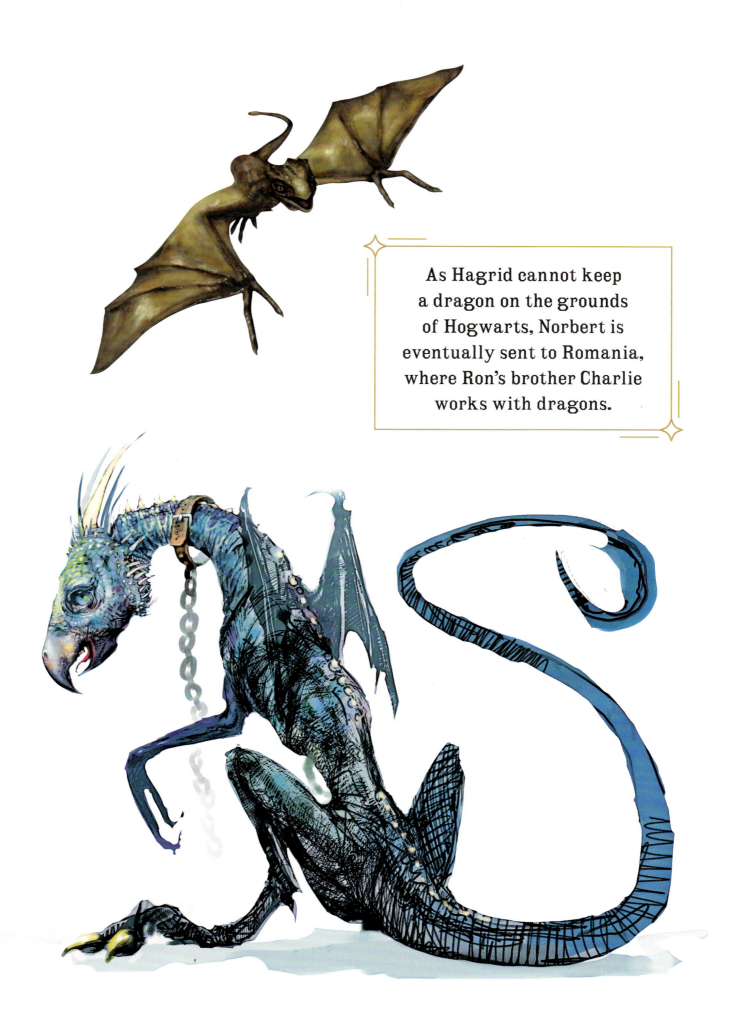

As Hagrid cannot keep a dragon on the grounds of Hogwarts, Norbert is eventually sent to Romania, where Ron's brother Charlie works with dragons.

PAGE 52: **The Hungarian Horntail breathes fire while taking flight in concept art by Paul Catling for** *Harry Potter and the Goblet of Fire*.
OPPOSITE: **Harry (Daniel Radcliffe) and Ron (Rupert Grint) in awe of the newly hatched Norwegian Ridgeback Hagrid names Norbert seen in** *Harry Potter and the Sorcerer's Stone*.
TOP: **A digital interpretation of Norbert.**
ABOVE: **Color study of a juvenile Ridgeback by Paul Catling.**

> The miniature Hungarian Horntail model shows up again in *Harry Potter and the Half-Blood Prince*, where its flame roasts chestnuts on a cart outside of Weasleys' Wizard Wheezes.

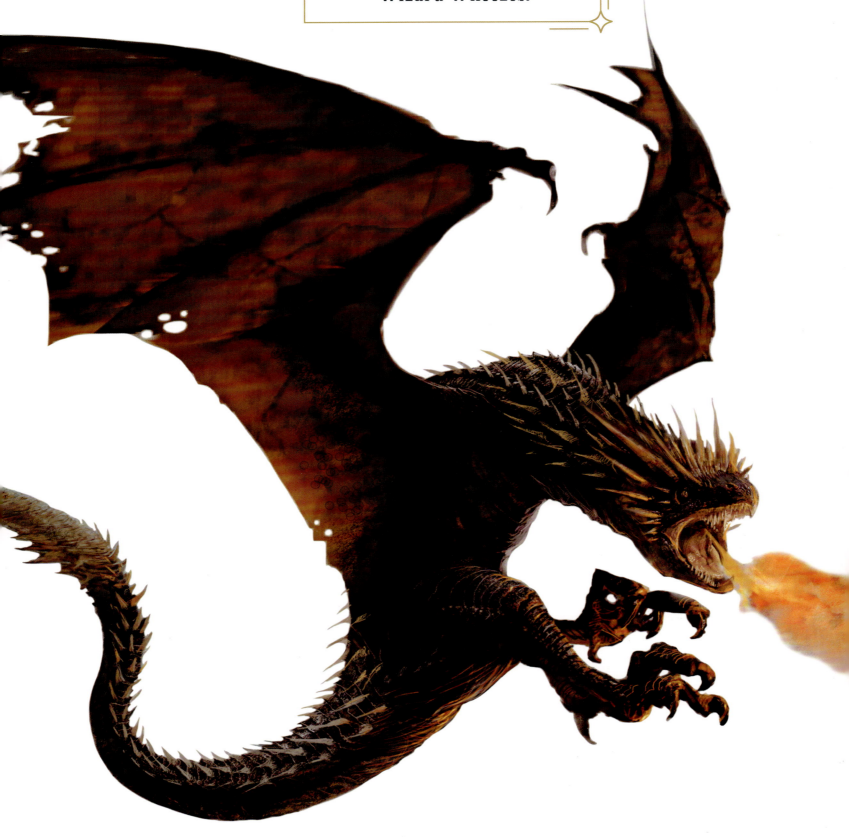

DRAGONS

Hungarian Horntail

The first task of the Triwizard Tournament in *Harry Potter and the Goblet of Fire* is to rescue a golden egg guarded by a dragon. The four champions select their dragons by pulling a miniature version out of a bag held by the Tournament's supervisor. Harry draws the Hungarian Horntail.

"The main problem with dragons," says special creature and makeup effects designer Nick Dudman, "is that the audience thinks they know exactly what a dragon should look like. So the task becomes creating a look for your dragon that is fresh and interesting. Obviously, we had something to start with for our dragon, it being a Hungarian Horntail, because it needed to have horns and a dangerous tail."

Concept artist Paul Catling offered several versions of the dragon with different types of horns and heads, some more serpentlike and others resembling a lizard. And, being a Horn*tail*, it was covered with spikes from its head down to its very vicious tail. Filmmakers envisioned the tail several ways: as a scorpion's stinger, a tail tip with clusters or rows of spikes, and a tail with one long spike. Catling gave special attention to the Horntail's skin texture, the shades of its red-and-gold burnished colors, and the shapes of its eyes. The final Horntail concept had a blunt, hawklike head, huge taloned wings, two heavily clawed legs, battle-scarred skin, and a ruff of spikes that ran down to its tail, which ended in a spear-shaped spike covered in smaller spikes.

Upon design approval, the creature shop crafted it into a quarter-scale maquette to be cyberscanned as a reference for the digital artists. A larger model to scan was requested, so a half-scale version at thirty feet long with a fourteen-foot wingspan was cast and painted. Then Nick Dudman decided they should create a full-size head. "A full-size model allows the sculptors to get real details in," he says, "and it also gives you something you can take on set as a lighting reference and for sight lines."

But the Hungarian Horntail that pursues Harry over and around the castle towers was computer generated. "Even though it's a mythical creature, our goal was to create some realism," says visual effects supervisor Jim Mitchell. "[Production designer] Stuart Craig and I decided that, as dragons are closely associated with dinosaurs, we would give it a raptor-like movement with bat wings. Then we aged it and tore up its wings to make it look as if the creature had lived for a number of years." The Horntail was given spikes that were made to look bent and broken from fighting through those years. Its quick, twitchy movements were taken from those of predatory birds: falcons, hawks, and eagles.

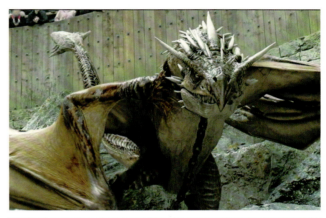

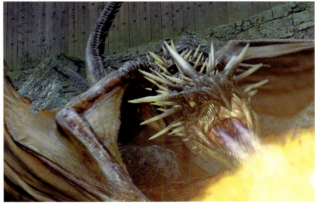

Harry summons his Firebolt broom so he can grab the egg by flying around the dragon, but the Horntail breaks her chains and chases him around the turrets of Hogwarts castle, an idea that came from Jim Mitchell. "I was checking out the huge physical model of the castle for some establishing shots, and I thought, how cool would it be to see Harry and the dragon flying through its deep ravines and under bridges," he recalls. "I imagined the dragon landing on one of the steep towers and roaring like King Kong on the Empire State Building. We could really show Harry's prowess on a broom as he battles the dragon. [Director] Mike Newell and the producers liked the idea and so the sequence grew to include the chase."

OPPOSITE: **The fiery Hungarian Horntail shows battle damage on its wings. Artwork by Paul Catling for *Harry Potter and the Goblet of Fire*.**
TOP AND ABOVE: **The Hungarian Horntail during the first task of the Triwizard Tournament, trying to prevent Harry from taking the Golden Egg it guards.**

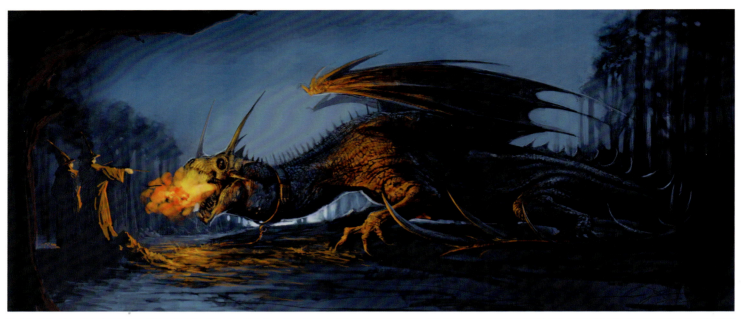

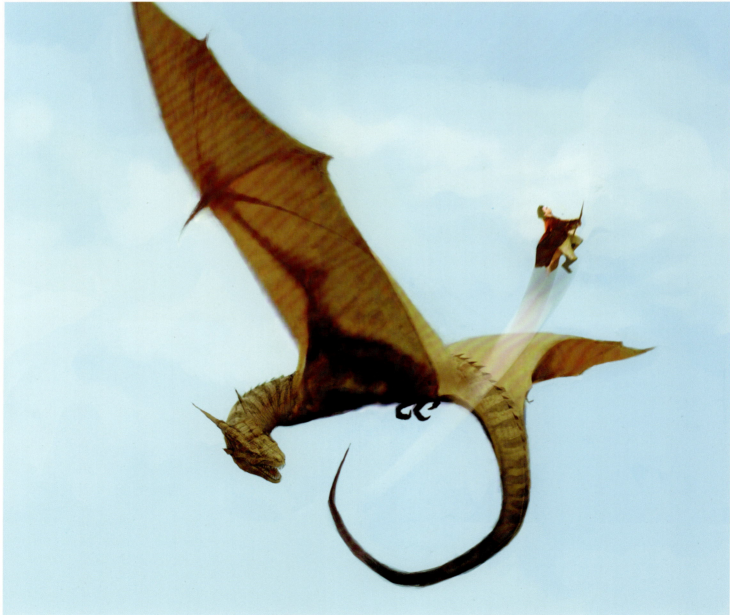

TOP: **Two wizards guard the Hungarian Horntail the night before the first task in artwork by Paul Catling for** *Harry Potter and the Goblet of Fire.*

ABOVE: **Development artist Paul Catling offered many variations on dragon types and coloration.**

OPPOSITE: **Harry escapes the Horntail on his broom in artwork by Paul Catling.**

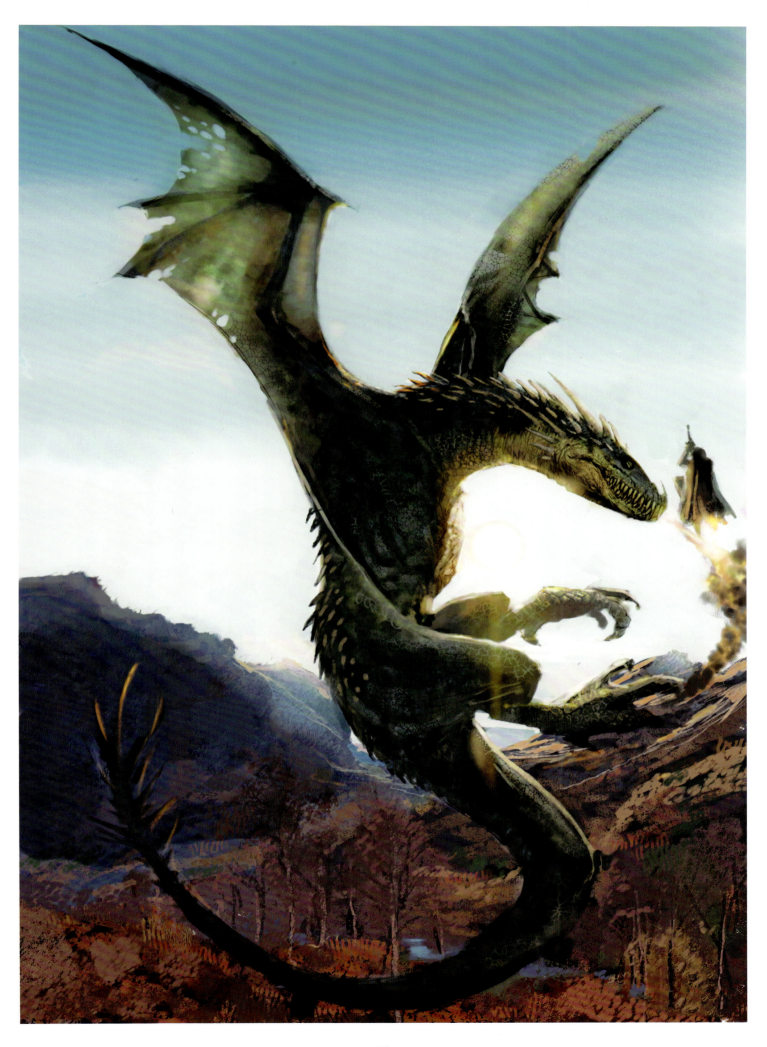

DRAGONS

Harry sees the Horntail the previous night, when Hagrid brings him into the Forbidden Forest to see the dragons, so Nick Dudman and his team were also asked to create a caged Horntail. "Well, you should never turn down the opportunity to build a dragon!" says Dudman. As there was already a full-size model of the head, the creature shop built the dragon's body and tail, forty feet long and seven feet tall at the shoulder, with an extended wingspan of seventy feet. Parts of the Basilisk and Aragog the Acromantula from *Harry Potter and the Chamber of Secrets* were recycled to construct the Horntail puppet. Almost three hundred resin spikes, in six different sizes, were placed on its head, neck, and back. Each spike was individually hand-finished and painted once in place on the Horntail. The dragon's animatronic head could perform a wide range of motions, with a movable neck, mouth, eyes, eyelids, and nostrils. The wings could make limited movements, and the body could move from side to side. Cameras filmed the puppet inside a hydraulically operated breakaway cage.

Members of the creature shop hid under the wings of the dragon, flapping them up and down. Others rattled and moved its cage. "But for me," Dudman says, "what really made it amazing was when special effects designer John Richardson put a flamethrower in it."

Having the dragon breathe fire required that a new head be cast in fireproof fiberglass with a fireproof Nomex snout. Twin flame jets, controlled by a performance computer system, projected a thirty-six-foot stream of dragon fire at the camera. To withstand the flames, the Horntail's beak was recrafted in steel, which glowed red when the fire passed through it.

"We were in the woods at night," Dudman remembers, "and I stood there looking at a fire-breathing dragon shaking a cage to pieces in front of me. And I thought—this is fantastic. This is what I joined up for."

THESE PAGES: **Close-up studies of the Hungarian Horntail by Paul Catling of its head, scales, and skin for** *Harry Potter and the Goblet of Fire*.

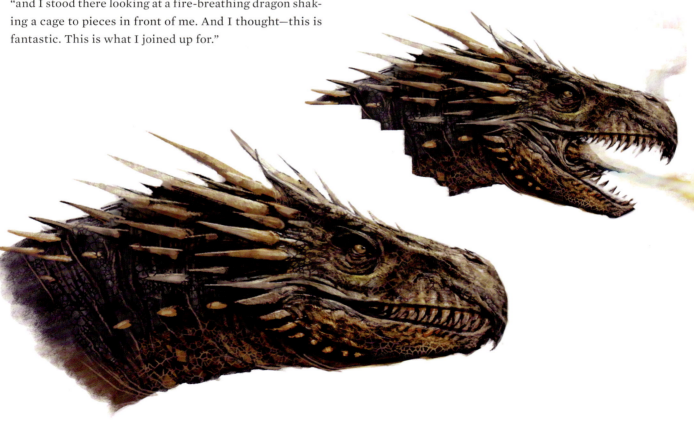

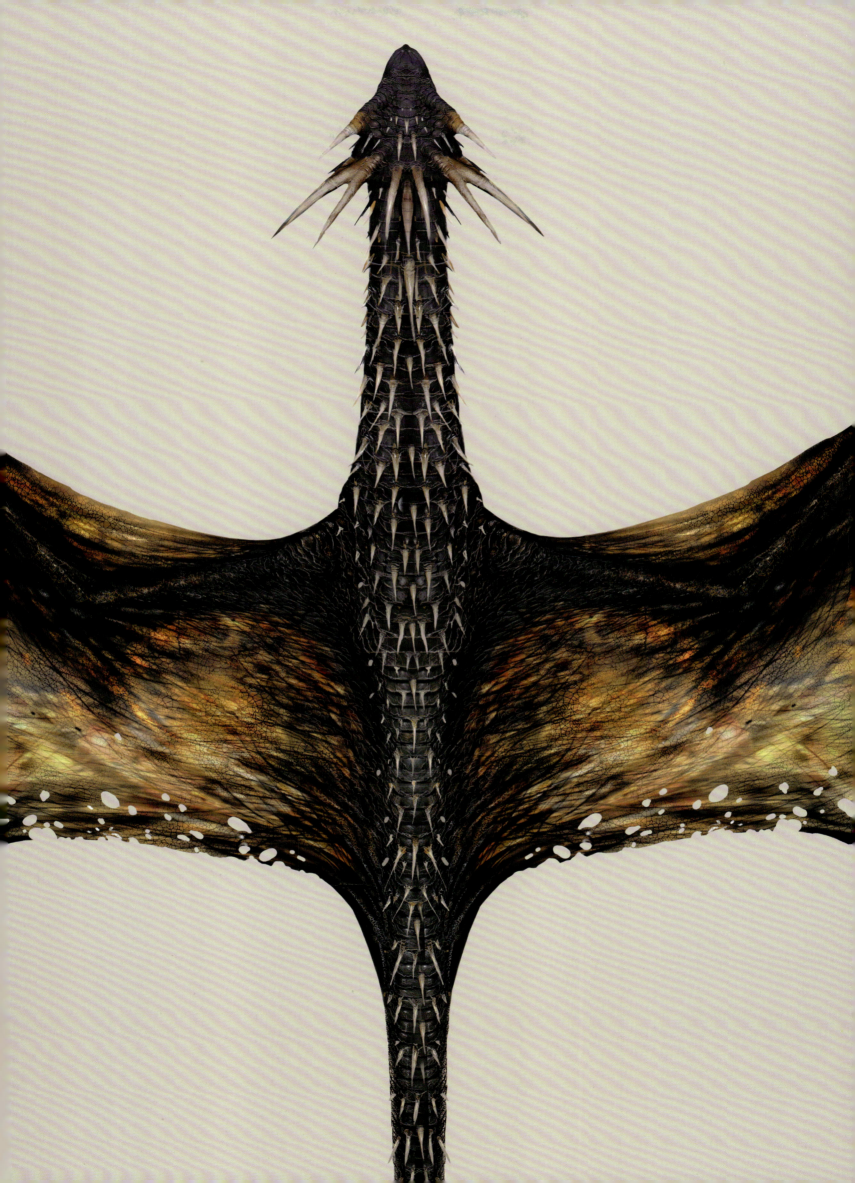

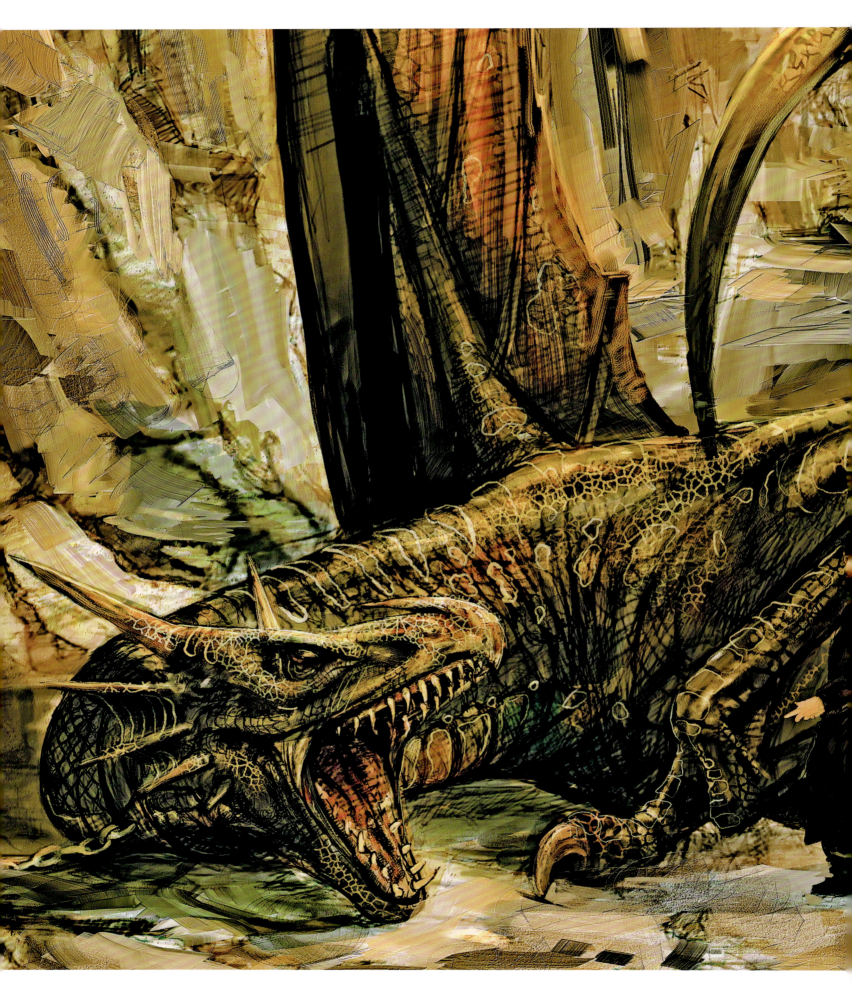

ABOVE: Artwork by Paul Catling of Harry looking for a way to take the Golden Egg from the Hungarian Horntail, for *Harry Potter and the Goblet of Fire*.

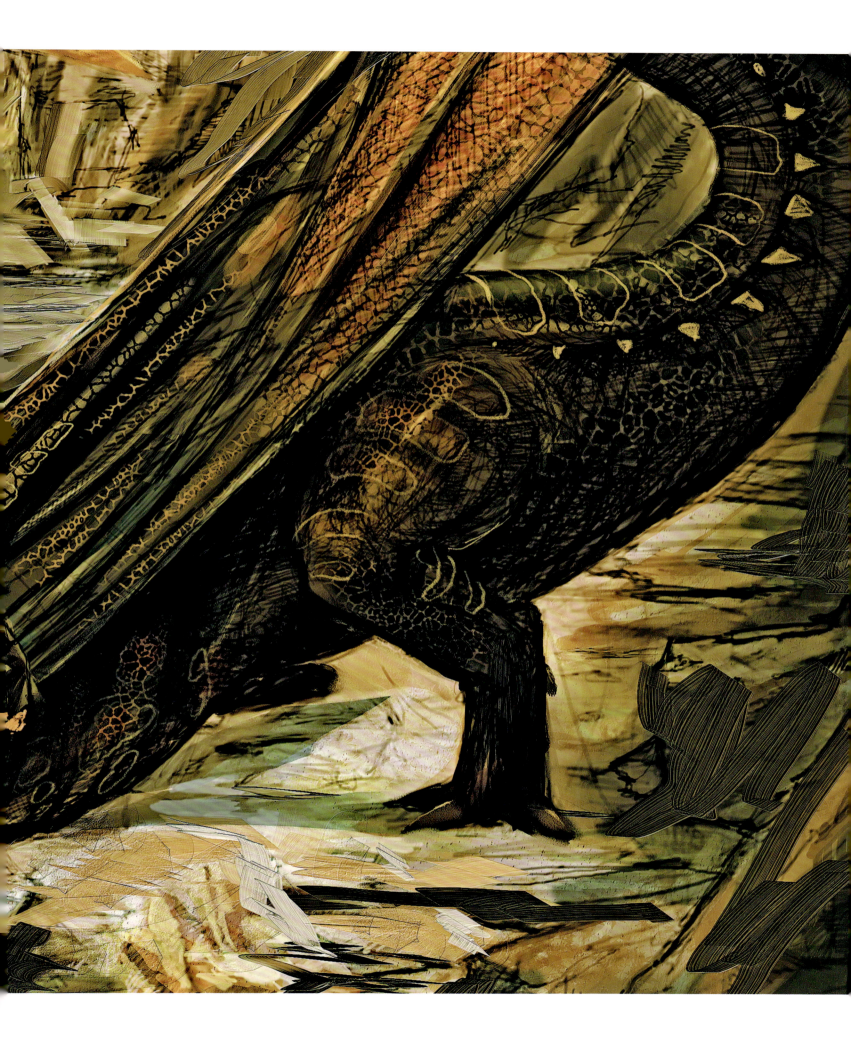

DRAGONS

Common Welsh Green, Chinese Fireball & Swedish Short-Snout

COMMON WELSH GREEN

Fleur Delacour is the Beauxbatons Academy of Magic's champion and the first to choose a dragon for the first task of the Triwizard Tournament in *Harry Potter and the Goblet of Fire*. She selects the Common Welsh Green. This dragon, native to the United Kingdom, has a hide colored in bright mustard green, and it breathes fire as it scurries around Fleur's palm. Before she even slips her hand into the bag, smoke emerges from the little fire-breathers inside.

Concept artist Paul Catling, who fellow artist Adam Brockbank calls "Dragon Man," explored versions of the Welsh Green with its battle-scarred wings extended and closed. Other artwork showed the dragon's skin with markings and mottling and possible ideas for textures. Catling and the other concept artists considered how each dragon's wings would attach to its body and then extend, which depended on the number of appendages. The Welsh Green is one of few dragons seen in the films with four legs. For one piece, artwork depicted the dragon blowing purple rings of smoke.

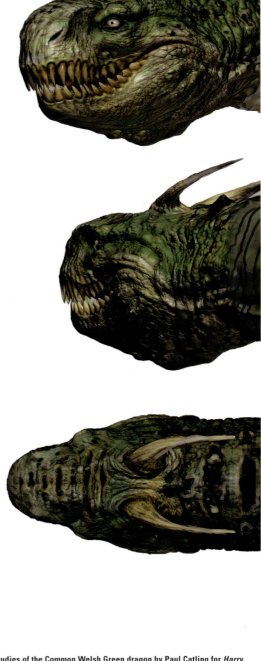

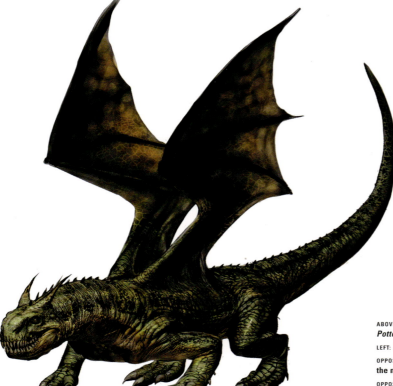

ABOVE: Head studies of the Common Welsh Green dragon by Paul Catling for *Harry Potter and the Goblet of Fire*.
LEFT: A Common Welsh Green with its wings extended. Art by Paul Catling.
OPPOSITE TOP: Paul Catling created a second version of two wizards watching a dragon the night before the first task, this time the Common Welsh Green.
OPPOSITE BOTTOM: The Common Welsh Green also shows battle damage in art by Paul Catling.

64

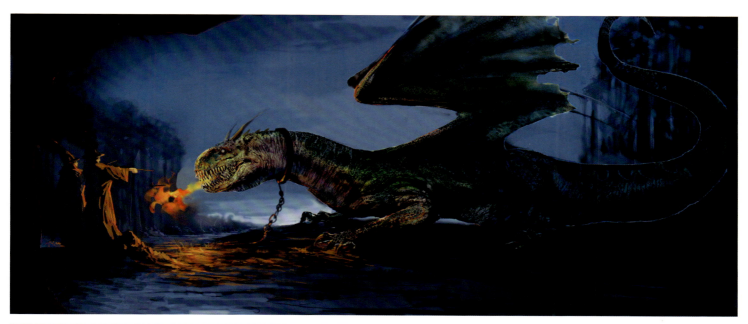
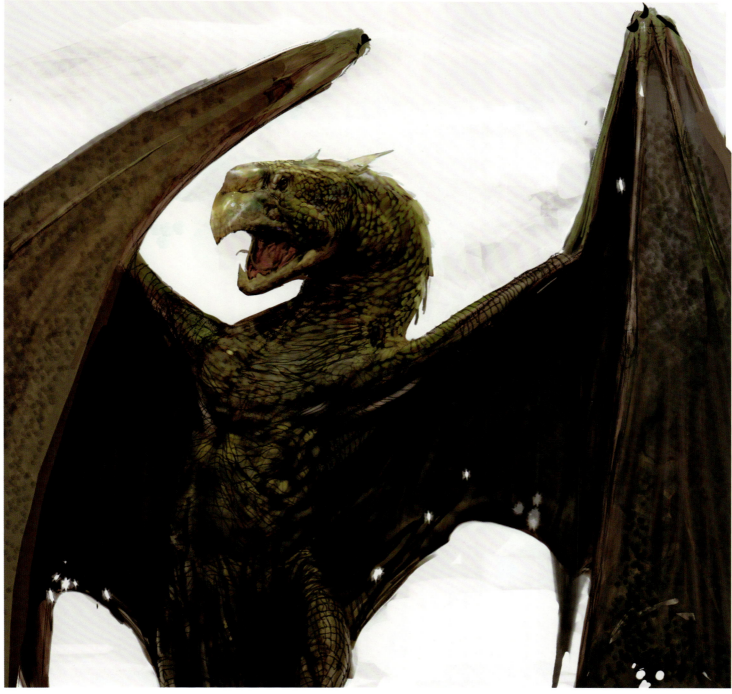

65

DRAGONS

CHINESE FIREBALL

Viktor Krum, champion for Durmstrang Institute, is the second to select a dragon, and he pulls out the Chinese Fireball. The Fireball has a more lizard-like body than the other dragons, as the artists referenced the idea that different cultures would have different-looking dragons. The smooth-scaled, scarlet dragon has a fringe of thin gold spikes around its face, which has a snubbed snout and long, sharp teeth. Its front legs connect directly to its wings, but in a different way from the Hungarian Horntail, so it cannot use them as "arms."

Catling's work has always included exploring different colorations for the dragons, although the "Fireball" part of this dragon's name inspired its red-and-gold palette and evokes the creatures of Asian mythology.

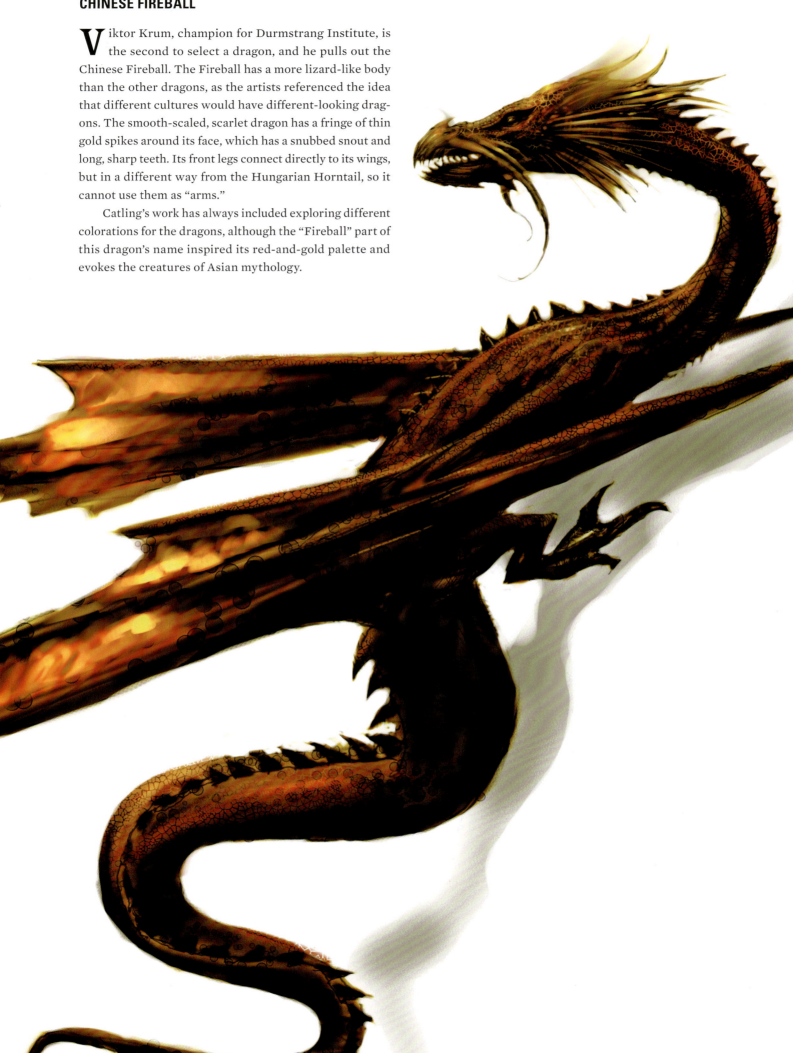

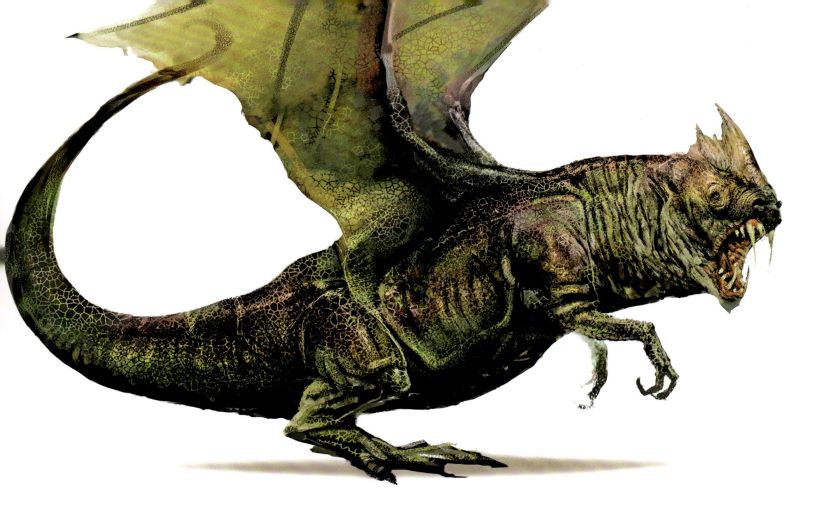

SWEDISH SHORT-SNOUT

Cedric Diggory is the first Hogwarts champion chosen for the Triwizard Tournament (Harry is the unprecedented second champion). Cedric pulls out the Swedish Short-Snout—the golden-hued dragon that complements the colors of Cedric's Hufflepuff house. It is obviously named for its shortened nose, and Paul Catling's artwork explored several versions of what the snub of its snout could look like.

As there have been many dragons already seen in films and featured in myths and legends, the concept artists kept in mind the idea that these dragons should not look like others that had come before. Innumerable colors, textures, profiles, and wing and tail forms were considered among the hundreds of ideas generated for the Harry Potter dragons. Some options borrowed from existing animals; one idea from Paul Catling was rhinoceros-like with blue skin; another resembled a Doberman. Dragons were rendered with teeth like a walrus's or a shark's, and with rows of large teeth or no teeth at all. Other dragons gave nods to lizards, snakes, and even tortoises.

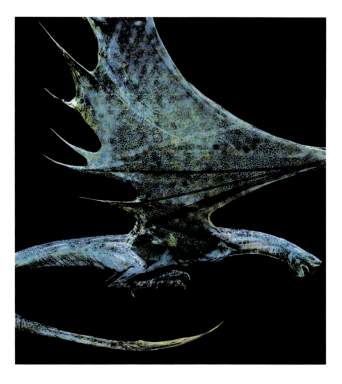

OPPOSITE: **Development art of the Chinese Fireball dragon by Paul Catling for** *Harry Potter and the Goblet of Fire*.
TOP: **Paul Catling proposed an assortment of "short snouts" for the Swedish Short-Snout. This one's snout was inspired by a rhinoceros.**
ABOVE: **Paul Catling explored color variations for each dragon in the Triwizard Tournament, giving this version of the Swedish Snort-Snout a mottled icy blue skin.**

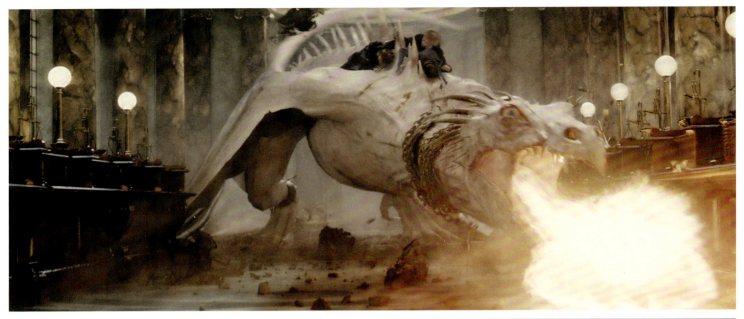
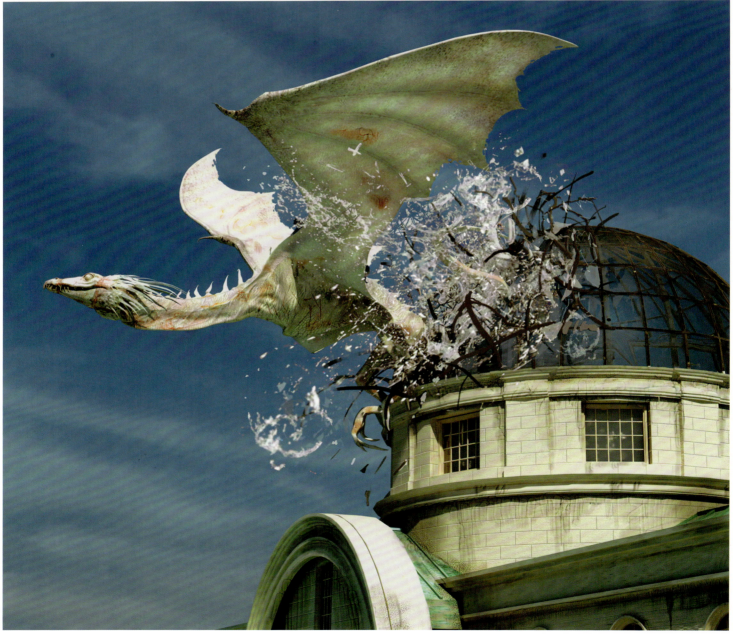

DRAGONS

Ukranian Ironbelly

In pursuit of Voldemort's Horcruxes, Harry, Ron, and Hermione, along with Griphook the goblin, travel to Gringotts Bank in *Harry Potter and the Deathly Hallows – Part 2* to investigate the vault of the Lestrange family. They have been told a possible Horcrux—the Hufflepuff cup—is inside, kept hidden by Bellatrix Lestrange.

The Lestrange vault is in the deepest, darkest part of the bank, where the oldest wizarding families' vaults are located. It is guarded by an ancient dragon—a sixty-four-foot Ukrainian Ironbelly, but this dragon has been neglected and ill-treated. "It's a different dragon than we've seen before," says visual effects supervisor Tim Burke. "This is a maltreated dragon who's been kept in a dark cave all its life. It's emaciated. It's partially blind. It's very, very dangerous."

Concept artist Paul Catling depicted the once-mighty creature bent but not broken, though the Ironbelly has been shackled and chained. What coloring it formerly displayed is faded, and its tattered skin is covered in scars from mistreatment by its goblin jailers. Catling included the chains and tethers that bind the dragon and stains of rust on its skin from years of imprisonment. He also chose a crown of thin horns for its head and a long, beaked snout.

The goblins control the angry dragon with threats of pain, so the filmmakers wanted to give the dragon the appearance of a captive. Tim Burke provided the digital artists with reference footage of rescue dogs and Russian circus bears, so the Ironbelly's behavior would reflect its condition as an abused animal. "The body language was so apparent in the way these animals held themselves," says Burke, "their posture, and their eyes. We showed that in the dragon when the goblins use the clankers"—metal instruments used to warn the dragon to move away or it will be hurt. "This creature has been taught to fear the noise—a bit like Pavlov's dog—and so it's cowering and terrified," he adds.

> **Though it was important to have the Ironbelly look unhealthy, director David Yates wanted audiences to have empathy for it, and yet at the same time be terrified.**

The creature shop created a small model of the Ukrainian Ironbelly, then had it cyberscanned for the visual effects team. Computer artists gave it loose skin that was an anemic grayish white, with bulging veins and old wounds. There's even a hint of what could be dragon mange on it.

Griphook helps the trio get into the bank, then leaves them to find their own way out. Hermione comes up with a "mad" idea—they'll fly out on the dragon. Releasing the dragon from its shackles, the trio is able to make their escape.

Though the Ukrainian Ironbelly was a digital creation, the creature shop created a portion of its body for the actors to jump on and ride out. They sculpted a twelve-foot-long section of the dragon's back covered in flexible foam latex hide, then mounted that onto a motion-based motorized gimbal. Special effects designer John Richardson built a mechanical rig to control its movement. Fully jointed shoulders could move in concert with the computer-generated flapping of the dragon's wings, and the rig had pneumatic rams to drive the dragon's shoulders up and down, twist the neck and spine in three places, and lift the top of the tail. "We programmed the base to follow the animation of the dragon," explains visual effects producer Emma Norton. "So when you combine the blue-screened actors who are sitting on the model with the CG animation track, they stick together and move in sync."

With the three heroes on its back, the Ironbelly flies hundreds of feet upward within the rocky environment, smashing through the floor of the bank. Scrambling madly with its legs and wings, it continues up, crashing through the glass roof and into freedom above the rooftops of London. The visual effects team referenced large flying birds, including the albatross, for the dragon's clumsy takeoff, but once airborne, the Ironbelly gains strength and majesty as it flies. "He was trapped," says Tim Burke. "Unable to fly. Partially blind. And he had been down there his whole life. It was important to emphasize that, so you wanted him to escape and when he did, he flew with majesty and pride. That was a lovely story to roll into the character of the dragon."

OPPOSITE TOP: **The Ukrainian Ironbelly, held captive by the goblins at Gringotts, finally escapes with the help of Harry, Ron, and Hermione in** *Harry Potter and the Deathly Hallows – Part 2*.
OPPOSITE BOTTOM: **Starved and abused for years, the Ironbelly gathers the strength to leave Gringotts bank and fly away.**

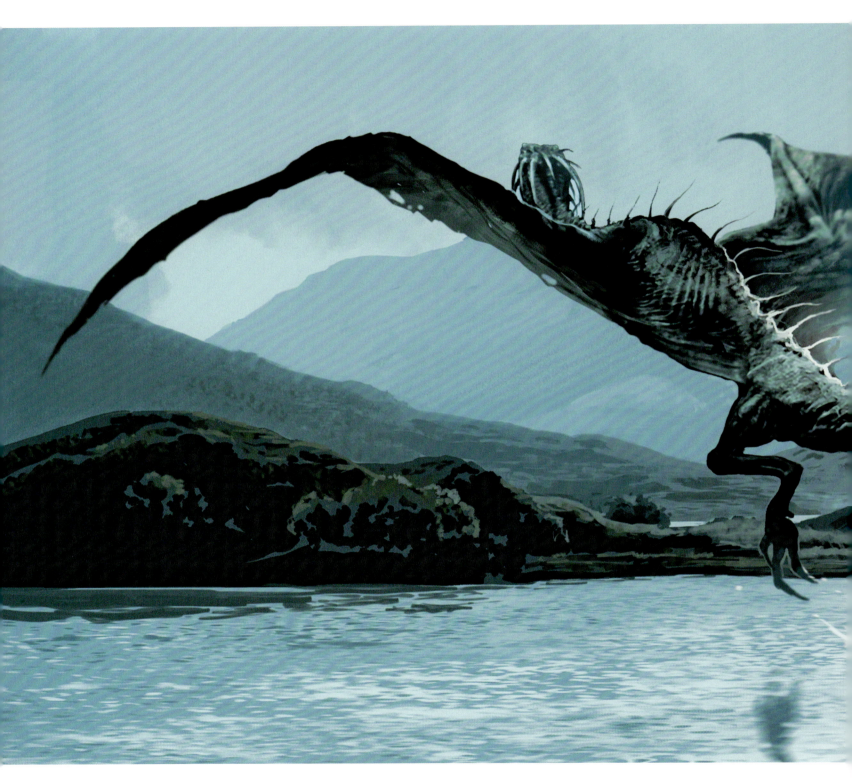

ABOVE: **The Ukrainian Ironbelly dragon flies Harry, Ron, and Hermione to safety in** *Harry Potter and the Deathly Hallows – Part 2*, **dropping them off in a lake near Hogsmeade in artwork by Adam Brockbank.**

70

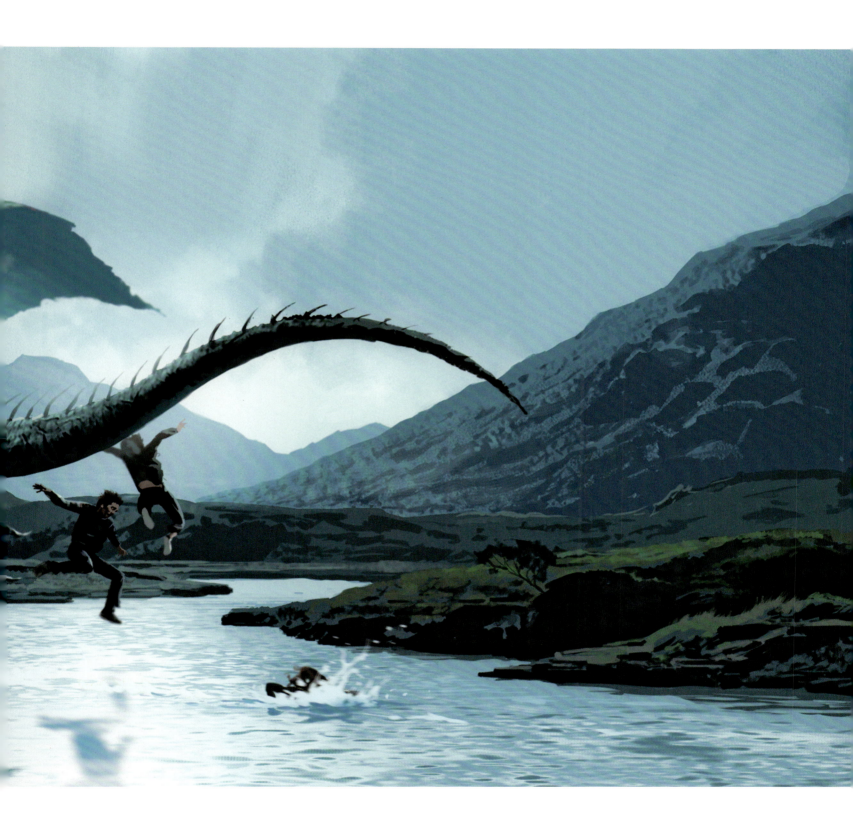

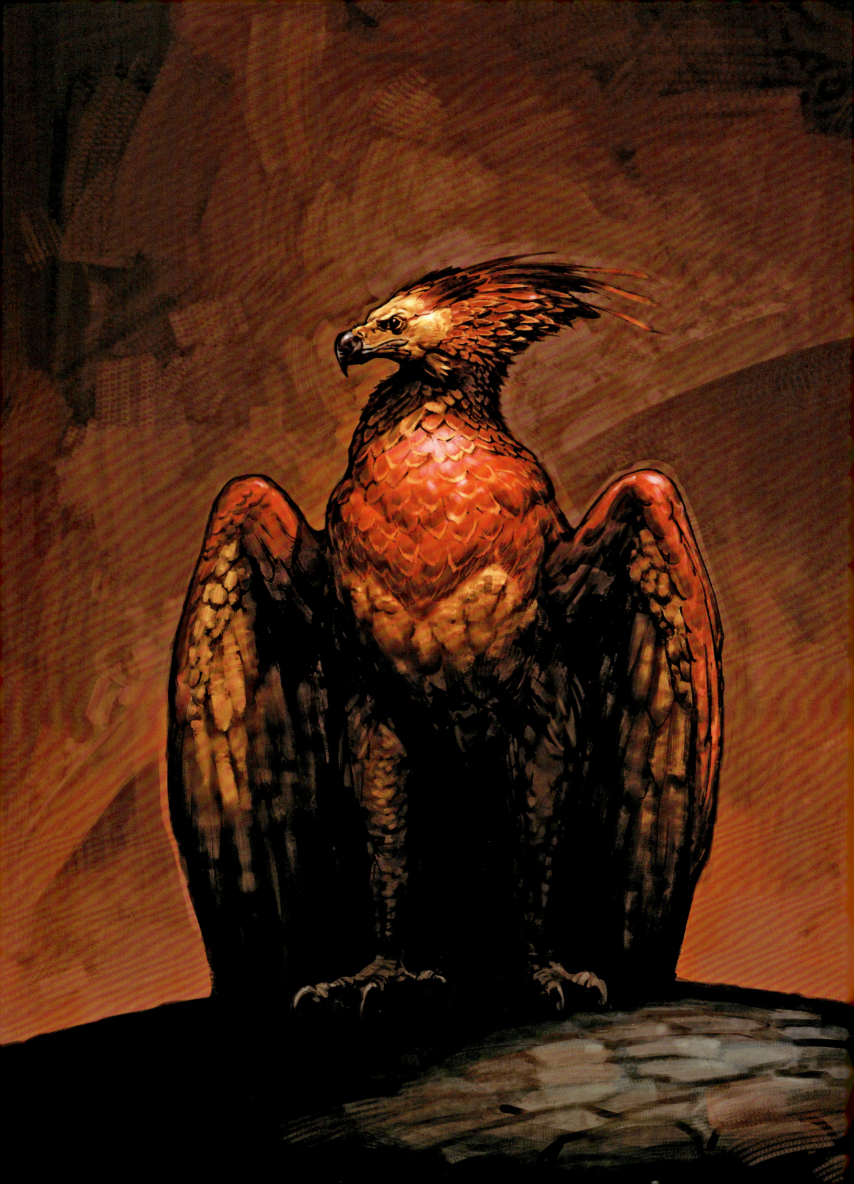

CHAPTER

3

COMPANIONS

COMPANIONS

Fang

It is fitting that the half-giant Rubeus Hagrid has an animal companion paralleling him in size. Fang is a large black dog that is gentle in nature but drools. A lot.

Filmmakers looked at an assortment of breeds that might fit Fang's description, including rottweilers, deerhounds, bullmastiffs, Dobermans, and Great Danes. But the breed that caught the producers' eyes was the Neapolitan mastiff. "It was the sheer size of them," explains animal trainer Julie Tottman, "and the breed hadn't been used in films before." Neapolitan mastiffs, one of the oldest breeds in the world, are known for their massive head and body, but they also have a very peaceful nature.

Four "Neos"—Hugo, Luigi, Monkey, and Gunner—performed the bulk of Fang's actions. Tottman always had at least two dogs on set who could swap out if one got tired, though, admittedly, the dogs were mostly sitting or lying down. Other dogs that worked in the role were Bella, Vito, Kato, and Bully. All the dogs were rescues. They endeared themselves to the cast and crew, with one notable exception. "The slobber's always a problem," Tottman admits. "I'm always on set with my tea towel."

Harry, Ron, Hermione, and Draco serve detention in the Dark Forest in *Harry Potter and the Sorcerer's Stone*, accompanied by Hagrid and Fang. When Draco is paired with Harry, he insists on Fang going with them, even though Hagrid calls his companion "a bloody coward." To protect the paws of the canine actor, the forest floor was covered in a thick layer of moss.

In *Harry Potter and the Chamber of Secrets*, Fang accompanies Harry and Ron when Hagrid directs them to "follow the spiders" into the forest, where they will be able to find information about the Chamber of Secrets. Fang is reasonably calm in the face of the giant Acromantula, Aragog, even when thousands of his descendants go after Harry and Ron as a free meal. In a thrilling rescue, the Ford Anglia Ron flew to Hogwarts with Harry shows up, having lived rough in the forest for a time, and as the car doors open, Fang jumps into the back seat.

Bella, who was the most comfortable in cars, handled the action. Yet, though the dog was the smallest one, the Ford Anglia needed to be equipped with an extra-wide back seat. For the scene where the car races out of the forest, an animatronic Fang was used. "You couldn't put a real dog in the back," says special creature and makeup effects designer Nick Dudman, "so we created a radio-controlled 'stunt' dog." The creature was also programmed to drool, about which Dudman jokes, "We put [it] in just to upset Rupert."

In *Harry Potter and the Order of the Phoenix*, Hagrid returns from parleying with the giants, his face sporting cuts and bruises. Harry, Ron, and Hermione join him as Hagrid holds a raw steak over his injuries, and Fang can't take his eyes off the meat. Eventually, Hagrid tosses it to him. Robbie Coltrane was given a fresh, trimmed steak to use for each take, and the dog, played by Monkey, was happy to complete the action as many times as needed. The trainers limited the number of takes for this scene, joking that this might be the only time an actor would ask for retakes.

Later, in *Harry Potter and the Half-Blood Prince*, after Harry, Hagrid, Fang, and Professor Horace Slughorn return to Hagrid's hut from the funeral of Aragog, Harry watches as Hagrid and Slughorn get a little inebriated and sing an old song together. Fang takes it easy, lying on the floor near a cheery fire. Monkey, who played Fang for this scene, felt so relaxed enjoying the warmth that he rolled over onto his belly and fell asleep.

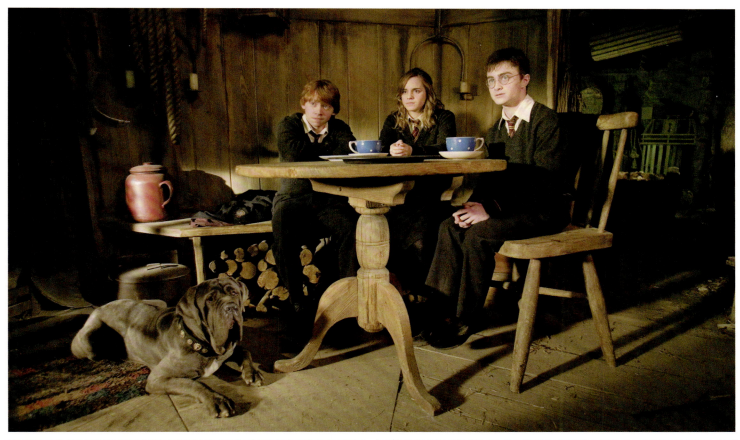

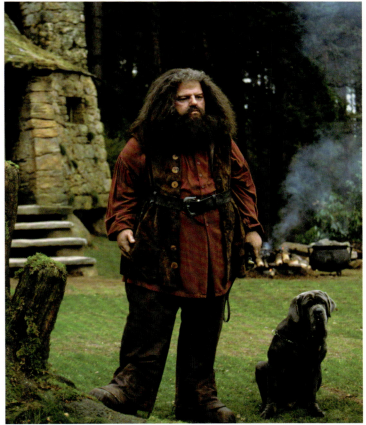

> Throughout the films, all the Neos learned behaviors to "stay" or "sit" on a mark, or "come" from one mark to another mark, but no trainer was able teach the large-jowled canines to learn a "don't drool" behavior.

PAGE 72: A study of Fawkes, Dumbledore's phoenix, in fiery reds and golds, by Adam Brockbank for *Harry Potter and the Chamber of Secrets*.

OPPOSITE: Fang, the beloved—and hefty—dog of half-giant Rubeus Hagrid, seen throughout the Harry Potter films.

TOP: Fang rests comfortably beside the Hagrid-size table when Ron (Rupert Grint), Hermione (Emma Watson), and Harry (Daniel Radcliffe) visit Hagrid in *Harry Potter and the Order of the Phoenix*.

ABOVE LEFT: Fang and Hagrid beside Hagrid's hut in *Harry Potter and the Sorcerer's Stone*.

ABOVE RIGHT: Fang accompanies Draco (Tom Felton) and Harry (Daniel Radcliffe) while serving detention in the Dark Forest in *Harry Potter and the Sorcerer's Stone*. Moss and other soft materials were laid on the forest floor to protect the dog's paws.

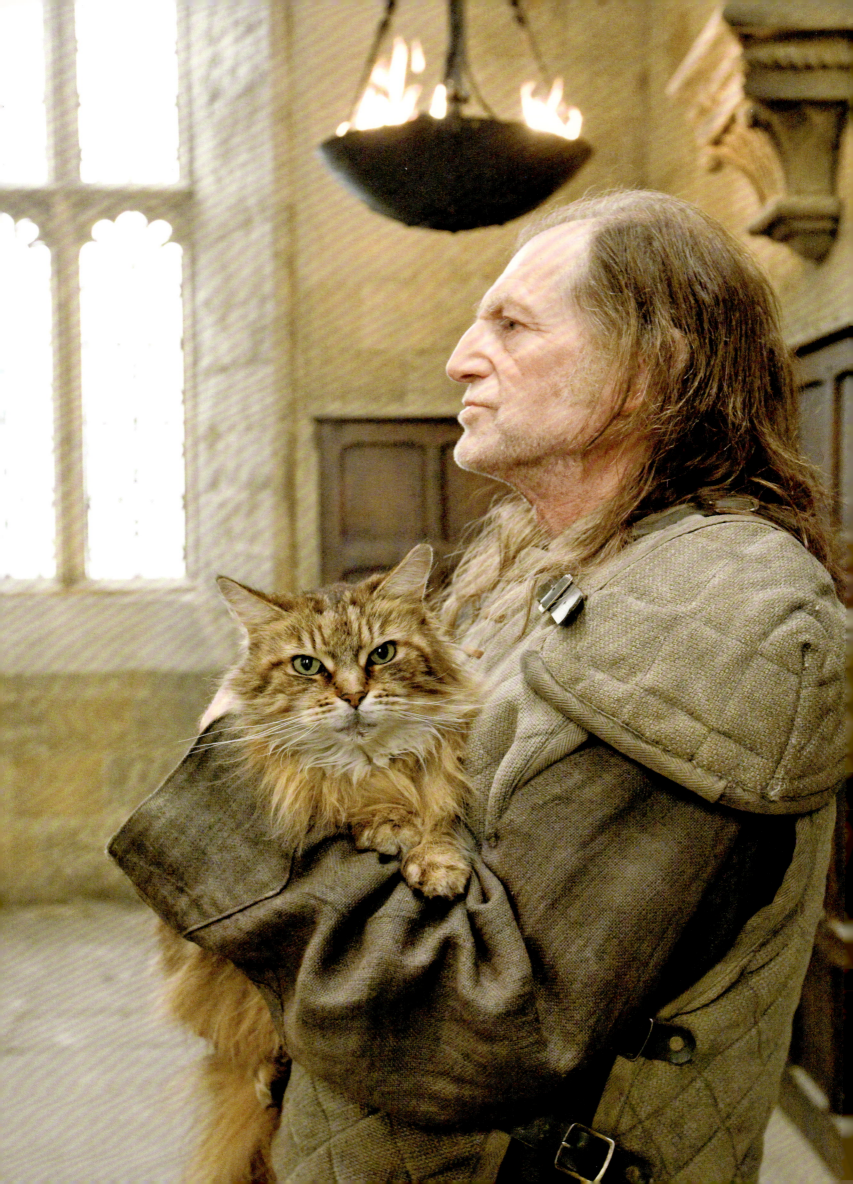

COMPANIONS

Mrs. Norris

Mrs. Norris is the beloved cat of Argus Filch, caretaker of Hogwarts castle. She patrols the corridors of the school on Filch's behalf, looking for misbehaving students. Once she finds them, there's an almost telepathic communication between Mrs. Norris and her owner, for Filch appears only moments after the cat has spotted any wrongdoing. "He not only worships Mrs. Norris," says David Bradley, who plays Filch, "he depends on her as his chief spy." Filch and Mrs. Norris have a very close relationship—they even share a dance at the Yule Ball in *Harry Potter and the Goblet of Fire*—**and he is rarely seen without her.**

Over the course of the eight Harry Potter films, a handful of Maine coon cats played Mrs. Norris, plus an occasional "stuffie" cat, and each cat had a specialty behavior or action. For example, Pebbles excelled at striding up and down the long corridors of Hogwarts and stopping on a mark. Maximus (Max) appeared as Mrs. Norris in each film and received the most screen time. Max was the best at riding on Filch's shoulders and around his neck, as seen in *Harry Potter and the Order of the Phoenix*. He was also good at running to or alongside the actor.

Alanis was the only female feline, also seen in every film in which Mrs. Norris appears. "Alanis is very good at nestling in my arms and will do so for hours," says Bradley. "Sometimes Alanis would fall asleep on camera." A bona fide cat lover, Bradley needed only to rub or tap her gently on her head and she would wake up and play her part. Cornelius was a backup for the other cats, though also seen in every film, and was trained to sit in place. The film crew, however, was challenged by Cornelius's tendency to meow and howl during filming.

Mrs. Norris is the first victim of the Basilisk in *Harry Potter and the Chamber of Secrets* when the Chamber is opened. Thankfully, she only sees the Basilisk's eyes reflected in a puddle of water and doesn't look directly into them, but it is enough to Petrify her. This was one of the few scenes that did not use a live cat; in this case, a faux "stuffie" cat was used.

Mrs. Norris is described in the books as having yellow, lamp-like eyes, but the filmmakers chose to make her eyes a glowing red for the early films, doing this digitally in postproduction. Bradley helped the computer artists with this. "When the cat's in my arms or in between my feet," he explains, "the cat had to be facing the camera so they could digitize its eyes to make them look red." Occasionally, instead of sitting on Bradley's head, the cat would sit on his shoulder with their rear end facing the camera. "So we'd do another one," Bradley continues, "They'd land and sit on my head and the tail would be across my lip like a mustache." He hoped to keep that one in the film, but it didn't make it on-screen. "It's always best when the cat's facing the camera," he adds, "though sometimes it takes a while to get."

"I think the cats know I'm a cat lover," says Bradley, "so it's very easy to have them crawling over my shoulder, sitting on my head, or whatever they have to do. And I just let them do what they want and steal the scene. I don't stand a bloody chance with them, mate!"

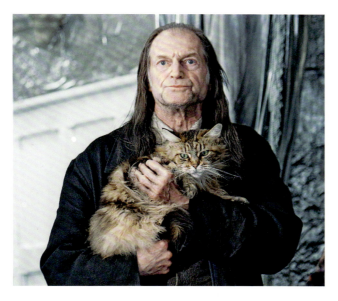

ABOVE: **Argus Filch (David Bradley) and his beloved Mrs. Norris attend the Yule Ball together in** Harry Potter and the Goblet of Fire.
OPPOSITE: **Even while contemplating the upcoming battle in** Harry Potter and the Deathly Hallows – Part 2, **Mrs. Norris lays calmly in Filch's (David Bradley) arms.**

> **To warm the paws and bodies of all the cats filmed on the cold stones of Hogwarts castle in the Harry Potter films, materials were provided to heat the floors.**

COMPANIONS

Crookshanks

For her third year at Hogwarts, Hermione Granger brings an extremely large orange cat named Crookshanks with her to the school, in *Harry Potter and the Prisoner of Azkaban*. Crookshanks literally races into view in her first appearance, chasing Ron's rat, Scabbers, down the hallways of the Leaky Cauldron, each landing in the arms of their respective humans.

A handful of different red Persian cats played Crookshanks over the course of the films. Crackerjack was the most versatile and had the most time on-screen. Prince preferred to be carried and held rather than anything else. He was only seen in *Order of the Phoenix*. Another cat, a rescue named Pumpkin, caused challenges for the sound department, as she sometimes purred too loudly during filming.

Animal trainer Julie Tottman was asked to find a grumpy-looking cat when casting began for Crookshanks. Each ginger cat's "grump" was dialed up by applying an animal-safe brown "eye shadow" around the mouth and eyes. Crookshanks's matted fur was created by trimming blobs of brushed-out undercoat fur, balling them up, and clipping them onto the cat's coat.

It took roughly four months to train Crackerjack and Dex, the rat that played Scabbers, to run down the hall of the Leaky Cauldron. While practicing, the animals ran in parallel lanes separated by a soft netting. At the end of their run would be critter treats. Normally, a rat would run quickly to avoid a scary cat confrontation, but Dex and Crackerjack became friends over time, and the rat had no fear of the cat. The animal trainers had to give Dex a substantial head start and encourage him to speed up so that Crackerjack wouldn't overtake him.

In *Harry Potter and the Order of the Phoenix*, Harry, Hermione, and the Weasleys are staying at Sirius Black's house. During a meeting of the Order, the kids attempt to eavesdrop on the adults by using a pair of Extendable Ears provided by Fred and George. Crackerjack, who had already learned how to stop on a mark, learned a new retrieving skill for this sequence. Once the Ear is lowered on a string from the second floor to the first, Crookshanks bats at the dangling Ear, wrestles with it, and then manages to yank it out of the twins' hands and carry it away, to the dismay of all. The trainers spent the better part of three months teaching Crackerjack, Prince, and Pumpkin to play with and then grab the Ear, take it away, and drop it in a bowl off camera, where a trainer waited to reward them with a kitty treat.

As the residents celebrate at Christmas dinner, Crookshanks watches on a stool. Sardine juice was rubbed on Crackerjack's mouth to encourage him to lick his lips, and a feather was used to direct the cat in which way to look. Trainers rewarded the cat with treats (not the Christmas turkey) once his part was complete.

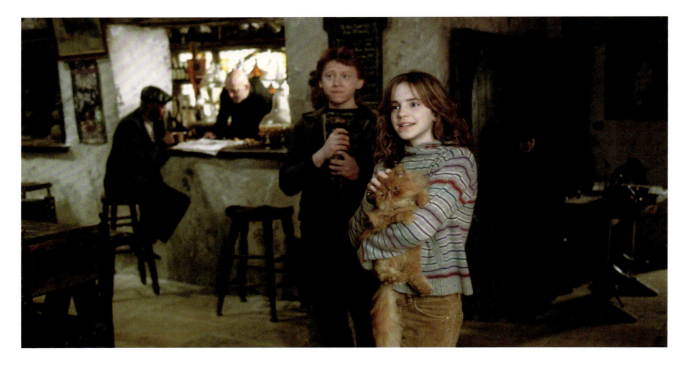

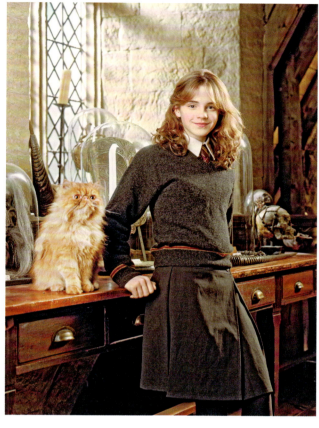

When Ron tells Hermione to keep Crookshanks away from his rat or he'll turn the cat into a tea cozy, she reminds him that it's just in the animal's nature. Ron counters that she shouldn't be sure it's a cat: "Looks more like a pig with hair, if you ask me."

OPPOSITE: **Ron (Rupert Grint) and Hermione (Emma Watson) hold their companions, Scabbers and Crookshanks respectively, after a running race in the Leaky Cauldron in** *Harry Potter and the Prisoner of Azkaban.*
ABOVE: **Crookshanks and Emma Watson (Hermione) in a publicity still for** *Harry Potter and the Prisoner of Azkaban.*
BELOW: **Crookshanks: the matted, furry, and devoted companion of Hermione Granger.**

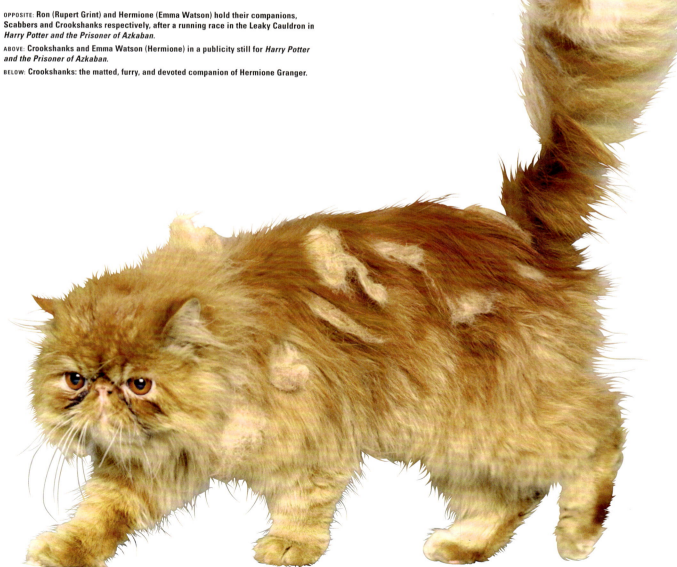

COMPANIONS

Trevor

For the "toad" in the "owl or a cat or a toad" that students are allowed to bring to Hogwarts, Neville Longbottom has Trevor. He does not have him all the time, however—Trevor tends to elude Neville and hop out on his own. In *Harry Potter and the Sorcerer's Stone*, Neville loses him twice—once on the Hogwarts Express and again right outside the Great Hall before the first years are sorted into their houses.

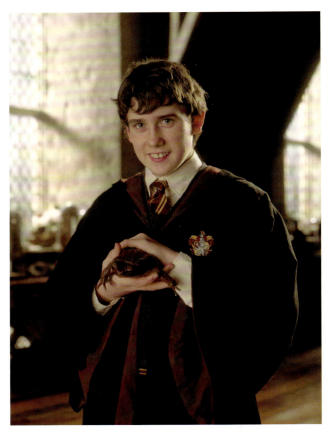

Four toads shared playing Trevor and stayed in a large, moss-based terrarium specially heated for their comfort when they weren't needed for a scene. When requested on set, a trainer either handed the toad to actor Matthew Lewis (Neville) or placed it on a prop, such as a stair step in front of the Great Hall or an armchair in the Gryffindor common room, and retrieved it immediately afterward to be placed back into its on-set terrarium.

The toad most frequently used was, oddly, named "Harry." However, Harry did not enjoy being held, and he would try to jump out of Lewis's hands into his face or onto other actors. "When he did behave," says Lewis with a laugh, "the only reason he did was because he wanted to relieve himself all over me. Which he did. It was like, 'Oh, I'll stay in your hands for this!' and he used to pee all over me." When this happened, Lewis would wash his hands and a new toad would be brought in. Lewis recalls, "They'd take Harry the toad away and give me a new one, which had a full tank, and he'd do the same thing!"

Neville held Trevor in a publicity shot for *Harry Potter and the Prisoner of Azkaban*, but Trevor wasn't seen in the films beyond that. Lewis remembers that David Yates, director of the fifth through eighth Harry Potter films, questioned him about what happened to the toad. "You want him back?" Yates asked. Lewis replied, "'Honestly, David, no, I don't.' And he was never seen again."

TOP: Matthew Lewis (Neville Longbottom) holds one of the four toads who played Trevor in a publicity still for *Harry Potter and the Prisoner of Azkaban*.
LEFT: One of the toads that played Trevor in the Harry Potter films, possibly the one named Harry.
OPPOSITE BOTTOM: Luna Lovegood (Evanna Lynch) offers some background on Pygmy Puffs to Ginny (Bonnie Wright) while enroute to Hogwarts in *Harry Potter and the Half-Blood Prince*.

COMPANIONS

Ginny's Pygmy Puff

The Weasley twins, Fred and George, leave Hogwarts during their sixth year and satisfy their entrepreneurial spirit by opening Weasleys' Wizard Wheezes, a joke shop, on Diagon Alley, in *Harry Potter and the Half-Blood Prince*. In addition to jokes and gags, they sell magical objects, especially defensive- and Muggle-based items, fantastic fireworks, and sickening sweets. One of their best-selling lines is their WonderWitch products: cosmetics, pimple vanishers, love potions, and Pygmy Puffs.

Pygmy Puffs are the miniature form of the Puffskein, a spherical creature covered in soft, fluffy fur. These mesmerizing creatures, which come in pink or purple, purr and chitter, and have been known to sing on Boxing Day (December 26).

The youngest Weasley, Ginny, purchases a pink Pygmy Puff from her brothers and names it Arnold. While traveling to Hogwarts on the Hogwarts Express after her shopping trip, Ginny perches her Puff on her shoulder while talking to her current boyfriend, Dean Thomas. Luna Lovegood admires the Pygmy Puff as she distributes copies of *The Quibbler*, calling him "lovely."

In *Fantastic Beasts and Where to Find Them*, Magizoologist Newt Scamander tells former Auror Tina Goldstein that the reason he's in New York is to buy an Appaloosa Puffskein as a birthday present. When he adds that there's only one breeder of Appaloosa Puffskeins in the city, Tina tells him that, as they don't allow the breeding of magical creatures in New York, that breeder was shut down the previous year.

> Pygmy Puffs are mentioned in the November 28, 1926, issue of *The New York Ghost*. The front-page article reports that a Pygmy Puff mistaken for a pincushion was rescued from a New York haberdashery. The paper also advertises a memory game called Pygmy Puff Pelmanism in the games section on the front pages of its 1926 December 1 and 2 issues.

COMPANIONS

Fawkes

Fawkes, a phoenix, is the faithful companion to Albus Dumbledore, Headmaster of Hogwarts. A phoenix is an immortal bird, a fierce protector, and a magical healer. Phoenixes undergo three cycles of life before they regenerate: After a long adulthood, they erupt into flames in their last stage, then come back to life as a chick reborn from the ashes. Phoenixes have tears that can heal, and they are able to carry heavy loads.

Harry is called to Dumbledore's office in *Harry Potter and the Chamber of Secrets*, where he notices a mangy, decrepit bird standing on a perch. Right in front of him, the bird bursts into flames. Harry is shocked, but Dumbledore is nonplussed, telling him, "About time, too. He's been looking dreadful for days." To their delight, a cooing chick pokes his head out from the pile of ashes.

"It was a given that Dumbledore's phoenix would have to be the color of fire. It'd be silly trying something other than that," says concept artist Adam Brockbank. "Fawkes's top is mainly burnt oranges and dark reds, while his underside is dominated by shades of gold, with lowlights of gray-black charcoal." The artists portrayed Fawkes in all three stages, and the molting phoenix in old age is vulturelike in appearance. "His neck is extended, a lot of the feathers have fallen out, and he has the coloring of a burnt-out match," Brockbank explains, "but there's still the last embers of brightness about the eye."

The reborn Fawkes also has a vulture's aesthetic, with an elongated neck layered with wrinkles. His color is a washed-out pinkish-red combined with ash gray, and he has a distinctive crest of pink feathers on his head.

Brockbank based the adult, "hero" Fawkes on the sea eagle—a bird of prey thought to be the world's oldest surviving species of bird. "Proportionately, he's a bit stretched, with a head that has a long, exaggerated crest, a bit like a bird of paradise," he explains. This plume of feathers gives him a noble mien. The adult Fawkes also has the sharpest beak and impressive claws; his coloring is a combination of fiery dark reds and oranges, with golds and lighter oranges on his throat and breast. Brockbank was provided with a selection of tail feathers from pheasants and other game birds, in addition to feathers key animatronic model designer Val Jones dyed herself. Brockbank grouped these together to experiment with shapes and layering effects for the adult Fawkes.

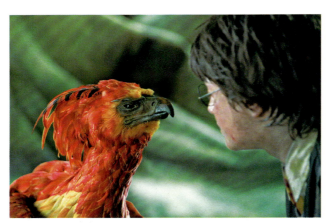

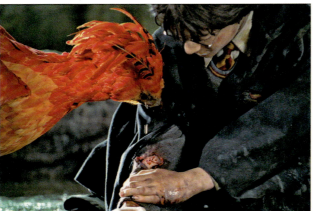

ABOVE: The baby Fawkes as portrayed in artwork by Adam Brockbank for *Harry Potter and the Chamber of Secrets*.
LEFT: Harry Potter (Daniel Radcliffe) is saved by Fawkes after being injured in the young wizard's battle against the Basilisk in *Harry Potter and the Chamber of Secrets*.
OPPOSITE: The noble mien of Fawkes, Dumbledore's phoenix companion.

82

> A combination of practical fire effects and digital flames was used when Fawkes burst into flames.

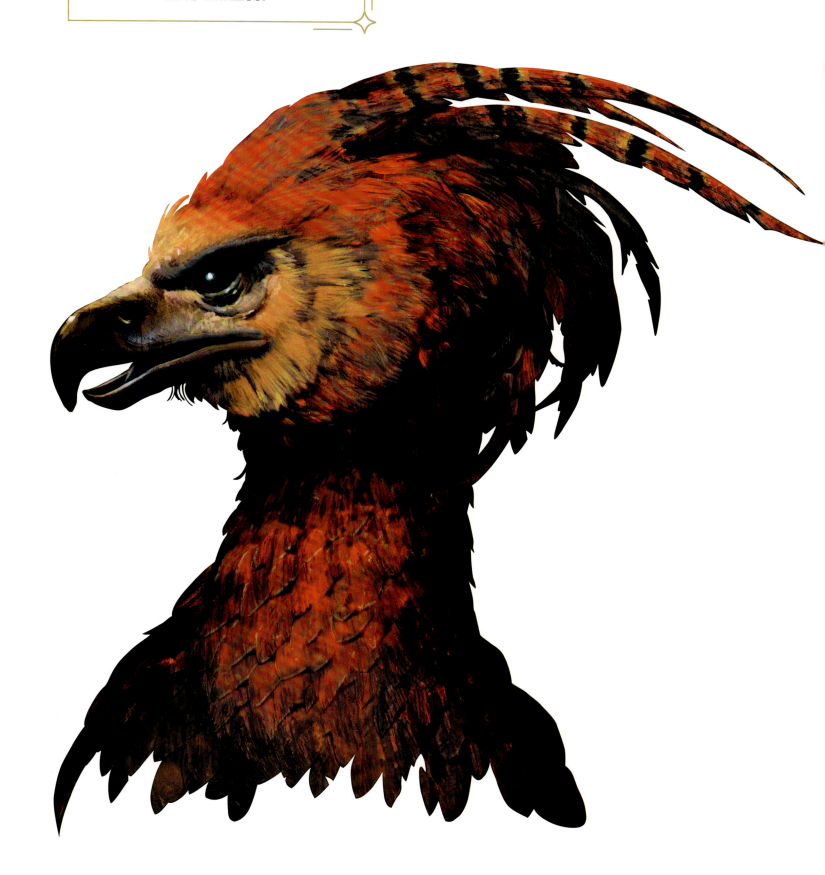

COMPANIONS

Fawkes's approved design was passed to both special creature and makeup effects designer Nick Dudman's creature shop, which created the Fawkes seen in Dumbledore's office and the Chamber of Secrets, and to the digital animators, who made Fawkes fly. "Computer-generated effects do the things that we physically can't," Dudman says, "but what we do with practical effects is create a sense of interaction that sometimes might be lost with CG." Three audio-animatronic versions of the bird were created, one for each stage of Fawkes's life cycle.

Both the audio-animatronic adult and end-of-life phoenixes were highly intricate mechanisms. The oldest Fawkes could slide on his perch and move in response to other characters in the scene. "One of the most wonderful moments I remember was Richard Harris [Dumbledore] walking up to Fawkes and thinking it was a real bird," says actor Daniel Radcliffe, who plays Harry. "Absolutely, 100 percent, believing it." Harris even went over to Nick Dudman to tell him how amazed he was by how well the bird was trained. "I told Richard that Fawkes was, in essence, a puppet, but he wouldn't believe me," Dudman recalls. "So I pressed a control button, bringing Fawkes to life. Richard was absolutely gob-smacked. I don't think we could have received higher praise."

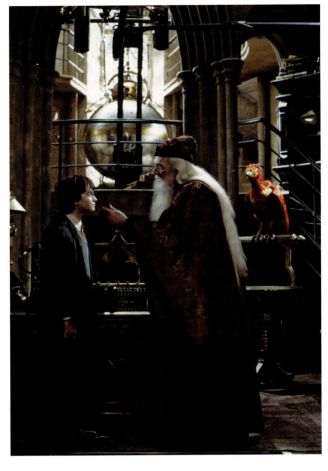

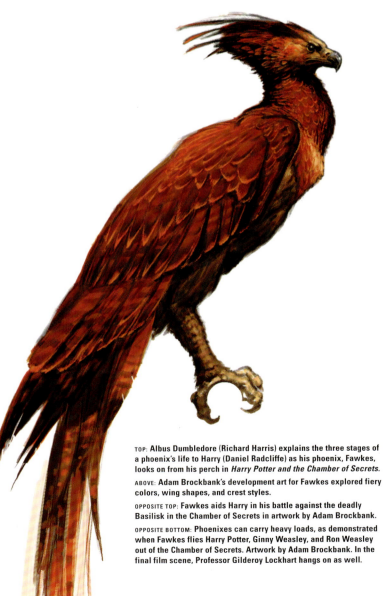

TOP: Albus Dumbledore (Richard Harris) explains the three stages of a phoenix's life to Harry (Daniel Radcliffe) as his phoenix, Fawkes, looks on from his perch in *Harry Potter and the Chamber of Secrets*.
ABOVE: Adam Brockbank's development art for Fawkes explored fiery colors, wing shapes, and crest styles.
OPPOSITE TOP: Fawkes aids Harry in his battle against the deadly Basilisk in the Chamber of Secrets in artwork by Adam Brockbank.
OPPOSITE BOTTOM: Phoenixes can carry heavy loads, as demonstrated when Fawkes flies Harry Potter, Ginny Weasley, and Ron Weasley out of the Chamber of Secrets. Artwork by Adam Brockbank. In the final film scene, Professor Gilderoy Lockhart hangs on as well.

Harry is threatened in the Chamber of Secrets by Tom Riddle, a memory of Lord Voldemort, who controls the deadly Basilisk. Suddenly, Fawkes flies in with the Sorting Hat, which holds the Sword of Gryffindor, and soars away. Harry is able to stab the Basilisk with the sword but is wounded by a Basilisk fang. Fawkes returns and cures the wound with his tears. This version of Fawkes was the most complex. "He could move his weight about the way birds do when they walk," says Dudman. "He could stretch out his wings and raise his crest. He could blink and had all sorts of little facial expressions." It took ten controllers to generate all his movements. And, says Dudman, "When he cries healing tears for Harry inside the Chamber, those are real tears welling up and running from his eyes."

Unlike many of the other creature creations seen in the Harry Potter films, the digital artists did not work with a cyberscan of the animatronic Fawkes, but they did take their design cues from Adam Brockbank's concepts, and they also observed real birds, including a blue macaw and a turkey vulture. New software was developed for the "feathering." Of course, it is the digital Fawkes that flies Harry, Ron Weasley, and Gilderoy Lockhart out of the Chamber.

Filmmakers created a new digital model of Fawkes for *Harry Potter and the Order of the Phoenix*, for the scene where the bird helps Dumbledore escape imprisonment during the Ministry's takeover of Hogwarts. They used this model again after Dumbledore's death in *Harry Potter and the Half-Blood Prince*, when Fawkes flies away from the school.

84

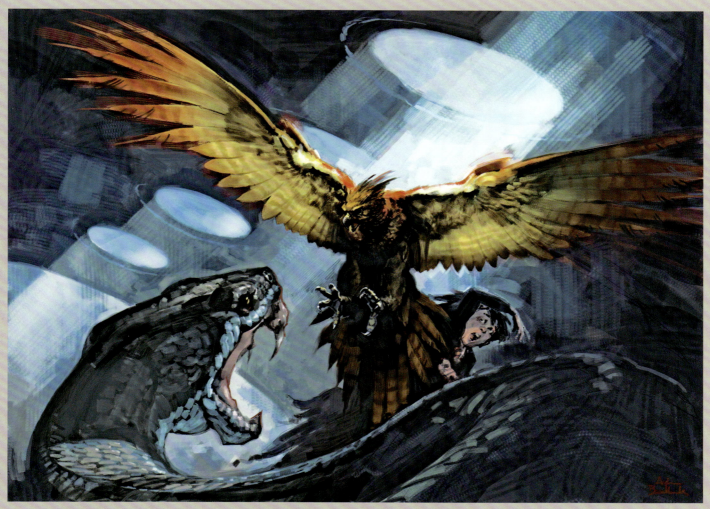
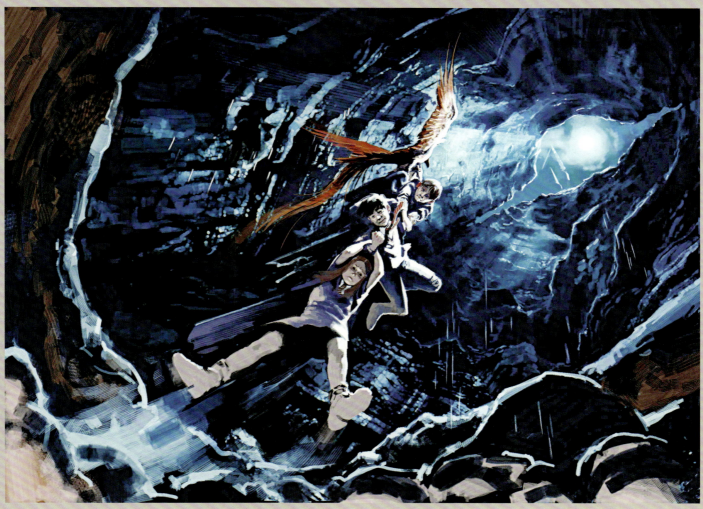

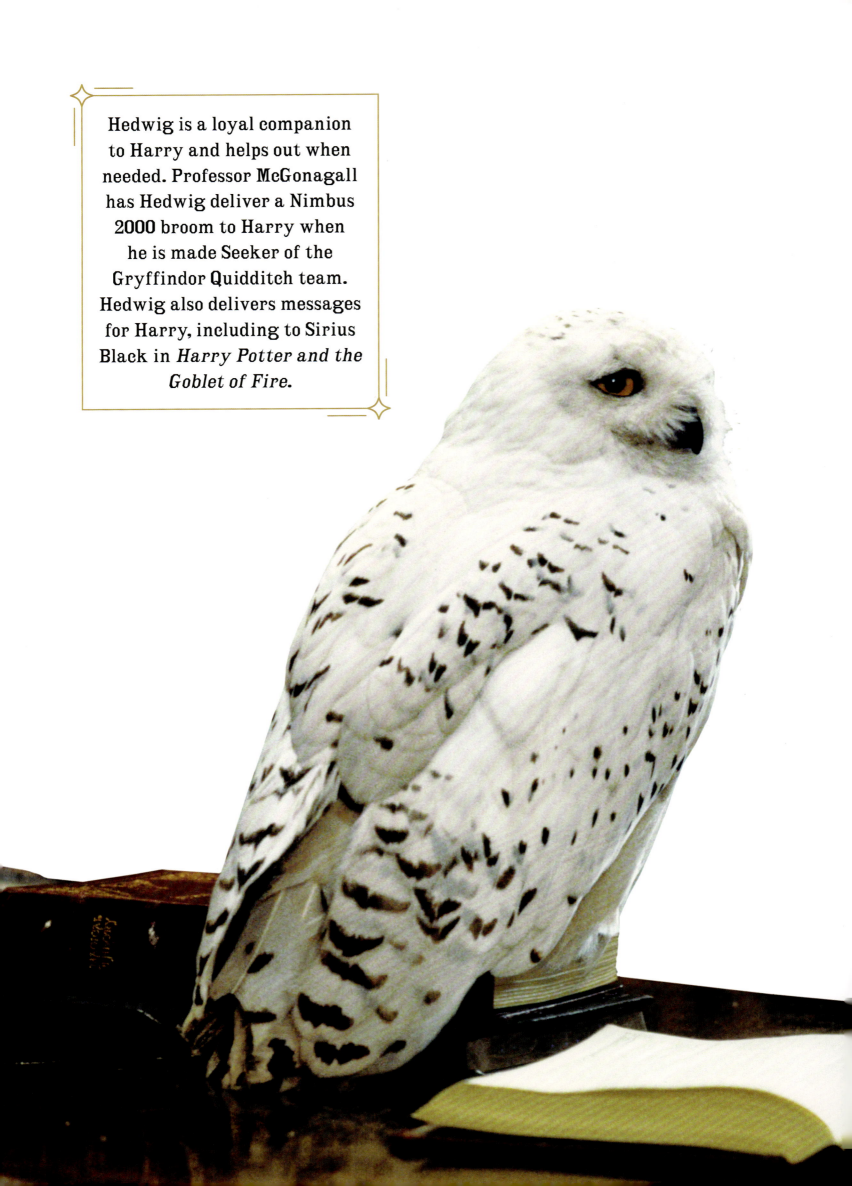

Hedwig is a loyal companion to Harry and helps out when needed. Professor McGonagall has Hedwig deliver a Nimbus 2000 broom to Harry when he is made Seeker of the Gryffindor Quidditch team. Hedwig also delivers messages for Harry, including to Sirius Black in *Harry Potter and the Goblet of Fire*.

COMPANIONS

Hedwig

In *Harry Potter and the Sorcerer's Stone*, once Harry Potter learns he's a wizard, Rubeus Hagrid, Keeper of Keys and Grounds at Hogwarts, takes him to Diagon Alley to pick up his "bits and bobs," as Hagrid says. According to the acceptance letter Harry has received from the school, students may bring, if they desire, an owl or a cat or a toad. Just as Harry gets his wand at Ollivanders wand shop, he hears a banging on the front window and sees Hagrid holding up a cage bearing a snowy owl. It's a gift purchased at Eeylops Owl Emporium for Harry's eleventh birthday, and Harry names her Hedwig.

Though Hedwig is female in Harry Potter's story, a dozen male snowy owls play her over the course of the films. Males are "snowier" in color and fluffier. Males also weigh less than females, which made them easier for actor Daniel Radcliffe, who plays Harry, to carry on his arm. For protection against sharp owl claws, Radcliffe wore a thick leather guard under his robe when carrying Hedwig, usually played by an owl named Sprout in these scenes. The owl most frequently seen on-screen is Gizmo, who was trained to pick up letters and carry a broomstick in his beak. Other owls seen were Elmo, Wton (which stands for "White Terror of the North"), Sprout, Ook, Kasper, Swoops, Oh Oh, and Bandit. Many of these were young rescues. Gizmo, Ook, and Elmo were actually cast before Daniel Radcliffe was.

The owls trained for specific actions. Elmo, who loved being around people, could sit quietly in a cage or stay on a mark atop a piece of furniture in the Gryffindor common room. Whenever a real owl was used in the background, one leg would be connected to a safety line attached to the furniture. Wton was used mostly for long flying shots. Other owls were used as stand-ins for Gizmo when the lighting for the scene was being worked out.

Animatronic versions of Hedwig that could turn their heads like real owls, as well as faux owls called "stuffies," were also used. Filmmakers employed fake owls when Hedwig was subject to bangs or tumbles, such as when Harry passes through the brick wall to platform 9¾ in the first film, or when he crashes into the wall in *Harry Potter and the Chamber of Secrets*. When Ron flies his father's Ford Anglia to Hogwarts because he and Harry can't get to the platform, he comes a bit too close to the Hogwarts Express as it speeds over a bridge. In this scene, although a stuffie was also used, an animatronic Hedwig in the back seat turns around and opens its eyes in alarm.

Hedwig is a fierce protector of Harry. In *Harry Potter and the Deathly Hallows – Part 1*, she saves Harry and Hagrid when they're attacked by Death Eaters while Harry is being transported away from Privet Drive. Hedwig's loyalty and affection for Harry is a comfort to him during his years at Hogwarts.

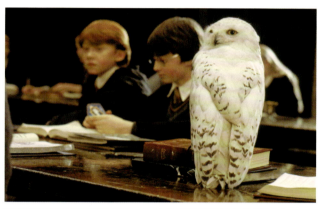

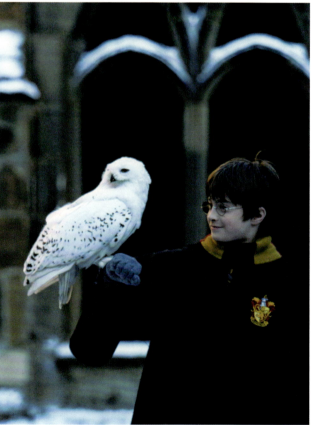

OPPOSITE: Hedwig, Harry Potter's loyal and affectionate companion, was seen in every Harry Potter film except *Harry Potter and the Deathly Hallows – Part 2*.
TOP: Hedwig joins Harry (Daniel Radcliffe) and Ron (Rupert Grint) (Hermione's there, too) during a study session in the Great Hall in *Harry Potter and the Sorcerer's Stone*.
ABOVE: Harry and Hedwig at Christmastime in *Harry Potter and the Sorcerer's Stone*. Actor Daniel Radcliffe wore leather protection under his robe against the owl's sharp claws.

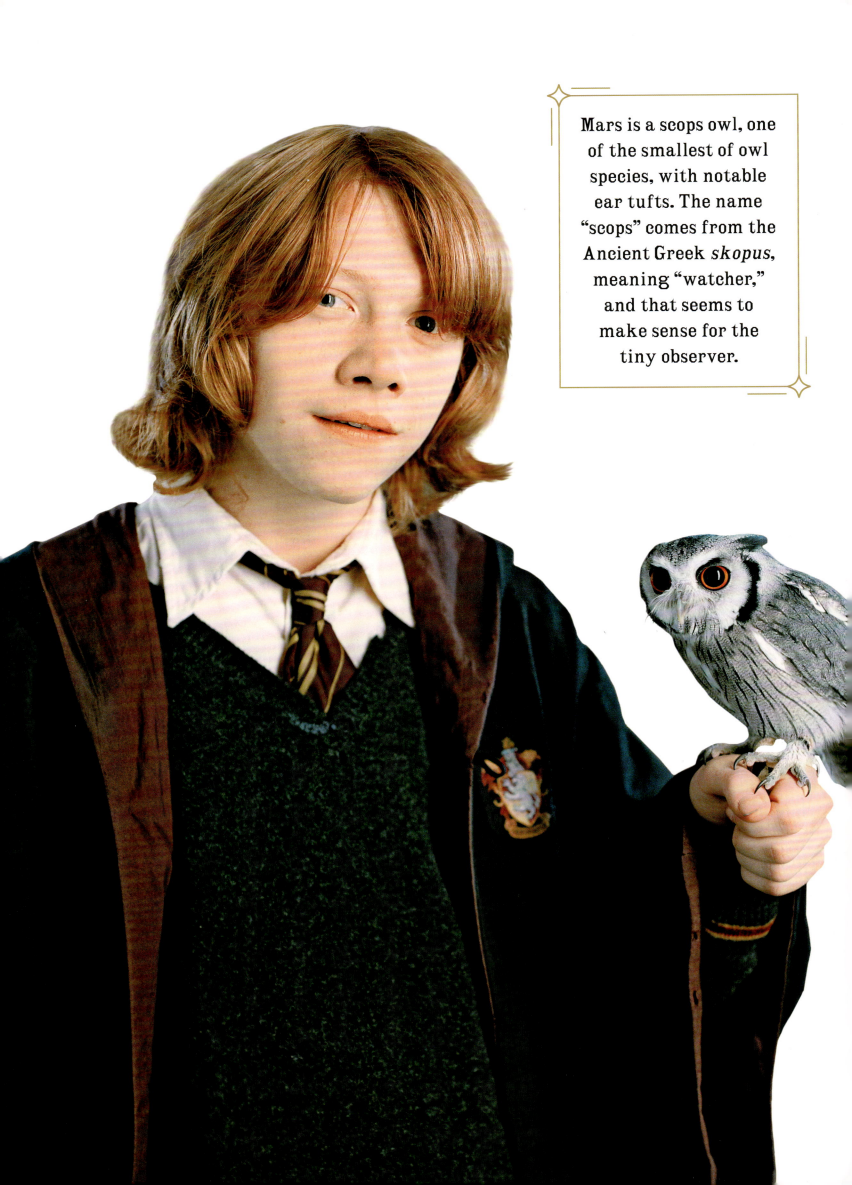

Mars is a scops owl, one of the smallest of owl species, with notable ear tufts. The name "scops" comes from the Ancient Greek *skopus*, meaning "watcher," and that seems to make sense for the tiny observer.

COMPANIONS

Pigwidgeon

Ron Weasley returns to Hogwarts in his later years with an extremely small owl he has named Pigwidgeon. Pigwidgeon is played by an owl named Mars, who posed in a promotional photo with actor Rupert Grint for *Harry Potter and the Goblet of Fire*. A scene where Pig (as he's nicknamed) is sitting atop the dresser next to Ron's desk in the Gryffindor dormitory was deleted, and another scene for *Harry Potter and the Order of the Phoenix*, with Pig filmed at platform 9¾, was also deleted. Finally, Pigwidgeon made his on-screen debut in *Harry Potter and the Half-Blood Prince*, perching on a rafter in the background of Ron's room in The Burrow watching Harry, Ron, and Hermione as they meet before returning to Hogwarts.

OPPOSITE: **Rupert Grint (Ron Weasley) and Pigwidgeon in a publicity still for *Harry Potter and the Half-Blood Prince*.**
LEFT: **Pigwidgeon made a small appearance in Ron's room at The Burrow before Ron's sixth year at Hogwarts.**

COMPANIONS

Errol

Errol, who belongs to the Weasley family, is not the most graceful of owls. On Harry's first visit to The Burrow, in *Harry Potter and the Chamber of Secrets*, Errol flies in to deliver the post; or rather, he flies toward the house and then smashes into the kitchen window. Percy Weasley retrieves the mail, which includes the young wizards' Hogwarts letters, as Errol rights himself on the windowsill.

Errol is played by Zeus, a great gray owl, known as one of the largest species of owl in the world. Zeus was trained to fly with a letter in his mouth and to lie down and then get back up. A faux owl digitally spliced into the scene did the actual banging into The Burrow window, as owls have hollow bones and cannot be trained to crash into anything solid.

Errol also delivers the Howler Molly Weasley sends to Ron at Hogwarts. He flies into the Great Hall gracefully enough, but then crash-lands into a bowl of potato chips. Owls are actually extremely graceful creatures, so Errol provides a fantastical comic counterpart to other owls seen in the films. Zeus flew from one point to another on the Great Hall table toward actor Rupert Grint, but a stuffie and computer-generated owls performed the actual collision into, and flipping over of, the bowl of potato chips. Then Zeus, again, hopped back up.

During the events of *Chamber of Secrets*, Hagrid is wrongly sent to Azkaban prison by one of the members of the Hogwarts Board of Governors, Lucius Malfoy. Once he is vindicated, his arrival back at the school is delayed. "The owl that delivered my release papers got all lost and confused," he apologizes to the students. "Some ruddy bird called Errol!"

BELOW: The faux stuffie iteration of Errol hangs out in the creature shop before his appearance in *Harry Potter and the Chamber of Secrets*.
OPPOSITE: Percy Weasley (Chris Rankin) takes the letter from Errol that lists the Weasley children and Harry Potter's necessary school supplies for their next year at Hogwarts.

90

> "The Niffler has such character that Newt can't help but love him," says actor Eddie Redmayne, "despite the fact that he is endlessly causing him trouble."

COMPANIONS

Teddy

In *Fantastic Beasts and Where to Find Them*, Magizoologist Newt Scamander has just returned from a year traveling the world observing magical creatures for a book he plans to write. He also rescues and rehabilitates these creatures, housing them in a space-defying leatherette case that, unfortunately, has a faulty latch. And when that latch pops open on its own, some of his creatures get loose.

The first creature to escape from Newt's case is a Niffler named Teddy, a small, beady-eyed, black-furred, mischievous beast with a long, rounded snout, who will pursue anything shiny with an unparalleled single-mindedness. "Who is the Niffler?" asks Eddie Redmayne (Newt). "The Niffler is the bane of my life. He's one of my favorite beasts but he causes carnage." The worst possible place the Niffler might escape to is a bank—and that's exactly what happens when Newt arrives in New York.

While following the cheeky creature, Newt meets Jacob Kowalski at Steen National Bank, where Jacob is looking for a loan. Newt is looking for the Niffler, who has been causing mayhem in his hunt for anything glittery. He finally tracks Teddy to the bank's vault, where the creature is stashing coins and jewelry into the pouch on his belly, which holds much more than seems possible. "This little thing manages to wind his way out of my case and wreak havoc. It all goes horribly, horribly wrong," says Redmayne, "and this one action is the catalyst that sets in motion an insane amount of events that just cause all kinds of chaos."

This opening bank sequence defines the relationship between Newt and the Niffler. "There was a history we had to get across," says animator Andras Ormos. "The fact that the Niffler was notorious for escaping and pickpocketing, and that Newt was going through the motions in trying to catch him. They understood each other; there were little looks, a language in their movement."

Nifflers appear to be a cross between an anteater (a long snout), a mole (a great digger), a badger (long claws), and an echidna (a marsupial-type pouch), with a good amount of platypus thrown in. "With the Niffler, we gathered a whole load of images of real-world animals and thought about which felt most charming and entertaining," senior animation supervisor Pablo Grillo recalls. "We honed in on the platypus as something that looked comical. It doesn't really move like other quadrupeds. Platypuses were constantly churning and looking through the silt and sand for food, and that felt like a good inspiration for the Niffler."

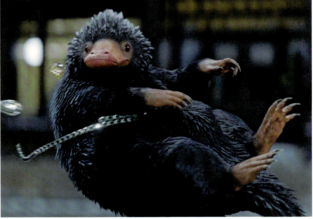

Grillo asked the animators to look at video compilations of animal fails. "One, they're very funny," he says. "But they're also a brilliant insight into animal psychology, which is different from humans. More often than not, these animals want to jump across a gap or across a space, and they screw it up or miscalculate it. It's a conflict between their desire and what their body is able to pull off in the end. I think that's what brings the charm—the clumsiness of that physicality juxtaposed against the desire."

OPPOSITE: **Teddy the Niffler, "the bane of my life" according to actor Eddie Redmayne, who plays Newt Scamander.**
TOP AND ABOVE: **Teddy manages to sneak into a bank vault and a jewelry store looking for sparkly items during the events of *Fantastic Beasts and Where to Find Them*.**

93

COMPANIONS

The team also looked at video resources of animals using their hands. "We found great footage of a honey badger in South Africa ransacking somebody's house," adds visual effects supervisor Christian Manz. "It was just an unstoppable desire for food, going through fridges and cupboards and all that sort of thing. A lot of those real-world animalistic traits are what went into the Niffler. That is why I think he's so successful, because he's all those things."

Throughout filming, Grillo and the puppeteers often worked with a representation of a creature while staging scenes. During rehearsals, these puppets provided proper eyelines but also interacted with the actors in order for them to understand the size, shape, movement, and, most importantly, the character of the creature. Prop maker Pierre Bohanna's team made a range of Niffler puppets for the production's use. Some contained a metal armature so they could be repositioned during a scene. Others, made of silicone, were used for "stunts." And simple hand puppet versions acted as "stand-ins" for the creatures.

In *Fantastic Beasts: The Crimes of Grindelwald*, "the Niffler's back with a vengeance!" declares Redmayne. Teddy helps Newt track Tina Goldstein in Paris. And when Gellert Grindelwald summons his followers to rally to pledge their fidelity, Teddy plays an important part in spoiling the Dark wizard's plans.

The puppets used for Teddy in this film had different variations. "There's a version of the Niffler where we can completely manipulate its head and its body," says puppeteer Derek Arnold. "There's a Niffler that's just a beanbag and Nifflers that are just the upper half or the lower half of its body. It always depends on what shot they need and what the actors need from it as well."

Grindelwald has in his possession a vial containing a blood oath between himself and Dumbledore that prevents them from fighting each other, and Newt has been tasked with retrieving it. Though Grindelwald disappears after a battle with English Aurors, Teddy emerges from the wreckage, limping and singed but holding the vial in his pouch.

In *Fantastic Beasts: The Secrets of Dumbledore*, he's once again incredibly helpful. "Teddy remains one of Newt's favorite creatures," says Redmayne. "And, as he always does, saves the day with Pickett." The help from Teddy and Pickett the Bowtruckle is vital to Newt saving his brother, Theseus, from being unjustly held in prison. Teddy recovers Theseus's Portkey tie, confiscated by the warder, and though he bungles the breakout a bit, he does manage to stuff a few gold coins in his pouch.

Redmayne acknowledges Newt has a love/hate relationship with Teddy, though its proportion favors the love. "It's just incredibly aggravating and wonderful at same time," he explains. "He's a complete nightmare, yet Newt gets off on his playfulness and single-mindedness."

BELOW: **The calm before the shiny storm that is Teddy the Niffler on the steps of Steen National Bank in** *Fantastic Beasts and Where to Find Them*.
OPPOSITE: **In order to force Teddy to release the golden items he's appropriated while in the bank vault, Newt Scamander (Eddie Redmayne) tickles his stomach.**

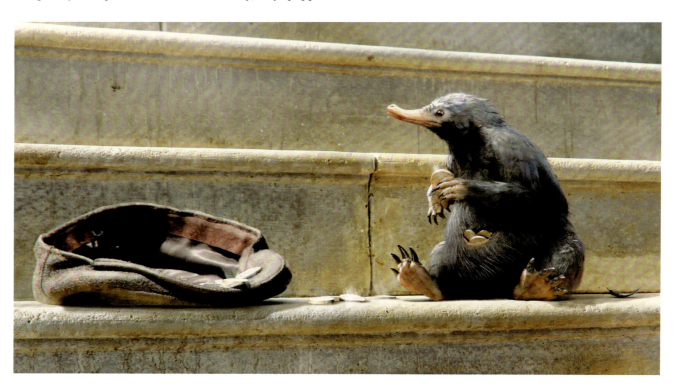

94

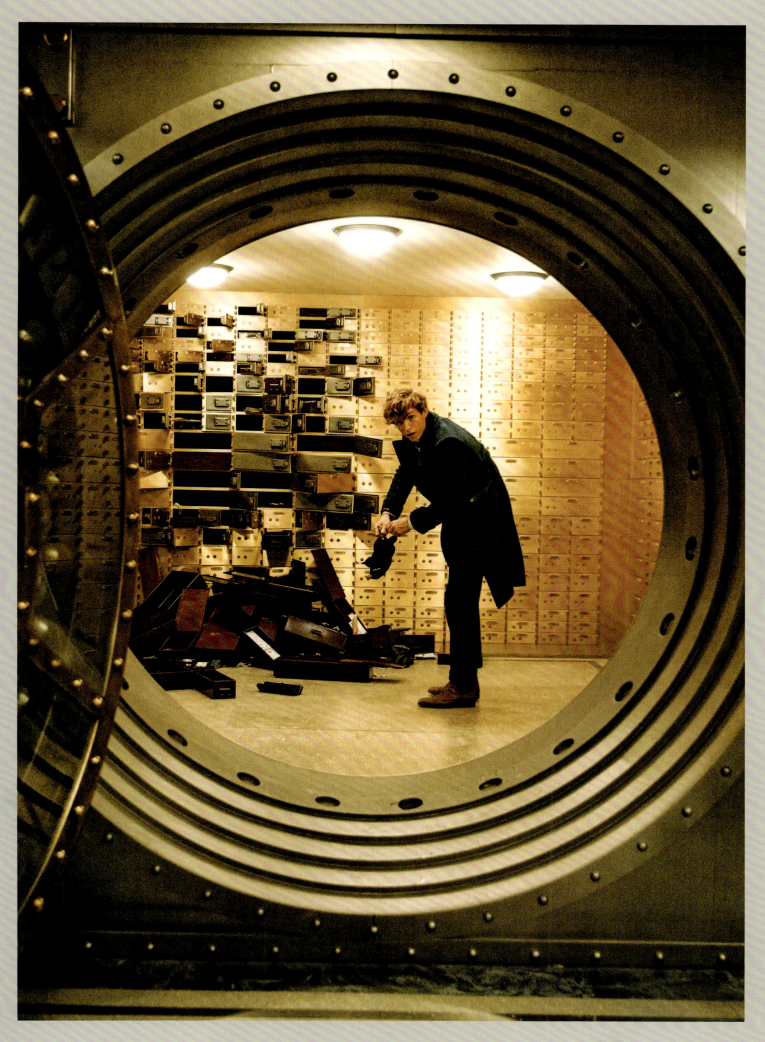

COMPANIONS

Pickett

Bowtruckles are tree-dwelling creatures that nest in wand-quality wood trees. They are shy but clever and appear to be a walking arrangement of twigs and leaves. A branch (family) of Bowtruckles live in a bamboo forest inside Newt's case; the group consists of Titus, Finn, Poppy, Marlow, Tom, and Pickett, although the latter prefers to reside behind Newt's coat lapel or in his pocket. "Pickett may be my favorite creature," Eddie Redmayne, who plays Newt, admits. Redmayne describes Pickett as being a loner who feels a bit bullied by his friends. "And he has attachment issues," he explains. Bowtruckles are incredibly agile, and because Pickett can pick locks, he helps Newt get out of several close calls.

Bowtruckles are also among senior animation supervisor Pablo Grillo's favorites. "I don't even really know what they are," he says, "but they're incredibly inviting." The Bowtruckle went through almost two hundred iterations before its final look was approved. Pickett's design needed to communicate the fragility of the animal, but without being weak. "Pickett, he's got a vitality about him. At the same time, he's very shy. He's a courageous creature, there's a heart and a valour to him," Grillo continues. "Pickett is also a bit of a social outcast like Newt."

Early concept designs included Paul Catling giving the Bowtruckle the appearance of a seahorse and Rob Bliss giving it the large eyes of a tarsier. Ben Kovar based the Bowtruckle on a silver birch tree or a fallen leaf curled in on itself. "Sometimes you have to try less obvious ideas," Catling explains, "before coming back to the fact that a 'twig man' should look like a man made out of twigs." The Bowtruckle became greener and leafier, balanced between a twig and an insect. From there, each Bowtruckle was given a different arrangement of leaves and twigs.

Pickett has tiny bulging eyes and a slit for a mouth, so one might think his simple face wouldn't require much animation beyond blinking eyes. To Pablo Grillo and the other animators, this was an exciting challenge. "Where you don't have to rely on a facial performance," he explains, "it very much comes through the actions to reveal the intentions." Adds visual effects supervisor Christian Manz, "[Pickett] has a lot of character without a lot of expression." Manz continues, "But he does blow a raspberry at one point. In the end, we added more shots of Pickett . . . as everyone just loved him."

Though Pickett is a computer-generated creature, Redmayne and other actors worked with puppeteer Avye Leventis to understand what it would feel like for a Bowtruckle to walk or perch on their bodies. "Pickett lives in my pocket, but frequently comes up onto my shoulder," says Redmayne. "I started by having the puppeteer literally using a finger puppet to do it, feeling what that was like. Then she had a long rod with Pickett made out of wire on the end. When we actually filmed, he was not there, but by [that time] I could play with him because I had a sense of him."

LEFT: Early development art of Pickett the Bowtruckle by Paul Catling for *Fantastic Beasts and Where to Find Them*, who mashed up an insect's body with a mouse's head in an effort to make the creature appear friendlier. At the time, Catling says, "No one was fooled."

OPPOSITE: Pickett, Newt Scamander's loyal Bowtruckle, seen in the Fantastic Beasts films.

> Before Pickett, a teenaged Newt became enamored with another branch of Bowtruckles while at Hogwarts, as seen in *Fantastic Beasts: The Crimes of Grindelwald*. In the film, when Newt sees his friend Leta Lestrange is troubled, he takes her to visit them on Bowtruckle Island cheer her up.

COMPANIONS

"He's actually the most technically complicated puppet we have to work with," says supervising creature puppeteer Robin Guiver. "But I've really grown to love our Pickett puppet. We can express a lot in the relationship between Newt and Pickett. And so, every time we get to a scene where he's there, it's really enjoyable to work out what his action will be and how he's involved."

To gain information from Gnarlak, the owner of The Blind Pig, about his missing creatures, Newt reluctantly offers Pickett as payment. "One of my least favorite moments when I read the script was when I use Pickett as a bartering tool with Gnarlak," says Eddie Redmayne. "And I then spend most of the rest of film persuading Pickett I wasn't actually going to let him go."

For *Fantastic Beasts: The Secrets of Dumbledore*, "Pickett is being brilliant and helping Newt, giving him a bit of TLC when he needs it," says Redmayne. When Newt injures his hand while searching for the Qilin in China, Pickett's hand even sports a similar bandage, as he's always trying to mirror the Magizoologist.

Filmmakers realized Pickett in a variety of new ways for this film: static versions, a version with moving parts, and a Pickett with a small armature running through it, allowing the Bowtruckle to pose in different positions. "When he's holding on to a wand or if he has to hang off something," explains supervising creature puppeteer for the film Tom Wilton, "we can have one arm up and have him rigged to whatever he's holding." Pickett also helps out when Newt's brother is unjustly jailed.

Pickett will always hold a place in Eddie Redmayne's heart. "I have a soft spot for him," Redmayne admits. "He's just so small and twiglike and sweet."

OPPOSITE: **One of Pickett's final designs for *Fantastic Beasts and Where to Find Them*, by concept artist Martin McCrae, who found the creature's design "tricky. The Bowtruckle needed to be friendly but also a little formidable."**
TOP: **Paul Catling gave the Bowtruckle's appearance the attributes of a seahorse in an "attempt to make [him] cuter."**
ABOVE: **The Bowtruckle's environment within Newt Scamander's case as conceived by Dermot Power.**
LEFT: **Another take on Pickett by Paul Catling, striving for "a reasonable balance between twig and insect."**

CHAPTER 4

NEWT SCAMANDER'S CREATURES

NEWT SCAMANDER'S CREATURES

Murtlap

In *Fantastic Beasts and Where to Find Them*, aspiring baker Jacob Kowalski is refused a bank loan and returns to his apartment on the Lower East Side of New York with his case of sample pastries. He's surprised when one latch on the case flies open—it should not be doing that. While Jacob examines the case, the second latch also flicks open on its own. The case shakes, and Jacob hears growls and squeaks. As he tentatively leans forward, the lid is thrown open by a small, angry beast who jumps out and fastens itself onto Jacob's neck—a Murtlap.

"The Murtlap comes out and bites me," says Dan Fogler (Jacob). "I get infected and think, maybe I've been infected with magic itself? Who knows? Maybe it's festering inside my body!"

Original designs for the Murtlap included a mix of an alligator, turtle, and rat by concept artist Arnaud Valette, who sketched potential skin textures in different lighting situations. Keeping in mind the original description of the creature in the script, however, ultimately made the concept artists' job very easy. "I suppose there's not a lot of possibilities for a rat-like creature with a sea anemone on its back," quips concept artist Paul Catling.

Former Auror Tina Goldstein, who has followed Newt to Jacob's apartment, discovers the No-Maj (non-magic person) on the floor, gagging as a reaction to the bite. Newt assures Tina that Murtlap bites aren't serious, but then admits, "That is a slightly more severe reaction than I've seen, but if it was really serious, he'd have . . . well, the first symptom would be flames out of his anus."

Production designer Stuart Craig thought it funny when the Murtlap bit Jacob. "It is quite serious," he explains, "but my first reaction was to laugh because it was so unexpected."

PAGE 100: **Concept art by Molly Sole of the Mooncalves with their crater-textured excrement for *Fantastic Beasts and Where to Find Them*.**

ABOVE: **Artist Paul Catling produced one version of the Murtlap, adhering to the description of a "rat-like creature with a sea anemone on its back."**
OPPOSITE: **The Murtlap in final art for *Fantastic Beasts and Where to Find Them*.**

Actor Dan Fogler proposes that Newt realizes that not only does he have to get all his creatures back, but "now he has to look after this No-Maj—he might die because he's been bitten by this thing. So [Jacob] gets pulled along the adventure with him trying to collect all these creatures to get them safely back home." Jacob becomes Newt's guide in the city. "I become like Newt's Sherpa, because he doesn't know New York very well," says Fogler.

NEWT SCAMANDER'S CREATURES

Fwooper

Fwoopers are birds, whose colors range from bright peppermint pink to lime green, sherbet orange, or buttery yellow.

Artist Paul Catling called Fwoopers the easiest concept he worked on for the film. "I just looked at [the] drawing in the book [*Fantastic Beasts and Where to Find Them*] and redrew it," he admits. "I did add a bit of an owl, though."

A Fwooper becomes part of a magical food chain in front of Jacob Kowalski as he helps Newt feed the creatures in his case. "There's one almost thrown-away moment where there's some Billywigs that get eaten by a Doxy, and then [the Doxy gets] eaten by the pink Fwooper in the foreground," says visual effects supervisor Tim Burke.

ABOVE: One of the earliest concepts for the Fwooper, with "a bit of owl added," according to artist Paul Catling for *Fantastic Beasts and Where to Find Them*.
OPPOSITE: Paul Catling sought an iconic silhouette for the Billywig, with its helicopter-like wings atop its head.

NEWT SCAMANDER'S CREATURES

Billywig

As Tina Goldstein escorts Newt Scamander through the streets of New York en route to the Magical Congress of the United States of America (MACUSA) in *Fantastic Beasts and Where to Find Them*, she notices a small flying creature zipping around them. It's a Billywig that has escaped Newt's case, but not his notice. When it nearly flies into her face, Tina asks Newt what it is. "Er—moth, I think," he answers innocently. "Big moth." It is clear Newt recognizes the creature.

Billywigs are fast-flying, electric sapphire blue insects with two different flight modes: the first mimics a dragonfly's movement, and the second is reminiscent of a helicopter. The animators looked at dragonflies and hummingbirds as references in addition to other small birds. Flies, who clean their own legs, were sourced, as the Billywig grooms itself as it hovers. The final Billywig concept by artist Paul Catling transformed the wings into a propeller. "There was a drawing in a book of a helicopter bluebottle fly that we've made more hummingbird size," says visual effects supervisor Christian Manz. "But it does helicopter around." Notably, a Billywig's wings are on the top of its head, and so they spin instead of flap.

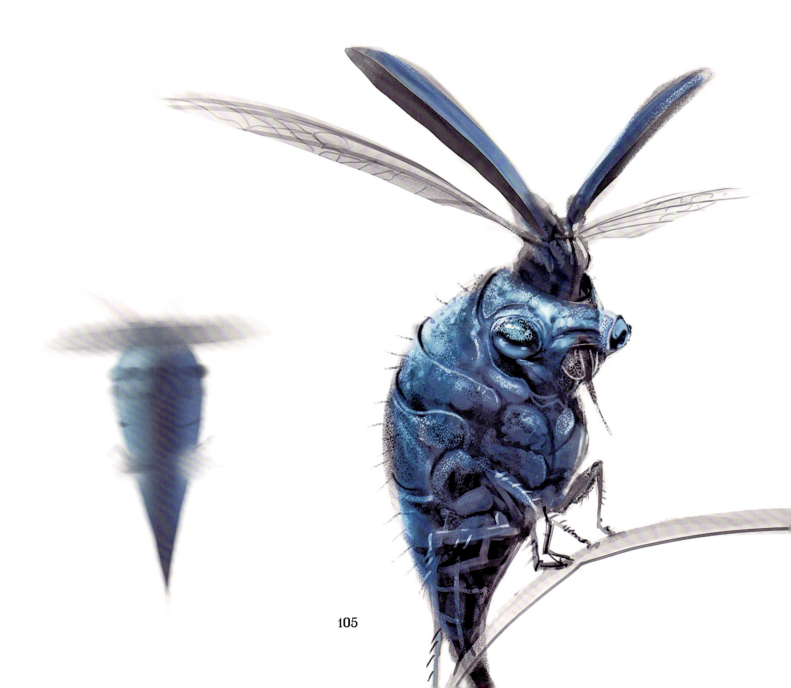

NEWT SCAMANDER'S CREATURES

Diricawl

The Diricawl is a plump, medium-size flightless bird resembling what Muggles and No-Majs call a Dodo, which greatly influenced its design. However, concept artist Max Kostenko wanted to ensure it didn't resemble the character of the Dodo in the Disney movie *Alice in Wonderland* too much, so he gave it bright multicolored feathers, a stubbier body, and a shorter beak.

The Diricawl's appearance was happenchance—the animators came up with an idea for a creature before they realized there was something that fit in with the fantastic beasts already thought up by J. K. Rowling. "I was thinking of a very familiar pastoral scene with moorhens and their babes," says senior animation supervisor Pablo Grillo, "which added potential for seeing animals and their broods. And I thought, 'Wouldn't it be funny if you had these creatures that would disappear?'" As it turned out, the Diricawl from the book *Fantastic Beasts and Where to Find Them* had that ability. "We've got a very little gag, a throwaway thing," says visual effects supervisor Christian Manz, "where you see the mother Diricawl losing control of her babies, trying to keep her chicks in an ordered row as they waddle along the deck inside the case. She is desperately trying to keep them in order while they keep disappearing and reappearing elsewhere." Or, rather, Disapparating and Apparating, as magical creatures do.

OPPOSITE: Artist Max Kostenko strove for a unique combination of colors for the Diricawl's feathers for *Fantastic Beasts and Where to Find Them*.

THIS PAGE: Although the ancient Dodo bird was a jumping-off point, Max Kostenko strove to reinterpret the inspiration for the Diricawl.

NEWT SCAMANDER'S CREATURES

Swooping Evil

The unfortunately named Swooping Evil was created for the film *Fantastic Beasts and Where to Find Them*.

During periods of inactivity, Swooping Evils live in spiky, green cocoons. Newt Scamander, who has been studying them, has developed a theory that the Swooping Evil's venom could be useful, when properly diluted, for removing bad memories. The Magizoologist extracts this luminous liquid by squeezing the cocoon covering the creature in its dormant state and collecting it in a glass vial.

"My inner nine-year-old is obsessed with the Swooping Evil," says actor Eddie Redmayne. "He's like this spiky ball with a thread that hangs down from Newt's finger. When you spin him out, almost like a yo-yo, he unfurls into this terrifying creature." And Newt does let the Swooping Evil loose to come face-to-face with Jacob Kowalski before pulling him back into his cocoon.

The unleashed Swooping Evil is a beautiful mash-up of a large butterfly and a prehistoric manta ray, with cape-like, spiked, green wings and a magnificent cobalt blue underside. Its skeletal head resembles a rodent's, with long, saber-shaped canine teeth. This creature is an encephalophage: an eater of brains. "But Newt has complete control of it," says visual effects supervisor Christian Manz. "He calls it. It wraps back up and he puts it in his pocket." The digital artists needed to work out how that happened and make it believable. "How do we get something that big into something small?" Manz asks. "And, of course, it's magic."

"Working on the Swooping Evil was a real joy," says concept artist Dan Baker. "I remember thinking the description of the creature was fantastic. I was looking at various butterfly species, as I liked the idea of this juxtaposing with that terrifying animal-like skull."

One philosophy behind creating the creatures for the Harry Potter and Fantastic Beasts films was that, whether created practically or digitally, their anatomy and movement should be based in naturalism and appear as a believable possibility. This requires much research and development before a final beast is approved. For the Swooping Evil, the artists studied birds, bats, and other flying mammals to observe their body structure. The skeletal structure of the Swooping Evil is evident in its thin wings, which also give it its incredible agility and strength. The artists investigated how feathers and fur could influence the wings' movement. And they created animated tests to see not only how fast the creature could move but also how fast it could change direction, inspired by the way swallows can make quick turns.

"We wanted to see Newt use his creatures to get himself out of a scrape," says Manz. This gave the Swooping Evil a chance to show how strong it can be. When Tina Goldstein is brought to a Death Cell at MACUSA, she's suspended over a pool containing a death potion that threatens to engulf her. Newt releases the Swooping Evil to distract the guards, then yells for Tina to jump on the beast as it flies in front of her, and she leaps to safety into his arms. As they continue their escape out of MACUSA, Newt once again lets the creature loose to attack their pursuers and knock them down, though he has to tell the Swooping Evil to leave their brains alone and come back to him.

Newt uses the Swooping Evil again while battling Percival Graves—the disguised Gellert Grindelwald—in the tunnels of the New York City subway. While the beast helps to shield MACUSA president Seraphina Picquery and her Aurors against Graves's spells, Newt is able to cast a rope of supernatural light that captures him.

The Swooping Evil proves crucial to Obliviating the bad memories New Yorkers have of the Obscurial Credence tearing up the city. A vial of the creature's venom is used for this, tossed by Newt up to Frank the Thunderbird, where it is dispersed by the rain Frank pours onto the New York buildings and streets.

> **The Swooping Evil was created for the film *Fantastic Beasts and Where to Find Them*. Says producer David Heyman, "It grew organically from the story that was being told."**

OPPOSITE TOP: **The different forms of the Swooping Evil as portrayed by artist Dan Baker, from cocoon to outstretched wings, for *Fantastic Beasts and Where to Find Them*.**
OPPOSITE BOTTOM: **A up-close study of the Swooping Evil's head by Dan Baker to investigate how its skull fit into its hoodlike body.**

Thunderbirds have the extraordinary talent of sensing danger. "But his mood is echoed by weather that will pour beneath him," says actor Eddie Redmayne. "So if he's frightened or excited, it *rains.*"

NEWT SCAMANDER'S CREATURES

Thunderbird

A Thunderbird named Frank is the real reason Newt Scamander is in New York in *Fantastic Beasts and Where to Find Them*. "He says he's there to get an Appaloosa Puffskein as a gift for a friend," says Eddie Redmayne, who plays Newt, "but that's just the excuse he's using to be there." Thunderbirds are magnificent, powerful creatures, native to the dry climate of Arizona. They are also incredibly valuable, and the one Newt rescued was trafficked to Egypt. "So, he brings him back to the States in order to release him in his native Arizona," explains Redmayne. "He wants to put Frank back where he belongs."

Noble birds of prey inspired the four-winged Thunderbird's design; its head is shaped like a bald eagle's, similar to a Hippogriff's in the wizarding world. "The Thunderbird was quite an interesting one because it came quite late in the script," says senior animation supervisor Pablo Grillo. It was originally intended that another beast, the Occamy, would have multiple wings. "There were bits in the script where we thought we'd see the Occamy flying out into New York and across the city," he explains. "It would be great to create the silhouette of this creature with all these wings caterpillaring through the sky." When story elements kept the Occamy grounded in the attic of a department store, the idea of multiple wings was reassigned. "We had a conflict of designs at that point, where the Occamy was a twitchy feathered bird, a bird of prey, very eaglesque," Grillo continues, "so we moved the Occamy more toward a dragon and decided to use the multiple wings with the Thunderbird."

It was a challenge to the visual development artists to conceive how the Thunderbird's pairs of wings could all fold together against its body. "The creature had to feel majestic and iconic to make it stand out from existing large birds we're used to seeing," says visual effects art director Martin Macrae. "Adding extra wings was, of course, something that distinguished its silhouette, but we wanted to add something else to make it more fantastical. The idea was in the name." Frank exists in a thunderous state, reflecting stormy clouds, darkening his feathers as he releases his energy. The flapping of a Thunderbird's wings creates storms.

His formidable wings also shimmer with cloud- and sunlike patterns. "The blood flow across his feathers creates the impression of cloudlike patterns moving through him," says visual effects supervisor Christian Manz. "His wings act almost like a stained-glass window with the light coming through them. Rain does not come from him

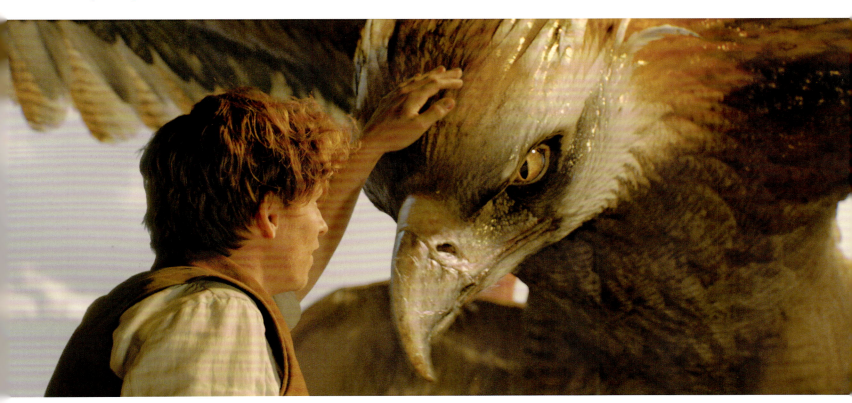

directly, but as he is flying and beating his wings, he is drawing water vapor in and around him to create clouds and, therefore, rain."

When Newt takes Jacob inside his case to show him his beasts, Frank is the first one Newt greets. Supervising creature puppeteer Robin Guiver was brought in to supervise a physical puppet of the creature's head for the scene. "First, that's about giving an eyeline for the actors, so we'll give them a point so they can all be looking at the same thing," says Guiver. The Thunderbird then flies down to stand on a rock, so the puppeteers wanted to provide a physical piece with which Newt and Jacob could have a real interaction. "More than just a tennis ball on a stick," he explains. "It gives a sense of character, something that's alive in the same way that working with an actor would be." Additionally, he says, "One of the things that was very important was for Eddie to get a sense of what his counterpart was," says Grillo, "especially since his relationship to these animals is so strong and so important."

As the events of *Fantastic Beasts and Where to Find Them* draw to a close, the president of MACUSA, Madam Picquery, needs to handle the exposure of nonmagical

NEWT SCAMANDER'S CREATURES

New Yorkers to the extensive amount of magical damage caused by the Obscurus—but can they Obliviate an entire city? "Actually," Newt tells her, "I think we can." Releasing the Thunderbird from his case, Newt tosses him a vial of Swooping Evil venom that will dissolve bad memories. As his feathers darken with the release of his energy, Frank summons a storm as he flies over the city and releases raindrops that distribute the venom.

"Frank was a lovely creature to bookend the film," says Grillo. "He plays a fundamental role: He goes up and sends out a potion that's going to make all of New York forget what they've just seen. It wraps the film up beautifully because in the end, the whole purpose of Newt going to America was to deal with this beast, to release it back into the wild, and it was an incredible thing to show [that]. I think it's a great symbol, in that sense of hope that it will do well."

PAGE 110: **An exploration of the majestic Thunderbird in a black-and-white color scheme, painted by Sam Rowan for** *Fantastic Beasts and Where to Find Them.*
PAGE 111: **Newt Scamander and Frank the Thunderbird share a tender moment.**
THESE PAGES: **The Thunderbird prepares to save New York City.**

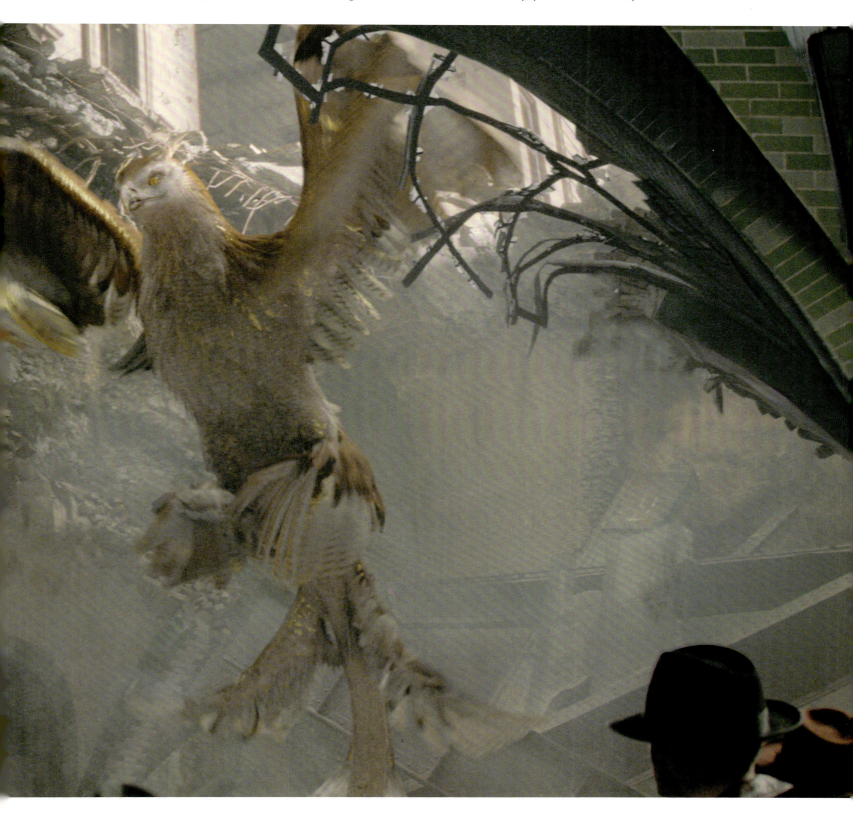

ABOVE: For his first color iteration of the Thunderbird seen in *Fantastic Beasts and Where to Find Them*, artist Dan Baker looked at tropical birds, particularly the kingfisher.

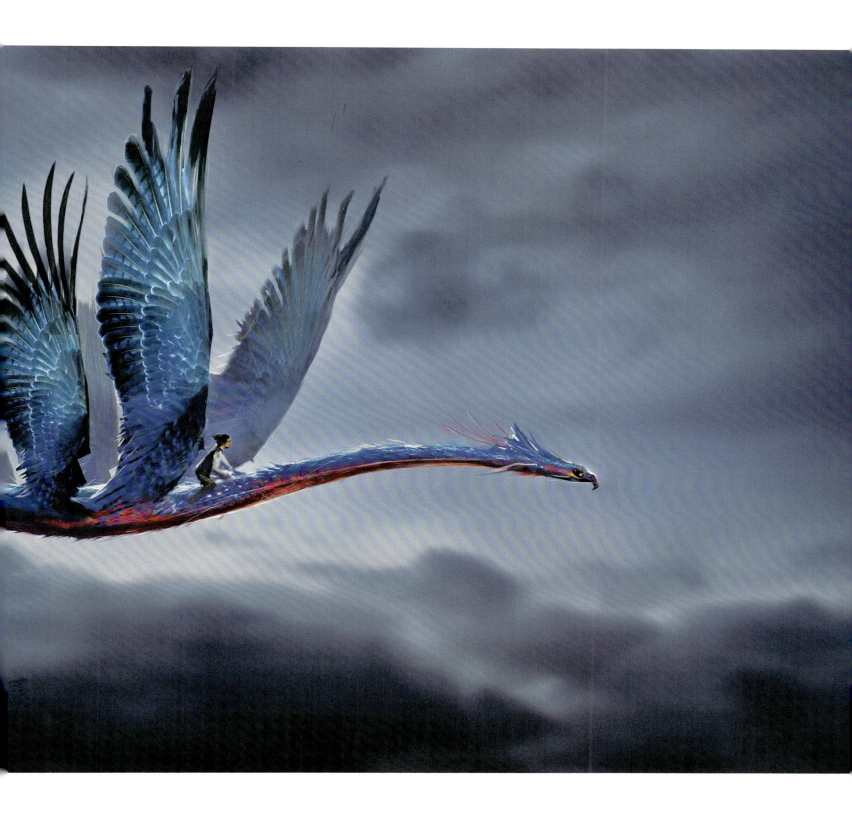

ABOVE: **The Thunderbird in flight by Dan Baker. The creature generates a ferocious thunderstorm from its wings as it flies in** *Fantastic Beasts and Where to Find Them*.

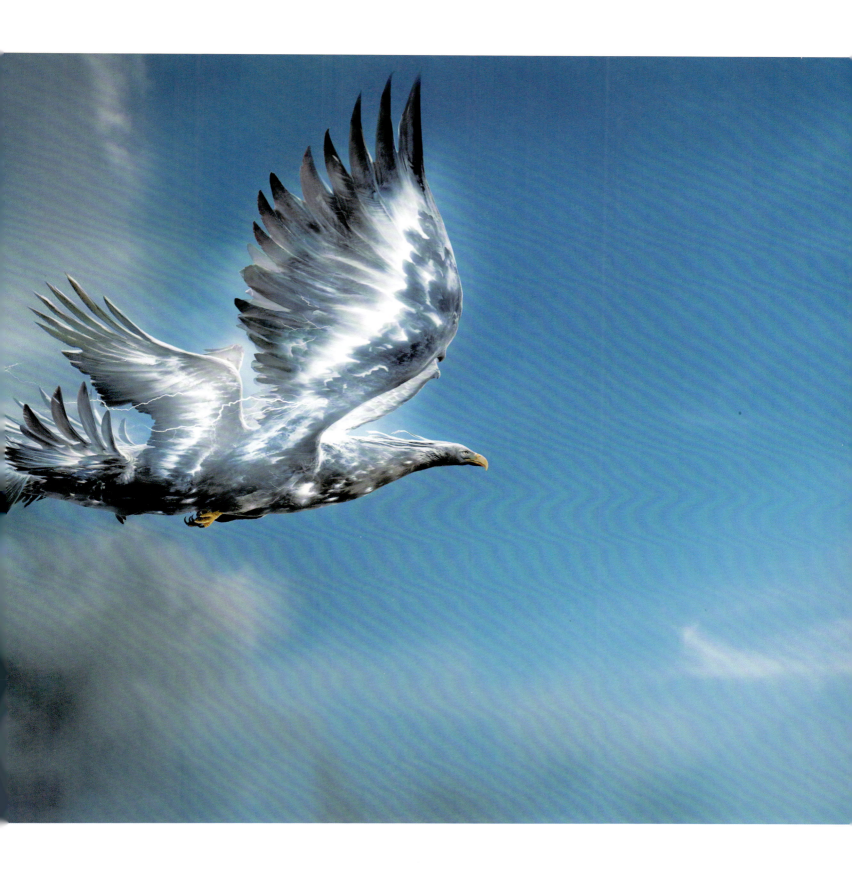

NEWT SCAMANDER'S CREATURES

Demiguise

The first time the Demiguise is seen in *Fantastic Beasts and Where to Find Them*, he isn't actually seen. As a little boy licking a lollipop in New York walks down the street, he sees an apple fly up from a fruit cart and get bitten to its core in midair. Then, whatever devoured the apple takes the boy's lollipop. At a nearby newspaper stand, the image of a woman on a large magazine suddenly opens her eyes, and then something duplicating her image walks away. It's Dougal the Demiguise.

"[D]irector] David Yates was very keen to represent the Demiguise like a little old wise man," says visual effects supervisor Tim Burke. "He suggested Jim Broadbent, who'd worked on the Potter films [playing Horace Slughorn], as a way to get into Dougal's character. We got into the spirit of this little old man who chatted away to himself and imbued that into the Demiguise personality and character."

One of the toughest challenges for the digital artists was the Demiguise fur, which was more long, flowing hair than fur, and which covered the creature's entire body. When the Demiguise literally went on the run, his hair needed to wave in the wind. The solution to do this digitally? Using a proprietary hair-grooming tool set allowing his hair to wave called ... Furtility.

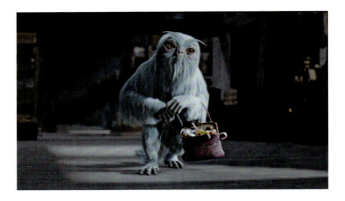

The other challenge was the Demiguise's invisibility itself as he transitions between being visible and invisible. The digital artists referenced the works of the model Veruschka and the photographer Liu Bolin, both of whom have worked with images where the subject (typically themselves) is painted to "disappear" into their environment. "The lovely thing about that," says Burke, "is that as you move around them with a slight perspective change, you will see a difference of relief to it. All of a sudden, you realize there's something there. We developed that idea for creating the Demiguise's invisibility where he takes up part of the background and it's only when the camera moves that you see the shift in perspective."

After the Demiguise escapes Newt's case, Newt needs to find the frequently invisible creature. "This proves a wee bit tricky, because the Demiguise can vanish at will," actor Eddie Redmayne says, "and he also has this capacity to see the future. So he can predict what people are going to do, which makes catching him a bit of a nightmare."

Newt receives a tip that something's been wreaking havoc in a Fifth Avenue department store. This proves true when Newt, Tina, Jacob, and Queenie see a handbag levitate off a mannequin's hand in the store's window and float down the aisle. Once inside, they also find a missing Occamy fledgling. "When one of the baby Occamys escapes, the Demiguise goes to make sure the newborn is going to be okay," says Redmayne. "He's babysitting it. One of the things I love about the writing is not only do we see Newt's relationship with the beasts, but also the relationships *between* the beasts."

A Demiguise has large owllike eyes that turn blue when it sees the future. "As the Demiguise can see different versions of the future, he can predict who is most likely to catch him," says David Yates. "In order to surprise him, Newt has to appear entirely relaxed and unpredictable, but the Demiguise knows him; he already has a sense of what he's going to do. So Newt encourages Tina to just be casual. That it's going to be up to her to catch the Demiguise, because he knows less about her." Redmayne considers this an important moment between Newt and Tina. "I think that not only is Newt trying to find the Demiguise, but subconsciously he's beginning to enjoy the proximity with Tina."

Jacob also has a moment during the Occamy's capture—not with Queenie, but with Dougal. "Jacob becomes very friendly with the Demiguise" says actor Dan Fogler. "For some reason, there's something in Jacob's nature that lets him feel that I'm not a threat. So there are these really sweet moments where the chaos is happening and the Demiguise looks at me. [He] gets so scared, he jumps up into my arms. And I'm like, 'It's okay, buddy.'" Jacob carries Dougal on his back in the scene, so Fogler wore a weighted backpack to give him the feel of the creature. The backpack was then digitally removed, and the Demiguise animated in.

TOP: **The Demiguise takes care of the Occamy when it's stranded in a large department store in Fantastic Beasts and Where to Find Them.**
OPPOSITE LEFT: **The final look of the wise, old Demiguise.**
OPPOSITGE RIGHT: **The earliest sketches of the Demiguise by Max Kostenko explored a sloth-like appearance.**

> "The Demiguise has the capacity to go from being visible to invisible, so their pelts can be used to make Invisibility Cloaks," explains actor Eddie Redmayne. This is why the Demiguise has become rare, as it's hunted for its silvery-white fur.

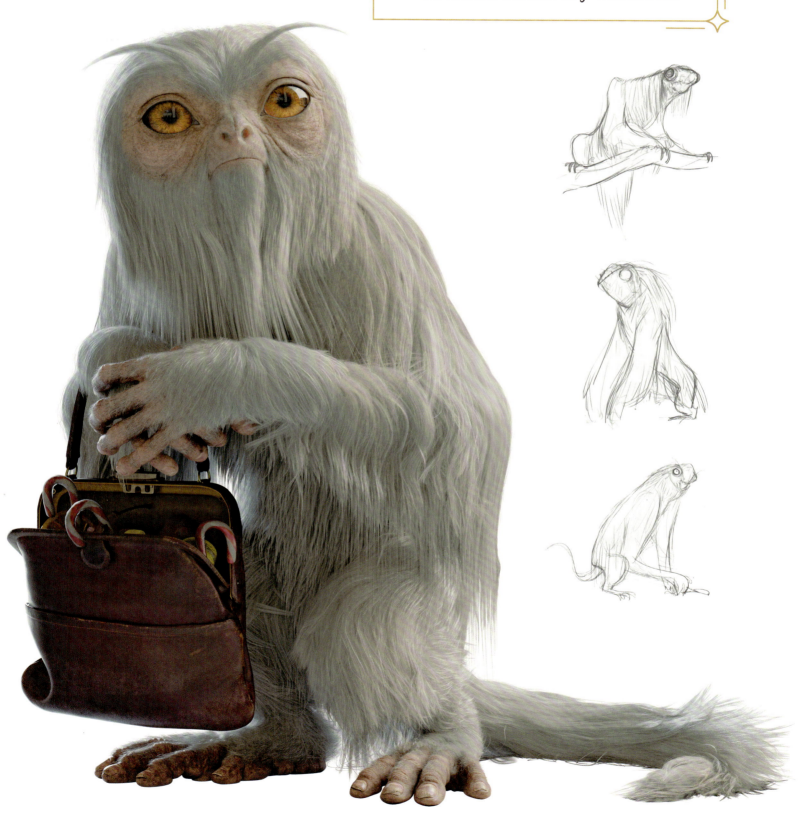

"*Choranaptyxic* is my favorite new word," says actor Eddie Redmayne about the word describing the Occamy's ability to expand or shrink to fill its allotted space. The actor had a long discussion with a dialogue coach about how the word should be pronounced. (It's *co-rah-nap-TISS-ick*).

NEWT SCAMANDER'S CREATURES

Occamy

In *Fantastic Beasts and Where to Find Them*, Newt Scamander and Jacob Kowalski first meet at a bank, where Jacob is seeking a loan and Newt is trying to recover his wayward Niffler. When Newt spots the creature, he accidentally lets an Occamy egg fall on the bench they shared as he rushes away. "Hey, mister!" Jacob yells after him, but Newt has disappeared, so Jacob pockets the egg. He doesn't get the loan, but he does walk out with a vibrating egg. When he spots Newt again, he yells, "Hey, Mister English guy, I think your egg is hatching!"

Jacob and Newt witness the miracle of the Occamy's birth from its pure silver eggshell—the reason why Occamy nests are ransacked by hunters. The cracked egg reveals a small, blue creature with the body of a snake and the feathered head and wings of a bird—multiple wings, to start with.

An early story point had the Occamy flying over the landscape of New York City, but the idea changed to have it room-bound in the attic of a department store. "[The wings] no longer fit the purpose of it being wrapped in a department store because you'd never see them," says visual effects supervisor Christian Manz. "So, we applied [them] to the Thunderbird instead." The Occamy became more snakelike but with the feathered head of a bird of prey—which conflicted with the Thunderbird's design. So the filmmakers gave the Occamy dragon-like features. "This was a hard creature to get right," says visual effects art director Martin Macrae. "She had to look elegant and mysterious but also needed to show a strong maternal side when threatened. To show her in a threatened state, we wanted the Occamy's feathers to have an animated, iridescent quality, so for inspiration we looked to peacocks. We also looked at cuttlefish and chameleons for their changing skin patterns." Artists researched birds whose feathers refract light, specifically herons and hummingbirds, giving them a brilliant sheen. Additionally, the plumage on a hummingbird's neck overlaps in a manner similar to fish scales, and that was used as well, as it seemed appropriate for the Occamy.

"For the baby Occamy, we had to show an obvious resemblance to its mother regarding features and colors, but it also needed to look strange and clumsy as a newborn chick," says Macrae. Its shell needed to maintain the same iridescent quality as the feathers of a full-grown Occamy. "This was a fun one to design and realize."

Newt places the Occamy chick in his case at the bank, but it escapes and is finally discovered in a department store attic, being babysat by Dougal the Demiguise. "It's quite a big sequence where they capture the Occamy," says visual effects supervisor Tim Burke. The Occamy has grown to a size that almost fills the entire attic space, as Occamys are choranaptyxic. "It can expand or shrink to fill the space it's within," Burke explains. "It can only grow to a certain size, but it can expand big enough to fill the space of the storeroom."

The Occamy becomes stressed out as Newt, Tina, Queenie, and Jacob attempt to snag it, and it grows even larger, sending shelves and boxes crashing; its tail smashes through the attic window. This sequence needed to be filmed sequentially. "As the Occamy gets more agitated and does more destruction, we had to actually destroy the set," Burke explains. "When it's startled, it's not aggressive, but it's frightened. And when it's frightened, because it's so big, it's clumsy, and its awkwardness means that it knocks a lot of things over." Newt eventually catches it using a cockroach and a teapot.

Jacob and Newt become friends early in the film when they accidentally exchange similar cases, so it's only fitting that cases are exchanged again at the end of the story. As Jacob leaves his job at the canning factory, his case is knocked out of his arms, and he struggles with its weight when he picks it up. Opening it, Jacob finds out why: Newt has gifted Jacob a case filled with silver Occamy shells as collateral to start his bakery.

OPPOSITE: Digital art of the iridescent Occamy, with its arrangement of feathers offering the impression of scales on its snakelike neck seen in *Fantastic Beasts and Where to Find Them*.

NEWT SCAMANDER'S CREATURES

Runespoor

The Runespoor is a large three-headed snake, colored a vivid orange with black spots. Each head serves a different purpose: The left head is a planner, the middle head is a dreamer, and the right head is a critic with extremely venomous fangs.

"The Runespoor was supposed to be a regular-sized snake, and everyone seemed fine with that," says visual effects supervisor Arnaud Brisebois. "Then, about mid-production, [visual effects supervisor] Christian Manz asked me to redesign it from scratch and make it 'fantastic' and 'huge.'" The length of the adult Runespoor isn't revealed at first. "We see a small infant one who has a cone on one of its heads to stop it [from] biting the other heads," says Christian Manz. "Then we reveal a very large adult in the background." The Runespoor's design was based on the African bush viper. "Though, of course, ours has three heads and a color scheme created to fit the cave we find them in," adds Manz.

Though Jacob does encounter the Runespoor inside Newt's case, unfortunately, the scene was deleted from the final film.

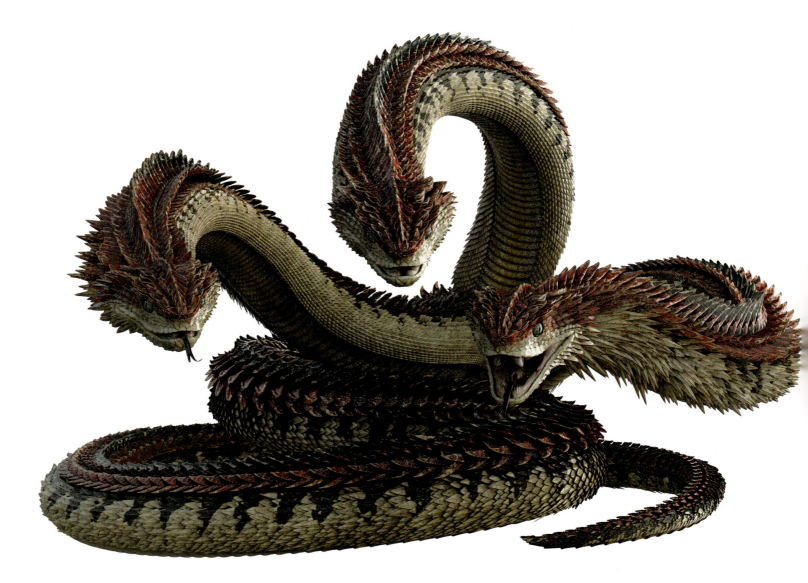

NEWT SCAMANDER'S CREATURES

Doxy

When Jacob goes to feed the Mooncalves in Newt's case, he passes by a tree covered with myriad brown and orange leaves. Suddenly, the "leaves" rise up and fly over the environs—these are not leaves but a flock of Doxies, large-eyed flying lizard-like creatures. They fly into a floating assortment of embryonic beasts held inside large drops of water. One particular Doxy lands atop one of these bubbly homes for a beat, then continues to flit through their ecosystem until it unknowingly flies right into a globule and gets trapped.

Although visual effects artists always consulted with the published book *Fantastic Beasts and Where to Find Them* for basic information on a beast, they decided to design a more animalistic version of the minute human form originally described in the book. "We looked at little lizards that use their ears as wings," says visual effects supervisor Christian Manz, "so now they're a multi-limbed insect with wings for ears."

Concept artist Max Kostenko imagined layers of black on the creature, such as the color of a black gorilla's fur or the bluish-black iridescence of beetles. In his artwork, Sam Rowan blended characteristics of a tree frog with those of a moth, based on earlier frog-like sketches by Ben Kovar. Rowan loved the idea of the Doxy using its ears as wings: "It added a nice bit of humor to the creature."

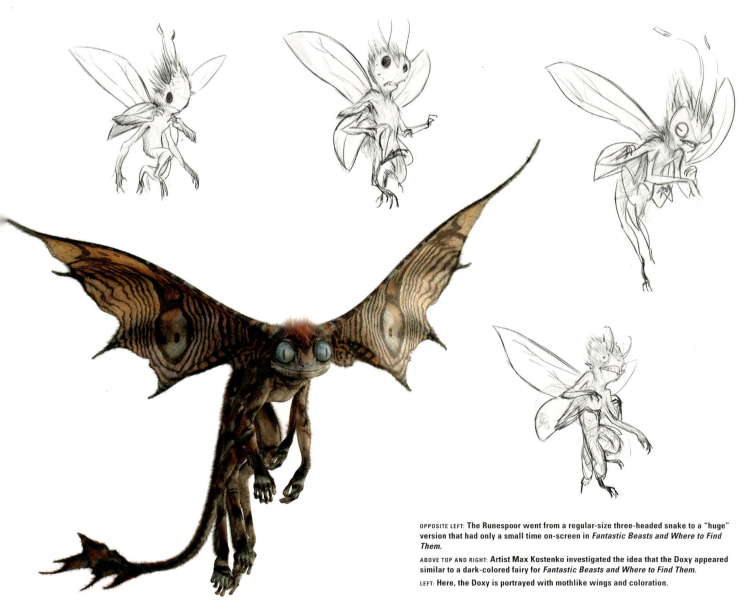

OPPOSITE LEFT: The Runespoor went from a regular-size three-headed snake to a "huge" version that had only a small time on-screen in *Fantastic Beasts and Where to Find Them*.
ABOVE TOP AND RIGHT: Artist Max Kostenko investigated the idea that the Doxy appeared similar to a dark-colored fairy for *Fantastic Beasts and Where to Find Them*.
LEFT: Here, the Doxy is portrayed with mothlike wings and coloration.

ABOVE: Concept artist Sam Rowan blended in aspects of tree frogs and moths in his take on the Doxy for *Fantastic Beasts and Where to Find Them*.

NEWT SCAMANDER'S CREATURES

Erumpent

The Erumpent could be the most intimidating of Newt's escaped beasts, and to add to the challenge of recovering her, she's in season! With the help of Jacob Kowalski, the Erumpent is located at the Central Park Zoo, and then the dance begins, literally, to get her back into Newt's case.

For any large beast with a large horn located right on its nose, it's hard to avoid comparisons with a rhinoceros. But as the Erumpent's horn actually holds a liquid sac that contains an explosive substance, comparisons end there. Early iterations by concept artist Dan Baker were of a "big playful creature, with elements of a bull terrier, dog, manatee, and a beetle," he says. Combinations of beasts explored by concept artist Paul Catling included a crab/rhino and a rhino/jellyfish, but Catling knew the Erumpent needed to be as sympathetic as she is huge.

"She's like a large grazer," says senior animation supervisor Pablo Grillo. "Doesn't have any more expressive potential than a cow. But through her actions, you totally get her motives—she wants love, she's in heat, and the juxtaposition of that scale, that clumsiness, and that incredible desire fuses into something incredibly entertaining and charming and enjoyable and slapstick."

"We wanted to give her a slight feminine quality without being too cartoony," adds visual effects supervisor Tim Burke. "We found footage of a man in the Midwest who kept bison and had invited one into his house. It was amazing how this large beast suddenly moved cautiously, daintily, in the living room."

In order to get the Erumpent back into the case, Newt has to entice her. "There was one scene in the script that just said, 'Newt performs mating dance,'" recalls Eddie Redmayne, who plays Newt. "Two words have never filled me with so much sweat," he laughs. "It was weirdly exhausting trying to seduce an Erumpent—but also a massive high point for me."

Redmayne researched unusual bird mating calls to help create the lowing and cooing Newt vocalizes to catch the Erumpent's attention. Then, he made a few videos of his ideas for the dance and sent them to director David Yates. "They were the most humiliating things you've ever seen in your life," he says. "And after waiting hours to hear his answer, his response would be, 'I'm not sure it's quite seductive enough.'"

Redmayne persevered, working with choreographer Alexandra Reynolds. "She and I watched birds do mating dances," he says. Reynolds videotaped Redmayne performing ten different dances, from which Yates chose the final movements. A video of the selected dance was given to the digital team to animate, and then the puppeteers received a copy of that to rehearse the Erumpent's moves.

The Erumpent puppet was seventeen feet tall, ten feet wide, and more than twenty feet long. It was created not just to give Redmayne an eyeline, but to give the actor and the director a physical character to play against. "It's there to enable their performances," says supervising creature puppeteer Robin Guiver. "And so David has something he can direct very specifically. He'll be able to treat it as if he would an actor. He can dictate moves or emotions as he needs to, and he can look at the blocking of that mating dance as a very real event, rather than just asking Eddie to have to imagine all that."

Pierre Bohanna and his props team created the Erumpent puppet, which at that scale needed to be incredibly lightweight. The wire-frame structure was made mostly from carbon fiber tubes for a total weight of one hundred pounds. The Erumpent's head was fixed to its body but had a cantilevered mechanism that allowed the puppeteers to give it movement.

The Erumpent's liquid sac made it slightly more unusual than a normal puppet. "It had to move and have internal lighting," says visual effects supervisor Christian Manz." The prop department made the final three feet of horn in a hollow and translucent form into which the electrical department inserted a lighting effect that brightened as the creature got more and more excited. The explosive quality of the sack was handled digitally.

"We had four people actually operating the puppet rig for every shot," says Burke. "Before we even shot, they rehearsed with Eddie so they could get a relationship down. For Eddie's character, it was all about having that relationship with the actual creatures themselves." Redmayne remembers that during the dance, the puppeteers made "sniggling" noises and flirted with his character.

To aid in his "seduction," Newt dabs a drop of Erumpent musk on his wrists. Jacob accidentally gets doused in it, and the Erumpent's attention is diverted. "We loved the idea of a relationship between Jacob and the Erumpent," says Yates.

Jacob gets his own moment with the Erumpent, but as Dan Fogler describes it, it's Newt's relationships with his creatures that really showcase the Magizoologist's abilities. "When Newt is trying to coax the Erumpent back into the case by doing a very sexy dance for her, it's hysterical," he says, "but it's also science." Once filmed, Redmayne says he was quite proud of being able to seduce an Erumpent.

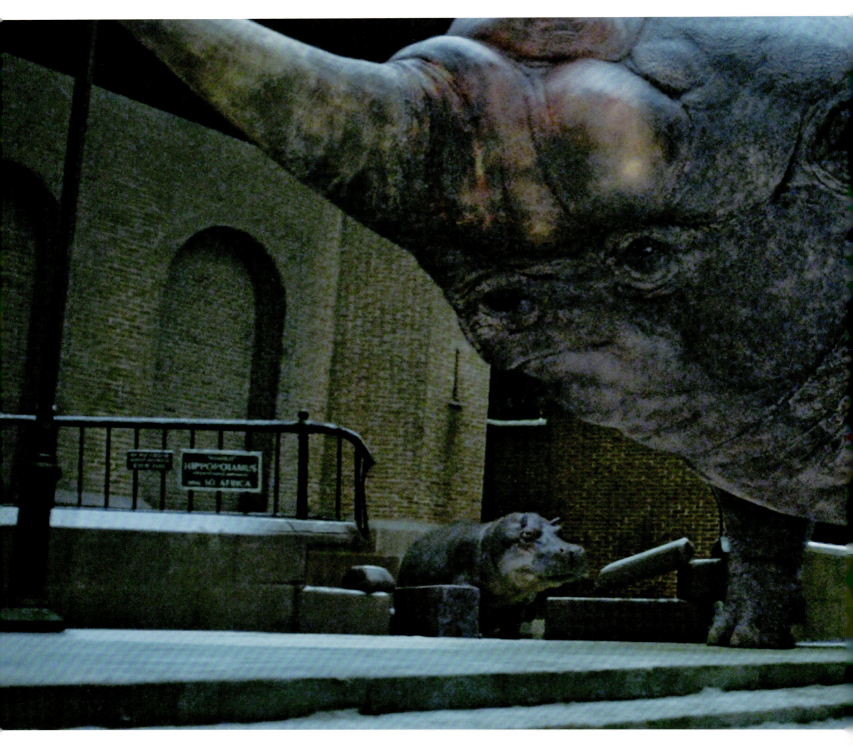

PAGE 127 TOP: With the skyline of Manhattan behind her, the Erumpent is portrayed with her horn filled with a glowing explosive liquid in artwork by Sam Rowan for *Fantastic Beasts and Where to Find Them*.
PAGE 127 BOTTOM: Eddie Redmayne (Newt Scamander) performs a mating dance to entice the Erumpent, here in its wire-frame form and operated by four puppeteers.
ABOVE: The Erumpent is portrayed in a calm moment in the Central Park Zoo, next to the hippopotamus environment, in *Fantastic Beasts and Where to Find Them*.

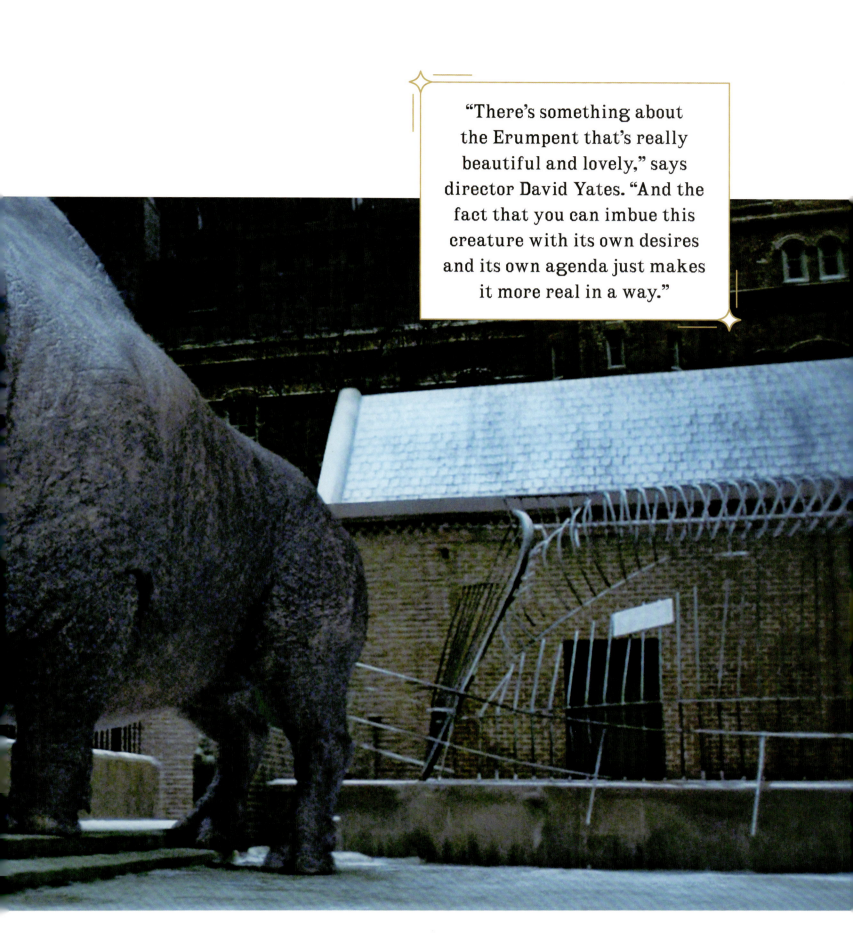

"There's something about the Erumpent that's really beautiful and lovely," says director David Yates. "And the fact that you can imbue this creature with its own desires and its own agenda just makes it more real in a way."

NEWT SCAMANDER'S CREATURES

Nundu

During Jacob's tour inside Newt's case, the Nundu makes its presence known when it stands upon a large rock, roaring at the moon near the Mooncalf enclosure. "We see it quickly inside the case," says visual effects supervisor Christian Manz. "It roars at you, pops its mane, and you think, 'Wow, that's amazing.' Then you move on."

"The Nundu is an exceptionally dangerous beast," says concept artist Ben Kovar, who explored a wide range of references to visualize the animal. One version was a mash-up of the hoods of medieval executioners and the bodies of hairless beasts. In its on-screen iteration, the Nundu has more than a passing resemblance to a lion, one difference being that its extremely large, unique mane bursts forth when it roars. "[This] idea combined spitting cobras and pufferfish, and the way they expand when threatened," Kovar explains. "I tried to apply this behavior to the creature's lionlike mane."

OPPOSITE TOP AND BOTTOM: **The Nundu in its normal and inflated states by artist Sam Rowan for** *Fantastic Beasts and Where to Find Them.*
BELOW: **Artist Ben Kovar was inspired by the hoods of medieval executioners for this hairless study of the Nundu.**

> While Newt empties a bucket of food for the Nundu, the beast makes a swipe at the mother Diricawl and her chicks, but they Apparate quickly out of reach.

NEWT SCAMANDER'S CREATURES

Graphorn

Among the beasts in Newt Scamander's case is a pair of Graphorns, the last breeding pair in existence. If Newt hadn't managed to rescue them, he tells Jacob, "it could have been the end of Graphorns forever."

Graphorns are large, carnivorous beasts built like saber-toothed tigers but with slimy tentacles at their mouths. They have grayish-purple hides that are even tougher than a dragon's, a humped back, and two very long, sharp horns. They also walk on four-thumbed feet. When Newt greets the Graphorns, the male wraps its tentacles around its head. "They're quite frightening in their scale," says senior animation supervisor Pablo Grillo about the Graphorns, whose females can top twelve feet tall, and whose males can reach thirty feet tall. "They look menacing. It says a lot about Newt's character that he shrugs at this enormous thing coming so close to him." A computer-generated version of actor Eddie Redmayne was created for the Graphorn's affection in the interest of "safety."

"We approached this like a real animal," says concept artist Rob Jensen. "It had to move like a cat but be big and powerful like an elephant or rhino. It had to be intimidating at first glance, but also enduring and nurturing with strong family bonds. Finally, it needed to have adapted its color and skin type to fit in its desert environment." Concept artist Paul Catling illustrated the Graphorn's aggressive nature by keeping its head low, "permanently in a ramming mode, its shoulders massive and unyielding yet with a slim, almost athletic rear end that can accelerate cheetah-like, propelling its huge bulk and sharp horns toward its foe."

"The Graphorn is a creature director David Yates liked from the beginning," says visual effects supervisor Christian Manz, "because it was a sleek predator-dinosaur, almost catlike. We've got a mum and a dad and two children," he adds. "It's a little family, so it tells that story." Its horned design was inspired by caterpillars, which sounds strange, but there is a horned caterpillar, the hickory horned devil, from which the shape of the Graphorn's horns was taken. The digital artists also studied rhinos, elephants, ostriches, hippos, lions, and alligators. In the end, "the Graphorns look[ed] completely real and believable, but otherworldly," adds Grillo.

LEFT: Artwork by Paul Catling for *Fantastic Beasts and Where to Find Them* kept the Graphorn's head low, as if always prepared for ramming potential challengers.
TOP: A tender moment between the Graphorn and its offspring seen in the film.
OPPOSITE: Concept artwork of the Graphorn by Rob Jensen stresses the Graphorn's many horns and its skin, rendered in colors that would fit in with its desertlike environment.

> Under Newt's care, the last breeding pair of Graphorns already have two offspring.

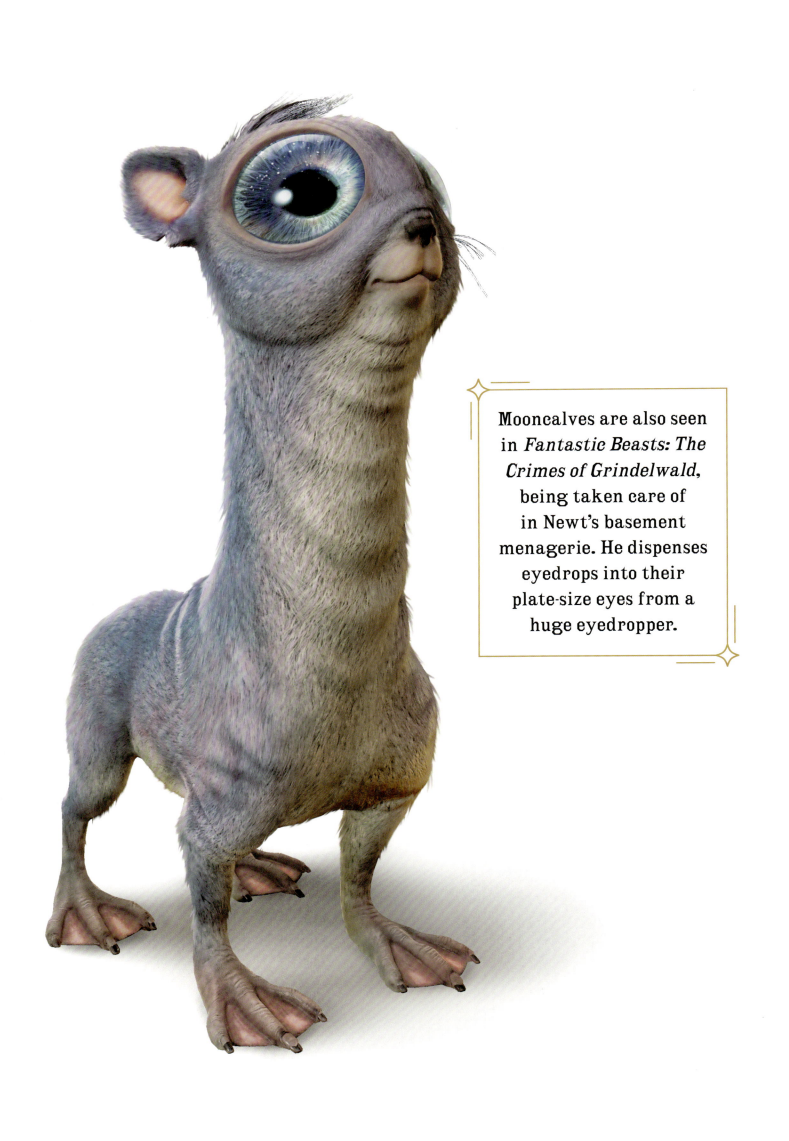

Mooncalves are also seen in *Fantastic Beasts: The Crimes of Grindelwald*, being taken care of in Newt's basement menagerie. He dispenses eyedrops into their plate-size eyes from a huge eyedropper.

NEWT SCAMANDER'S CREATURES

Mooncalf

As Newt tends to the creatures in his case in *Fantastic Beasts and Where to Find Them*, he employs Jacob to feed the Mooncalves—huge-eyed, adorable mammals. "They're like little mountain goats with very long necks and eyeballs like radar, stuck on top of their heads," says senior animation supervisor Pablo Grillo. "They behave a little like prairie dogs and live in clusters."

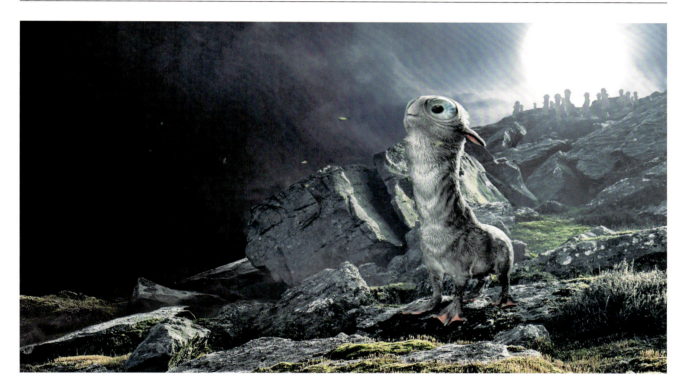

The nocturnal Mooncalf is actually a rare sight, as it is extremely timid and only emerges from its underground burrow during the full moon. Its smooth skin is pale gray, and it has four spindly legs with large, flat feet. "The Mooncalf was described as having eyes on top of its head," says concept artist Paul Catling, "which gives the notion that the Mooncalf had somehow evolved solely to stare at the moon, so I thought I'd strip away any features that didn't fit that idea." Early versions were more goatlike, or had the creature looking up with a barn-owl-like face. "Designing realistic facial features while preserving the cartoon proportions that gave the Mooncalf its endearing look was a fine balancing act," adds visual effects matte painter Samantha Combaluzier.

"They're bizarre creatures that can only look up," says visual effects supervisor Christian Manz, who suggested that the pellets Jacob feeds them should float "so he can feed them like fish."

The concept artists had another assignment for the Mooncalves: their dung. "To design the droppings of any magical creature is a bizarre and exciting brief," says concept artist Molly Sole. "We considered the characteristics and habits of the moon-worshipping miniature calves, and gave the droppings a size and texture we felt naturally befitted them, along with a distribution in the meadow, which would give it a lived-in look." The "pats" are created when the creatures come out at night and stare at the full moon, "clustering their excretions in one area so as to protect the grass from becoming sour," Sole continues. "Much like a cowpat, the surface is pitted and irregular, faintly resembling the craters of the moon. The silver-dusted surface is a small clue to the superpower of the dung when used as a fertilizer on plants and vegetables."

OPPOSITE: **Artist Samantha Combaluzier and VFX Supervisor Arnaud Brisebois combined their ideas to create concept art of the Mooncalf for *Fantastic Beasts and Where to Find Them*.**
ABOVE: **Digital art created for *Fantastic Beasts and Where to Find Them* depicts Mooncalves atop the environment Newt Scamander conjured for them in his case.**

NEWT SCAMANDER'S CREATURES

Baby Nifflers

As Newt Scamander approaches the door of his London flat in *Fantastic Beasts: The Crimes of Grindelwald*, he notices a light in his sitting room is flashing on and off. Newt enters the house with care to find the culprit is a baby Niffler, who has been working on removing the brass cord for the table lamp. With the cord halfway stuffed into its pouch, it notices Newt and scampers off the table. At the same time, another baby Niffler is working on stealing the small gold weights on a pair of scales.

Newt overturns a small saucepan on top of the first baby to capture it, then throws an apple onto one of the scales, sending the second baby flying into the air. He manages to put both babies in his coat pocket before opening the door to his basement. But then he notices a third baby Niffler wrestling with the gold foil on the cork of a bottle of champagne. It is inevitable that the cork will pop, sending the third baby with it as it flies through the open door. "Bunty!" Newt cries out, "The baby Nifflers are loose again!"

"How do you make something that was funny and cute even cuter without being overly sentimental?" asks concept artist Carlos Huante. "Niffler babies are essentially the kinder and gentle version of what they will become. They are beautiful—but keep an eye on your valuables."

Newt's assistant, Bunty Broadacre, played by Victoria Yeates, knows exactly how to wrangle the mischievous Nifflers. She tempts the champagne-cork-riding Niffler with a gold piece at the end of a chain, then picks up the other two from Newt. They're placed into a wicker cage filled with shiny objects.

Multiple Nifflers, even small ones, required their own forms of puppetry. "We have ones that have a little rod in their heads and are really good at looking and interacting and making eye contact," says supervising creature puppeteer Robin Guiver. "Other ones are on the end of sticks that we can run around very fast. And we've got ones that are just like a big, black, weighted beanbag." Each physical iteration of the babies allowed the actors to get the best sense of their feel and weight. "So, as the actors rehearse, if they're picking something up, they're not having to worry about miming it while they're performing," he continues. "We'll pass things to them so they're actually holding this thing that has some weight and some body to it. They can physically touch. And so every time they do touch it, the animators can see how the skin, on a very detailed level, is affected by that. Or on an emotional level, feeling something that you touch there has an impact on that performance as well."

Newt brings the baby Nifflers with him to Paris, telling Jacob, "I don't think it's reasonable to ask Bunty to cope with everyone in here and a bunch of newborns, so." Jacob asks him if he's insane, remembering the Niffler who escaped from the case in *Fantastic Beasts and Where to Find Them*: "You've got a pack of Nifflers now?" But Newt assures him he's fixed the lock.

"Oh, those Nifflers are such a pain," Yeates says with a laugh. "They don't ever do what she [Bunty] tells them to. I was happy to give them short shrift."

ABOVE: **Like Teddy, the baby Nifflers are attracted to shiny objects, seen in film stills from *Fantastic Beasts: The Crimes of Grindelwald*.**
OPPOSITE: **Artist Carlos Huante based his concepts of the baby Nifflers on a guinea pig owned by VFX lead Nordin Rahhali.**

"The Nifflers had babies," says actor Eddie Redmayne. "So, there's not only one scene stealer, there's now an entire family of scene stealers. They're causing Newt quite a headache, but trying to wrangle a fleet of little babies was one of my most enjoyable scenes."

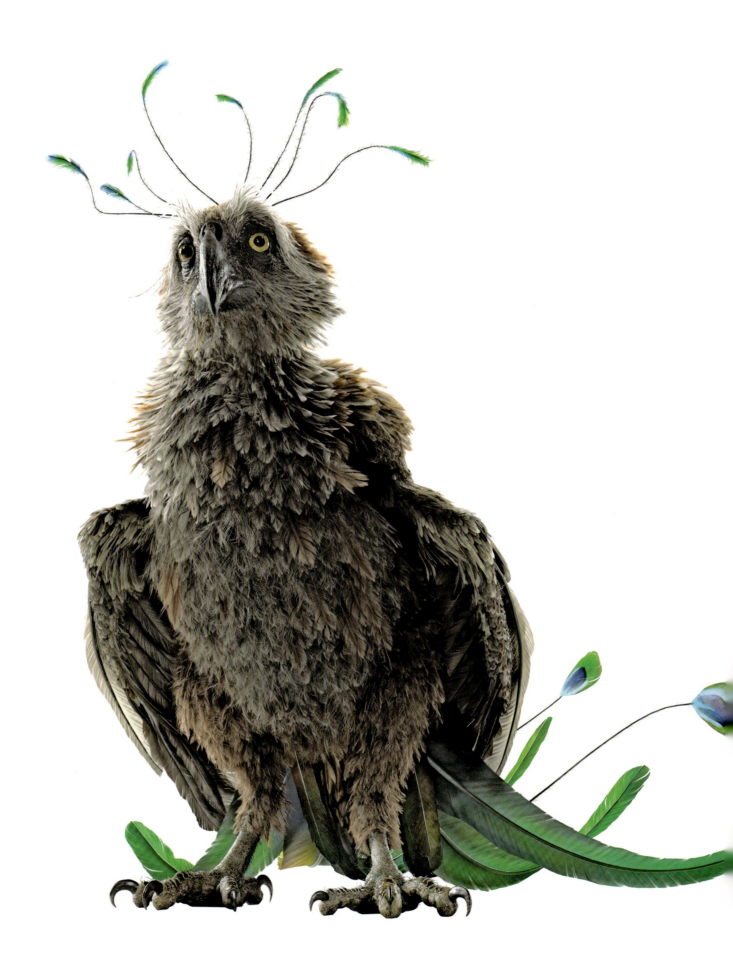

NEWT SCAMANDER'S CREATURES

Augurey

As Jacob Kowalski descends into the basement menagerie of beasts in Newt's home in *Fantastic Beasts: The Crimes of Grindelwald*, he hears the coo of the Augurey, whose forlorn look prompts Jacob to comment, "I've got my own problems." The Augurey resembles a depressed-looking, owllike bird.

In early concepts, artist Sam Rowan depicted the bird as being an old, ragged recluse that had let itself go a little, or resembling an old, pompous knight. Concept artist Jamie O'Hara explored potential types of birds the Augurey might have been. "The idea it was once a powerful bird of prey lent itself as a contrast to the now weary bird," he explains. Owls, eagles, and vultures were considered. O'Hara also played with the character traits of the Augurey, deeming that giving it a slightly half-hearted wingspan added charm and humor to this character. "The concept of the Augurey was to have a more comedic feel," O'Hara continues. Concept artist Dylan Baker used owls and moths as references where the antennae, eyebrows, and feathers could help convey the creature's mood, even experimenting with setting "eyes" in its wings like those of peacocks and moths. "Plumage played a huge part in capturing the Augurey's personality," adds O'Hara. "The ruffled and sporadic feathers really enhanced the character."

The Augurey flies from the top of the menagerie down to Newt's "office" and alights on a chair (rather clumsily) to join the action below. For this, the puppeteers mocked up a little puppet of the bird that consisted of a foam football with sprayed-on eyes and some simple feathers for the actors to focus upon when necessary.

THIS PAGE: **The Augurey watches the proceedings inside Newt's basement during the events of *Fantastic Beasts: The Crimes of Grindelwald*.**
OPPOSITE: **The Augurey's head and tail feathers are reminiscent of a peacock's.**

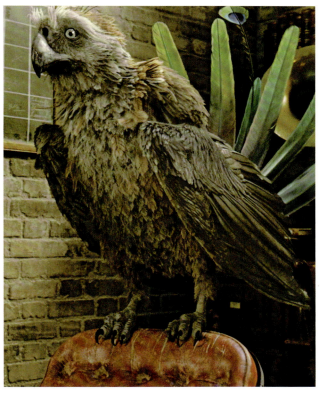

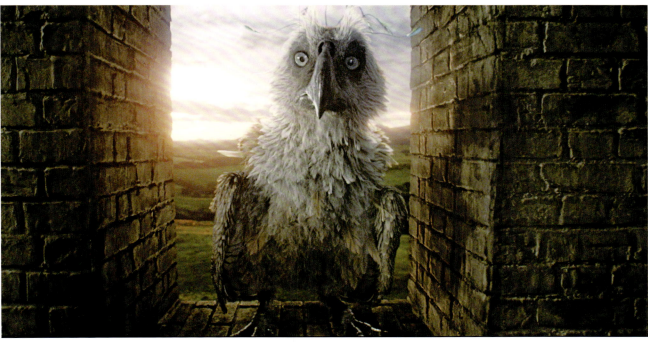

NEWT SCAMANDER'S CREATURES

Kelpie

One of the duties Newt must attend to when he returns to the basement menagerie in *Fantastic Beasts: The Crimes of Grindelwald* is placing some ointment on a wounded Kelpie. Kelpies are large underwater creatures that can shape-shift into any form; this Kelpie has equine features covered in seaweed-like tendrils. Newt must jump into the Kelpie's large water environment, mount it, calm it, and ride it to a side wall where he can hold it steady and apply the salve.

"The Kelpie was described to me as a wild mustang needing to be tamed," says concept artist Jamie O'Hara, and he imagined Newt's interactions with the beast as similar to an underwater rodeo. "It's a beautiful and powerful creature that looks almost as if it was made of seaweed and kelp," says concept artist Dan Baker. Artist Jama Jurabaev explored the idea of the Kelpie being covered in weeds resembling a horse's mane, and the concept that the Kelpie used the weeds to camouflage itself. "The Kelpie was quite a challenge to design," says concept artist Paul Catling. "It would be boring to just put some seaweed on a horse, but at the same time if we took it too far from the description we had, it would not be a Kelpie."

The creature was one of the most complex to accomplish for the digital artists, with the combination of its giant size, its flowing kelp, and, especially, its motion underwater. "It's this big horse/jellyfish/squid creature, so of course I looked at horses for reference," says animator Blair McNaughton. "[It's] also got a lot of kelp tentacles, which I felt moved like a jellyfish's." The animators used larger, pectoral-like kelp sections on its body to drive the creature through the water. Moving sections of the kelp in the same way as traditional fins gave its motion a more natural feel. For example, "main" fins were established that drove the Kelpie through the water.

Another challenge was having the Kelpie breach the waterline and leap out of its environment while Newt is riding it. The sequence was broken into sections: the Kelpie breaking the surface; the dive back underwater; and the Kelpie resurfacing with Newt on its back, in control of the beast. The animators referenced whales and orcas for the Kelpie's leaps and dives.

The sequence where Newt rides the Kelpie was filmed in one of the biggest underwater filming tanks in Europe at roughly twenty feet deep, forty feet across, and fifty feet wide. The stunt team felt Eddie Redmayne was more than capable of performing the bulk of the stunt. "We like to do that so that we get more 'face time' with the actor," says Martin Wilde, Redmayne's stunt double. Redmayne learned how to scuba dive and perform the proper breath holds. "We've a very high-esteemed actor we're actually dragging through the water on a rig," says assistant stunt coordinator Marc Mailley, "[and we] have him break the surface and ride out, which is obviously quite a feat to get all in one. And Eddie absolutely smashed it!"

Redmayne made one request after watching an early previsualization of the scene, asking if they could make the action gentler. Considering the beast's horselike qualities, the actor wanted to be perceived as more of a horse—or Kelpie—whisperer.

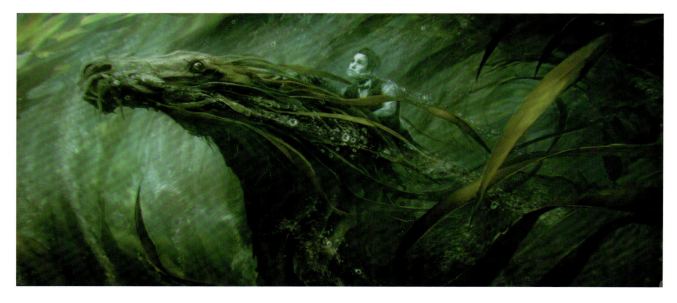

NEWT SCAMANDER'S CREATURES

Hinkypunk

Hinkypunks were first introduced into the wizarding world in the third Harry Potter book, *Harry Potter and the Prisoner of Azkaban*. They are mentioned by Hermione Granger when Severus Snape temporarily takes over Remus Lupin's Defense Against the Dark Arts class while the professor is indisposed. But these ethereal beasts did not make it on-screen until *Fantastic Beasts: The Crimes of Grindelwald*.

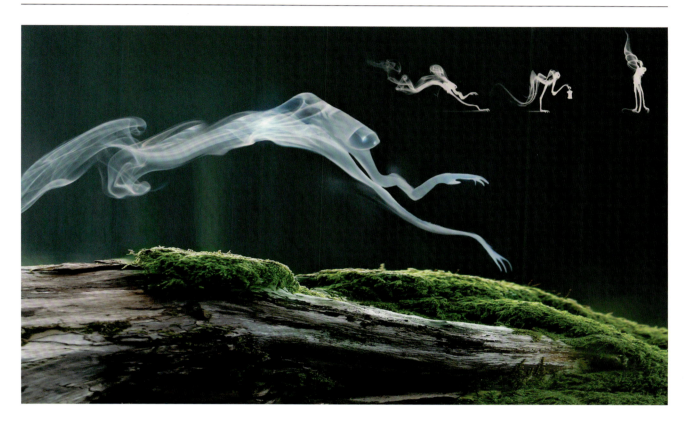

Although Hinkypunks seem no more than a blend of wisps and smoke, they can disrupt tracking charms, which Newt feels he needs to locate Tina in Paris. He packs the Hinkypunk in his case, along with the baby Nifflers and Teddy.

"As we tried to imagine how the ethereal Hinkypunk might look, a wide variety of ideas were put forward," says concept artist Max Kostenko. "The main part of the work was developing the idea of the creature—how this guy can move and jump," he explains. "I used a photo of smoke and transformed it along the contour."

Other ideas by Kostenko for the Hinkypunk included one resembling a ghost with "fluorescent essence." In another idea, concept artist Dan Baker wanted the Hinkypunk to look deranged. "I imagined it giggling and talking to itself when it moved around the darkness." This iteration had three arms, which Baker felt could lead to interesting animation possibilities. He also imagined Hinkypunks as a cross between a fungus, a ghost, and an animal.

Another concept was closer to the final version. This illustration, by artist Ben Kovar, was of a magical lantern surrounded by smoke and shadow that resembled the shape of a body. "The smoke body can change shape, but the lantern remains a solid object," Kovar explains. "I liked the idea that it would inflate itself in order to scare someone, then try to escape through a tiny keyhole—only to be frustrated when its lantern couldn't fit through the gap." What made it to the screen was almost an inversion of that idea, seen when Newt packs up a lantern-like metal enclosure that holds an excited blob of smoke: the Hinkypunk.

OPPOSITE: **Newt rides the Kelpie in digital artwork by Dan Baker for *Fantastic Beasts: The Crimes of Grindelwald*.**
ABOVE: **Artist Max Kostenko photographed smoke for insight into the movement of the Hinkypunk.**

NEWT SCAMANDER'S CREATURES

Leucrotta

When Newt Scamander arrives back at his London home in *Fantastic Beasts: The Crimes of Grindelwald*, after a meeting at the Ministry of Magic, he finds the baby Nifflers have gotten loose and heads for his basement menagerie to tell his assistant, Bunty. Bunty is in the middle of taking care of a Leucrotta, a large moose-like beast with an enormous mouth. And that is no exaggeration. When opened, its mouth takes up the better part of its head.

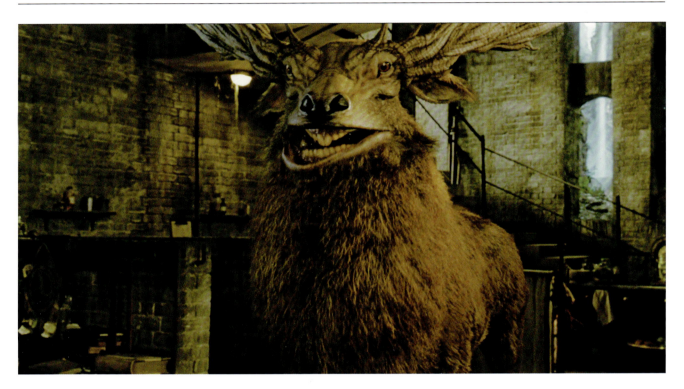

"The open mouth needed to make sense," says concept artist Carlos Huante, "so it was a challenge to make it believable in sketch and design." Artist Dan Baker was inspired by another large-mouthed creature: the basking shark. "The idea was that maybe this creature feeds in the same way, whereby it opens its huge maw and swallows swarms of insects in one big gulp. In the end, I was happy with how naturalistic it turned out."

Bunty is inspecting the Leucrotta's mouth when Newt interrupts her, and though the Leucrotta was created digitally, the puppeteers wanted to provide something that actor Victoria Yeates could work with in the scene. "We needed Bunty to put her head into the Leucrotta's mouth and look around," says supervising creature puppeteer Robin Guiver. "We used a big iron hoop, which didn't really do anything, but we put eyes on top of it, and a big bag below, so it gave the right shadows and gave Victoria something to interact with."

> The Leucrotta is another creature that was created directly for the film *Fantastic Beasts: The Crimes of Grindelwald.*

ABOVE: **The Leucrotta, as seen in Newt's basement in** *Fantastic Beasts: The Crimes of Grindelwald*.
OPPOSITE: **Dan Baker was inspired by basking sharks for the look of the Leucrotta, here in a digital rendering of the creature with Newt Scamander.**

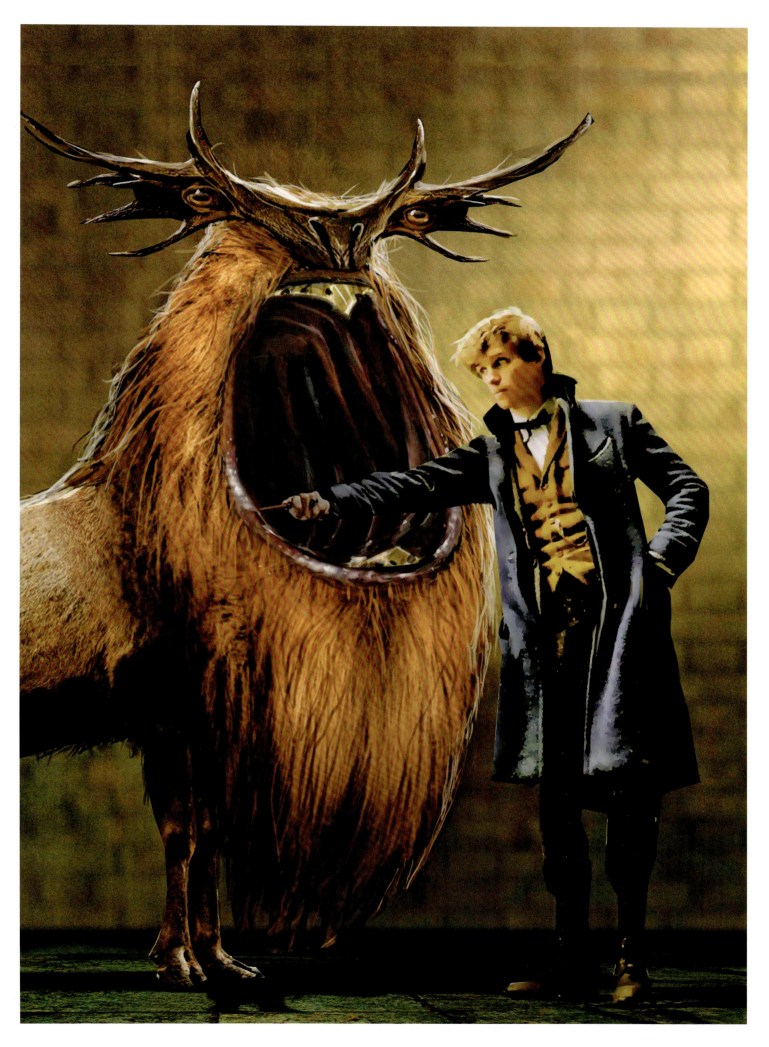

NEWT SCAMANDER'S CREATURES

A Magizoologist's Tools

In the year prior to the events of *Fantastic Beasts and Where to Find Them*, Newt Scamander has been working in the field, researching his best-selling book of the same name. The Magizoologist rescues, studies, and rehabilitates beasts he comes upon in his travels, so in order to carry them around, he keeps them in an unassuming, leatherette locked case.

The case itself is brown and battered, a latch that causes Newt trouble by springing open of its own accord. When he arrives at the Port Authority of New York, the latch flips open, attracting the eye of the customs agent. Newt discreetly moves a brass dial on the front to read "Muggleworthy," and when he opens the case, all the agent sees is an alarm clock, maps, a magnifying glass, and Newt's Hufflepuff house scarf.

When the case returns to its true purpose, it isn't long before the latch flicks open and a handful of beasts escape into the wilds of Manhattan. In addition to his reasons for coming to the United States, Newt must now recover these beasts, and he finds help in the nonmagical Jacob Kowalski. Newt and Jacob are taken in by Tina and Queenie Goldstein, but Newt is anxious to check on his beasts. That night, he opens the case and walks down into it, gesturing to Jacob to join him. Descending a squeaky ladder, Jacob finds himself in a vertically elongated shed.

"One of our early decisions was to give Newt a shed in this magical space," says production designer Stuart Craig. "[It's] where he keeps his medicines, his potions, and all other equipment needed to capture and care for the creatures. It's the center of the operation, for he is really an animal conservationist."

The shed serves several functions. First, it is a place for the tools of his trade. It houses a tripod camera, a pickax and rope nets to work in difficult terrain, and collecting jars, of course. There are sacks of feed against one wall, and a dried carcass that Newt cuts up to feed the creatures. For the care of beasts that have been mistreated, there are potions and pills on shelves and in drawers.

"It is quite a journey," Craig explains. "Right at the top, you pass through the paraphernalia of a gamekeeper, really, then down through this huge pharmacy, past all sorts of units, filing cabinets, little drawers. It's like an old apothecary's shop, but there are hundreds of shelves containing all manner of herbs and medicines Newt uses to maintain his world of exotic creatures, as well as remedying the odd sting or bite." Medications include a case of Billywig Stings and a bottle containing Essence of Dittany.

LEFT: **Newt Scamander's potion rack, used to mix antidotes for stings and bites, as seen in *Fantastic Beasts and Where to Find Them*.**
ABOVE: **Newt's leather journal is monogrammed with his initials.**
OPPOSITE: **Eddie Redmayne (Newt Scamander) perches atop one of his character's most important pieces of equipment: a case that houses the rescued and rehabilitated beasts Newt cares for in a publicity still for *Fantastic Beasts and Where to Find Them*.**

NEWT SCAMANDER'S CREATURES

The shed's interior was an opportunity to develop the environment and props to convey the world of Newt and his personality. "The idea developed from a standard garden shed that was adapted and distorted in dimension to create an unusually tall, narrow, and extremely confined space," says set decorator Anna Pinnock, "and dressed to suit Newt's otherworldly and eccentric personality." Within the space is an old heating stove and a teapot, a well-worn armchair, cabinets, and a long, narrow workbench with a bed underneath it. "We set about researching what a conventional chemist, zoologist, or zookeeper might be equipped with in our period," she continues. "With that knowledge, we began sourcing, designing, and fabricating unusual items that were exaggerated and different but still had some resemblance to familiar instruments and tools."

One important directive was to suggest Newt had traveled extensively "in both the Muggle and magical worlds," Pinnock continues. "So we introduced ethnic pieces, agricultural and zoological tools, and a great variety of unusual containers and receptacles. Every item had to have a function or purpose. The prop making team enhanced the sourced items as well as creating new ones from scratch."

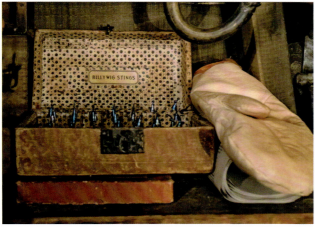

OPPOSITE: **Eddie Redmayne (Newt Scamander) poses with two of the Magizoologist's greatest tools—his case and his coat—in a publicity photo for *Fantastic Beasts and Where to Find Them*.**
TOP RIGHT: **Newt's costume, designed by costume designer Colleen Atwood, drawn by Warren Holder, highlights the many pockets concept from its original design for *Fantastic Beasts and Where to Find Them*.**
TOP LEFT: **A note from Newt to his assistant, Bunty, so she won't worry about missing baby Nifflers, created by the prop makers for *Fantastic Beasts: The Crimes of Grindelwald*.**
ABOVE: **A case of Billywig Stings, used in potions in *Fantastic Beasts and Where to Find Them*.**

The prop and graphics departments created handwritten labels for the potions and ingredients Newt uses to care for his beasts, his research notes, and wall charts for the room. "We made a feeding chart because we realized that, apart from incidental dialogue, you don't ever see or hear the names of the animals," says graphic designer Miraphora Mina. "It's something Newt might have made himself, in it's a bit rudimentary."

In one corner, there are a well-used typewriter and a pile of manuscripts as a nod to his work writing the book *Fantastic Beasts and Where to Find Them*. Tacked onto the walls are notes, maps, and drawings of beasts. The room also includes a photograph of Leta Lestrange, someone who was once very special to Newt.

"The day I went to shoot that first descent into Newt's case," actor Eddie Redmayne remembers, "the set Stuart had created was everything I could have dreamed of and more. It really is Newt's character described in the most intricate physical terms."

Boswell St. Newt's Menagerie_mooncalf floating Island Size 02 DP150729

NEWT SCAMANDER'S CREATURES

Environments

To transport his collection of beasts in his innocent-looking leather case, Newt Scamander created a series of distinctive environments. "The most remarkable thing about Newt's case is that it's not bigger than your average brown-leather briefcase," says production designer Stuart Craig. "However, when you open it, you step inside this seemingly limitless world of magical creatures." After the audience sees that beasts had escaped the case when the latch popped open, anticipation grows for the reveal of how the beasts were corralled and cared for within the case. "It's one of the biggest sequences in the film," says director David Yates. "Newt introduces Jacob and us as the audience to this amazing world where he keeps all his beasts. That took a lot of R&D [research and development]."

The first rule for Craig to follow was that "there were no rules [and] no precedents." He admits, "We went through many, many iterations of what it might be. We talked about cabinets with dioramas, or possibly a Victorian-type museum, but those wouldn't do for live animals." A zoo-type approach was not acceptable either, as Craig knew that Newt would not keep his beasts in cages. "Newt is about the preservation of these creatures and their happiness in their respective environments," he reiterates.

Concept artist Dermot Power had the impression that Newt "loves these animals so much he's gone to great trouble to create these worlds for them, but he doesn't see his career as being the greatest 'world creator.' His career is taking care of animals. So, if the environments are a bit shaky, he just makes sure they work. If things break off, he'll patch it. They're slightly off, slightly chunky. He's just pleased that the animals are happy in the worlds he's created."

Newt has magically created individual areas deep in the case to mimic each beast's natural habitat, including a snowy tundra, a bamboo forest, and a savanna. Power painted a few sample landscapes at the beginning of the design process. "They were only sections, but they were useful to give us an idea of the style of painting Stuart wanted and an idea of scale," says visual effects supervisor Christian Manz. When he saw the painting of the Thunderbird's Arizonan environment, he says, it was "a eureka moment. I thought, 'That's amazing, that looks real.' Then I walked up to it and could see the brush strokes." Manz immediately thought, "What if we did that digitally?"

Two strong real-world examples influenced the visual development of the beasts' areas, one being the dioramas at the American Museum of Natural History that illustrate animals' habitats. "They're painted to look real, but when you're standing looking at them, you're aware that they're not," Power explains. "But you're feeling the reality of it."

Another key reference used by Power was images of Buffalo Bill's Wild West shows from the nineteenth century. "They used painted backdrops, and you could tell in these photos they had really made an effort to make it look like a realistic landscape, but then had hung it up really carelessly," says Power. Marcus Williams, the film's scenic artist, created real painted backdrops to establish the correct aesthetic and serve as the starting point for the animated environments.

Additionally, "with each of the creatures, what was important for me was that Newt has a different relationship with them but also that they have a relationship with each other," says actor Eddie Redmayne. "They all live down in this case, and I think he's in some way parenting their relationships with one another. We played around with different ideas for this, and the answer was that it varies from character to character." Each beast has its own magically realized habitat, but there can be interaction between the beasts, as these areas are not walled off, separate containers except for the habitats of some of the bigger beasts. "Newt's case is his world," adds Redmayne. "You see the passion he has for these different animals. And once you descend into his shed and then out into the world of the case, well, it really pushes imagination to new extremes."

"The key for us is that this whole place, the environment is made by Newt himself," says Craig, "so it has this homemade DIY look. But as you get further involved and step inside what looks like a theatrical backdrop of scenery, it becomes this real and fantastic landscape. It changes in character the more you immerse yourself in it. Interesting to look at though crude at first, but magical and seemingly endless the farther you go in. It's a showcase for the creatures and they are, after all, the center of the movie."

OPPOSITE TOP: **The Mooncalves raise their heads to stare at the full moon set into their environment within Newt's case in** *Fantastic Beasts and Where to Find Them.*
OPPOSITE BOTTOM: **The floating "planet" habitat of the Mooncalf by Dermot Power. The semisphere is tethered to the floor of Newt's shed to prevent it drifting away.**

NEWT SCAMANDER'S CREATURES

In *Fantastic Beasts: The Crimes of Grindelwald*, audiences get the chance to see where Newt Scamander lives in London. "And he lives in this pretty stark, slightly dry house," describes actor Eddie Redmayne. "But, Newt being Newt, you go down into the basement and find this absolutely mind-boggling menagerie, a hospital where he's looking after injured and damaged beasts." Redmayne described walking onto the M. C. Escher–like three-story staircase of the basement set as "breathtaking."

Early on, Redmayne discussed with the director, screenwriter, and production designer whether or not Newt actually slept in the bedroom of his flat. "That didn't make sense to me," he explains. "Newt's a man who's much more at home traveling through the jungle or out in the field, with the idea being he had lived in his case for the year when he was collecting information for his book. I felt he would rather sleep on a hammock in the basement, so the apartment on the ground floor is very much for show. Upstairs is not really where his world is. It's only when you go down into this menagerie you see Newt's character and personality in his real life," he explains. "That's where his home is."

ABOVE: Newt Scamander (Eddie Redmayne) at home in London, trying to wrangle wayward baby Nifflers in *Fantastic Beasts: The Crimes of Grindelwald*.
OPPOSITE: The basement of Newt's home took the concept of Newt's shed and expanded it into an Escher-like "mind-boggling menagerie," according to Eddie Redmayne, where Newt can look after injured and damaged beasts, seen in concept art by Dermot Power.

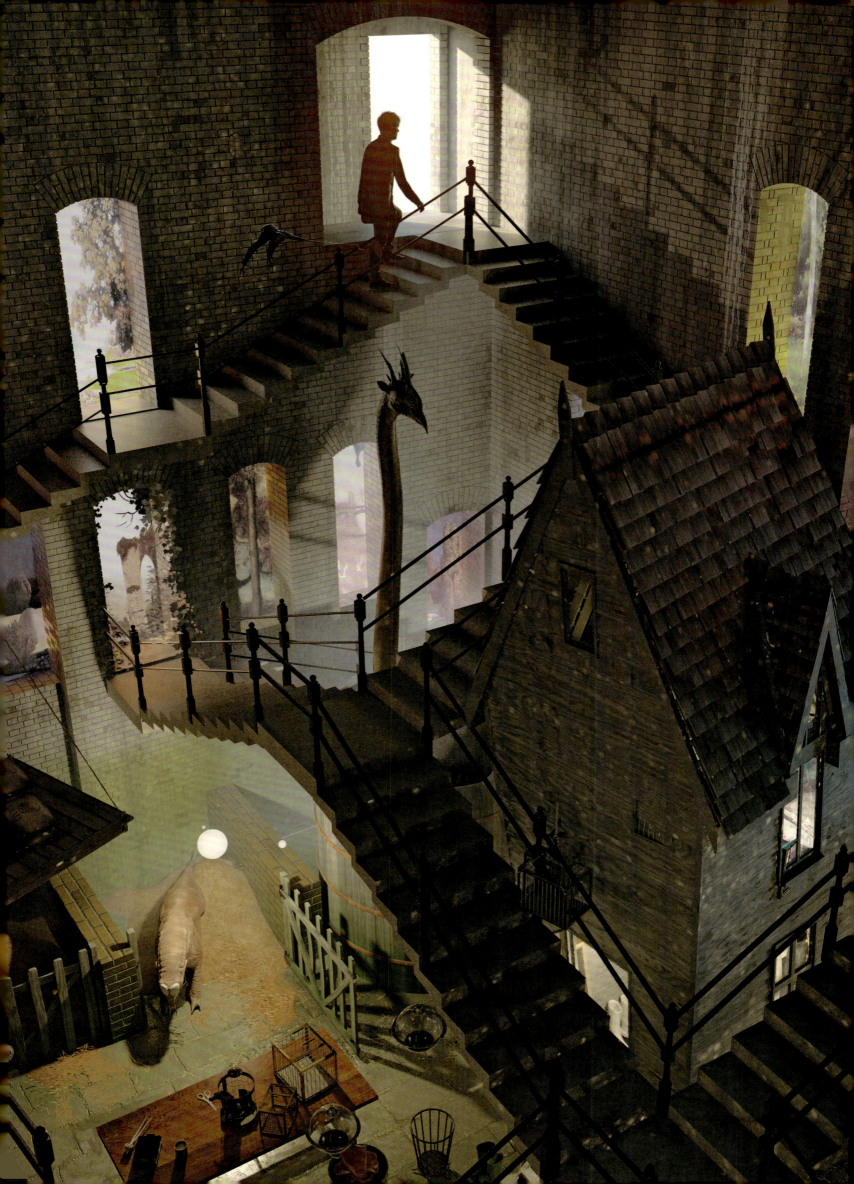

NEWT SCAMANDER'S CREATURES

Set decorator Anna Pinnock and her team's research prior to populating Newt's basement included visiting the ZSL London Zoo and looking around its veterinary department. Though *The Crimes of Grindelwald* was set in the late 1920s, "much of [the film's] supplies are as they would do in the zoo today," she says. Some of Newt's tools were made from bits of string, pipe, and cardboard in their manufacture, but, as Pinnock explains, these are "things they do to improvise medical equipment for animals, which vets do today." The filmmakers, she says, "tried to do much the same thing, though [they] did make a lot of his equipment for the basement."

Pinnock also included some pieces Newt could not have constructed himself. "We gave him a telescope," she says, "and an X-ray machine, based on one from the 1950s. We also had a great, big operating light based on one from the 1960s, but added to it. That's what's so much fun, actually, adding earlier period details onto something from a different era."

"It's a beautiful magical environment," says assistant production designer Martin Foley. "He's taken the basement of his townhouse in London, applied some magic, and made it into a slightly exaggerated version of a Georgian basement." The production designers retained the look of Georgian architecture but exaggerated its ubiquitous brick arches and cantilevered the staircase out from the wall. "Some of that staircase would collapse in a real building," Foley admits, "but the magic is there, so you believe it won't." The stairs reminded Foley of the moving staircases in the Harry Potter films. "So there's a slight nod to that," he says, "and what was really nice was Newt's house upstairs. He lives there alone, but he doesn't really live up there. He lives with the beasts in the basement." In order to get to the lowest level, however, Newt needs to pass through a cupboard in the hallway that leads down to the stairs. The cupboard wasn't actually written into the script, "but, again a slight nod there to young Harry," says Foley, "which was a nice part of the design, and everyone quite liked it."

Another aspect of the design for the basement caused great controversy. "In the middle of the basement, we have the stairs, the animals, their environments," Foley expounds. "Then [production designer] Stuart [Craig] decided to put Newt's tall, thin shed from the first film, which was inside his case, in the middle. That threw everyone." Foley remembers producer David Heyman asking how could it actually be there, as it was in Newt's case. "And his case is on a table," Foley continues. "We had big, circular arguments trying to work out the logic." As Stuart Craig explains, "It looks fantastic, this shaft. You're cutting through all these crossing staircases. It looks amazing. That's the end of it." Foley agrees. "And no one can argue with that," he says. "At the end of the day, there is a magical part to this, so we don't have to tie ourselves up in knots. We just have to enjoy it."

In the basement menagerie, each beast's environment is reached through the brick archways in the room. "Within Newt's case, the environments were temporary placeholders he used to transport his creatures," says concept artist Dermot Power. The basement is a slightly more permanent home, and there's a hospital environment "in between, somehow," Power adds. "It was decided that the habitats would be more 'real' this time, as opposed to the theatrical versions in the first film, and that we would not follow Newt through the alcoves. As such, we didn't need to design each habitat in advance of shooting." Power describes the overall view of the creatures in their basement alcoves as resembling a wizarding world Advent calendar.

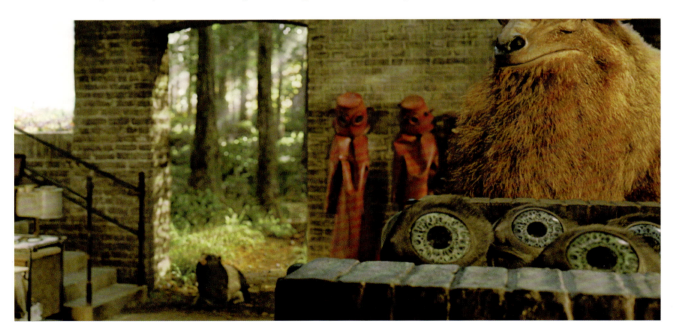

ABOVE: **Newt's basement houses a variety of creatures of assorted sizes and strengths, such as the Leucrotta and Mooncalves, as seen in *Fantastic Beasts: The Crimes of Grindelwald*.**
OPPOSITE: **Newt's assistant, Bunty (Victoria Yeates), helps Newt (Eddie Redmayne) as he prepares to administer medication to an injured Kelpie in his home's basement sanctuary.**

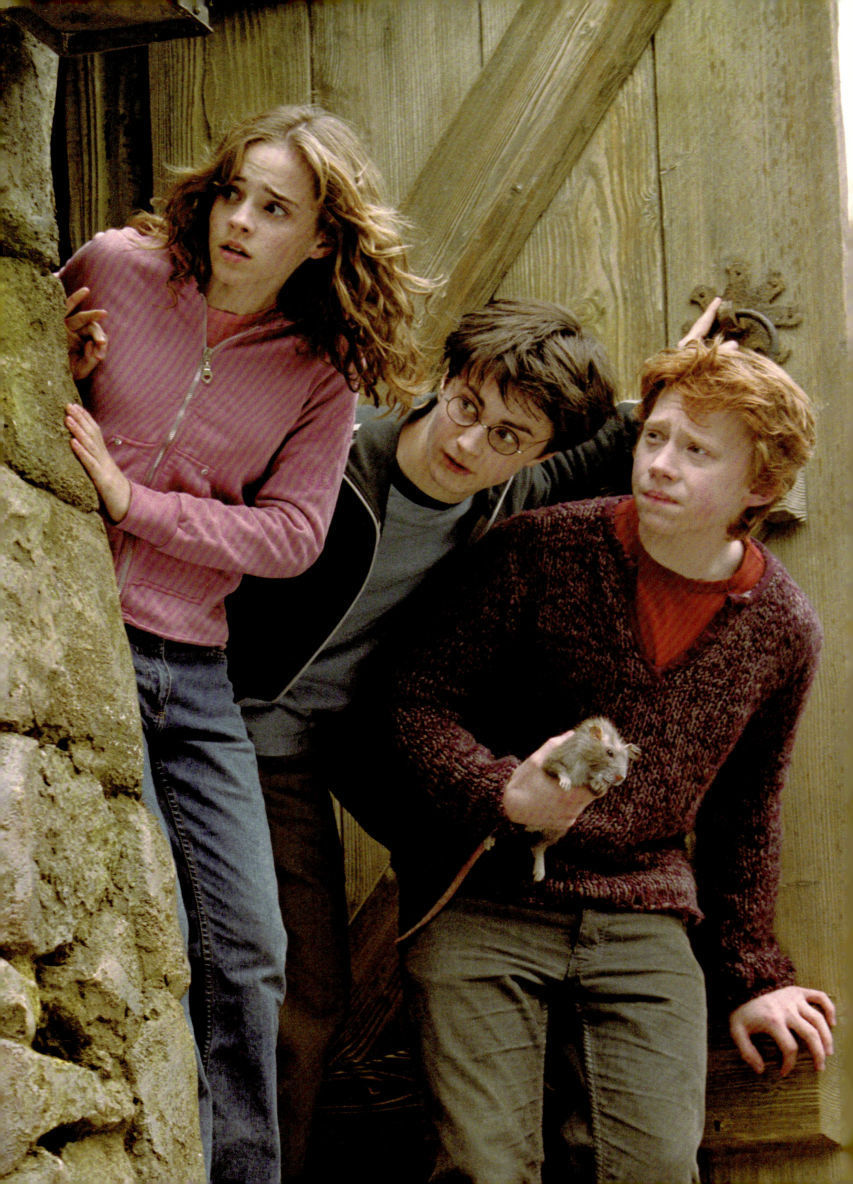

CHAPTER 5

ANIMAGI

ANIMAGI

Cat Animagus: Minerva McGonagall

An Animagus is a witch or wizard who has studied and developed the ability to choose at will to transform themselves into an animal. Professor Minerva McGonagall, played by Dame Maggie Smith, is one, and she can change herself into a gray tabby cat, played by a feline named Mrs. P Head.

The Animagus form of McGonagall is acknowledged immediately by Hogwarts Headmaster Albus Dumbledore in *Harry Potter and the Sorcerer's Stone* when he joins her in front of number four, Privet Drive. She has been observing the activities of Vernon and Petunia Dursley, Harry Potter's uncle and aunt, while waiting for the infant Harry to be brought by Hagrid. Her transformation back to her human form is seen in shadow as she berates the Dursleys as "the worst sort of Muggles imaginable."

McGonagall uses her *Animagus* form again, sitting on her desk as she serenely monitors her first years' Transfiguration class. The students are working quietly under her watch when suddenly Harry and Ron run into the classroom. Not seeing the professor, they feel they've gotten away with being tardy for class. "Can you imagine the look on old McGonagall's face if we were late?" asks Ron. Suddenly, the cat jumps off the desk and rapidly changes into their teacher, which doesn't scare Ron as much as impress him: "That was bloody brilliant!"

To create the transformation between cat and human, an animal trainer was underneath the desk, holding the end of an invisible safety harness settled on the animal actor. Sitting directly above the trainer, Mrs. P Head was given a cue to spring off the desk while the safety harness was released at the same time. This film segment was composited with a computer-generated transition from feline to the filmed Dame Maggie walking away from the desk.

It has been observed that the Patronus of an Animagus is often the same animal species, and occasionally the Animagus form of a wizard may display a recognizable mark, physical or nonphysical. In McGonagall's case, the pattern of her spectacles is visible on her Animagus cat. Mrs. P Head already had markings around the eyes that resembled the professor's glasses, so there was no need to use either special or visual effects to create this design.

PAGE 154: **Hermione (Emma Watson), Harry (Daniel Radcliffe), Ron (Rupert Grint), and Ron's rat, Scabbers, on the Hogwarts grounds in *Harry Potter and the Prisoner of Azkaban*. Scabbers is, in fact, the *Animagus* form of the traitorous Peter Pettigrew.**
THESE PAGES: **Scenes from Transfiguration class as seen in *Harry Potter and the Sorcerer's Stone* show Professor McGonagall's cat Animagus form diligently monitoring the students.**

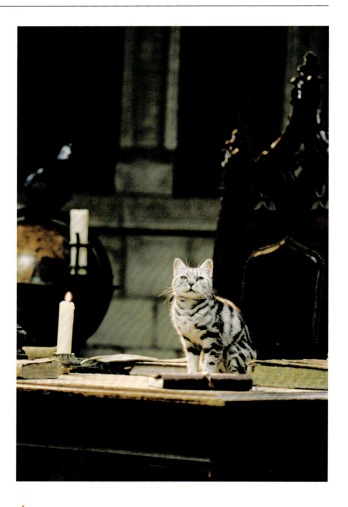

> Children still stop Dame Maggie Smith in the street. They "ask me to turn into a cat," she says, "which is very, very tricky because I can't do it. I wish I could."

156

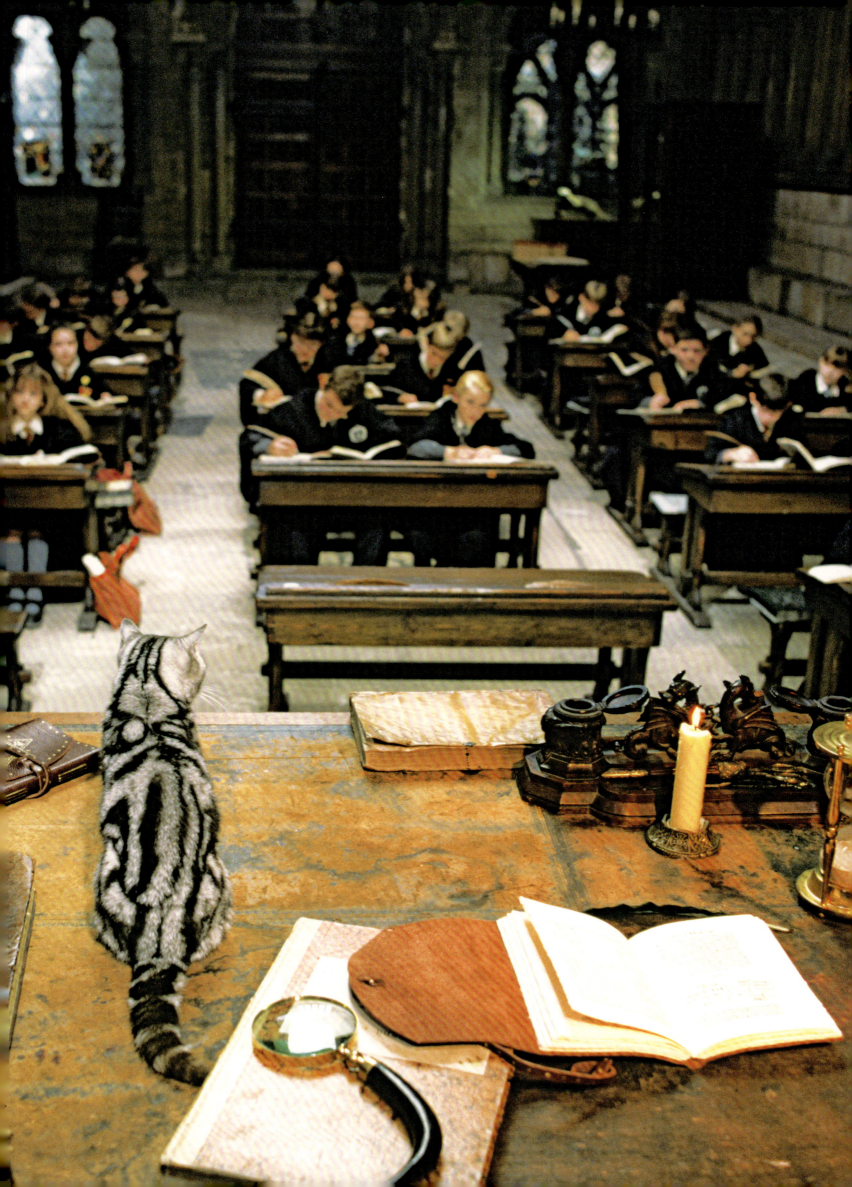

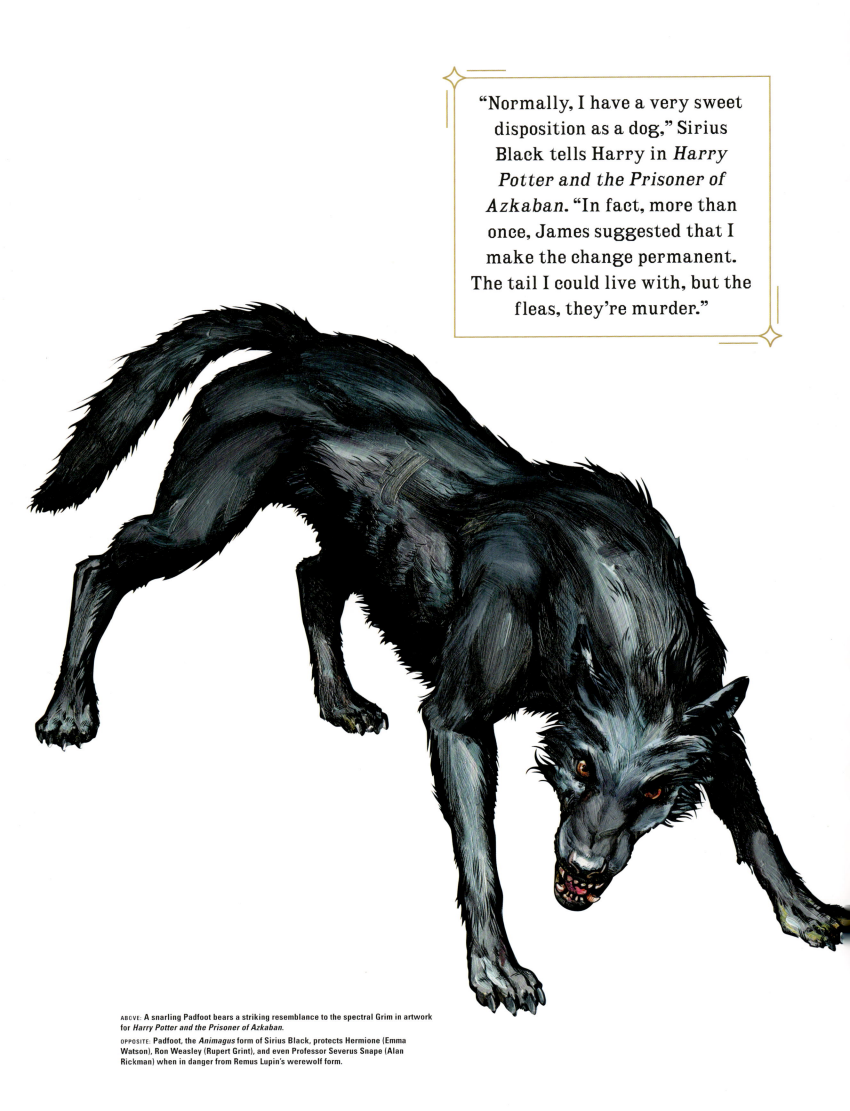

"Normally, I have a very sweet disposition as a dog," Sirius Black tells Harry in *Harry Potter and the Prisoner of Azkaban*. "In fact, more than once, James suggested that I make the change permanent. The tail I could live with, but the fleas, they're murder."

ABOVE: **A snarling Padfoot bears a striking resemblance to the spectral Grim in artwork for *Harry Potter and the Prisoner of Azkaban*.**

OPPOSITE: **Padfoot, the *Animagus* form of Sirius Black, protects Hermione (Emma Watson), Ron Weasley (Rupert Grint), and even Professor Severus Snape (Alan Rickman) when in danger from Remus Lupin's werewolf form.**

ANIMAGI

Dog Animagus: Padfoot/Sirius Black

When Harry's father, James, was a young student at Hogwarts, he and his friends Sirius Black and Peter Pettigrew learned to become Animagi to support their friend Remus Lupin, who had been bitten by a werewolf and was subject to transform every month. Together, the quartet called themselves "The Marauders."

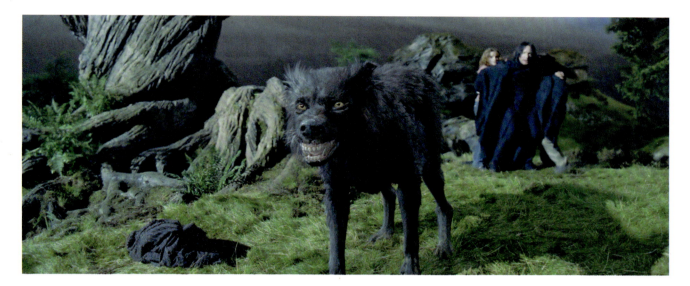

James Potter's Animagus form was a stag nicknamed "Prongs." Peter Pettigrew became a rat called "Wormtail." And Sirius Black, who was later named Harry Potter's godfather, was a large dog named "Padfoot." After Hogwarts, Pettigrew became a follower of Voldemort and falsely accused Sirius Black of revealing the secret home of James and Lily Potter to the Dark Lord, leading to their murder. In an ensuing wand battle, Black was implicated in the death of twelve Muggles and possibly Pettigrew, who set him up and betrayed him. Black was sentenced to Azkaban prison for these crimes.

In *Harry Potter and the Prisoner of Azkaban*, after twelve years of incarceration, Sirius Black has escaped and is believed to be looking for Harry, to take out the one wizard in the way of Voldemort's ultimate victory. One night, Harry leaves the Dursleys' after inflating Vernon's sister, Marge, and storms down Privet Drive. When he stops in front of a children's playground, the streetlights flicker out and the wind picks up. And then suddenly, peering and growling at him from the bushes across the street, is a large black dog.

A Kilbourne deerhound show dog named Fern (full name: Champion Kilbourne Darling), was fitted with pointed ears and taught to stop at a mark for movements to be used as reference for the digitally created dog on Privet Drive.

Fern also learned to jump a ramp with an eight-foot gap, again used for digital reference. As Ron races after his rat, Scabbers, he stops in front of the Whomping Willow, followed by Harry and Hermione. They tell him to run, but he points to a large black dog that jumps over Harry and Hermione to get to Ron (he's actually going after Scabbers, who is, in truth, Peter Pettigrew). Fern had a backup Kilbourne deerhound, named Cleod, also an award-winning show dog (full name: Champion Kilbourne MacLeod). Cleod's normally gray fur was darkened with a temporary rinsible (and animal-safe) black dye.

Padfoot returns in *Harry Potter and the Order of the Phoenix*, when Sirius, in dog form, cannot resist accompanying Harry and members of the Order of the Phoenix Alastor Moody and Tonks to King's Cross station. He follows Harry across a platform and into a waiting room, where he transforms back to his human appearance. Sirius's Animagus form was recast for the film and played by a rescued Scottish deerhound named Quinn. Quinn was trained for three separate actions for three separate shots: to walk across the bridge platform at the station, to walk down a flight of stairs, and to walk through a door. The transformation from Sirius's canine form to his human form in the waiting room is seen silhouetted in shadow behind a frosted glass door.

ANIMAGI

Rat Animagus: Scabbers/Peter Pettigrew

Ron's rat, Scabbers, makes his debut in *Harry Potter and the Sorcerer's Stone* with his head stuck in a box of candy. Scabbers, a hand-me-down from Ron's brother Percy, is missing one toe, and is, as Ron describes him, "pathetic." But there's so much more to this rat.

Scabbers takes the Hogwarts Express along with his companion for Ron's first year at the wizarding school. On the train, Harry watches as Ron (Rupert Grint), tries to perform a magic spell, provided by his brother Fred, on Scabbers. "Sunshine, daisies, butter mellow, turn this stupid fat rat yellow!" Scabbers has been rooting around in an empty box of Bertie Bott's Every Flavor Beans, and all the spell does is create a yellowish light that forces the rat out of the box. For the majority of the scene, an animatronic rat played Scabbers, but for the actual movement caused by the spell, he was played by a rat named Dex. The candy box, with a wire attached to it, was gently placed over Dex's head. When a cue was given, the animal trainer pulled on the wire and the box popped off of Dex, making it appear as if Scabbers was moving backward to end up sitting on Ron's lap.

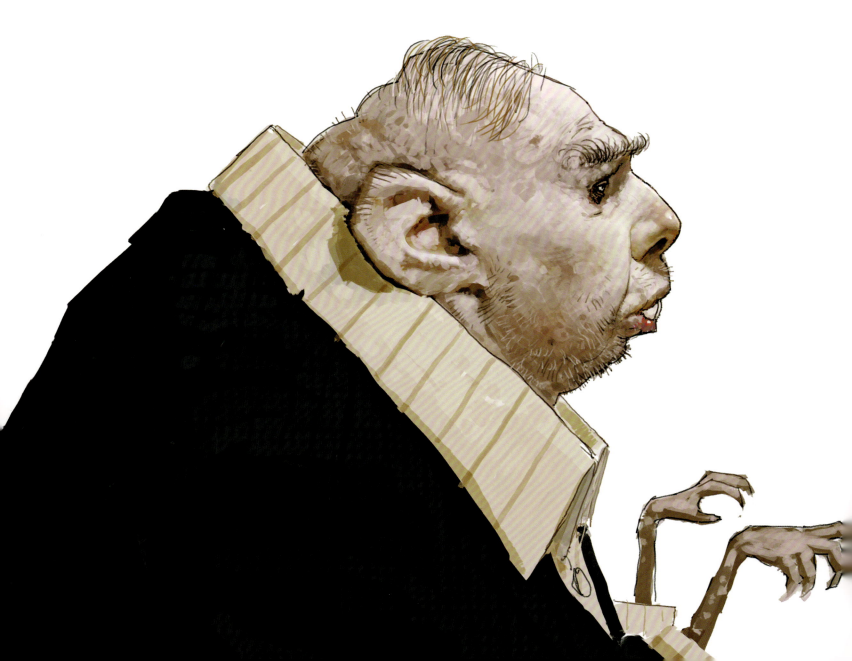

Over the course of the films, twelve real and several animatronic rats played the part, but the work was primarily performed by Dex. Scabbers is temporarily turned into a furry water goblet, complete with tail, in Ron's second-year Transfiguration class in *Harry Potter and the Chamber of Secrets*. Once again, Dex was brought in and placed on top of a stack of books, supervised as always by trainers who stood off camera during filming. As Ron was using a broken wand to cast the charm, it didn't work as it was supposed to. The actual Transfiguration of Scabbers into a goblet was a digital effect.

It's in *Harry Potter and the Prisoner of Azkaban* where Scabbers is discovered to be the Animagus form of Peter Pettigrew, nicknamed Wormtail. Pettigrew became an Animagus at Hogwarts, along with Harry's father, James, and his eventual godfather, Sirius Black. It's assumed that after Pettigrew betrayed James and Lily Potter to Voldemort and blamed Sirius for it, he went into hiding at the Weasleys', becoming their family pet, Scabbers.

When it is announced that Sirius Black has escaped Azkaban prison, Scabbers disappears. (Ron blames Hermione's cat, Crookshanks.) Scabbers is finally discovered by Hagrid in a jug at his hut. As Harry, Ron, and Hermione make their way back to the castle, Scabbers becomes agitated, bites Ron, and escapes. Ron runs after his rat and catches him, but he is caught himself by a large black dog that pulls Ron (actor Rupert Grint, holding an animatronic rat) into the Whomping Willow. Harry and Hermione join him where a path has led to the Shrieking Shack, followed by Remus Lupin, Sirius Black, and Severus Snape. Black reveals that Scabbers is really Peter Pettigrew and casts a spell to transform the rat back into a human.

A combination of real and animatronic rats were employed for the sequence where Wormtail runs over the piano and across the floor, transforming once he hits a wall. For the scene, "the animal department shaved bits of [Dex's] fur off so he would look manky," says Rupert Grint, "but he's really a nice, healthy rat who just had a bit of a makeover." Grint, who was known for disliking spiders, says, "I think rats are quite cool, so I didn't mind doing my scenes with Scabbers." At first, Grint held Dex, but it was an animatronic rat that was snatched out of his hands by Gary Oldman, who plays Sirius. Dex had been trained to run from a point A to a point B for his many scenes, and in this instance he ran over the top of the piano and then across the floor. The animatronic rat "hit" the wall before the digital transformation into Peter Pettigrew.

> Unlike other Animagi, Pettigrew retains his ratlike teeth and nails and exhibits Wormtail's twitchy behavior in his human form. The texture and color of the actor's wig was designed to match the animatronic Scabbers's fur.

OPPOSITE: **The rodent-like Peter Pettigrew as envisioned by concept artist Rob Bliss for *Harry Potter and the Prisoner of Azkaban*.**
TOP: **Scabbers, Ron's hand-me-down companion rat.**
RIGHT: **Ron (Rupert Grint) attempts to Transfigure his companion, Scabbers, into a water goblet during class in *Harry Potter and the Chamber of Secrets*. Using a broken wand, he manages to create a furry goblet sporting a tail.**

CHAPTER

6

HOUSE-ELVES & GOBLINS

HOUSE-ELVES & GOBLINS

Dobby

Harry Potter and the Chamber of Secrets introduces Dobby the house-elf, who has big eyes, big ears, and big intentions to keep Harry safe, but his "help" often backfires, with Harry getting in trouble, or worse.

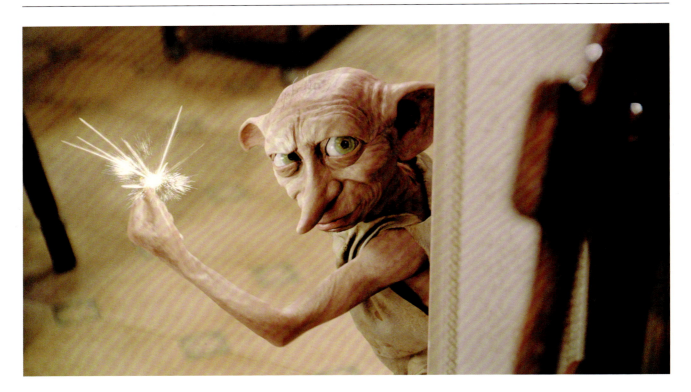

House-elves are bound to serve one wizarding family for their entire life unless they are freed. They are dependable and faithful, and any command their master gives them must be obeyed, though it helps to be specific, as they may not interpret the order exactly as it was intended. House-elves can only be released from their servitude by a gift of clothing from their master.

Dobby, who serves the Malfoy family, was the first entirely digital character in the Harry Potter films. "With Dobby, I wanted to create a CGI character the audience would fall in love with," says director Chris Columbus. "We talked about building Dobby, and we did, for some eyelines and over-the-shoulder shots. But Dobby was always going to be a CGI character, and I'm very proud of how he turned out."

Dobby went through many design ideas before the big-eyed, bat-eared, pointy-nosed house-elf emerged. To establish his look, the concept artists considered what his life had been like before he met Harry. It's clear Dobby was mistreated, so he was given a gray, sallow, "prisoner-of-war" appearance, with grimy skin and little or no muscles.

Special creature and makeup effects designer Nick Dudman's creature shop produced several full-size, articulated models of Dobby in silicone with a complete functioning skeleton inside. Each model was fully painted and detailed, right down to the veins in the house-elf's eyes. The models were occasionally posed on the set before a scene was filmed, to assist the lighting designers and help the actors know where Dobby would be.

Before the digital artists began, actor Toby Jones recorded Dobby's lines, and his facial expressions and physical movements were filmed. "We [did that] to relate it back to Dobby," says visual effects supervisor Tim Burke, "and put in all that emotion from his performance. This way, we can create a character who can be directed by the director as an actor would." To enrich the characterization, the animation team paid special attention to Dobby's movements: He is often hunched over, and he wraps his arms around himself or curls inward in fear, trying to protect his body and make himself a smaller target. After Dobby is freed, he walks much straighter.

PAGE 162: **Concept artwork of a goblin by Paul Catling for *Harry Potter and the Sorcerer's Stone*.**
ABOVE: **Dobby the house-elf, in the kitchen of Harry's aunt and uncle, creates chaos for Harry in *Harry Potter and the Chamber of Secrets*.**
OPPOSITE: **Development artwork by Rob Bliss of Dobby in his tea towel.**

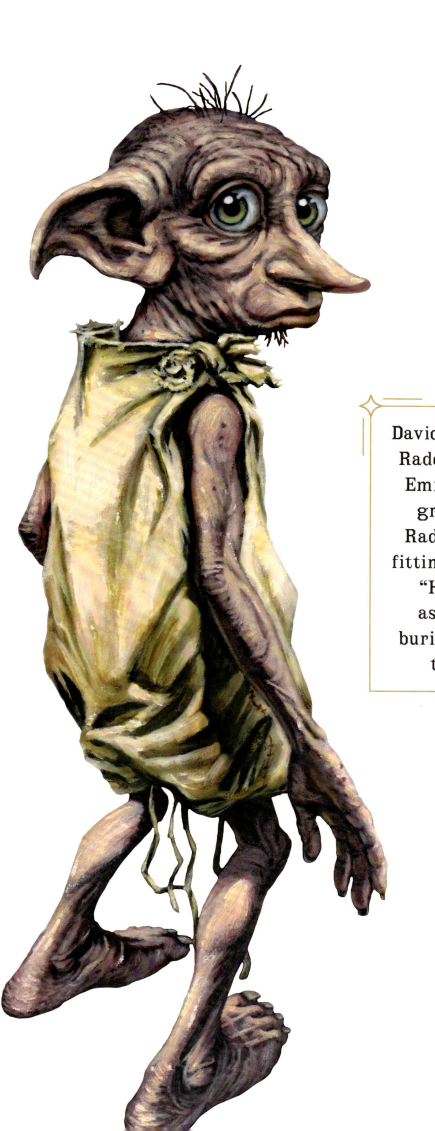

David Yates had actors Daniel Radcliffe, Rupert Grint, and Emma Watson dig Dobby's grave with their hands. Radcliffe thought this was fitting and right, explaining, "Harry wants to invest as much love in Dobby's burial as Dobby showed him throughout his life."

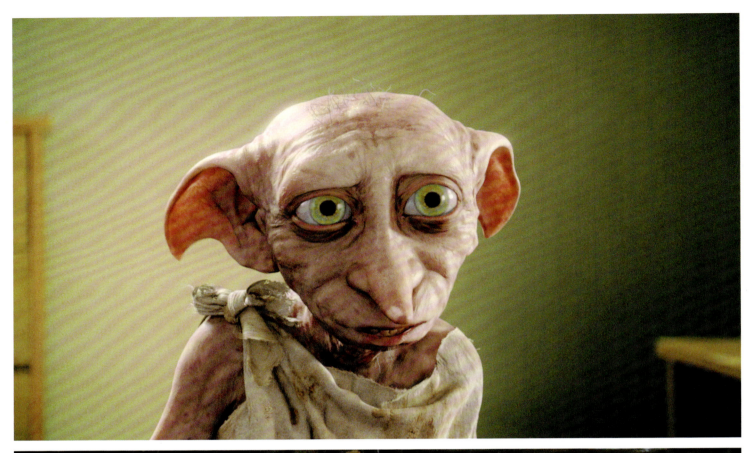
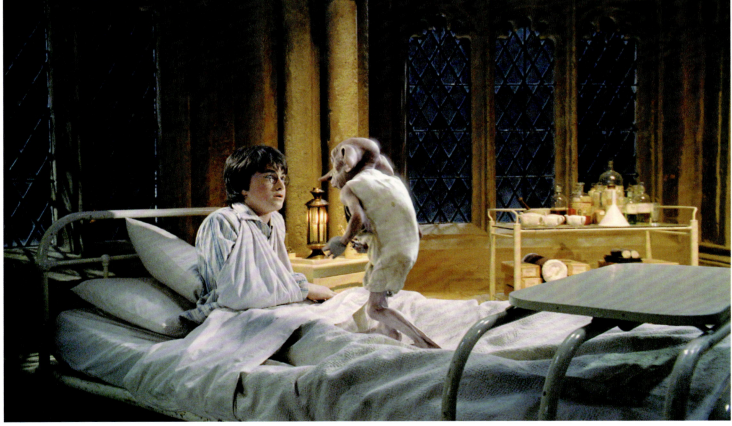

HOUSE-ELVES & GOBLINS

Despite Dobby's meek stature and frustrating attempts to prevent Harry from returning to Hogwarts, Harry knows that the house-elf is only trying to protect him, and his friendship with Dobby directs Harry to set him free, which makes Dobby even more loyal to Harry and his friends.

Dobby returns in *Harry Potter and the Deathly Hallows – Part 1*. "The audience really liked Dobby," says producer David Heyman, "and it had been a while since we'd spent any time with him in the films. We wanted to make sure the audience was invested in him." Harry, Ron, and Hermione send the Black family's house-elf, Kreacher, to locate the thief Mundungus Fletcher. Dobby notices Kreacher in Diagon Alley and hears Harry Potter's name mentioned, so Dobby accompanies Kreacher in bringing Mundungus to Grimmauld Place.

For this film, director David Yates and the visual effects team felt the audience needed to have more of an emotional connection with Dobby, and so they "humanized" him. Filmmakers softened his features and, as several years had passed, made him look older. They also shortened his arms, smoothed out his neck and face, and reshaped his eyes to make them appear less saucerlike and less bulging. He's still dressed in his tea towel, but it's cleaned and pressed, and he's wearing shoes—actually, red sneakers. He has a radiant look, which the filmmakers felt made him even more sympathetic.

When Harry, Ron, Hermione, and other allies are imprisoned at Malfoy Manor by Bellatrix Lestrange, Dobby saves them by dropping a chandelier on Bellatrix and Apparating them away—but not before Bellatrix throws a knife at them, which strikes the house-elf.

Dobby dies from her attack in a strong, emotional scene the filmmakers decided was the best way to end *Deathly Hallows – Part 1*. "The burial of Dobby enforces Harry's commitment to carry on and find the means with which to defeat the Dark Lord, no matter what," says Yates. For his final appearance, designers reimagined Dobby once more. "People had to empathize with him when he died," says Burke. "If Dobby didn't look like he had a soul, we would have lost any sadness at the end of the film. Toby Jones gave us a brilliant performance to reference, and then the excellent animators rendered a highly emotional moment just beautifully." For the scene where Dobby passes, the digital artists made his eyes appear watery and slowly desaturated his skin to get it paler and paler.

"In a way, Dobby represented an aspect of [Harry's] childhood, and Dobby's such an innocent character," says Heyman. "That's why it's so powerful—it represents this loss of innocence, this loss of childhood."

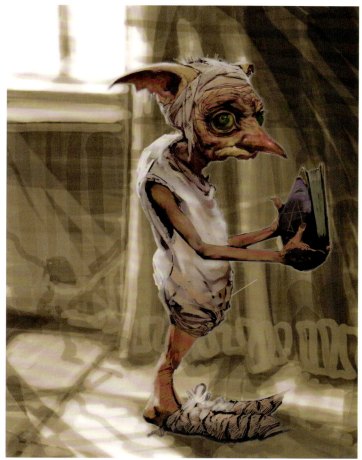

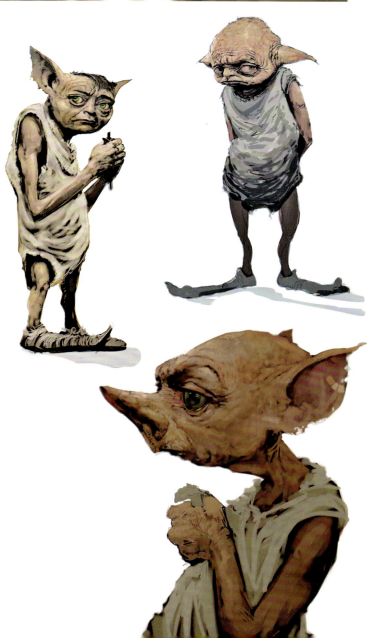

OPPOSITE TOP: **Dobby tries to persuade Harry *not* to go back to Hogwarts in their first encounter, in Harry's bedroom, in *Harry Potter and the Chamber of Secrets*.**
OPPOSITE BOTTOM: **Dobby again tries to protect Harry in hospital even after he causes Harry a broken wrist through a rogue Bludger during a Quidditch game.**
TOP: **Early concept drawing of Dobby covered in tea towels.**
MIDDLE RIGHT AND RIGHT: **Visual development of Dobby created by members of the art department for *Harry Potter and the Chamber of Secrets*.**

167

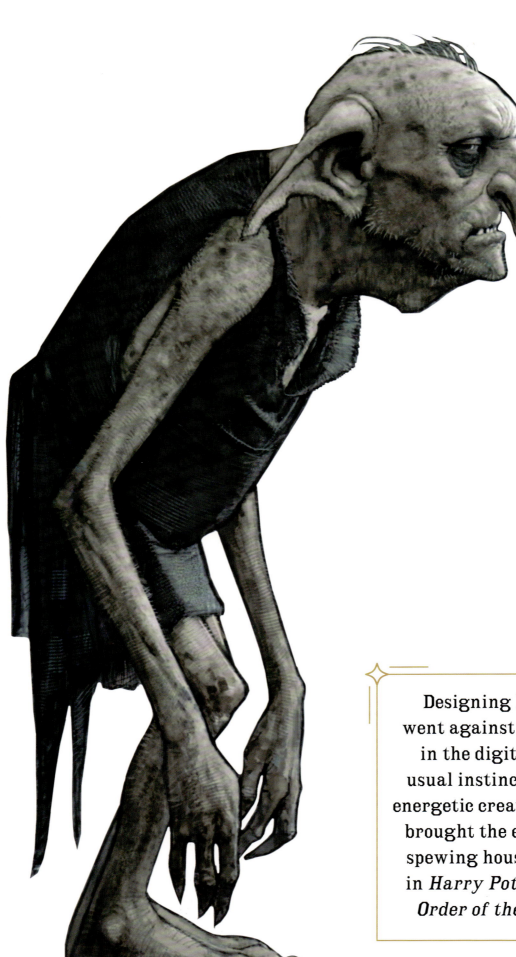

Designing Kreacher went against everything in the digital artists' usual instincts to create energetic creatures as they brought the elderly, bile-spewing house-elf to life in *Harry Potter and the Order of the Phoenix*.

HOUSE-ELVES & GOBLINS

Kreacher

Kreacher is the house-elf for the "Noble and Most Ancient House of Black" at number twelve, Grimmauld Place, the childhood home of Sirius Black. "Whereas Dobby is the house-elf you love, Kreacher is the house-elf you hate," says producer David Heyman. "Kreacher is the very loyal house-elf to Sirius Black's mother, and Sirius Black's mother loathed Sirius because Sirius had gone on the side of Dumbledore and [Kreacher] most certainly would loathe all the people who are within Grimmauld Place." Those "people" are members of the Order of the Phoenix, many of whom are half-bloods and even Muggle-borns. "This disconcerts [Kreacher]," adds Heyman. "He's not very nice, but you take great pleasure in him because he's so deliciously nasty, spitting vermin and vitriol."

Special creature and makeup effects designer Nick Dudman wanted to make the nasty house-elf revolting and ghastly in every way possible. "His ears droop much more than Dobby's," Dudman outlines, "he's flappy all over, he's bent over with age, and he barely moves when he walks." Filmmakers decided that at his age, Kreacher most certainly walks slowly and always seems to be creeping up on people, which makes him all the more unappealing.

Kreacher was voiced by Timothy Bateson for the house-elf's debut in *Harry Potter and the Order of the Phoenix*, and just like Toby Jones for Dobby, the actor's performance was filmed, but it was up to the animators to create the old house-elf's plodding movements and facial expressions. Bateson actually sat in a chair while he read his lines, restricting his movement.

The designers gave Kreacher soft and stretchy collapsing skin and long, dragging ears complete with ear hair. They even added a few wisps of hair on the top of his head, unlike Dobby. In addition to his hunchbacked posture, he had a dewlap under his chin, rheumy eyes, and a stance that exuded intolerance and disgust.

Kreacher almost didn't make it into *Order of the Phoenix*. "Kreacher had actually been written into the first few drafts of the script," says screenwriter Michael Goldenberg, "but in trying to get the page count down, we decided to cut him." A copy of the script without Kreacher was sent for author J. K. Rowling's input; she advised them Kreacher needed to stay in. "Fortunately, it was as easy as just undeleting things that had already been written," says Goldenberg. "I was personally happy to get him back in there."

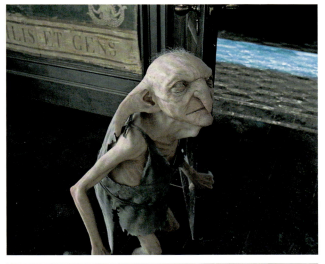

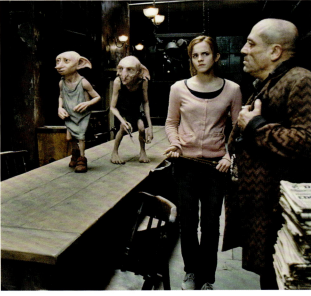

OPPOSITE: Concept artist Rob Bliss captures Kreacher the house-elf's hunched-over stance and caustic attitude for *Harry Potter and the Order of the Phoenix*.
TOP: Kreacher, house-elf for the Most Ancient and Noble House of Black, confronts Harry in the family tapestry room in number twelve Grimmauld Place.
ABOVE: Hermione (Emma Watson) keeps a close eye on Mundungus Fletcher (Andy Linden) after Dobby and Kreacher bring the thief to Grimmauld Place for questioning in *Harry Potter and the Deathly Hallows – Part 1*.

HOUSE-ELVES & GOBLINS

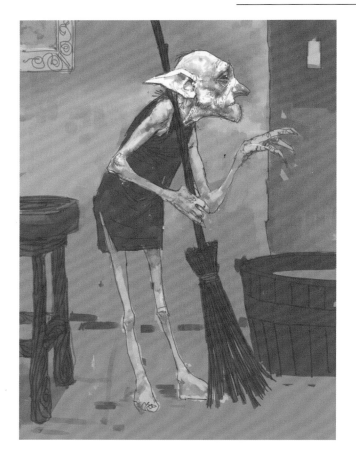

Kreacher is ordered to find Mundungus Fletcher, and he returns not only with the thief but with Dobby close at his knobby heels. Actor Simon McBurney performed Kreacher in this iteration, and he filmed the entire scene with Toby Jones where the two house-elves explain to Harry, Ron, and Hermione what occurred before their arrival. This was done so the animators could see the way the two actors looked at each other and interacted with the other characters. "Toby and Simon did an incredible job," recalls Heyman. No motion or facial capture was used. "Mo-cap is often a director's or supervisor's first choice when looking for photo-real humanoid performances," says animation supervisor Pablo Grillo. Grillo believes that mo-cap's ability to capture "everything" can just as easily result in quashing emotion. "Our animators were able to carefully craft emotive and believable human performances from careful observation of a variety of sources," he says.

The scene was filmed again with little people actors covered in gray material fitted with reference points to give the animators and actors a proper eyeline, and, in a technique similar to motion capture, for the digital team to use to align the positions of the characters during the scene.

Goldenberg felt that part of Kreacher's importance was helping reveal a bit about Sirius. "Their interaction tells us a lot about his childhood. When you see him being upset by Kreacher's rudeness to him, when Sirius says to Harry that Kreacher was never pleasant—'When I was a boy. Not to me anyway'—there's almost a sense that you're seeing the younger Sirius and what it must have been like for him growing up in that house."

Harry, Ron, and Hermione seek refuge at Grimmauld Place while they search for Horcruxes in *Harry Potter and the Deathly Hallows – Part 1*. Kreacher is even less amiable to their stay, but as Harry is the late Sirius Black's godson, Kreacher must obey him. As Dobby was "humanized" for sympathy and aged up to show the effects of the six years since his previous appearance, so was Kreacher. Director David Yates and the visual effects team felt the audience needed to have more of an emotional connection with Dobby, and they wanted one with Kreacher as well. Filmmakers softened Kreacher's features and smoothed his skin. They reduced the size of his nose. And not only did they trim his ears to be shorter, they also trimmed his ear hair.

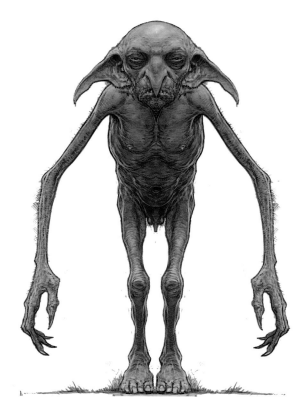

TOP: **Concept artist Rob Bliss portrays the Black family's house-elf, Kreacher, at work for *Harry Potter and the Order of the Phoenix*.**
ABOVE: **Another study of Kreacher by Rob Bliss.**
OPPOSITE TOP AND BOTTOM: **Color and skin studies of Kreacher by Rob Bliss.**

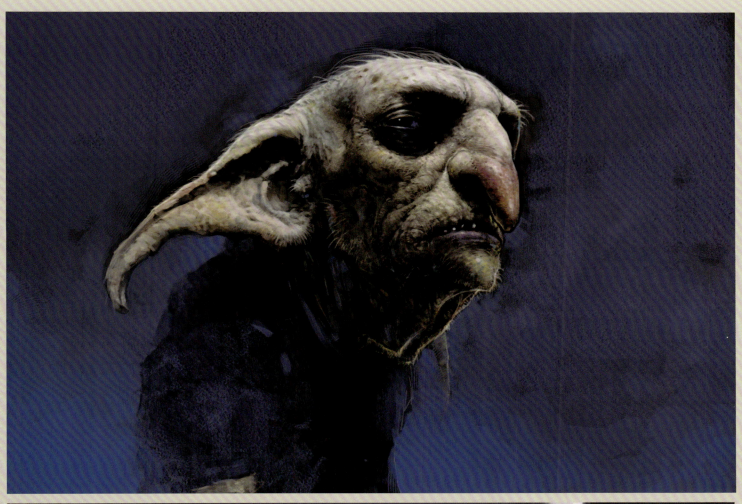
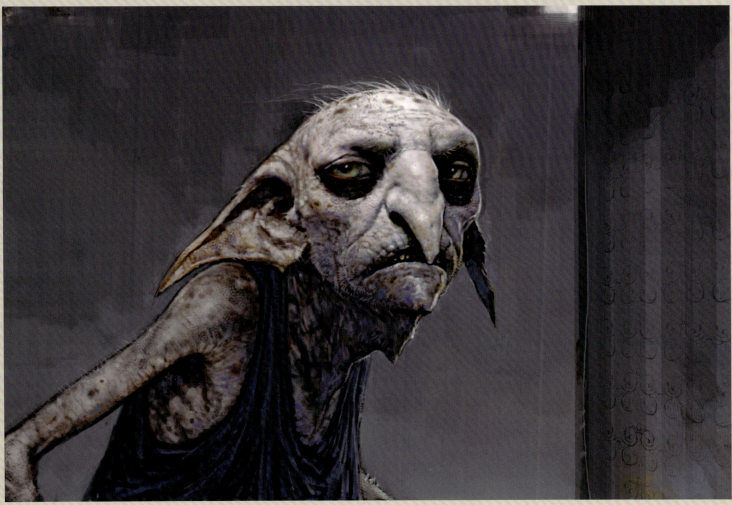

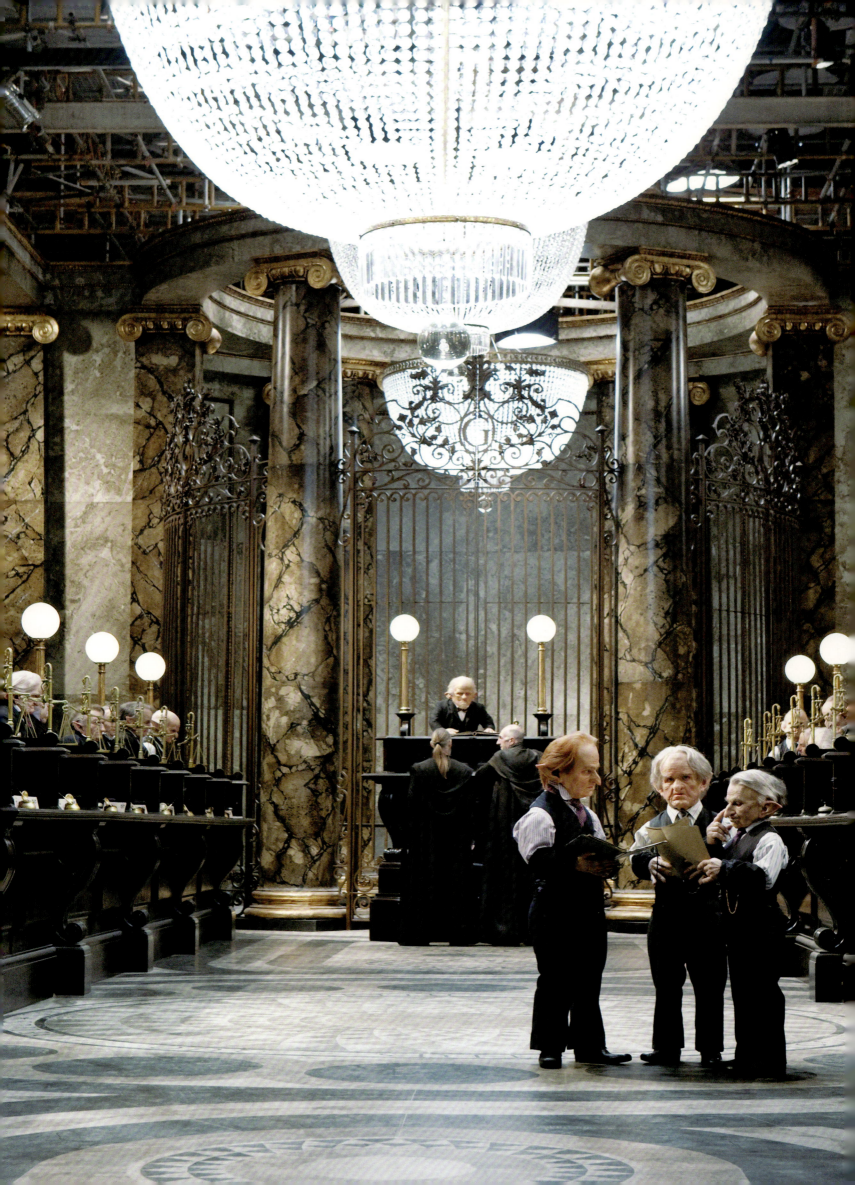

HOUSE-ELVES & GOBLINS

Gringotts Goblins

Goblins work as tellers and bank officials at Gringotts Bank in Diagon Alley, and they are the first magical creatures Harry Potter encounters in *Harry Potter and the Sorcerer's Stone*. "Goblins are as clever as they come," says Hagrid when he takes Harry to withdraw money from his family's vault at the bank, "but they are not the most friendly of beasts."

During preproduction for *Sorcerer's Stone*, special creature and makeup effects designer Nick Dudman and others were invited to Warner Bros. Studios in London to watch a short digital animation of goblins. "It was lovely," says Dudman. "It was a very short clip, but it was beautiful. Then the question became, can you do that practically? And I just said yes."

However, "The goblins were tough," he admits. "First, it was essential to get away from any obvious approaches." Concept artists worked up designs that offered an inspiring revelation: not all goblins are alike. "We realized their most important feature was character," Dudman explains. "So we would create an interesting character, and then 'goblinize' it, maintaining that there isn't a set look for goblins any more than there is a set look for human beings."

The next challenge was the available technology. "I wasn't totally convinced of the effectiveness of silicone at that point, but it seemed like a risk worth taking," says Dudman. "Yes, at times, it seemed to be against us. But we cracked it, learned a lot, and I was very pleased with the way the goblins worked out. Though there were so many of them to do!"

Goblins return in *Harry Potter and the Deathly Hallows – Part 2*, when Harry, Hermione, Ron, and the goblin Griphook travel to the depths of Gringotts searching for one of Voldemort's Horcruxes. Once again, the number of goblins proved challenging. "You design a goblin, and it looks fantastic," Dudman says. "You design ten goblins, they all look nice and different. You design sixty goblins, and you can run out of ideas." Dudman decided that life casts would be made of the actors playing the goblins, and then sculptors would "goblinize that bloke," as he puts it. "That way, each one of them came out differently."

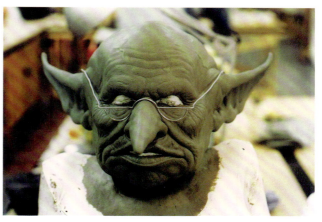

Once each character emerged, Nick Dudman designed their wigs. "I would look at the sculpt and think, this guy would look fantastic with swept-back gray hair and a combover. Another would be good if he had russet hair and gray sideburns and a ducktail." Hair sewers inserted one hair at a time to create the goblins' hairlines, and an assembly line of artists painted the goblins' hands and faces. The goblins' eyebrows were precurled and put in at the same angle in order to match the day's shooting of that particular character.

Of course, the silicone used this time had advanced in the ten years between films. "Modern silicone is the nearest thing to human skin I've come across," says Dudman. "It moves and feels exactly like flesh, and when it's glued on, it actually comes up to body temperature." The downside was that once removed at the end of the day, the prosthetics could not be reused.

OPPOSITE: The goblin tellers and other personnel at Gringotts bank serves wizards' and witches' financial needs, as seen in *Harry Potter and the Deathly Hallows – Part 2*.
TOP: "Goblinization" at its best for *Harry Potter and the Deathly Hallows – Part 2*.
FOLLOWING PAGES: Each goblin teller has a unique personality exemplified in their clothes and attitude, as seen in *Harry Potter and the Deathly Hallows – Part 2*.

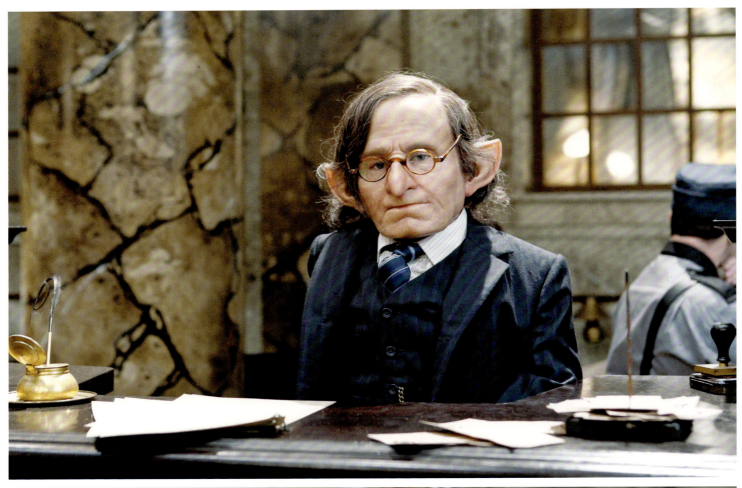
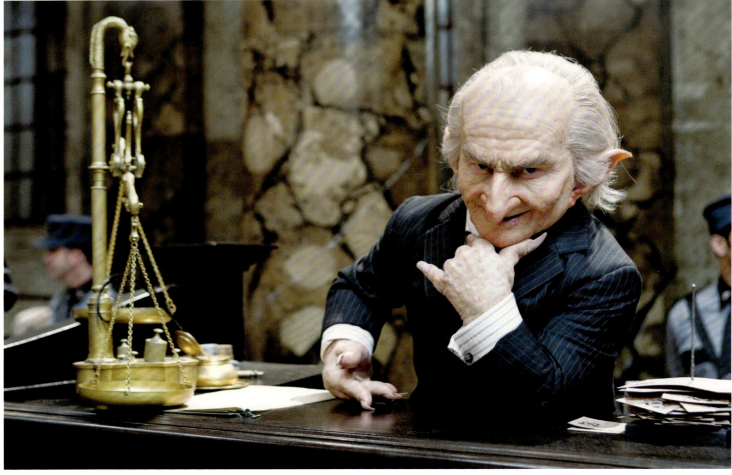

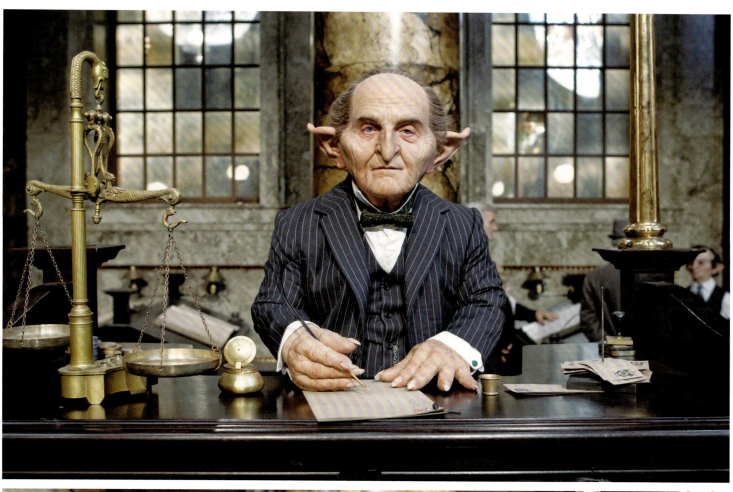
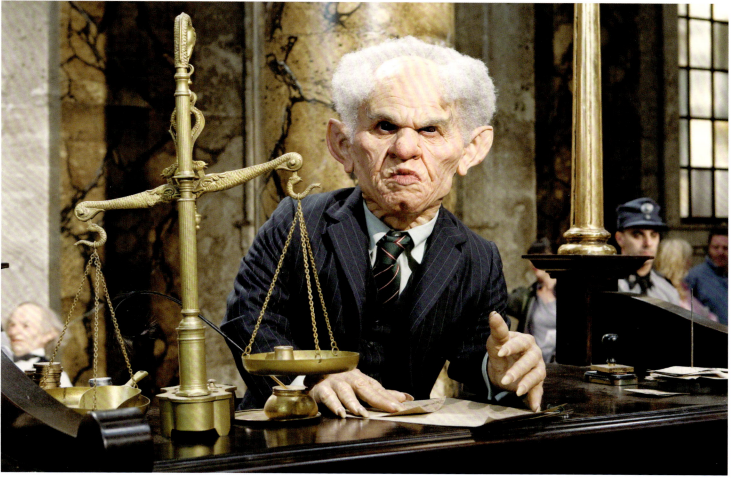

HOUSE-ELVES & GOBLINS

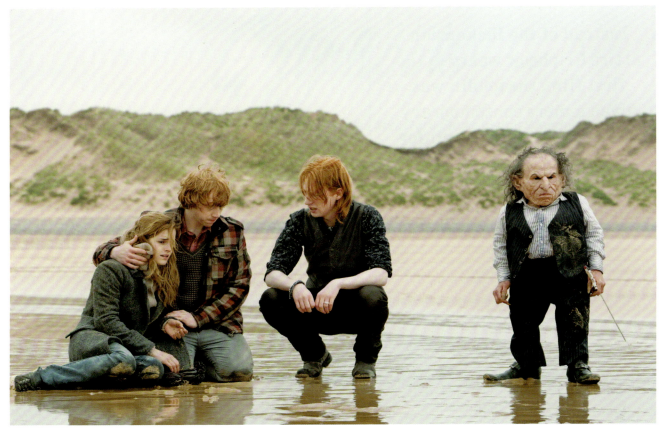

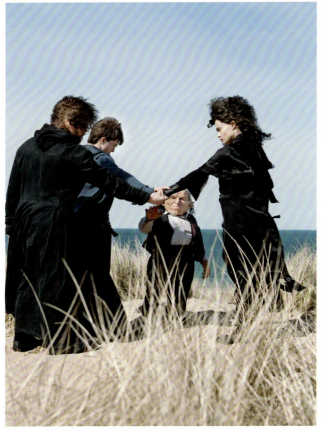

"Flitwick is a lovely, amusing character, but he didn't have any particular bearing on the storylines," Davis explains. "Griphook is an integral part of the plot, and essentially a villain, which is more fun to play. It was a complete physical change," he adds, "not only the look, but the way I stand, the way I talk. And it was nice [director] David Yates had the faith and trust in me to be able to pull it off."

Davis underwent a four-hour process each day of filming to become Griphook. The makeup included a prosthetic that covered Davis's head and extended down his neck, dark contact lenses, and false teeth sharpened to such a point that, he recalls, "I'd have to be very careful when I talked during a scene. If I wasn't, I'd bite my tongue, which happened a bit too often for me."

The goblin reveals his true self when he betrays his rescuers in Bellatrix's vault by alerting his former coworkers to their scheme. Griphook ends up back in Malfoy Manor, where he is killed by Voldemort.

ABOVE: **Ron Weasley (Rupert Grint), Harry Potter (Daniel Radcliffe), Griphook (Warwick Davis) and Hermione Granger in the disguise of Bellatrix Lestrange (Helena Bonham Carter) Apparate to Gringotts bank in search of the Hufflepuff cup Horcrux in** *Harry Potter and the Deathly Hallows – Part 2.*
TOP: **Hermione (Emma Watson), Ron (Rupert Grint), and Bill Weasley (Domhnall Gleeson) mourn the loss of Dobby the house-elf as Griphook (Warwick Davis) recovers from their escape from Malfoy Manor.**
OPPOSITE: **Warwick Davis as Griphook the goblin holds the fake Sword of Gryffindor while at Shell Cottage in** *Harry Potter and the Deathly Hallows – Part 2.*

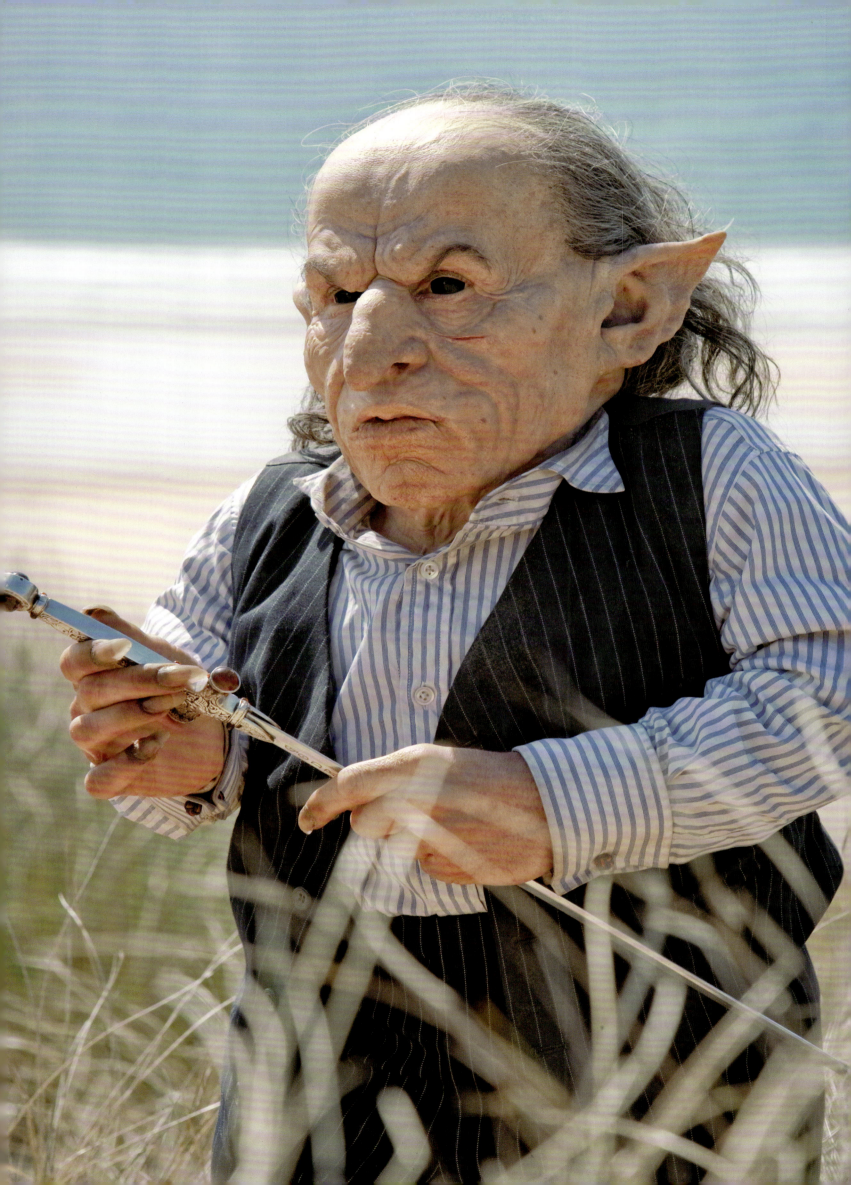

CHAPTER 7

WIDER WIZARDING WORLD

Says director Alfonso Cuarón, "The dynamic we establish between Harry and Lupin is never that it's a kid hanging with a werewolf, it's this kid hanging with his favorite uncle who has this disease."

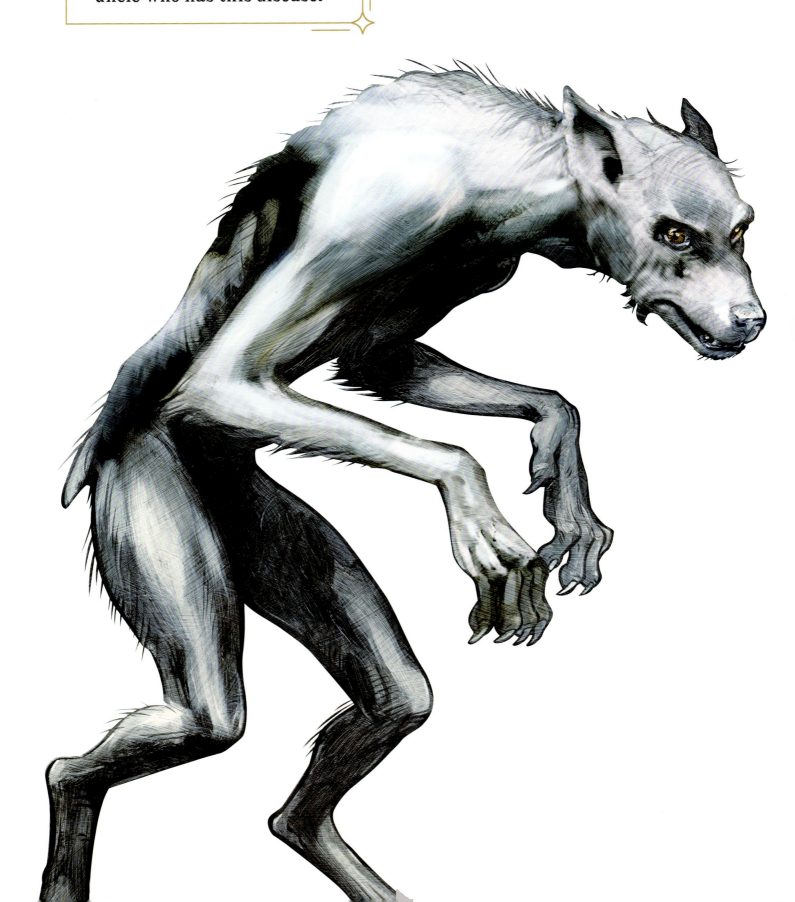

WIDER WIZARDING WORLD

Werewolf: Remus Lupin

Remus Lupin, the Defense Against the Dark Arts professor for Harry's third year, is perhaps the favorite professor of the students. "I'd say he's very avuncular, very kindly," says actor David Thewlis of his character, first seen in *Harry Potter and the Prisoner of Azkaban*. Lupin also has a dark secret: As a child, he was bitten by the werewolf Fenrir Greyback. "Lupin's introduction is a little ambiguous," says Thewlis. "At first, you may suspect he's sinister, but you find out very soon that he's on the level, apart from not knowing about him being a werewolf. But that's something he can't control, and when he transforms back into human form, he's back to the same old lovable Lupin."

Thewlis wondered what Lupin would be like when he's *not* a werewolf, and researched lycanthropy for any clues. "I've always found the *why* with werewolves very strange; why the myths exist in the first place. What is there to find out about their history? There's an enormous amount of folklore, but it's folklore," he explains. "There's nothing factually you can find out, so I thought then there's no real point in playing Lupin overtly as a werewolf. There wouldn't be anything in his character that shows it, other than the transformation. Physically, he's scratched, but in terms of playing him, I based him on teachers I'd known without thinking about the werewolf aspect of him for most of the role. I only really took that onboard when we talked about the transformation and afterward."

Werewolves have been a cinematic convention in more than one hundred iterations, so how could this werewolf stand out from the pack? Director Alfonso Cuarón found a new interpretation that would influence the design of both human and wolf: seeing lycanthropy as a disease and not an affliction.

"We needed to challenge the concept of the iconic transformation from a man into werewolf," Cuarón explains. "After looking at reference material on all the great werewolves on film, one way we could do this was to create a hairless werewolf. Filmmakers always do werewolves by adding hair to a human. But losing hair plays into the idea of it being a disease."

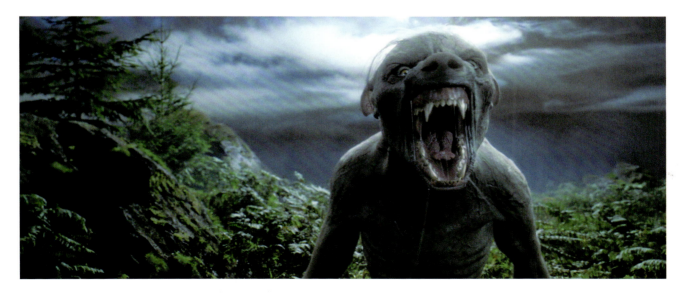

PAGE 180: **Early concept art of Remus Lupin in his werewolf form by for *Harry Potter and the Prisoner of Azkaban*.**

OPPOSITE: **Rob Bliss visualized the werewolf form of Remus Lupin in cool colors in this development study.**

ABOVE: **The fully transformed werewolf Lupin in a scene from *Harry Potter and the Prisoner of Azkaban* is far from the avuncular professor the students all love.**

183

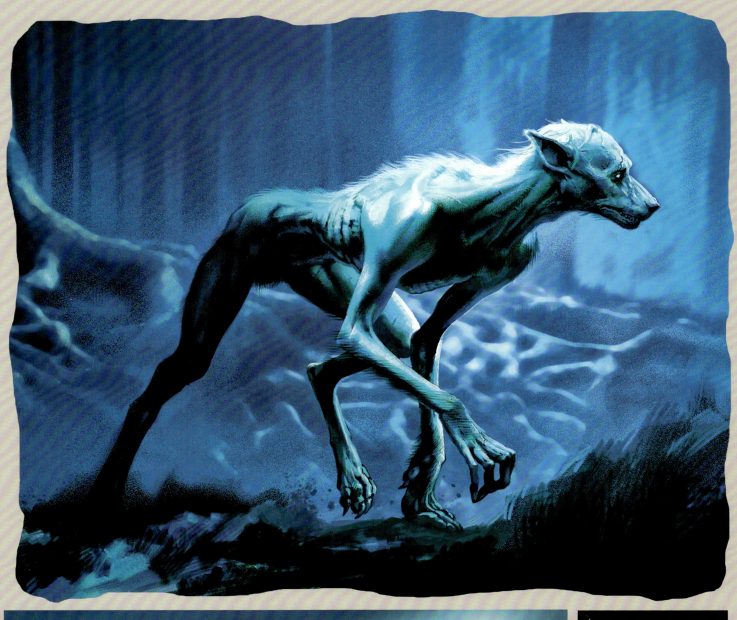

WIDER WIZARDING WORLD

Cuarón wanted Lupin's affliction to be seen as dangerous, but also wanted a tragic element to it. He felt this real-life reference allowed for a close, emotional relationship between Lupin and Harry. "We wanted the werewolf to look sick," he explains. "We didn't want it to be something healthy and powerful; we wanted to see not only the obvious danger that being a werewolf is to everybody else, but also the tragedy that it is for Lupin."

Lupin's werewolf form is as sad as his downtrodden human one. "We always bear in mind that children are coming to the films," says special creature and makeup effects designer Nick Dudman. "With this werewolf, we tried to make it threatening and scary, but more important, we wanted to preserve Lupin." Werewolves are not "hybrid" creatures, and the filmmakers wanted to ensure that Lupin's humanity was retained even in his transformation. This werewolf is thin and mangy, with long limbs and very little fur.

Cuarón says he always hopes to find a practical rather than a digital solution for an effect, so the idea of prosthetics on a human was considered. "We tried guys in full werewolf suits on stilts," says Dudman, "but once we got them on set, while they were incredible performers, it was just not at the level Alfonso wanted. Being on stilts and adding the constraints of the makeup made it too difficult to perform naturally." The werewolf became primarily a digital character, but the transformation itself was performed practically.

The scene was shot over four days. "I only spent one day in the full makeup before the character became a wholly CG creature," says Thewlis. "So, it's only me up to a certain stage, but that was great because I'd never done anything with that scale of prosthetics before. To watch yourself transform and become unrecognizable over the space of six hours was exciting and remarkably fascinating."

The actor was fitted with stages of prosthetics that changed his eyes, teeth, and hands. Inflatable bladders were placed on his neck, and another piece under the back of his coat was cable-controlled to expand and rip apart the material. There was also a certain amount of insert work. "We made separate legs that stretched out at the ankle and split out of their shoes," Dudman recalls, "with wolf feet on them. And because digital would be taking over, he had strange little balls and colored things on his head at times. It was bizarre, but David was great, as that must have been very uncomfortable for him."

It is Hermione who finally figures out Lupin's secret. "You don't know for most of the film, though Hermione starts to suspect," says Thewlis. "Once it's revealed, I get to actually do the werewolf transformation, which was great fun to do and something I'm proud of."

BELOW: **Development art of Remus Lupin's werewolf form by Rob Bliss for *Harry Potter and the Prisoner of Azkaban*.**
OPPOSITE TOP: **One of the final realized concepts for the werewolf Remus Lupin by Adam Brockbank.**
OPPOSITE BOTTOM LEFT: **Lupin, in his werewolf form, howls at the full moon.**
OPPOSITE BOTTOM RIGHT: **Concept studies by Rob Bliss for *Harry Potter and the Prisoner of Azkaban*.**

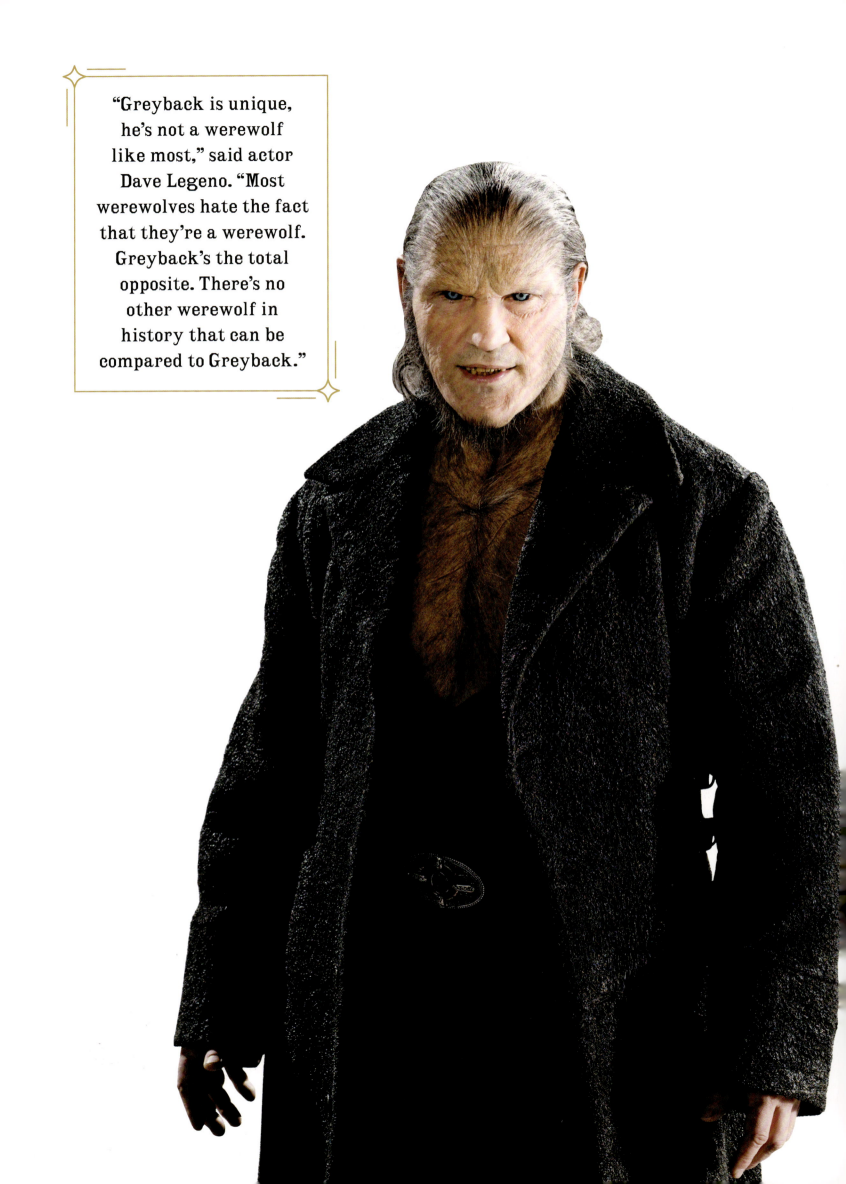

"Greyback is unique, he's not a werewolf like most," said actor Dave Legeno. "Most werewolves hate the fact that they're a werewolf. Greyback's the total opposite. There's no other werewolf in history that can be compared to Greyback."

WIDER WIZARDING WORLD

Werewolf: Fenrir Greyback

The difference between Remus Lupin and Fenrir Greyback is that Fenrir Greyback *likes* being a werewolf. "And he wishes everyone would join him," said Dave Legeno of the character he first played in *Harry Potter and the Half-Blood Prince*. Though not a Death Eater, Greyback is allied with Voldemort and is involved in the attacks on Diagon Alley, Hogwarts' Astronomy Tower, and The Burrow in *Half-Blood Prince*, and he participates in the Battle of Hogwarts in *Harry Potter and the Deathly Hallows – Part 1* and *Part 2*.

Unlike Remus Lupin, Greyback does not transform completely from man to beast and back again. "What we wanted to do with the werewolf Greyback," says special creature and makeup effects designer Nick Dudman, "was create a look that, if you saw this guy at a distance, you'd just think he's a big, threatening guy. But when you got closer, you'd think, what's going on here?" Fenrir Greyback is suspended animal and human, not fully transforming, and so he is both wolf and man, another unusual take on the iconic werewolf creature.

The designers looked at the patterns of a wolf's coloring, the timber wolf in particular, and the texture of a wolf's pelt. "Greyback is a large silicone makeup that looks like a subtle hair job, which is what I wanted," explains Dudman. "So he doesn't actually look like he's wearing much makeup even though he's covered in it." Similar to other hybrid creatures designed for the Harry Potter films, there is no demarcation line between his two forms. "We brought the fine down of a wolf into his face and chest," Dudman continues, "which follows the direction of an animal, not a human. You're not quite sure where human hair begins and where this slight pelt ends. We've restructured his face slightly and removed his eyebrows but otherwise he's human." Legeno wore very dark contact lenses that reflected light back in the same way as a wolf's. "He's got very dark eyes with a bright gray center that reflects light in a stronger way than a human eye. But the eye itself is really dark, which is very animal and very odd," Dudman explains. "This was a fun opportunity to do a nice character makeup that just happened to have a slightly weird side to it."

When filmmakers reviewed the initial version of Greyback's makeup, one producer asked if the nose wasn't a bit too big. "And it was actually my own nose," said Legeno. "That was the only thing they found a problem with and there wasn't anything I could do about it."

Legeno discussed his character with director David Yates, "to get an idea about what makes him tick," said Legeno. "I felt most for myself that Greyback feels rejected by the world. And rather than wanting to join the rest of the world, he wants them to join him." Greyback is the werewolf who bit Remus Lupin, and in *Deathly Hallows – Part 1*, we learn he has also bitten Bill Weasley, the oldest son of the Weasley family.

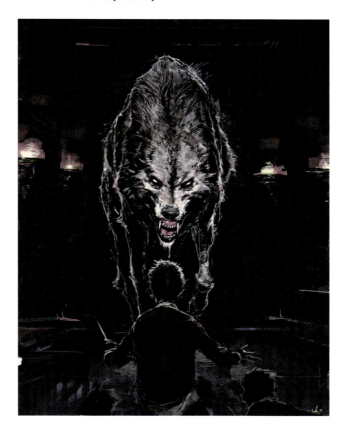

OPPOSITE: **Actor Dave Legeno strikes a threatening pose as Fenrir Greyback in *Harry Potter and the Half-Blood Prince*.**
RIGHT: **Harry tries to fend off Fenrir Greyback during the Battle of Hogwarts in development artwork by Rob Bliss for *Harry Potter and the Deathly Hallows – Part 2*. The encounter did not occur in the film.**

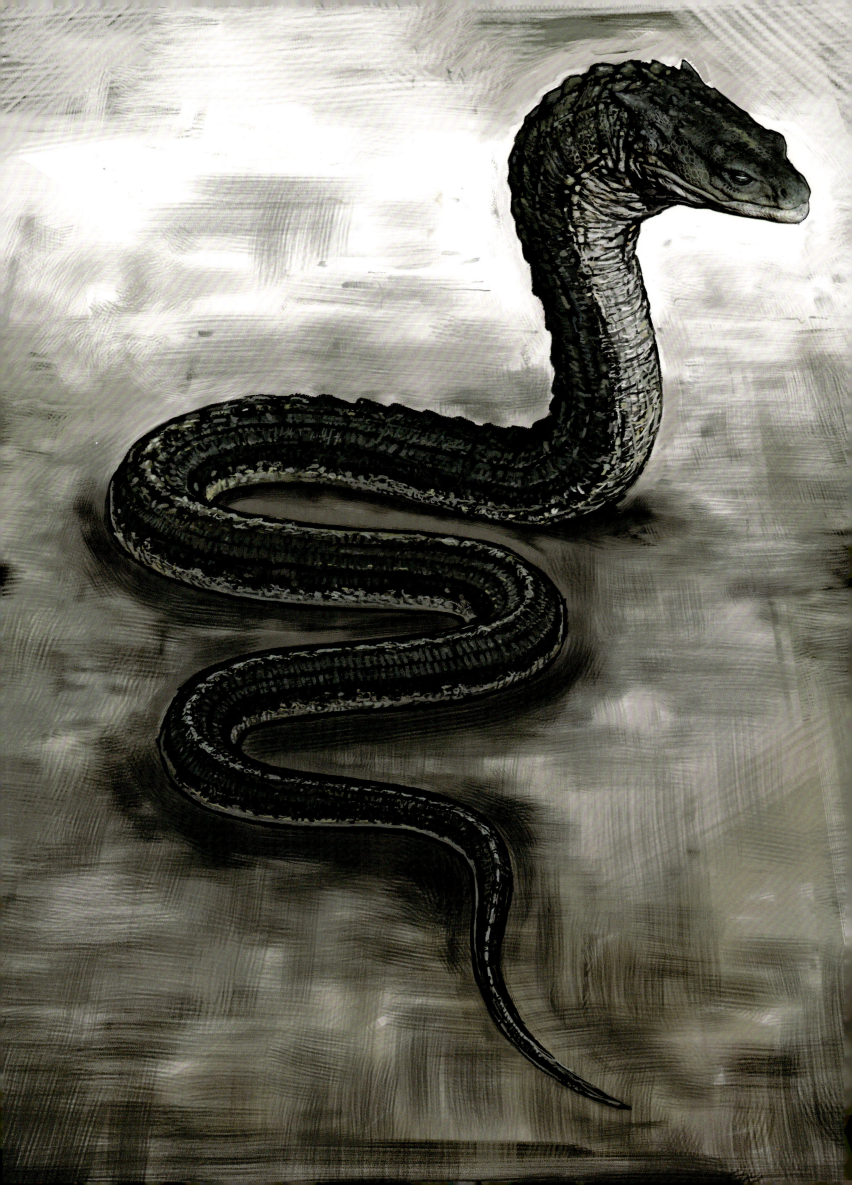

WIDER WIZARDING WORLD

Basilisk

When Hogwarts School of Witchcraft and Wizardry was built roughly one thousand years ago, one of the founders—Salazar Slytherin—wanted to teach only pure-blood students at the school. This idea was rejected by the other founders, and Slytherin departed—but not before he sealed a dangerous creature called a Basilisk in a room he called the Chamber of Secrets; when released at the command of the true "Heir of Slytherin," the serpent would eliminate half-bloods and Muggle-borns. One look into its eyes causes death.

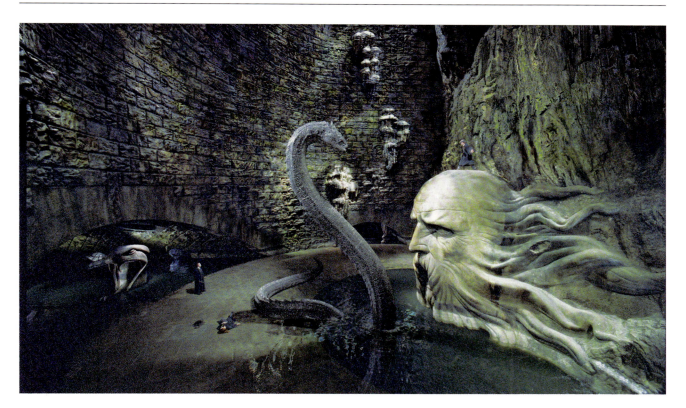

Concept artist Rob Bliss designed the Basilisk. He, along with the visual effects department, observed live snakes, including an eight-foot-long Burmese python named Doris. As concepts progressed, the artists added characteristics of other reptiles, including monitor lizards and crocodiles, which resulted in the Basilisk taking on an almost dragon-like appearance. Its textures were based on snakes but exaggerated, with bony plates and hard scales. Bliss's design was turned into a small-scale painted maquette for cyberscanning.

Harry discovers the entrance and goes with Ron and their professor, Gilderoy Lockhart, to confront the Basilisk. In tunnels leading to the Chamber, they see an intact skin shed by the serpent. For this, the creature shop created a forty-foot snakeskin made from urethane rubber to give it a translucent quality.

ABOVE: **Harry Potter (Daniel Radcliffe) protects Ginny (Bonnie Wright) from the Basilisk during its death throes within the Chamber of Secrets in** *Harry Potter and the Chamber of Secrets*.
OPPOSITE: **The deadly Basilisk envisioned by concept artist Rob Bliss.**

> The Basilisk returns—or at least its corpse does—in *Harry Potter and the Deathly Hallows – Part 2*, when Ron and Hermione enter the Chamber to retrieve a fang to destroy the Hufflepuff cup Horcrux. An eight-foot-long model of its fang-filled skull and neck vertebrae was sculpted and molded in fiberglass for the actors to play against.

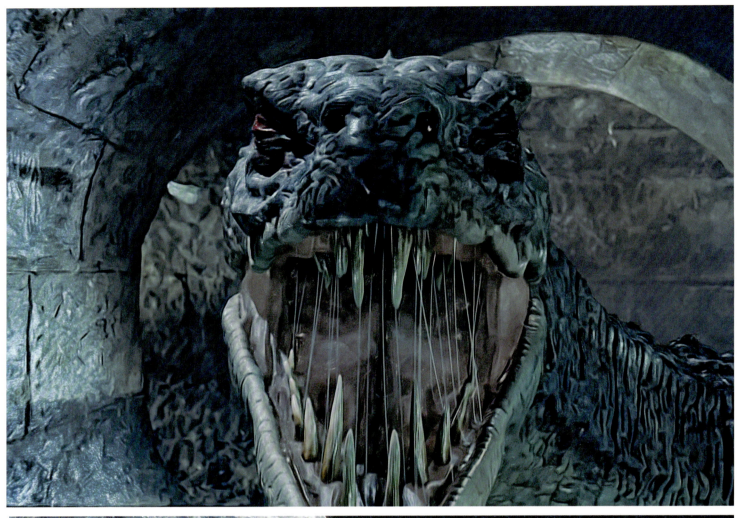
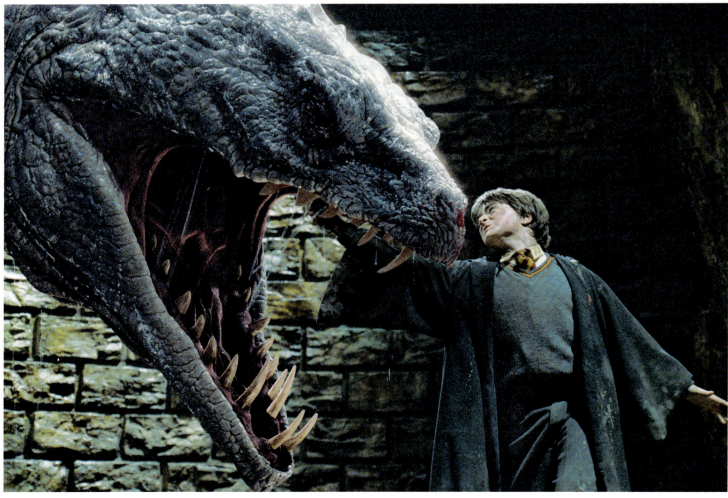

WIDER WIZARDING WORLD

Harry makes it into the Chamber and finds a possessed Ginny Weasley under the control of Tom Riddle, a memory of Lord Voldemort kept in a Horcrux diary; Riddle now controls the serpent. Harry battles the Basilisk with the Sword of Gryffindor and kills it. He also destroys the diary with a Basilisk fang, rescuing Ginny.

A general assumption for the filmmakers was that whenever a creature was in motion, visual effects would make it that much more believable. But director Chris Columbus wanted Daniel Radcliffe to have something practical to work with when he was battling the Basilisk.

The creature shop made a practical form of the mouth of the Basilisk for Radcliffe to stab with the sword, to which the digital artists added. But, Dudman says, "If we were going to sculpt all the teeth and the inside of the mouth, we should just sculpt the entire head. It would save them a CG shot. This led to a request to sculpt a bit of the neck. 'And can you make the jaw open?' Well, we could mechanize it, yes. 'And when it's stabbed, wouldn't it be good if the nose could twitch?' Okay. 'And could its blind eyes move? And if its fangs could hinge backward, as any venomous snake's does, so that it could close its mouth?' So by the time you've done that and run blood tubes through it, we ended up with twenty-five feet of an animatronic Basilisk on a dolly track." The retraction of its fangs in its three-foot-deep haws was cable-controlled and the model used aquatronics in his mouth and body for smooth slithering.

A good portion of that twenty-five feet was the neck of the Basilisk, which proved challenging to create. What Dudman had in his mind was to construct a six-sided geodesic shape and brace it at regular intervals with lengths of aluminum. "Since we were going to be hurling it at our leading man, we needed to make it as light as possible," he explains. "To do this, we were going to have to drill a lot of holes in the aluminum that would take fairly intricate machine work and be extremely time-consuming." While contemplating this, one of his crew suggested using aluminum stepladders for the interior. "I thought he was joking," remembers Dudman, "but that was essentially the form. So we did—cutting them up and using the side pieces that already had holes where the rungs had been attached to make the Basilisk's neck." This practical part of the serpent, covered in a painted foam rubber skin, was placed on a track laid on the floor to slither forward and close in on Harry during the fight scene. A counterweighted pole arm raised and lowered the creature, which allowed it to slide closer and closer to Harry as they fought. Although the Basilisk was lengthened to its full forty feet through digital animation, the parts created by the creature shop still weighed one and a half tons.

The Basilisk hisses and roars, and after Harry defeats him, groans in pain. Sound designer Randy Thom put together a mash-up of animal sounds, including horse and elephant vocalizations, a tiger's roar, and even his own voice.

OPPOSITE TOP AND ABOVE: **Close-ups of the Basilisk's head. Its fangs hinged backward, mimicking the way real venomous snakes close their mouths, seen in *Harry Potter and the Chamber of Secrets*.**
OPPOSITE BOTTOM: **Harry (Daniel Radcliffe) defeats the Basilisk with the Sword of Gryffindor.**

191

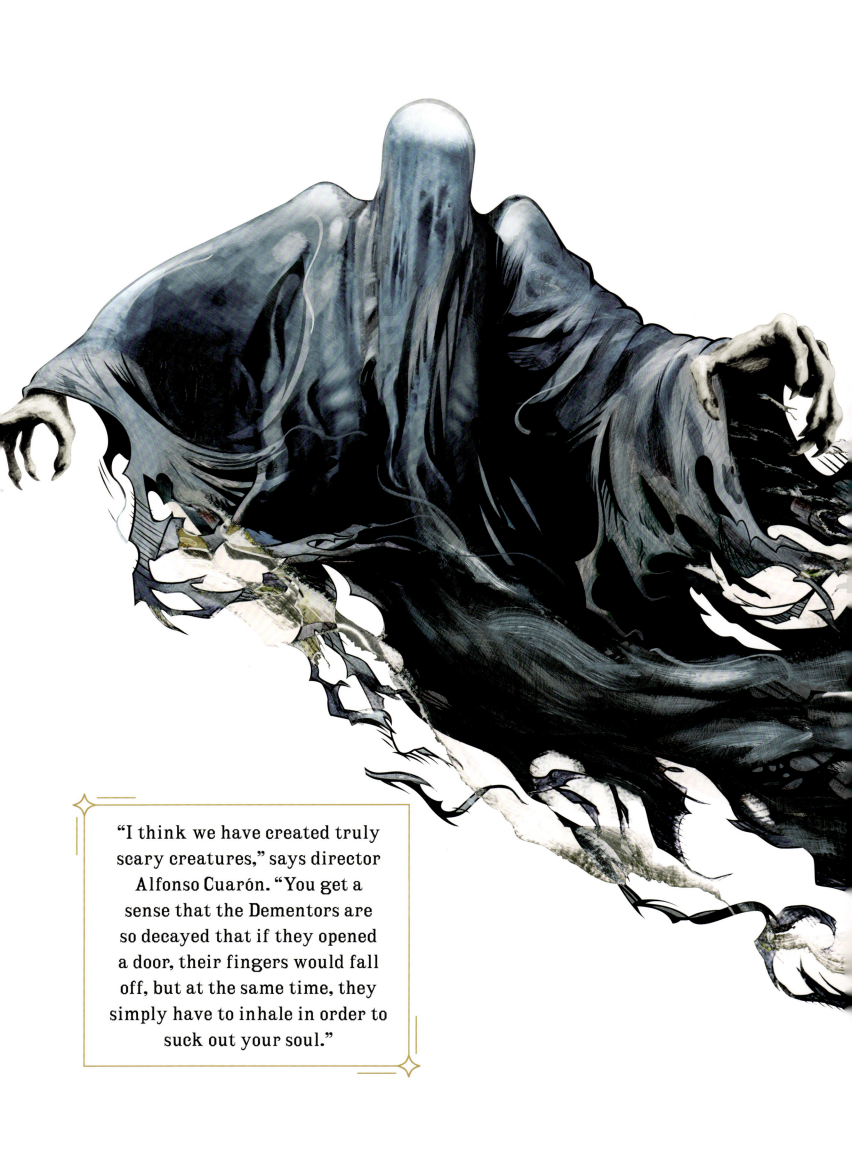

"I think we have created truly scary creatures," says director Alfonso Cuarón. "You get a sense that the Dementors are so decayed that if they opened a door, their fingers would fall off, but at the same time, they simply have to inhale in order to suck out your soul."

WIDER WIZARDING WORLD

Dementors

Dementors are "amongst the foulest creatures to walk this earth," says Defense Against the Dark Arts Professor Remus Lupin in *Harry Potter and the Prisoner of Azkaban*. "They feed on every good feeling, every happy memory, until a person is left with absolutely nothing but his worst experiences."

This is what Harry feels when Dementors surround and infiltrate the Hogwarts Express in their search for escaped prisoner Sirius Black. One Dementor enters the compartment containing Harry, Ron, Hermione, and Lupin, but it gravitates toward Harry, who seems to be affected more than most. "The Dementors were probably the scariest element we had to deal with," says executive producer Mark Radcliffe. "You're talking about something sucking out your soul and leaving you lifeless."

The Dementors' look began with director Alfonso Cuarón's vision for spectral, hovering creatures with arms but no legs. Concept artist Rob Bliss created images where the Dementors' robes became more of a veil, with just a suggestion of an anatomical frame when the Dementors glided in the air, and swathed them in shroud-like black robes hanging from their skulls. Artists further explored the creature's interior structure as a legless skeleton with a spine ending in a pronounced tail section instead of a coccyx, and wrapped all this in decaying skin. There are no other features on the head except for a yawning, lamprey-like mouth.

OPPOSITE: **A Dementor floats in concept art by Rob Bliss for *Harry Potter and the Prisoner of Azkaban*.**
ABOVE: **Rob Bliss's development art of Dementors played with ideas for colors and textures.**
FOLLOWING PAGES: **Instructed by the Ministry of Magic, Dementors surround Hogwarts castle during the search for the titular prisoner, Sirius Black, in *Harry Potter and the Prisoner of Azkaban*.**

WIDER WIZARDING WORLD

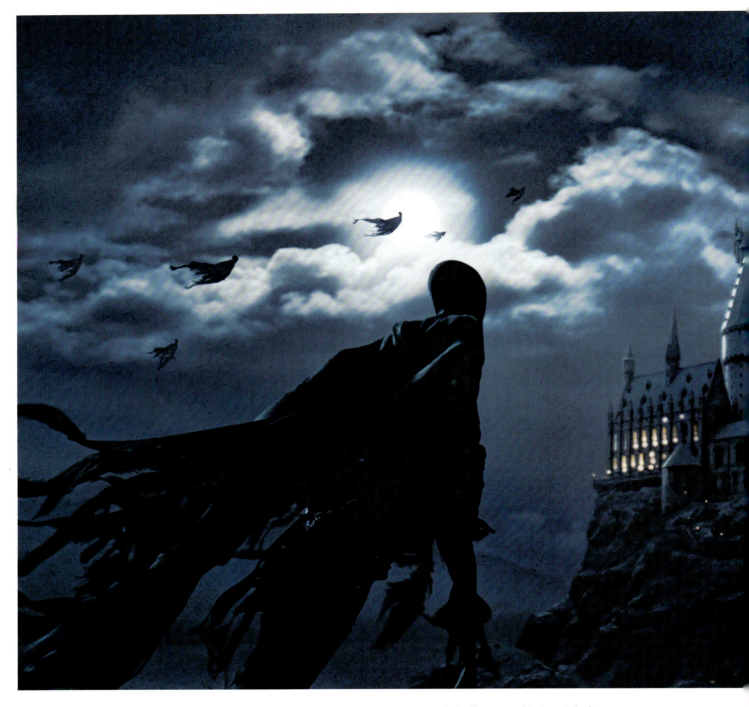

Costume designer Jany Temime participated in the Dementor development process. Temime based her interpretation of the Dementors' robes on a bird's wing. "We tried every single fabric that could float," says Temime. "Silicone, nylon, just to find the best floating effect." Early one morning, Temime walked into her workroom. "I saw that dark thing in front of me and I was frightened," she laughs. "So I thought it might work."

The Dementors' naked form was translated into two maquettes, one in one-third scale size and another full size, both cast in silicone and painted. Because the Dementors were mostly seen in darkly lit scenes, their coloration was a combination of dark grays and blacks, so they wouldn't completely disappear. Artists referenced embalmed bodies, with rotting and loose wrappings, for the texture of both their skin and robes, and overlaid textures to give the appearance of layers of decay.

"It was a real challenge to distinguish the Dementors from other dark-hooded characters that have existed on film," says producer David Heyman. As the Dementors do not speak, movement was the key to communicating for the chilling characters. "So, Alfonso began by experimenting with slow-motion movement." The director's thought process was that the Dementors knew they would get their quarry, so they weren't in any hurry; they should move like royalty, with no urgency.

Cuarón worked with puppeteer Basil Twist to explore how this slow effect could be achieved. "We tested various Dementor forms in a huge water tank to get an idea of their movement," he explains. They shot the tests in slow motion, which was beautiful, but they quickly discovered that this method was not practical to use for the film. "Every now and then, this produced some really wonderful effects," says special creature and makeup effects designer Nick

WIDER WIZARDING WORLD

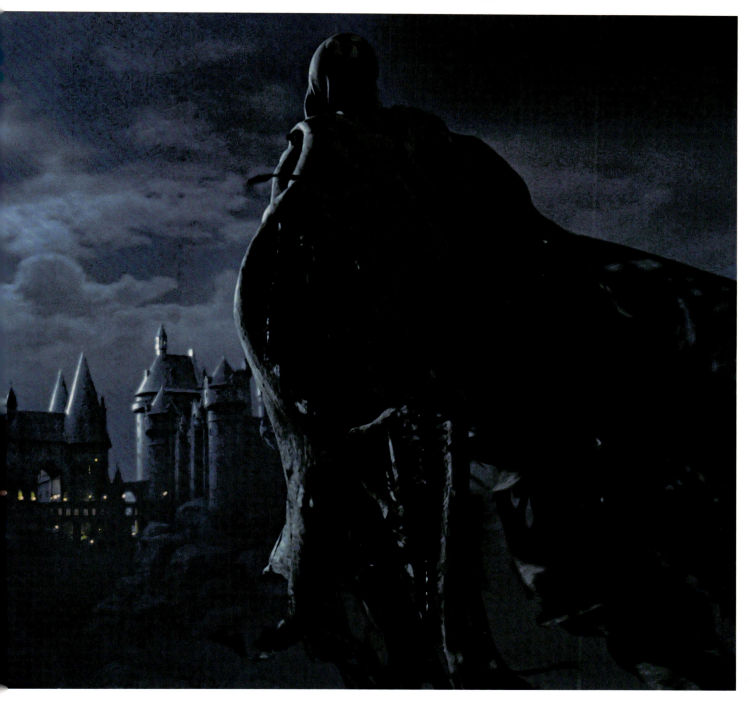

Dudman, "but, most of the time, it didn't, because it was impossible to control. There was no way we could make the movements match a live-action plate. It became obvious that the only logical way to do this was CG." Cuarón did select key moments from the tests that he thought captured his intended character of the Dementors. "Alfonso wanted to do something abstract and metaphysical," says visual effects supervisor Tim Burke. "It was these early tests that provided the creative direction for the Dementors."

The one-third scale Dementor maquette served as a scanning reference for the digital model, which the visual effects team then enhanced. "Although we had proved it was going to be pretty much impossible to do what we wanted to do with puppeteers," says Cuarón, "the amazing thing was that we got the look we wanted. We used all the puppeteers' reference so the visual effects artists would have a perfect sense of what kind of movement and textures we wanted to achieve." The full-scale maquette provided by Dudman's team was used as an on-set lighting reference.

"Alfonso wanted to underplay them in a natural way, without making a big spectacle of every effects shot," says visual effects supervisor Roger Guyett. "We've always been asked to always see the creature as big as possible, and always in focus. But when we talked about adding more detail to the Dementors, for example, Alfonso insisted, 'No, let's just make it dark and shadowy. We don't have to see every detail all the time.' There's a lot to be said for not having the effects jump out at you."

In *Harry Potter and the Order of the Phoenix,* Dementors attack Harry and Dudley Dursley in Little Whinging, but Harry manages to drive them away with the *Expecto Patronum* spell. Filmmakers redesigned the Dementors with their hoods removed and their robes open to show decaying rib cages. Their anatomical makeup now included articulated hands with long, bony fingers and emaciated arms.

WIDER WIZARDING WORLD

Inferi

Harry and Professor Dumbledore visit a sea-swept cave while searching for Voldemort's Horcruxes in *Harry Potter and the Half-Blood Prince*, where the Dark Lord has hidden a locket believed to hold one of the pieces of his split soul. Once inside, the pair find a large underground lake with a small island in its center. On the island is a liquid-filled crystal basin; in order to retrieve the locket at the bottom, Dumbledore drinks the liquid, but it disables him. Trying to soothe his Headmaster's distress, Harry fills the crystal goblet with lake water and is suddenly confronted by a mass of withered bodies crawling up onto the island: Inferi.

> Film footage was shot of actor Daniel Radcliffe in a water tank being dragged beneath the surface and then embraced by a female Inferi to ensure the actor's hair and clothes floated naturally for that part of the sequence.

Inferi are resurrected corpses bewitched by a Dark wizard, in this case to guard the crystal basin and its contents. Director David Yates wanted the Inferi to evoke emaciated skeletons, but he very specifically did *not* want them to look like zombies. "David wanted the audience to feel for the Inferi because they're victims of Voldemort," explains visual effects supervisor Tim Alexander. The creatures needed to be both frightening and sympathetic.

"You're trying to find a unique twist, not slavishly copy anything," explains Yates. "But the minute you say: one, they're in a cave; two, it's dark; three, you've got to be able to see their eyes; and four, they're basically walking corpses, you think zombies. So you look at film zombies. Whenever you design anything that is basically an archetype or heading in the direction of a cliché, you have to look at everything that's been done before so you don't accidentally reinvent the wheel."

Creating the design of the cave's inhabitants fell to special creature and makeup effects designer Nick Dudman's creature department. "That was a difficult one design-wise, although they ended up being CG," he admits, "but we still have to produce a whole range of maquettes and scanning models for it." Concept artists Adam Brockbank and Rob Bliss came up with endless drawings. Using photographs of dead bodies submerged in water to determine how that condition affected the color and texture of skin, Bliss designed an Inferius. Then, sculptor Julian Murray studied woodcuts from the Middle Ages containing images of the misshapen and monstrous, along with classic works such as Dante's *Inferno* and John Milton's *Paradise Lost*. Remembers Dudman, "Julian Murray, who is my key sculptor, went off on a private pilgrimage to find all sorts of creative references, anything that depicted creatures in a hell-like location. He spent months doing endless small maquette collections of bodies in different positions to try and find the mood."

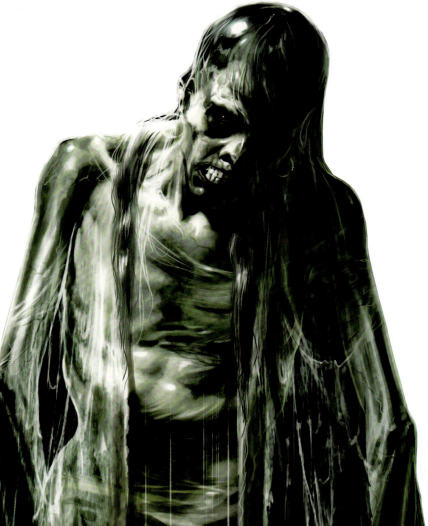

LEFT: **Study of an Inferius by Adam Brockbank for *Harry Potter and the Half-Blood Prince*.**
OPPOSITE: **Harry Potter is swarmed by the Inferi when he and Albus Dumbledore look for the Slytherin locket Horcrux in artwork by Rob Bliss.**

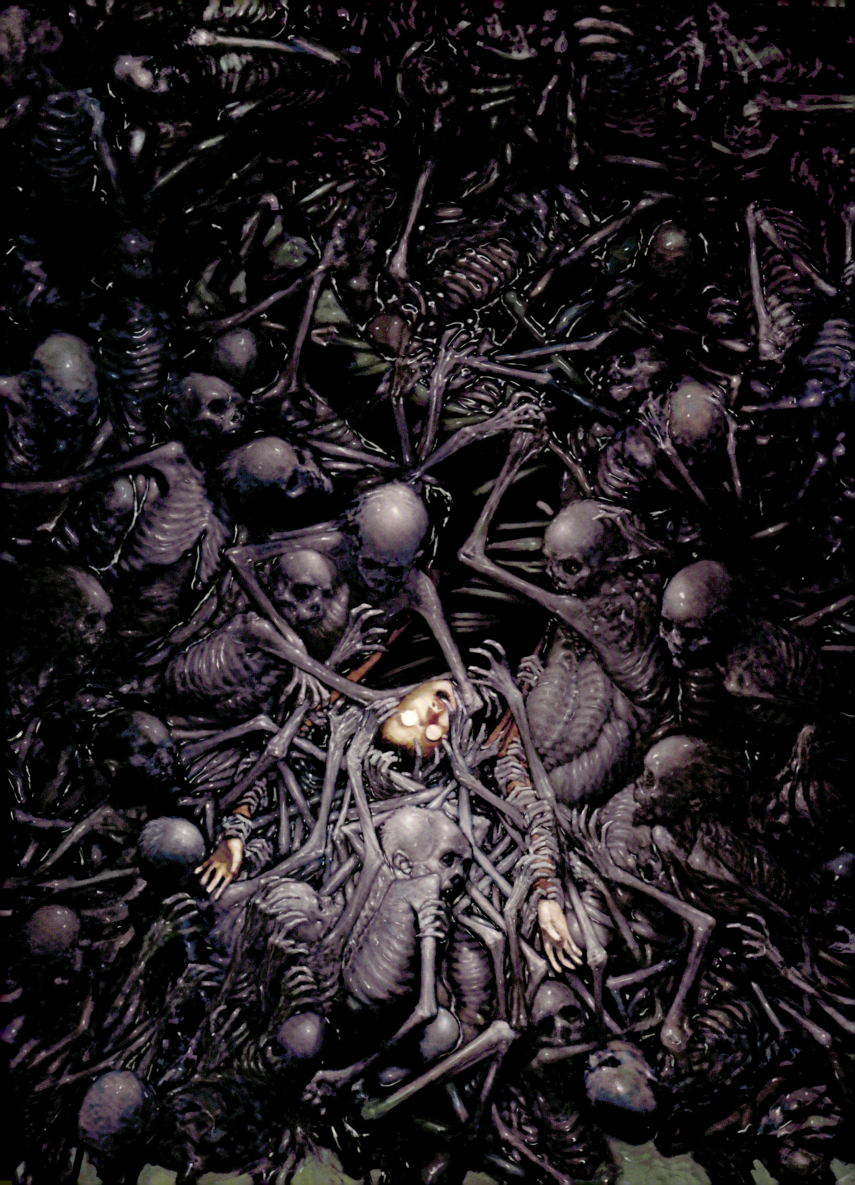

WIDER WIZARDING WORLD

As with any design—human, animal, or Inferius—an artist must start with an approach to the creature's basic anatomy. Dudman also considers the emotional core of any being. For the Inferi, Dudman says, "The key thing was the *pathos* of them. That was why having Julian Murray do the sculpt was really important to me and to [production designer] Stuart Craig, because he is absolutely superb at pulling emotion out of mud. Julian captures the soul of something in his sculpting, and that was what was needed. At the same time, it was also creepy, because they wanted creepy more than anything. It took two or three goes to arrive at something we liked."

Murray sculpted models of a male and a female version of an Inferius at full size but did not paint them before they were cyberscanned. The visual effects team incorporated a digital skeleton so the Inferi could be animated; they painted them in the computer. They layered on tones of gray and black and added a texture that gave the Inferi the essence of having once been covered in flesh.

Yates was also adamant that their movements not mimic the cliché of the movie screen zombie. Cameras filmed a cast of men and women in motion capture as though they were coming out from water and grabbing at Harry, so the Inferi's expressions and movements had a realistic but tortured, humanlike quality. "Not having them groan or stick their arms out helped get them away from anything zombielike," Alexander explains. "We wanted them to move more fluidly when coming out of water." Filmmakers combined this with computer-animated Inferi for their final version. In addition to men and women, there were two children Inferi, which added to their plight. The final shots above and below the water consist of thousands of Inferi entwined in a chaotic mass.

Nick Dudman describes the Inferi as "Clammy.... clammy and pitiful. And they are threatening, but there is an empathy with them. You don't know how they got there. You don't really know the back story, so you're not really clear what their motivation is or where they're from. You only know Voldemort did something dreadful and these are his victims."

OPPOSITE: **Studies of male and female Inferi by Adam Brockbank for *Harry Potter and the Half-Blood Prince*. Although the Inferi were terrifying, they also needed to evoke sympathy at their tragic plight.**
BELOW: **Inferi surround Harry and Dumbledore atop the crystal island in the Horcrux cave.**

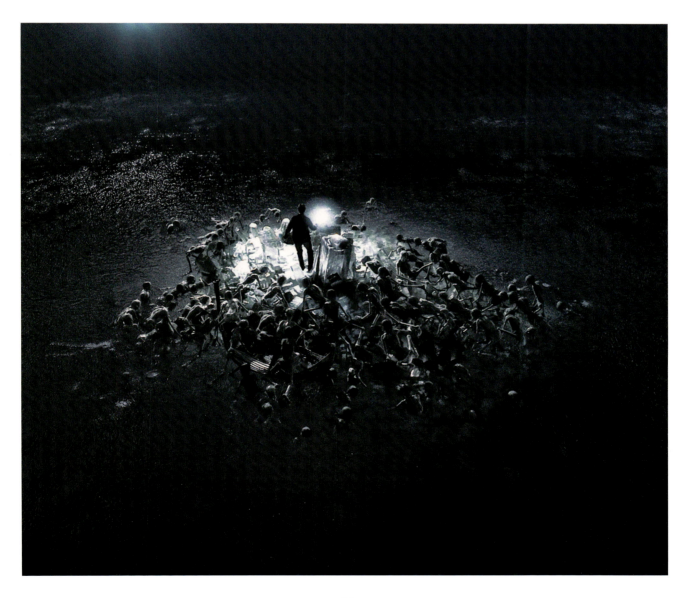

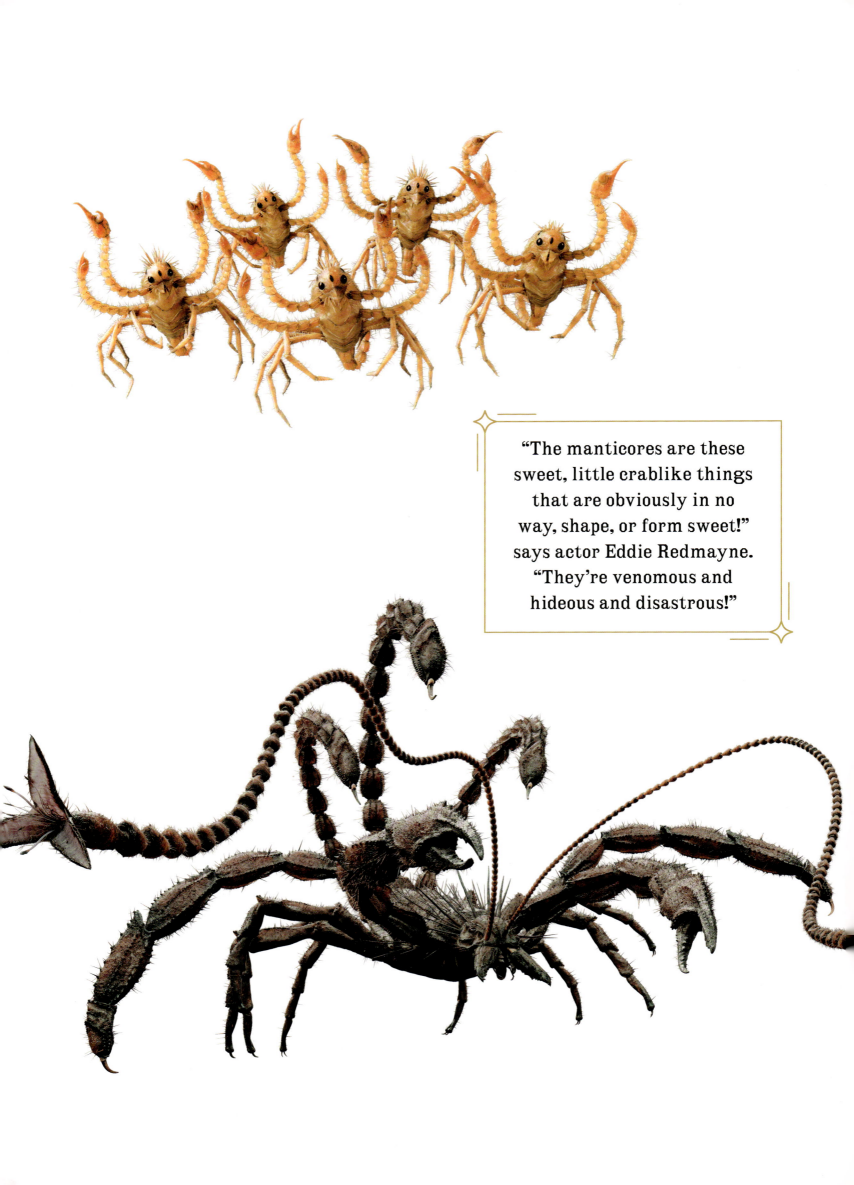

"The manticores are these sweet, little crablike things that are obviously in no way, shape, or form sweet!" says actor Eddie Redmayne. "They're venomous and hideous and disastrous!"

WIDER WIZARDING WORLD

Manticore

When Newt and his brother, Theseus, attend an event at the German Ministry of Magic in *Fantastic Beasts: The Secrets of Dumbledore*, Theseus recognizes a number of Grindelwald's acolytes in the room—and they recognize him. He tries to arrest them for the crimes they committed in Paris, but they knock him out with a spell and incarcerate him in the abandoned prison Erkstag.

The dark, damp prison is host to thousands of baby manticores. Manticores traditionally have the body of a lion and the tail of a scorpion. However, visual effects supervisor Christian Manz explains, "We started exploring what a creature could be that was mainly scorpion, but when it sits, we see it as little babies. It's got its tail curled around it, and it's wagging the tail as its little head looks up, so it looks like a little kitten. But then it sticks out its claws and it's quite obviously insectoid."

Director David Yates described himself as "desperate" to have a sequence with a very scary monster. "There are lots and lots of babies that are very hungry and need to be fed," he illustrates, "and a great big scary mother monster that resides in the depths of the jail, occasionally grabbing prisoners and feeding them to the babies. It sounds really horrible, and it *is* really horrible. But it is also slightly bizarrely funny because Newt's way out of the prison is to encourage the little baby manticores to do a little dance."

"It wouldn't be a Fantastic Beasts film without me having to go through some ritual humiliation, normally involving a ridiculous dance of some description," bemoans actor Eddie Redmayne.

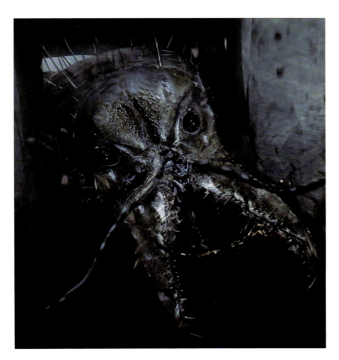

As Newt searches for Theseus's cell, he sees an adorable baby manticore. And then another. And another. Newt is intent on saving his brother, and the baby manticores are intent on following Newt. "Rescuing me, are you?" Theseus asks when he sees the babies following along as Newt performs some unusual crablike moves. "And I presume that whatever it is that you are doing is strategic?" Newt explains he's using a technique called "limbic mimicry."

"Because we'd done the Erumpent dance in the first film, we wanted to give something else for Eddie to have to do," says Manz. "We came up the idea of 'limbic mimicry,' where Newt has to do a specific walk that keeps the baby manticores from killing him." Manz suggests that in addition to the tension of Newt and Theseus's escape, "this sequence is all about what would you do to make your big brother look stupid, getting him to do this silly dance."

Redmayne worked with choreographer Alexandra Reynolds to create the unique walk. "What I love about Eddie is he's so committed and enthusiastic and determined," says Yates. "And in the case of the manticore sequence, it required giving it all in terms of that movement. Eddie doing that swivel of the hips might not look that difficult, but when you do it take after take, for about six or seven hours, by the end of it, you need a chiropractor!"

The brothers are safe in their escape until Theseus bungles the dance and steps on a baby. "And then chaos ensues," says Manz. "The mum arrives." The mother manticore, who is huge, is not seen entirely but suggested by massive hands and claws, operated by puppeteers, that lunge out of the prison's pit. "The mother's tail also fires venom that melts the rock walls," adds Manz. "I don't think we've ever done anything this scary."

OPPOSITE TOP: **Manticores in their sweet, puppylike version seen in *Fantastic Beasts: The Secrets of Dumbledore*.**
OPPOSITE BOTTOM: **The mother manticore, seen in a digital rendering.**
LEFT: **Concept art of the largest manticore by Dan Baker.**

WIDER WIZARDING WORLD

Matagots

Matagots are feline spirits with large, glowing eyes that protect Le Ministère des Affaires Magiques de la France (the French Ministry of Magic). These are "very unusual cats," says director David Yates. "They walk around the Ministry and bring people cappuccinos and pastries, among other things. They're very surreal, and that's why they're fantastic."

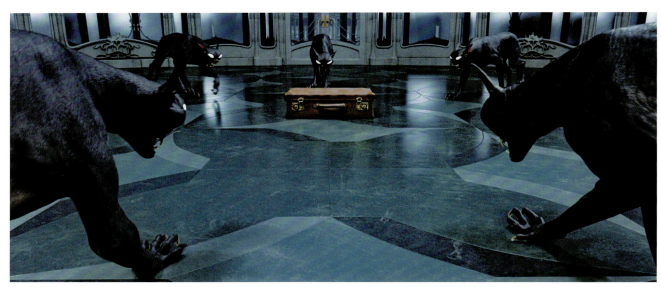

Creature designer Ken Barthelmy describes working on the Matagots as "great fun. These creatures are black spirit cats, partly spectral, with solid outer extremities." Barthelmy referenced running cheetahs to capture the elegance and power of the Matagots' legs, but at the same time, he knew his design needed to look scary and a bit aggressive. "We started with a 3D maquette and tried to make each angle visually interesting." To add more creepiness, he included big eyes and skinny legs to the design. Barthelmy admits developing the spectral nature of the creature was a challenge. "Once the 3D maquette was approved, we provided the director with options to explore the more ethereal quality," he explains. "Translucency and glowing eyes gave the design a very supernatural look." The final illustration by the concept artists captured a dynamic pose to show the strength and energy in the arms, neck, and shoulders.

Puppeteer Tom Wilton calls the Matagots "wonderful spiritual cat guardian creatures." Wilton, among other puppeteers, portrayed their movement to give the actors eyelines and to understand their interactions. "Physically embodying them meant that, take after take after take, we were quadrupeding on all fours, crawling along to the top deck of this beautiful set, being catlike."

ABOVE: **The Matagots act as a kind of security force in the records room of the French Ministry of Magic in a scene from** *Fantastic Beasts: The Crimes of Grindelwald*.
OPPOSITE: **Artist Ken Barthelmey portrays a Matagot pouncing in attack.**

202

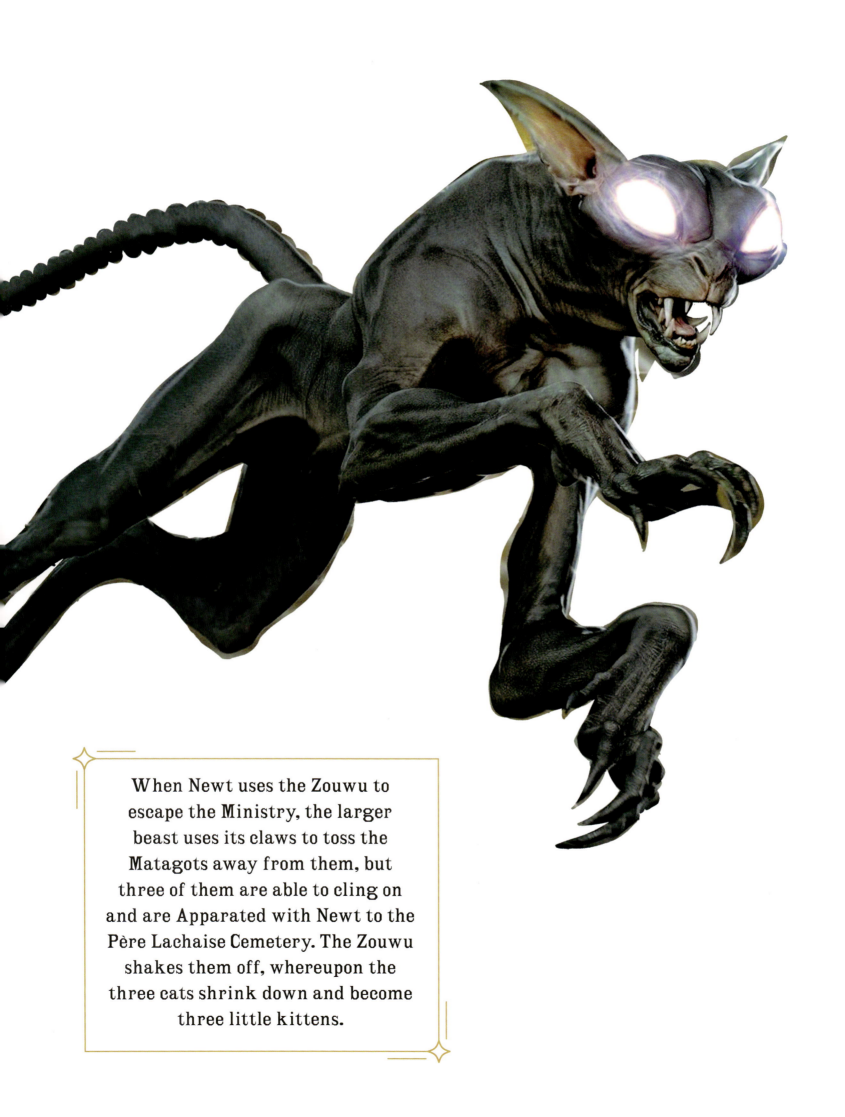

When Newt uses the Zouwu to escape the Ministry, the larger beast uses its claws to toss the Matagots away from them, but three of them are able to cling on and are Apparated with Newt to the Père Lachaise Cemetery. The Zouwu shakes them off, whereupon the three cats shrink down and become three little kittens.

WIDER WIZARDING WORLD

Serpent

The faithful serpent, Nagini, is not only a servant to Voldemort but his final Horcrux, who could be seen as an evil creature in her own right. Nagini debuts in *Harry Potter and the Goblet of Fire* at the estate of the Riddle family, nursing a weak, infantile form of Voldemort to help him gain strength.

For *Goblet of Fire*, the creature shop created a full-size model of the snake at twenty feet long, based on the features of a Burmese python and an anaconda. The digital team then painted, cyberscanned, and enhanced the snake. Filmmakers used the same model for Nagini's digital animation in *Harry Potter and the Order of the Phoenix*.

For *Harry Potter and the Deathly Hallows – Part 1* and *Part 2*, Nagini played a bigger role, which gave the designers a chance to make her even more terrifying. "In this film, she was going to have a lot of chances to scare the kids," says production visual effects supervisor Tim Burke, "so, we redeveloped her character. For this one, we based her on a real python, but gave her more scary characteristics. I felt that when we'd last seen her, she wasn't quite a real snake."

The digital artists started from scratch and created a new version of the serpent that was a hybrid of a python and an anaconda, with added cobra- and viperlike movements. A snake wrangler brought a real python to the Warner Bros. Studios in Leavesden, and the digital team was able to observe, sketch, and film the snake. They also took high resolution images of individual scales and used them to create new colors and textures. This not only added an iridescent quality to Nagini but also gave her the reflective properties of true snake scales. The artists also gave her sharper fangs. "And we gave her the eyes of a viper," adds Burke. This gave her more animation around her brows and eyes.

Fantastic Beasts: The Crimes of Grindelwald reveals Nagini's history, when it is discovered that Nagini, who comes from the depths of the Indonesian jungle, is a Maledictus: a human who carries a blood curse. Her curse is to turn into a snake every night before she goes to sleep. At the Circus Arcanus, she is also ordered to make the transformation in front of the crowds, as she is able to turn into the snake at will. "The Maledictus is a prisoner in the circus," says Claudia Kim, who plays Nagini, "and she's also bound to become a prisoner in her own body."

Eventually, the curse will make her transformation permanent. "She's turning into a snake," says director David Yates, "but she wants to be a woman while she can. So there's this really beautiful story of how she tries to cling to her humanity in the brief time that she has."

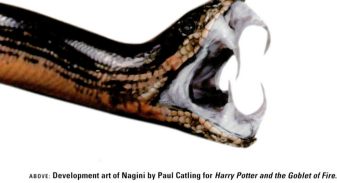

ABOVE: **Development art of Nagini by Paul Catling for** *Harry Potter and the Goblet of Fire*.
OPPOSITE: **Actor Claudia Kim as the Maledictus in her "snakeskin" dress in** *Fantastic Beasts: The Crimes of Grindelwald*.
PAGE 206: **Publicity still of Claudia Kim as the tragic Maledictus, later known as Nagini, for** *Fantastic Beasts: The Crimes of Grindelwald*.
PAGE 207 TOP: **Concept art by Paul Catling of the serpent Nagini, who was intended to suckle the embryonic form of Lord Voldemort in** *Harry Potter and the Goblet of Fire*.
PAGE 207 BOTTOM: **Nagini and Barty Crouch, Jr. (David Tennant) attended to the infant-like version of Voldemort in** *Harry Potter and the Goblet of Fire*.

WIDER WIZARDING WORLD

"It [is] interesting to see another side of Nagini," says Kim. "You've only seen her as a Horcrux. In [*Crimes of Grindelwald*], she's a wonderful and vulnerable woman who wants to live. She wants to stay a human being, and I think that's a wonderful contrast to the character."

For the serpent version of the Maledictus, designers once again observed a real python. This snake was also filmed wrapped around a mannequin so the designers could observe how the scales worked when it curled around a human form.

At some point, Nagini was completely transformed by the curse and acquired by Voldemort to become a Horcrux and his companion. In *Deathly Hallows – Part 2*, she is the last Horcrux to be destroyed before Harry can defeat a mortal Voldemort. It is Neville Longbottom who swings the Sword of Gryffindor and ends Nagini's sad life.

> While in Godric's Hollow, Nagini attacks Harry and Hermione at the home of magical historian Bathilda Bagshot, who has been taken over by the serpent. Nagini bursts through her body, a composite of live-action shots and digital versions of Hazel Douglas (Bathilda) and Daniel Radcliffe.

WIDER WIZARDING WORLD

Chupacabra

As MACUSA prepares to extradite Gellert Grindelwald into the hands of the International Confederation of Wizards, a metal box is presented to the Chief of Incarceration, Rudolph Spielman. "Mr. Spielman," says Abernathy, who works in the Wand Permit Office, "we found his wand hidden away." But this is a lie. Abernathy is now an acolyte of Grindelwald's, helping him to escape in a Thestral-driven carriage, and he hands Grindelwald his wand. When Spielman opens the metal box, he finds a lizard-like Chupacabra that jumps out and attacks him.

For an early sketch of the Chupacabra, concept artist Tyler Scarlet looked at bat skulls and their teeth arrangement. He gave the beast raptor-like claws for holding on to its prey in addition to a snakelike, prehensile tail. "I wanted it to look fierce even though it was tiny," Scarlet explains. Prior to starting his work, concept artist Sam Rowan visited the Grant Museum of Zoology and found strange specimens in jars. He liked the translucency in these specimens' skins and thought it was fitting for the character.

The concept artists tried many variations for the Chupacabra. In what he called the "snake" Chupacabra, Rowan gave the beast a bit of hair so that Grindelwald could stroke it. "I also played with long tentacle limbs," he says. "I liked the snakelike feel of it." There was even a "parrot" Chupacabra, a combination of a baby parrot and a monitor lizard, which Rowan thought was a strange combination of cute and gross.

"In some lore, there are references to the Chupacabra leaving puncture marks on its prey," Scarlet says. "I incorporated this into the head design by adding three large fangs. Its body was also heavily inspired by baby kangaroos and rats to give it a mischievous rodent feel."

As the Chupacabra might be considered a companion to Gellert Grindelwald, it needed both an affectionate and a vicious nature, so it was decided the Chupacabra needed to be cuter. More ideas sprang forth, including one where Rowan played with the idea of it being a spoiled pet, and expanded that to make the creature a rotund, corpulent version with both rat and lizard features.

The Chupacabra turns nasty, so Rowan added the look of holly leaves to its now fringed neck—"because of its untouchable nature," he explains. He also added retractable thorns and a holly-like crest. The leaves were originally colored green and red, but Rowan moved away from that palette and looked at the reds and blacks of deadly snakes for inspiration.

Grindelwald rescues the six-legged Chupacabra from Spielman's neck and cradles him like a favorite pet. "I know, okay, I know, Antonio," coos the Dark wizard. The little lizard almost purrs in his hands. Suddenly, Grindelwald's expression changes to one of disgust. "So needy," he says, and flings the beast through an open window of the carriage.

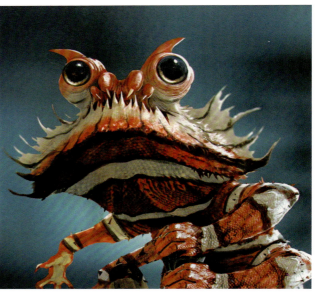

TOP: The Chupacabra aids Gellert Grindelwald in his escape from **MACUSA** in *Fantastic Beasts: The Crimes of Grindelwald*.
ABOVE: Artist Sam Rowan's "cute" version of the Chupacabra before it turns nasty.
OPPOSITE: The inflated version of the Wyvern carries Newt Scamander out of danger in concept art for *Fantastic Beasts: The Secrets of Dumbledore*.

WIDER WIZARDING WORLD

Wyvern

"The Wyvern has a pretty seminal role in an early moment in the film," says Eddie Redmayne, who plays Newt Scamander. After rescuing the second Qilin in *Fantastic Beasts: The Secrets of Dumbledore,* Newt is exhausted from, and battered by, his wand battle with Credence and other acolytes of Gellert Grindelwald in the jungles of the Tianzi Mountains in China. As he lays back and rests, Teddy the Niffler comes up out of the case to check on him, then scurries back inside, Pickett following.

Deep below, in the belly of the case, Teddy gets the attention of a large, birdlike creature filling its belly with fish in a swampy environment: the Wyvern. Answering Teddy's call, the Wyvern, which at this point has a spoon-shaped bill and body shape reminiscent of a dodo, flies up and out of the case with its long, feathery tail and short, stubby wings. It quacks at Newt, then rises up and begins inflating parts of its body until it resembles a small hot-air balloon. The Wyvern wraps the bulk of its tail around Newt, who is cradling the baby Qilin, then closes the case with its tail tip and slips its tail through the handle. Flapping small, iridescent wings resembling a hummingbird's, it lifts Newt and the case gently into the air, ascending into the dawn sky. Once it clears the top of the mountains, its body dramatically deflates, and it extends a set of majestic wings resembling those of a dragon as it flies toward the horizon.

"The Wyvern is a dragon-like, or birdlike, creature with a long tail," says visual effects supervisor Christian Manz, "and it can puff up like a like a pufferfish. So, it goes from looking like a little dragon to being something more like a hot-air balloon, with a long tail that can wrap around Newt. It has massive wings, so he can be flown away to safety by this creature."

The visual artists looked back at the dragons in the Potter films and decided they'd do something different for the Wyvern. "And very early on, one of our artists came up with a brilliant idea of this hot-air-balloon-type dragon that could blow itself up to escape," says Manz. "It felt very much of our world, you know, something that was a bit bonkers and fun."

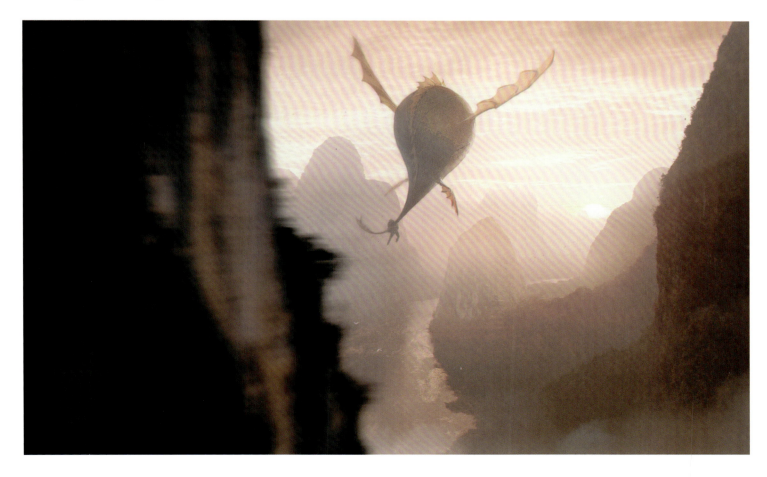

WIDER WIZARDING WORLD

Qilin

The election of a new Supreme Mugwump to head the International Confederation of Wizards involves the approval of the Qilin, a revered, small, deerlike creature that has the ability to look into a person's soul and see if they carry true goodness within them. In *Fantastic Beasts: The Secrets of Dumbledore*, that election is upon the wizarding world, and so a Qilin must be found.

"There's this extraordinary creature that is incredibly enigmatic called the Qilin," explains Eddie Redmayne, who plays Newt Scamander. "The Qilin arrives historically in moments of great change within people in power." Dumbledore assigns Newt to travel to the Tianzi Mountains in China and retrieve this mythological beast. "When we find Newt at the beginning of the film, we meet a mother Qilin giving birth," says Redmayne. "The baby Qilin is incredibly beautiful and fragile, with an inner light that glows and a wonderful, gentle cry." Redmayne found the birth of the Qilin one of the more intense and emotional scenes of the film to shoot. "The puppeteers were not only moving the Qilins and the puppets, but making the sound effects. It really felt like you were there for the birth of something special."

Redmayne had been asking director David Yates to show Newt out in the world. "In the first film, he spent a year researching his book; he's been traveling around the world with his case," says the actor, "and I always wanted to see him in that environment in which he feels at his most compelling and most at ease. I was so thrilled when I got this script and saw that at the beginning, we would get to see him in the Tianzi Mountains in China."

Visual effects supervisor Christian Manz estimates the digital artists may have gone through three hundred concepts for the Qilin before deciding on its final look. Qilins come from Chinese mythology, where they are usually pictured as deerlike dragons with scales. "We went down the route of deer," says Manz, "which is not a traditional look, but because we felt the audience could relate to that." This Qilin was also influenced by the look of a dik-dik, a tiny antelope with a snout almost like an anteater's. "As the Qilin is a relative newborn, director David Yates wanted it to be a bit puppylike and naughty," Manz continues. "Then, at that one moment, when it bows to the new leader, it's got the necessary dignity—that was really nice and fun to play with."

As Newt delights at the birth of the baby Qilin, he's attacked by Credence Barebone and other acolytes of Grindelwald's, who also seek the creature. Newt grabs the newborn to save it. "When Newt rescues the baby Qilin, he dives over the edge of the forest and plummets down," says puppeteer Tom Wilton. "We did some really exciting work with stunts where they were essentially puppeteering the camera. They had it on wires coming down, moving very fast. Our Qilin puppet was flat-out going down this steep gradient. That certainly put me through my paces!

"Her characteristics are [those] of being delicate and fragile, but also inherently noble," Wilton continues. "Rod attachments were used on her legs and back for movement, and she had different heads, including one with a moving mouth."

The ceremonial election is called "The Walk of the Qilin," which occurs in a temple called the Eyrie, above Bhutan. Graphic artists Miraphora Mina and Eduardo Lima developed an iconography of graphics around the Qilin, seen in the ceremonial flags and homemade bunting displayed in the wizarding village, as well as in the tickets to the event. "The Qilin is what binds the place together," says Mina. "We drew a lot of versions of the Qilin, including the stance it takes when it chooses the candidate, and used that for decoration everywhere, for souvenirs and flags, painted on the sides of building, and ultimately in the temple itself." Mina and Lima chose an inky blue-black with gold embellishments for the palette of these hanging pieces to provide a quick visual means of reference.

TOP: **For a digital rendering, Grindelwald's acolytes Vinda Rosier (Poppy Corby Tuech), Carrow (Maja Bloom), and Credence Barebone (Ezra Miller), set out to find the Qilin at the same time as Newt Scamander in *Fantastic Beasts: The Secrets of Dumbledore*.**
OPPOSITE: **The Qilin mother and one of her babies in artwork by Sam Rowan.**

WIDER WIZARDING WORLD

> The Qilin puppets can light up. "This is part of her spirit when she finds a wizard or witch who is worthy," puppeteer Tom Wilton explains. "She can approach them and bow, and the ground is suffused with a nice glow."

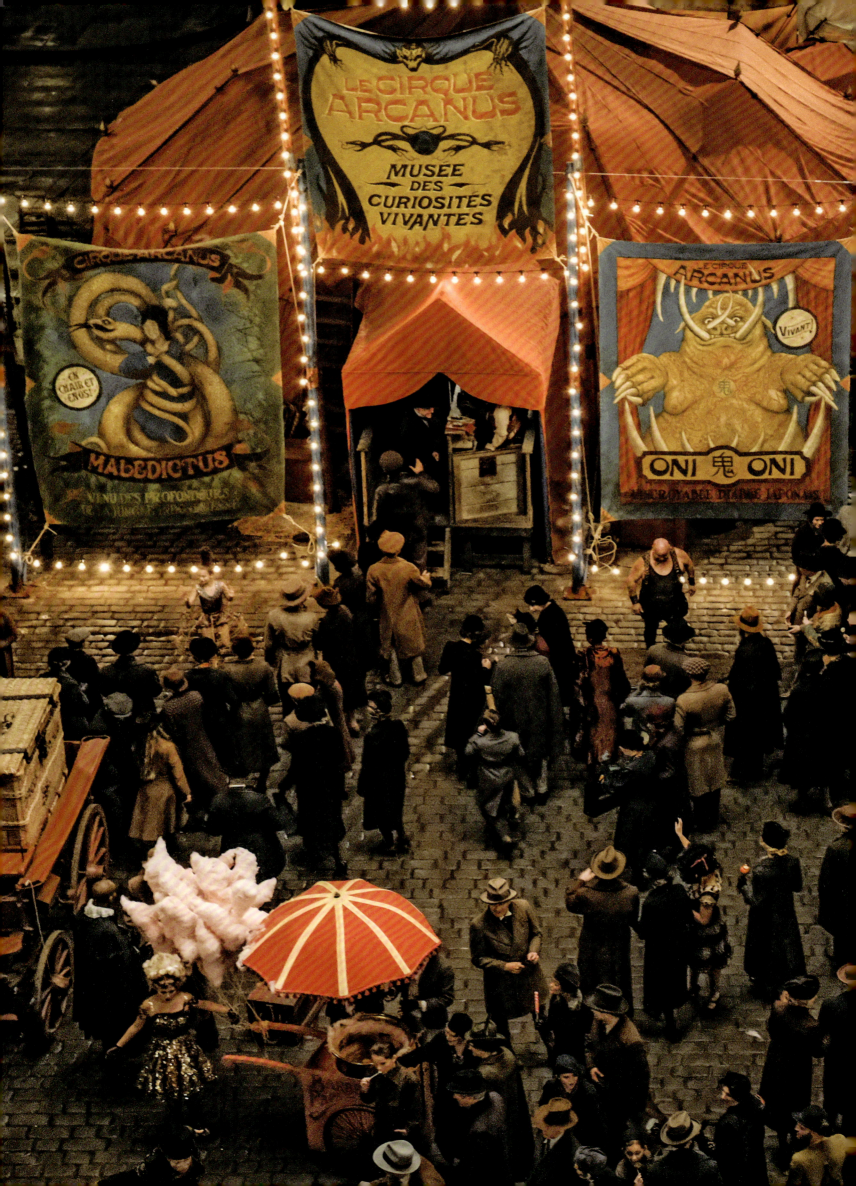

CHAPTER

8

CIRCUS ARCANUS

CIRCUS ARCANUS

Zouwu

The Zouwu is a regal, catlike, Chinese beast the size of an elephant with striped fur and a long, plumed tail that triples its length. A Zouwu is one of the magical beasts displayed at the Circus Arcanus in *Fantastic Beasts: The Crimes of Grindelwald*, but it has been chained and abused. When Credence sets the circus on fire, the Zouwu is able to escape its crate, and it disappears into the Parisian streets.

The Zouwu has two looks in the film. The first is the underfed, untrusting beast in captivity at the Circus Arcanus, deprived of its magical powers through the use of copious chains. At first, this catlike creature's mane was made of tentacles. "Trapped in its cage, the tentacles are slick to the beast's body," explains concept artist Sam Rowan. "When the Zouwu's temper flares, so does its mane, but [the tentacles] are limp, reflecting its despair." As work continued, concept artist Rob Bliss changed the mane of tentacles to a mane of hair. Artist Julien Gauthier explored how the Zouwu might appear as a combination of dragon, horse, lion, and deer. Once the Zouwu was freed, Gauthier noted, though injured, it had to be agile enough to climb, jump, and run.

Visual effects supervisors Christian Manz and Tim Burke asked the concept artists to focus on capturing an Eastern feel in the beast. Rob Bliss imagined that the Zouwu resembled the bronze Chinese guardian lions traditionally seen beside doorways come to life. "That was the origin of the design," he says, "somewhere between a lion and a dragon and cat and a dog."

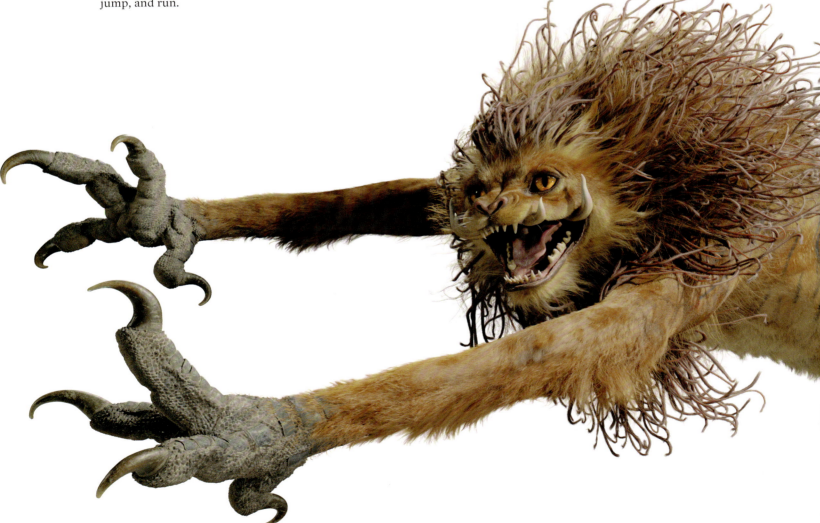

"When Newt first meets the Zouwu," says supervising creature puppeteer Robin Guiver, "it's injured and vulnerable. And despite the fact that it's a magical beast, there's a reality to that story we can all relate to, seeing how this happens in the real world. Newt recognizes this."

CIRCUS ARCANUS

Gauthier looked at Japanese Kabuki masks and Chinese dragon motifs. "The character needed to look proud, powerful, and formidable," says Rowan, who incorporated retractable teeth, an intimidating addition that carried through to the final design. Adds Bliss, "In trying to get an Eastern feeling to the character of the Zouwu, I looked at Chinese dragon masks, along with a mix of different animal anatomies, such as crow's feet, feathers, and fish scales." He continues, "Capturing the mad and crazed look of the masks was really important, too."

Newt first learns of the Zouwu while tracking Tina in the Place Cachée, where the Circus Arcanus performed. Newt uses the tracking spell *Appare Vestigium*, which reveals traces of magic, especially footprints and tracks in a specific area, and sees a vision of the fleeing creature.

As Newt, Tina, and Jacob pursue Grindelwald, Newt hears an earth-shattering roar. "Well, that'll be the Zouwu," he says, and Apparates to find the terrified beast on a Parisian street, swiping at passersby and cars. Newt opens his case and lays it down. As he stands and waits

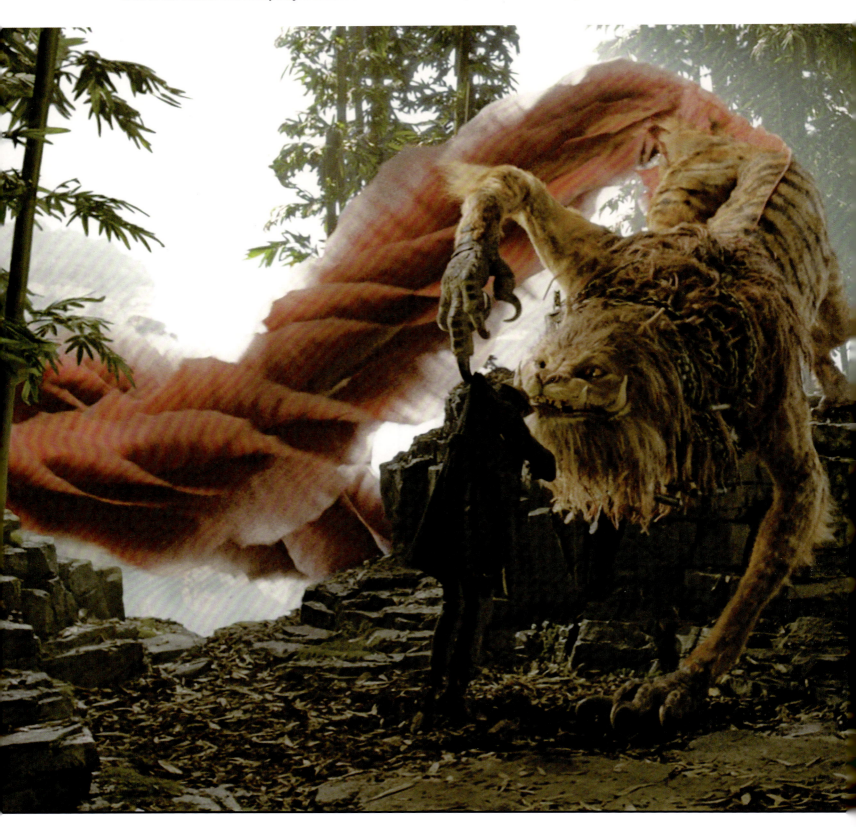

CIRCUS ARCANUS

patiently, the Zouwu advances toward him, snarling and baring its teeth. Suddenly, Newt holds something up. "It's a fluffy, furry giant cat toy," says prop workshop supervisor Christian Short, who worked on the item. "It even squeaks a little bit and has a bell." The Zouwu crouches down, then leaps toward the toy, and at the last moment, Newt drops it into his case and the Zouwu follows. Newt slams the case shut.

"Newt sees through that fear to what's going on inside it," says supervising creature puppeteer Robin Guiver,

PAGE 212: **Excited witches and wizards visit the Circus Arcanus while in Paris in** *Fantastic Beasts: The Crimes of Grindelwald*.
PAGES 214–215: **The Zouwu developed in leaps and bounds before the final look in this VFX rendering.**
BELOW: **Newt created an environment for the Zouwu inside his case, whom he enticed inside with a feathery cat toy.**
FOLLOWING PAGE: **The Zouwu in a rare calm moment, seen in a digital rendering.**

CIRCUS ARCANUS

"and fortunately knows how to handle it to get it into a safe place." While inside, Newt releases its chains and the Zouwu is able to recover from its wounds.

When Newt, Tina, and Leta Lestrange need to escape from the French Ministry of Magic, Newt releases the Zouwu, who helps him evade the Matagots that are attacking. Newt rides the Zouwu out before Apparating to their next destination. Man and beast land in Père Lachaise Cemetery, where Grindelwald is holding a rally. As Newt opens the case for the women to exit, the Zouwu comes up to Newt and nuzzles him in affection.

"We can tell they've bonded, but there's a lot of story to get into a very short moment," says Guiver. "Rather than ask our actors to mime this, we can have real physical contact. We had the Zouwu molded in soft foam, which has a lovely texture to it. We had the head of the Zouwu for Eddie to interact with, to stroke, to make eye contact with as well. It's the last time we see it, and they have this real big human and giant magical character cuddle."

"I think some of the most enjoyable work for me on this film is getting to interact with the creatures and working out the best way to do that," says Eddie Redmayne (Newt). "It's really a team effort. It's an entire concoction of puppeteers, stunt specialists, movement coaches, and visual effects guys." For Redmayne, the Zouwu is a perfect case in point. He reflects, "These guys crafted an extraordinary, green, bucking bronco of engineering that has three or four men dressed in full-on green screen suits moving it around. And then, at the front is an actual sculpted head, puppeteered by Robin Guiver, that gives Newt a friendly lick and a hug." Redmayne considers this some of the most surreal work he's ever had: "God, they're entertaining. You always end up with the weirdest pains and muscles you didn't quite know existed because you repeated being pulled or licked by the Zouwu."

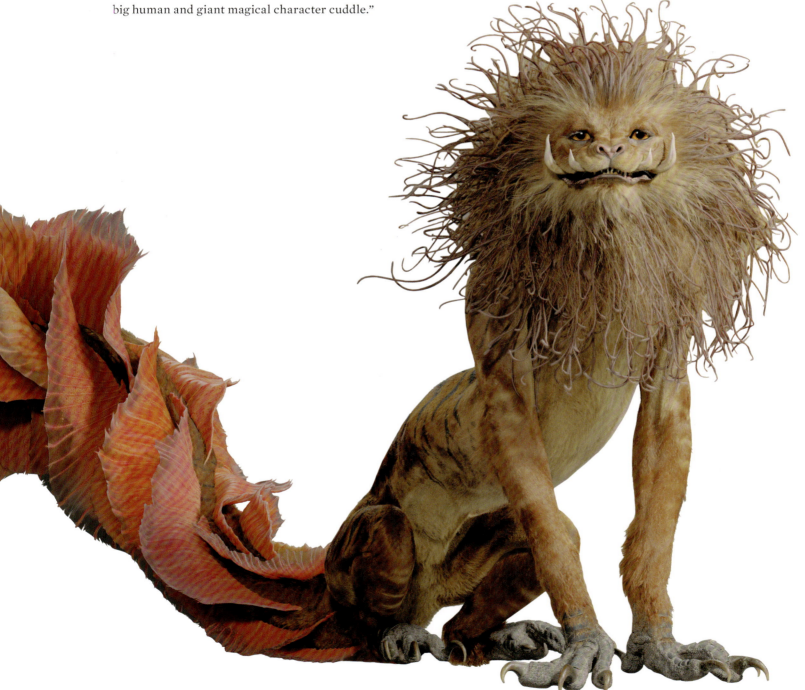

CIRCUS ARCANUS

Firedrake

Firedrakes may look like miniature dragons, but they are more like lizards and cannot breathe fire. They do create sparks with their tails, which, according to concept artist Paul Catling, was added to give the creatures a sense of movement. Red and gold sparks start at the base of the tail and run downward, falling onto whatever is beneath, which, in *Fantastic Beasts: The Crimes of Grindelwald*, is a very annoyed Kappa.

While Credence Barebone searches for his real mother in Paris, he finds work at the Circus Arcanus, a magical show run by the unpleasant ringmaster Skender. Credence has fallen in love with the Maledictus, Nagini, to the ire of Skender, who tries to keep them apart. One night, the same night Tina Goldstein visits the circus looking for Credence, he states to Nagini that this night they will escape.

Skender tries to get a reluctant Nagini to change into her snake form, yelling at her and hitting at her cage. Once transformed, Nagini lashes out at Skender, which Credence takes as his cue. He strikes at a cage of Firedrakes, who fly into the circus tent and set it and the small tents surrounding it on fire.

> Once filmmakers approved the design of the Firedrakes, artists reworked their design to ensure their proportions worked within the round cage in which the beasts are housed in the film.

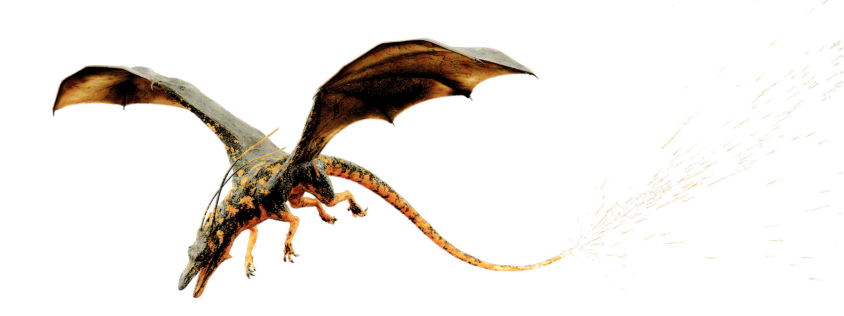

ABOVE: An early concept of the Firedrake for *Fantastic Beasts: The Crimes of Grindelwald* by Paul Catling, who also developed many of the dragons seen in the Harry Potter films.

219

CIRCUS ARCANUS

Kappa

One of the featured exotic beasts shown at the Circus Arcanus is the Kappa, a Japanese water demon, which was originally to be seen in *Fantastic Beasts and Where to Find Them*. "There were tons of creatures we designed and built," explains Pablo Grillo, animation supervisor on the first *Fantastic Beasts*.

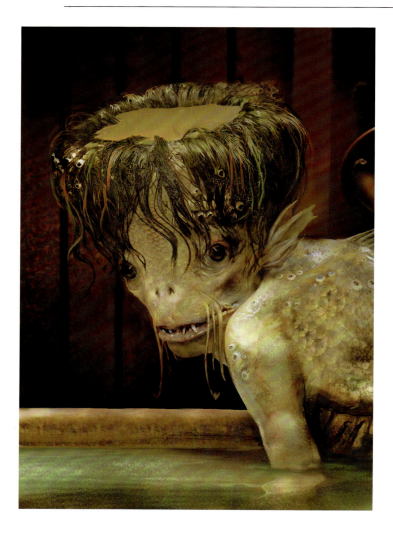

"Lots of the ones we built for Newt's case never made it. . . . we'd build these things and put them in front of [director] David [Yates], and say, 'What do you think of this' and he'd say, 'It's good.'" The creatures stayed under consideration, but if one conflicted with another, the idea was scrapped. "We did build quite a few," Grillo continues. "There was one called the Lethifold, and another called the Kappa. . . . The Kappa is a water creature that's incredibly powerful, but in order to outwit him, you have to make him spill the water he carries in a cup in his head. But he's very clever and tricking him into doing so is very challenging. So there was a scene where they confront a Kappa, and so we did go down the line of designing this bizarre Japanese animal, but it didn't make it [into the film]."

The design for the Kappa originally intended for the first film was revisited for *Crimes of Grindelwald*. "[It had] facial features borrowed heavily from the scaly looking wolffish, but the design direction soon changed," says concept artist Paul Catling.

Supervising creature puppeteer Robin Guiver and his puppeteers helped with establishing the size and shape of the Circus Arcanus creatures, even though the performing beasts were generally computer generated. For some digital beasts, colorful cutouts were used as stand-ins. "But, for example, as our young circus handler was scrubbing the Kappa, we had one of our puppeteers there holding up a big plastic chair for him to have something real to scrub against," says Guiver. "Very low-tech!"

> The Kappa is seen in an impression of the creatures who have been on the streets of the Place Cachée in the Circus Arcanus when Newt casts *Appare Vestigium* to track Tina Goldstein's whereabouts.

CIRCUS ARCANUS

Oni

The Circus Arcanus advertises the Oni as "the amazing Japanese devil." Concept artist Ben Kovar's first drawings of the Oni were based on a huge, rock-carved Buddha statue. He added body paint to the beast after seeing photographs of painted Indian elephants.

"I like the idea that the Oni was a gentle giant that let itself be painted by children," Kovar explains.

Production visual effects supervisor Christian Manz enjoyed researching the beasts seen at the Circus Arcanus, but sadly, he says, they are "animals that don't exactly look like they've been cared for the best, and you've got to feel for them. They've got to have that heart, and it's quite nice to be able to try and create that."

The celestial map that magically rotates on the main dome of the ceiling of the French Ministry of Magic features the Oni, the Kappa, and other beasts seen in the first two Fantastic Beasts films. "When we first did [the dome]," says concept artist Dermot Power, "we based it on existing astronomical charts from the 18th century, from beautiful, engraved calendars and other items." But the filmmakers decided they didn't want to use the existing zodiac or astronomical chart familiar to Muggles. "So," Power says, "I came up with another, rough version." However, Power didn't want to be the one to decide what the wizarding world's astronomical chart should be. Screenwriter J. K. Rowling sent a list to the artists including nearly all the fantastic beasts from the first movie, plus others from the Harry Potter books and films to choose from. For this astronomical map, for example, rather than Capricorn, it is a Graphorn.

OPPOSITE: **Artist Sam Molyneaux's work was a continuation of earlier concepts for the Kappa in its watery environment in** *Fantastic Beasts: The Crimes of Grindelwald.*
ABOVE: **An early drawing of the Oni by Ben Kovar, based on a rock-carved Buddhist statue.**
FOLLOWING PAGES: **Concept art of the celestial map on the French Ministry of Magic's ceiling, featuring the Oni, Kappa, and other beasts instead of existing zodiac imagery.**

PO Box 3088
San Rafael, CA 94912
www.insighteditions.com

Find us on Facebook: www.facebook.com/InsightEditions
Follow us on Instagram: @insighteditions

Copyright © 2024 Warner Bros. Entertainment Inc. WIZARDING WORLD characters, names and related indicia are © & ™ Warner Bros. Entertainment Inc. WB SHIELD: TM & © WBEI. Publishing Rights © JKR. (s24)

All rights reserved. Published by Insight Editions, San Rafael, California, in 2024.

No part of this book may be reproduced in any form without written permission from the publisher.

ISBN: 979-8-88663-157-9

Publisher: Raoul Goff
VP, Group Publisher: Vanessa Lopez
VP, Creative: Chrissy Kwasnik
VP, Manufacturing: Alix Nicholaeff
Art Director: Matt Girard
Designer: Lola Villanueva
Senior Editor: Anna Wostenberg
Editorial Assistant: Sami Alvarado
VP, Senior Executive Project Editor: Vicki Jaeger
Senior Production Manager: Greg Steffen
Senior Production Manager, Subsidiary Rights: Lina s Palma-Temena

 REPLANTED PAPER

Insight Editions, in association with Roots of Peace, will plant two trees for each tree used in the manufacturing of this book. Roots of Peace is an internationally renowned humanitarian organization dedicated to eradicating land mines worldwide and converting war-torn lands into productive farms and wildlife habitats. Roots of Peace will plant two million fruit and nut trees in Afghanistan and provide farmers there with the skills and support necessary for sustainable land use.

Manufactured in China by Insight Editions

10 9 8 7 6 5 4 3 2 1